LARRY'S KIDNEY

ALSO BY **Daniel Asa Rose**

FICTION

Small Family with Rooster

Flipping for It

NONFICTION

*Hiding Places: A Father and His Sons Retrace
Their Family's Escape from the Holocaust*

LARRY'S KIDNEY

Being the True Story of
How I Found Myself in **CHINA**
with My **BLACK SHEEP** Cousin
and His **MAIL-ORDER** Bride,
Skirting the **LAW**
to Get Him a **TRANSPLANT**—
AND
Save His **LIFE**

Daniel Asa Rose

wm WILLIAM MORROW
An Imprint of HarperCollins*Publishers*

HarperCollins books may be purchased for educational, business, or sales promotional use. For information please write: Special Markets Department, HarperCollins Publishers, 10 East 53rd Street, New York, NY 10022.

FIRST EDITION

Designed by Betty Lew

Library of Congress Cataloging-in-Publication Data has been applied for.

ISBN 978-0-06-170870-1

09 10 11 12 13 OV/RRD 10 9 8 7 6 5 4 3 2 1

FOR THE PATIENTS . . .

If a mad dog runs at you, whistle for him.

—ANCIENT CHINESE PROVERB

Contents

Author's Note

When Larry and I were in China, a number of people put themselves and their livelihoods on the line to help us. Throughout the writing of this book, it has been crucial to protect these people by preserving their anonymity. For this reason, I have changed names, locations, and key features of several individuals and institutions, and have compressed a few time lines connected to their activities, so that they may continue their lives without being identified.

A word about the dialect: Although it has traditionally been considered condescending to write in dialect, the climate seems to be changing—and for good reason. In his recent book about India, *The Elephanta Suite,* Paul Theroux uses such locutions as "wicious" for "vicious," "moddom" for "madam," and "wee-icle" for "vehicle" in an effort to transmit more shades of emotional truth than a sanitized transcript can. Nor is the practice limited to native English writers. By writing, "My bawss was sacked, so we got laid all together" in his recent novel *A Free Life,* the Chinese-American author Ha Jin suggests how cross-cultural communication is a creative process for both native and visitor, with results that are sometimes as revealing as Freudian slips. Track-

ing both how foreigners use the English language and how an American visitor scrambles to make sense of foreign sounds is here meant to transmit the spirit of modern travel—equal parts charming and alarming.

Larry's dialect, meanwhile, is another matter entirely.

CHAPTER 1

The Phone Call

The cautious seldom err.

"Huwwo?"

"Hello, who's this?"

"Huwwo, Dan?"

"Yes. Who's this, please?"

"This is Larry, Dan."

"Who?"

"Larry. Your cousin."

"Whoa, my long-lost cousin Larry?"

"Yes, Dan, that's a fair description. I deserve that. I take full responsibility for being out of touch."

"My black-sheep cousin Larry?"

"That's also apt, as long as you're simply stating a fact and don't mean it in a negative way. Where did I reach you?"

"Actually, I'm on a chairlift in the Colorado Rockies, Larry, a couple of miles above sea level."

"In the middle of summer? I'm somewhat dubious. Not that I'm calling you a liar, necessarily, but people have been known to alter their whereabouts to avoid speaking to people they aren't necessarily eager to speak to."

"I'm with my mountain bike, Larry—about fifty feet in the air, over-looking miles of ski trails that double as bike trails in the summer."

"There, you see? I'm not dubious anymore. A perfectly cogent explanation. Some family members who will go unnamed—except that it's Cousin Burton—consider me an unreasonable man, but I just object to being lied to, or considered an idiot simply because I dropped out of high school instead of taking the standard family route of going to Harvard or Brown, which you never did."

"Never did what?"

"Considered me an idiot, at least to my face, which is one of the reasons I always looked up to you, Dan, even though you did go to Brown. Are you alone?"

"I'm here on vacation with my wife and two sons."

"I heard you got remarried. I've been meaning to call you. Congratulations."

"Well, that's fourteen years ago now, Larry, but thanks. Where are *you*?"

"I'm under my blankets in my Florida condo. I haven't come out for two days."

"What're you doing there?"

"I'm [-*SQUAWK*-]ing, Dan."

"You're what? We're passing over some sort of radio tower or something. What'd you say you were doing?"

"[-*SQUAWK*-]ing."

"What?"

"*Dying,* Dan. I need a favor."

[*Click.*] The line goes dead.

The phone rings again twenty seconds later. I scramble to adjust my bike so I can keep one hand free, and there it is again, the lugubrious voice, like that of a funeral director with a slight speech impediment. "Huwwo."

"Larry, sorry about that. Hold on a second, I've got to take these earplugs out. Okay, I can hear you better."

"What's with the earplugs? Is it cold?"

"No, nothing. My kids are nine and twelve, is all. It gets kinda noisy. Guys," I say, securing a couple of fast-moving collars within my fist so they stop ramming their handlebars into each other, "if you don't stop fooling around, someone's going to fall right under the—"

"Huwwo?"

"Larry, I'm still here. So what do you mean, dying? Literally or metaphorically?"

"Literally, Dan. Kiddie disease."

"Kiddie—"

"Kidney, kidney. Consequently, I'm depressed beyond all measure. More than depressed: I'm depressionistic. But first I have to ask: Are you still mad at me?"

"Mad? You mean for ratting me out to the FBI that time, telling them I'd inflated my income on a condo mortgage application, which you specifically advised me to do because you needed the commission?"

"I was upset, Dan. I'm not proud of it."

"And why were you upset? Because I had the gall to ask for the thousand dollars back that I'd loaned you to spot your latest invention."

"You're right, Dan, I regret it."

"Which as I recall was for wooden neckties."

"Which you could sponge the gravy stains off of. I still maintain that would have been huge if I'd had the proper financing."

The chairlift stalls above a grove of majestic pine trees, allowing the boys a momentary calm to see how far they can dangle one of the front wheels off the side. I nearly lose the phone grabbing a tire.

"No, I'm not mad at you anymore, especially since the FBI laughed it off. Besides, who the hell cares about that, if you're literally dying?"

"Oh, it's literal all right. Diabetes claimed first one, then bofe my kidneys. For two years I've been on a dialysis machine four hours every other day, watching my life ebb away before my eyes. Solution number one is off the table, because I'm not about to ask anyone in the family for their kidney, given how much they dislike my guts, which I assure you is mutual. But solution number two is surprisingly doable: I've been re-

searching the Internet from under the blankets, and it turns out China does more kidney transplants than any other nation. And I won't have to wait on a list seven to ten more years for a cadaver kidney, as my overcautious American doctors are telling me to—we could get a live one fairly quickly, if we make the right connections."

"Larry, hold on—what do you mean 'we'?"

"You're an old China hand, Dan. You used to do that travel column in *Esquire*—"

"Larry, I haven't been to China in twenty-five years! I don't have any more contacts there than you do."

"At least you know your way around. I've hardly ever been out of the States, except for luxury cruises to the Caribbean, which I could maybe fix you up on sometime, because college girls do things on a cruise ship they'd never dream of doing on shore, believe me, you could pass yourself off as a professor—"

[*Click.*] The line goes dead.

"Huwwo."

The chairlift is still stalled in the middle of the Rockies, giving me a chance to take in the scenery: azure peaks crosshatched by bicycle spokes. My wife's provisionally pacified the boys with an emergency Milky Way.

"Larry, I can't promise we won't get cut off again. The wind's kicking up, and we're swaying like a—"

"This must be eating up your airtime, Dan. I apologize. No, I'll do better. Send me the bill, you know I'm good for it—in fact, let me buy you a coupla new cell phones, those new ones that work at any attitude? I don't want to put you out any more than I have to."

"You're not putting me out, exactly, Larry, it's just—"

"We go there, we grab a kidney, we come back. Couldn't be simpler. Only one glitch, Dan, which honesty bids me report, because I want to start a new slate with you and be on the up-and-up about everything: They've made it somewhat illegal."

"They've made what somewhat illegal?"

"Certain select transplants."

"What are you talking about?" I say. "You're telling me—"

"Not for everyone! Most of the world can still come to China for transplants, exactly like I said. Everything I told you is correct down to the last letter of the law. It's just that the Chinese have made it illegal for certain select persons to get a transplant there."

"Which persons?"

"Western persons."

The chairlift creaks and moans as a second Milky Way is passed around.

"But, Larry . . ."

"Yes, Dan . . ."

"*We're* Western persons."

"Dan, we're *smart* Western persons. In the most populous country on earth, don't you think we're intelligent enough to find some people with loopholes? And I don't know about you, but loopholes are my bread and butter."

"But—"

"Don't always focus on the negative, Dan. Where there's a will, there's a way. And word to the wise: Just because you've got seniority over me by two years, don't lord it over me, okay? We're both in our fifties—big deal. The important thing is to not get off on the wrong foot and shoot the messenger. If it's one thing I've learned in almost nine years of off-and-on therapy, mostly off, it's that when you get bad news, you respond appropriately. Don't take it out on me, is all I'm saying. It's not my fault China has these crazy restrictions."

"Guys," I say, now that the sugar's kicked in and they're helping the wind make us rock, "if you keep that up, we're gonna flip right upside—"

"I commiserate with your cold feet, Dan, but I doubt it will be like last time you were there, when you got yourself thrown in jail—"

"Don't even bring that up, Larry."

"I'm just saying, anyone would be cowardly after that, but it was only three hours—a harrowing three hours, I know, but you're more mature now, you won't be tempted to clown around. . . ."

Pause while the chairlift restarts with a jolt. My wife lunges to seize both boys in the nick—

"Of course, maybe you've got more pressing concerns," Larry says. "I realize you're in a different league from me. I'm just a lowly worker bee and you don't necessarily want to get your hands dirty—"

"That's not it, Larry. Jeez, what a thing to say. I'm really sorry to hear about your condition, but I'm just not prepared to drop everything and—"

"How's life with the heiress, by the way?"

"That was a couple of wives ago," I remind him. "She wised up a long time—"

"Well, anyhow, in my humble way I'm just trying to make a clean chest right from the start," Larry says, "everything out on the table, no hidden agendas."

"Which reminds me," I say, "*are* there any hidden agendas?"

"None I can think of off the top of my head. Except that I'm [-SQUAWK-]—"

"What?"

"I'm getting [-SQUIZAWK-]"

The boys break out of their mom's body lock to start straddling the rail. "Guys, I'm serious now, someone's gonna break their neck if you keep—"

"[-SQUAWK- SQUEAK-SQUIZAWKING-]"

"Listen, Larry, this is a terrible connection. You're feeling merry? What?"

"[-SQUAWK-SQUEEEEEEE-ZAWK-]"

"Whatever, Larry. This is all too sudden. I'd have to run it by my wife, and I gotta warn you, she can be hell on wheels—"

I dodge the playful squirt from my wife's water bottle. "What, Larry? Someone was harassing me."

"I said, do what you have to do, Dan, the last thing I want is to pressure you, even though this *is* a matter of life and death and you *do* kind of owe me from the time I bailed you out at my bar mitzvah, remember, Dan?"

"Uh, not really, Larry, I have to admit your bar mitzvah's not shining real bright in my mind just at the moment."

"Well, even more recently, when you graduated college, I set you up renting slum apartments and let you stay in my spare bedroom and even let you steal my Valium, which you said at the time was a lifesaver. Seems like only yesterday, doesn't it?"

"Actually, no, it seems like a few decades ago. But listen, Larry, this is serious. Can't you find someone who actually knows what he's doing?"

"Dan, believe me, I wouldn't be calling if I had any other options, but it's not like I have a dime to help defray someone's expenses. Matter of fact, I keep finding these shady characters in Guam who want ten grand just to track a few unstable connections. There's very few people you can trust out there, plus most of them work for a living or let's say have jobs they can't take with them on a moment's notice the way a writer can — that's why I'm handpicking you, Dan. You could think of this as an honor, in a way."

"Who else do you have left, Larry, after you issued that fatwa against Cousin Burton. How'd you expect the family to react?"

"It wasn't a *fatwa* fatwa, exactly. Let's call it a wake-up call. A rather rude wake-up call, I grant you. But don't mire us in that again, Dan. I was upset. That's behind us now."

"Is it? Is the feud really behind us? I'm glad to hear that. Burton was hiding out in a cheap motel for two weeks."

"Oh, he's too high-and-mighty to stay in a cheap motel?" Larry says with some heat. "Just because he's the biggest brain surgeon in Boston, with his limo and his driver, he can't hide out in a cheap motel like us little people when we receive a threat?"

"It wasn't a question of high-and-mighty, Larry," I say as, mercifully, the chairlift station comes into sight. "He was fearing for his safety!"

"He tried to swindle my mutha, Dan. He made her cry on her deathbed, don't get me started."

"That's still no reason to sic the Motor Men on him, Larry."

"The Motor Men get a bad rap, Dan. And I'm glad you remember to use their code name, because they don't like to have their real name

dragged through the mud. But some of them are very tender underneath. When I told them about my mutha, a couple had tears in their eyes, they wanted to do the job for free. . . ."

"Larry, can I get back to you on this?" I say. "We're about to disembark here, and I've been promising the kids this vacation for like a year now."

"Dan, not to be blunt, but it's almost Labor Day—let's not play games and pretend the vacation isn't winding down. You think this is patty-cake we're playing here? My life's hanging by a thread, not that I want to intrude."

"It's not intruding, exactly, Larry. It's just, I mean—"

"Take your time, Dan. I'll work around your schedule, whenever's good for you. This is *you* doing me a favor for a change, Dan, it's not *me* doing you a favor. So what's your closest airport? Denver? You're in luck, there's a nonstop to Beijing at eight A.M. next Sunday."

"What, you've been Googling the whole time we've been talking, Larry?"

"You don't even have to change planes, Dan."

"But that gives us no time to plan this thing, Larry!"

"All due respect, Dan, but you suck at planning. You're a seat-of-the-pants-type guy, as I am. You know as well as I do that ninety percent of the world's deals get made not because of planning but because you happen to be standing there when the deal goes down. We can plan this to the nth degree, and it won't be as good as just hopping over there and winging it. . . ."

"Guys! The bar stays *down*!"

"I'm feeling encouraged now, Dan, I'm crawling out from beneath my blankets. Next Sunday? Next Sunday would be good."

FIRST FIVE REASONS TO HANG UP THE SECOND YOUR LONG-LOST COUSIN ASKS YOU TO GO WITH HIM TO CHINA

1. Familially, you and he aren't that close. You didn't see each other all that much growing up, and, in fact, have been estranged for two decades.

2. Morally, what he's suggesting is murky. C'mon, are we just another couple of arrogant First Worlders who think they can snatch an organ from the Third?

3. Medically, it's even murkier. Take him away from his American doctors to find a foreign organ that may or may not be up to snuff?

4. Legally—let's not even go there. Even Larry admits it's illegal.

5. For all these reasons, and countless more that flood the brain, it's clearly a fool's errand.

So, case closed. It's a few hours later, and the chairlift is shut down for the night. The kids are fast asleep in the darkened hotel room on either side of their sleeping mom in the king-size bed. With a light on in the adjoining bathroom and the door closed, I'm sitting in the empty bathtub Googling the words "transplant," "kidney," "cousin," "death." Just to satisfy myself that what Larry's asking is preposterous.

Kidney: The organ that cleans blood, without which the body shuts down and dies.

Dialysis: The procedure to artificially clean blood when kidneys fail. The patient is hooked up to the dialysis machine at least three times a week for at least four hours per session, typically followed by twelve hours of addled sleep.

Transplant, waiting list: A dire situation. In America alone there's a backlog of seventy-four thousand patients, forty-four hundred of whom died last year while waiting. Average wait is seven to ten years, longer if other medical problems make patient a less desirable recipient.

Transplant, options: Given the dismal prospects, more and more people around the world are crossing international borders to obtain the care they can't get at home. So-called medical tourism is risky and controversial, but sometimes it's the only viable option.

Transplant, donation: I'm off the hook, in case there was a question. Our DNA's so distant it's doubtful we'd have a match. Larry and I are probably as different in that division as we are in everything else.

Guilt: I don't need to look that up. I know all about how Larry missed

out on the privileges the rest of the family enjoyed. But is that any rea-
son to consider raiding the home piggy bank, especially at a time when
my books aren't exactly feathering the nest? Of course not. No, no, the
answer is no.

The tub's getting crampy. I perform a couple more searches before
shutting down the laptop. Oh, here's a nice one now: *kidneys, eaten*. Ap-
parently, back in 1968 at the height of the frenzy that was China's Cul-
tural Revolution, several accounts report that the bestial Red Guards ate
human kidneys as part of their revolutionary zeal. Simmered the corpses
of their enemies in large vats, then fried their organs in oil.

Great place he's asked me to revisit. Typical Larry.

I flick off the bathroom light and make my way across the hotel room
by the glow of the moon coming through the curtain. For a minute I
watch over the sacred sight that is my family in the moonlight. A vein
ticks in each of their necks, blue and tender, right below the surface
of the skin. A microscopic image comes to me from my Googling: the
tips of two fifteen-gauge needles piercing a blood vessel for the dialysis
procedure. Then, just as quickly, I'm into macroscopic mode, picturing
the millions of haggard patients languishing on kidney lists around the
globe.

Their veins ticking, too.

What was that memory Larry was alluding to? Bailing me out at
his bar mitzvah? I have a faint recollection of the tubby thirteen-year-
old mumbling his prayers into the microphone, softly impedimented, as
though he had strawberries in his mouth. I remember feeling sorry for
him. I remember feeling *angry* for him. But nothing beyond that. Some-
thing about a piece of cake . . . ?

And then, more recently, something about Larry going to China
alone, pathetically trying to find a kidney without me, dying over there all
by himself? Or maybe that's a memory that's not supposed to happen?

I watch my wife and boys in the moonlight, pooling their body heat
as they sleep. They're healthy, thank God; Larry's not. Luck of the draw.
But why would I, flawed and fucked-up as I am, why would I desert my
darlings to go half-cocked into business where I don't belong?

Game plan: Why doesn't my laptop have a link for *that*? Where's the Web site to tell me what to do? But what if—being completely crazy here for a minute—what if I promise my family I'll make it up to them, entrust the boys with feeding the ducks in our pond when they get home to Massachusetts, arrange to meet Larry in Beijing, and buy a round-trip ticket with the return date to be decided later? Then—still speaking theoretically—say we give it one week in China and another week or two in neighboring countries, just long enough to prove that it's an impossible mission?

I yearn to stay and share in the body heat my family promises. A shiver of cold runs through me, to think how wrenching it would be to thrust myself into the vast beyond. I'd have to force myself to be extra chipper, and chipper is the last thing I feel.

Sleepily, I climb in among the bodies of my family, making four. Soon enough, in the cosmic scheme of things, each of us will end up going our separate ways to points unknown, but for this night we share a king-size bed. "Dad?" cries one of the boys, looking up startled. He takes my hand and curls it with him back to sleep.

I lie awake.

Chapter 2

McMao

You cannot fight a fire with water from far away.

Commotion. On the next Sunday, I'm being driven from the Beijing airport through the sweltering smogshine that feels like a moist anvil on my head. I've managed to hustle an assignment from a magazine to report on the changes in Beijing since I was here twenty-five years ago—airfare and all expenses paid for one week. The hotel package comes complete for six days with this Red Flag limo, mercifully air-conditioned, and a fetching tour guide. Very fetching.

But what changes! Ole BJ has been buttered and Botoxed for the Olympics. Once a low-lying labyrinth of grainy neighborhoods, it now reminds me of Kryptonopolis in the early Superman comics, a futuristic metropolis with soaring trains and heatstroke-inducing architecture. All the feverish activity of twenty-five years earlier—men and women scampering across bamboo scaffolding like ants on a picnic plate—has resulted in a supersonic McCity of gleaming chrome and smoked glass and blue kryptonite-duplicator rays, for all I know. The effect is akin to going from the run-down department store that is your everyday life, with its faulty fluorescents and grimy escalators, into a strobe-lit video arcade. Snap, crackle, zap! Instead of those grandmothers you could still see a quarter century ago shuffling through the rag stalls with bound

feet, movie starlets with French pedicures are mobbing the malls, impatiently stamping their designer sandals. The tour guides have changed, too—twenty-five years ago they were tight-lipped and severe, hiding their little hair buns in gray Mao caps. By contrast, the luxurious Yuh-vonne from Happy-Go-Luck Travel bounces flirtatiously, with nuclear pink highlights in her pageboy that's like the mane of a punk thoroughbred.

"I like you shirt, blue and green!" Yuh-vonne says vivaciously, sitting in the leather-seated back with me while the driver bullies his way through the circuslike traffic. "Blue and green is good omen in China. Green thimble-ize humanity. Blue thimble-ize heaven, divine, all that. Red, what does red thimble-ize?"

"No idea: blood and death?"

"Oh, you are clever one. Hairy homeboy, you make deep impression! No, red does not mean blood and death. It mean longevity! So many thing in China mean longevity! Ward off evil spirits, blah, blah, blah. Quiz at end of car ride, ha, ha."

"What is this?" I ask, pointing at a four-story computer store pulsing orange beams through the milky air like a space-age lighthouse.

"'What is this, what is that?'" Yuh-vonne mimics me. "You so curious man, ask many question. I like curious man, but not too much!" she says, tugging playfully on the brim of my panama hat.

"Hey, look," I say, "*Mamma Mia* is playing in Beijing!"

"Hey, look," Yuh-vonne says, "what are you job?"

"Free-range writer," I say. I'm in an okay mood because my nonstop scoot from Denver was so short it felt like a nap—not even long enough to incur bad breath.

"Ow my God," Yuh-vonne says, hiding her smile with rhinestone-covered fingers. "A writer, my God!"

"Believe me, it's nothing to get worked up about," I inform her. "We're a dime a dozen back on the East Coast."

"But not travel with family? Selfish bad boy!" she says, jabbing me playfully in the ribs. "I only joking," she resumes, for the record. "Your wife is a considerate girl. Beautiful, too?"

"Oh, yes, very. Very."

Yuh-vonne is momentarily subdued enough to adopt a serious tone. "Yuh-vonne not my real name," she says. "My Chinese name unlikable for you, so I take name I read on Web site for my favorite TV show. You know *Batman,* Adam West, all them dogs?"

"Yvonne what's-her-face? The one who played Batgirl?"

"See resemble?" she says, flitting her long eyelashes. "But correct pronunciation Yuh-vonne."

"But it's French—"

"Your bad! I read on official Web site!"

"Whatever," I say. "And you can call me WillandGrace."

"Ha ha, that's a humor one!" Yuh-vonne laughs, slapping my knee. Aren't you supposed to slap your own knee when amused? I can't remember. I'm forgetting my American customs already. The flirtatiousness is making me a little light-headed, though I remind myself not to take it personally—beautiful Asian women often waste their wiles on undeserving Western visitors, just in case we're higher up on the food chain than we necessarily are. Anyway, I'm fascinated by her laugh, which is more like an openmouthed bray, before it turns suddenly into a rough bark at the driver, who executes an extreme left turn across four lanes. Lesser cars scurry to acquiesce, for the sole reason that we're bigger and shinier. At home if a limo barged through like this, he'd get the finger at least, but here everyone clambers to the curb as though we were a shiny black fire engine.

"I can't believe this traffic," I marvel to myself.

"You prefer last time, only bicycles, eh?" Yuh-vonne says.

"That's right. But how'd you know I was here before?"

"Fact file," Yuh-vonne says, yanking a bright red three-ring binder onto her lap. "Free service kindly provided by my agency. Have you age coordinates, you food preference, even you college transcript. Not so good in French language, we note, maybe that why you have problem with my fine name?"

I'm not sure if she's kidding and all those pages are merely the itinerary she's worked up for our week together. But the laugh's on her in any

case, because I didn't even take French in college—further evidence that Chinese surveillance, if that's what this is, is more Keystone Kops than anything else. A fact I learned to my amusement and horror twenty-five years ago, and one that even Yuh-vonne seems ready to concede.

"But fact file have sorrowful gaps," she goes on, "as to what-is-you-mission, what-is-you-choice-liquor-recreation, so on so forth. You fill us in, please, so we make accommodate as possible."

"Well, it's true I'm partial to bicycles," I say, relaxing into a reminiscence. "The whole way in from the airport last time, we were practically the only car, it was past midnight and the driver kept his lights off to save gasoline, flashing them from time to time to light up the swarm of bicyclists everywhere. Then we had these banquets twice a day that called on us to make these amazing toasts—"

"What-is-you-mission?" Yuh-vonne barks, so severely that she reminds me of the guides of twenty-five years ago.

I weigh the question. Only a few minutes in the country and here it is already, the first test of my undercover chops. I'm aware that this is the moment I'm supposed to be super-surreptitious in this top-secret assignment of ours. But you know what? Surreptitious isn't going to get me where I need to go. Furthermore, Yuh-vonne doesn't seem to know such basics as my arrest here last time. So much for her alleged "fact file." Even if she *were* a Keystone Kop, I wouldn't judge her a threat.

"I'm here to help my cousin Larry," I say.

A statement that sends Yuh-vonne into eye-flitting mode again. "Laurie is handsome?"

"Whoa!" I say, almost bumping my head against the ceiling when we run over an unknown object. The pause gives me time to be judicious. "Well, he has a certain animal vitality," I reply. "If you've ever heard of a guy named Al Goldstein—publisher of *Screw* magazine, squat and tough—Larry looks sort of like him, minus the cigar. Kind of the friendly family pornographer type, but you know he could deck you with a sucker punch if he wanted to."

"He bald as billiard ball?" Yuh-vonne asks.

"Great head of hair, I'm happy to say. Women find him endearing."

"Now is talking turkey!"

"Yeah, well, he's a charmer when he chooses, with a razzle-dazzle smile despite a couple of teeth knocked out when he was a kid. And he uses these quaint expressions from an earlier age when chivalry wasn't quite—"

"Cutting to chase, what are he job?"

"Hard to describe," I say.

"You not like Yuh-vonne enough to try?" she says, pouting. She also slaps my wrist. Not that playfully.

"Okay," I say, "you've probably never heard of a professor packing a semiautomatic before."

"True that!"

"Well, I exaggerate," I say. "Or rather *he* exaggerates. He calls himself a professor, but really he's just an adjunct at some Catholic college down South, with links to the underworld and a sometimes-lucrative sideline of suing people. Mostly he's an inventor of get-poor-quick schemes. The latest one I heard was Canine Kippahs, yarmulkes for dogs, though that might have been one of my inventions I was trying to sell him. That's the thing about Larry: He's so much like a part of you that you don't want to admit, you start to think like him after a while and come up with wacka-doo schemes yourself. At least I do. But the point is that everything the guy's ever touched has turned to dust. He's been close to making a mil-lion dollars more times than I can count, and always at the last minute he blows it, like he's programmed to self-destruct over and over again."

"Bottom line, he is unemployed?" asks Yuh-vonne, a little winded from working to stay ahead of me.

"Always been his own boss," I clarify. "He's an operator, a finagler holdover from the Old World, which is why the rest of the family's kind of embarrassed by him, a throwback to the ghetto—the kind of shtetl gangsta some of us may have been before we all evolved into Ivy League doctors/lawyers/Indian chiefs."

"I want meet him!" Yuh-vonne says.

"Let's let him rest till tomorrow," I say. "He was scheduled to get into his hotel late last night and must be exhausted. He's got a lot on his plate the next few days."

"What on he plate, exactly?"

Here it is again, another moment when the rule book calls for caution. But caution works best, sometimes, when thrown to the wind. I've decided to try to enlist Yuh-vonne's help.

"We're trying to find him a kidney transplant," I say.

Yuh-vonne betrays no emotion at this news. "But so then Laurie is Chinese?"

"American. Why?"

"How he can use Chinese kidney?"

"We're all brothers and sisters under the skin," I say. "In fact, come to think of it, that may have been one of the toasts I made twenty-five years ago. Let me think a minute. . . ."

"I am suspicion of that biology," Yuh-vonne says. "Look me in the eye."

"It's true, organs aren't race-specific," I say. "So Larry and I've had a couple of conversations, and the plan is, we're giving it one week in China, and if nothing turns up, we'll try the Philippines, then maybe Singapore and Hong Kong, see if we can shake something loose."

"You one sunny-side-up dude. How you go about it?"

"Haven't the foggiest yet. Black market, maybe? Is there maybe a Kiwanis-type club for kidneys or something? Networking one way or another, isn't that always how it goes?"

"Hmmm," Yuh-vonne says. "You have contacts?"

"Only a distant one," I admit. "Some embassy friend of a friend I e-mailed the night before I left. But I have something better than contacts. From my previous visits, I have a sense of how huge China is and how things tend to fall through the cracks. One hand doesn't know what the other's doing, plus the law isn't applied equally. There's even a proverb that says the farther you are from the emperor, the less you can hear his voice. Meaning things are a little looser away from the center of—"

"I mean contact *lenses*," Yuh-vonne interrupts. "Your eyes behold me so bright!"

"Oh," I say. "Must be the pollution."

Yuh-vonne has one word for me. *"Guanxi."*

"Guanxi?"

"Connections. Meaning it more depend on who you know to get things done, personal relationship under radar, so to procure what you desire without no one knows."

"Perfect," I say. "So I'll jump right in by asking if you have any leads."

"I? Ha ha ha."

"What about our driver?"

Yuh-vonne performs a double gesture, one hand waving no, the other to her lips with a shushing sound. "But why no relative depart him with kidney?" she asks in a whisper.

"Well, that's a sad story," I say. "Larry had a twin, Judy, who would have been the ideal donor, but she was chronically depressed and killed herself last year. By the time they found her, the kidney was beyond salvaging. And the rest of his immediate family's gone. He's all alone in the world, except for the larger family that he's alienated because he's got a chip on his shoulder."

"This of course not microchip you speak about."

"No, more like a gigantic grievance because of the way the family is structured," I say. "See, he's the son of my grandmother's baby sister—technically, he's my first cousin once removed—but the family dynamics were such that he was born into a different class from everyone else. My grandmother was this regal Boston lady, kind of like a prettier Eleanor Roosevelt wrapped in a Persian lamb collar, but by the time her baby sister was born, eighteen years after her, her parents had fallen on hard times and the sister ended up marrying a lovable but illiterate garage mechanic who kept having strokes. Shall I go on?"

"You talk like roller coaster! I like!"

"I know it's a lot," I say. "Getting this close to Larry must be going to my head. So anyway, they were good people—'salt of the earth,' in my family's rather patronizing phrase—but Larry always felt he didn't measure up, even though he's compensated for it by getting a million degrees."

"They no like him?"

"They appreciate a lot about him—his fight, maybe even his lack of pretense—but not the baggage that goes with it. He truly has a heart of gold unless you cross him, which he feels some members of the family have—"

And then suddenly there he is. Not Larry but Mao—twenty feet high and airbrushed since I last saw him. Hanging above the main entrance to the Forbidden City, his portrait looks younger than before, a little less weary and a little more cheery, more like a slightly menacing Ronald McDonald than the wart-faced tyrant of yore—the despot as Fred Flintstone. Twenty-five years ago, I got a bout of dysentery walking beneath him, but this time, squinting through the smoglight, I feel a family connection—that roly-poly skepticism, that chunky bullheadedness—so help me, he looks like a Chinese version of Larry.

And of course, across from the portrait looms Tiananmen Square, still as gargantuan as ever. Last time it was a geologic anomaly: the largest public square on earth, the size of ninety football fields. But this time it reminds me of the infamous student massacre, which offers me a chance to turn the tables and ask Yuh-vonne some questions.

"Do you know what happened here?"

Yuh-vonne winks lasciviously. "Inside those walls, emperor spend so much time playing with his concubine," she says.

"No, not inside the Forbidden City," I say. "Across the street in the square. In 1989."

Yuh-vonne quickly averts her gaze. "Our elders will not tell us," she says. "Many time we ask them, but they say don't ask."

"Do you know that students were hurt here?"

"A few," she says carefully. "That about it."

I bring her gaze back to me with a hand on her shoulder. "Not a few," I say. "Hundreds. The tanks rolled right over them when they were protesting."

"Ow my God!" she says, sucking in her breath. "I have to go tawlet!"

"Seriously?"

"No, I can wait," she says, but she looks constipated suddenly, buttoned up.

On the square as we drive past, children are flying kites and shriek-
ing. Young women are ambling through with frilly little ankle socks.
Old women are limping along with parasols held high against the sun.
But where are the people my age? Where are the Red Guards of the sev-
enties who performed such monstrous deeds against their countrymen,
to say nothing of the Tiananmen Square student protesters of the late
eighties? They couldn't all have been massacred here, could they? Or do
they avoid this spot? Come to think of it, I've seen hardly any people my
age since arriving at the airport.

Mostly what I see are soldiers, skinny adolescent soldiers everywhere,
clumps of sunken-chested, pimply boys at rest, horsing around in their
olive green uniforms, fragile boys encased in weaponry, roughhousing
with one another, bored and playful as boys anywhere, putting one an-
other in headlocks, dropping spit bombs before smearing them into the
concrete with their boots, snapping cell shots to send their mothers. Boys.

"You know the Cultural Revolution?" I ask Yuh-vonne.

"It-take-place-'67- to -'77," she says in a flat tone. "But I didn't born
then."

"What do you think of it?"

For the first time, I see that her lips are bitten up, self-inflicted, be-
speaking an inner severity at least as harsh as any state-sanctioned one.
"Maybe-a-good-thing-in-beginning-but-then-a-bad-thing."

"So where the hell are all—"

"People nowaday very happy and rich," she says, to shut me up at last.
As if on cue, we get cut off by a limo even bigger and shinier than ours.

"We only poor limo, but he rich rich limo!" She rolls down the win-
dow and sticks the upper half of her body out. *"I love you, China!"* she
shouts, arms outstretched.

And off we speed down the avenue to my hotel a few blocks away,
the damp furnace of China's summer air blasting in through the open
window.

"Over the next few days, I'm going to be in need of some rather non-
traditional tour-guide services," I tell her when we get there. "You avail-
able to step off the straight and narrow?"

"I am at your service night and day," she says.

"Bingo," I say. "What's the forecast?"

"Smoky."

As I open the car door, a flash of something comes back to me. I turn to face Yuh-vonne. *"Jong may, jong moy . . . ?"* I say experimentally, trying to remember the toast I knew twenty-five years ago. "Long live the friendship between the Chinese and American peoples: *jong mee?*" But it escapes me.

Yuh-vonne disregards my effort and grips my hand meaningfully. "Night and day," she says.

CHAPTER 3

The Larry and Mary Show

A sly rabbit will have three openings to its den.

Chamomile. The smell of chamomile.

After a good day's sleep, I wake at 5:00 P.M.—it's 5:00 A.M. at home—with visions of kidneys floating in my mind like dust motes on the surface of my eyes. I shake them off and lift my head from the chamomile-infused pillows. My expense account has provided me a luxury suite with private butler who brings me coffee that is distinguishable from tea—a welcome change from the beverage they served twenty-five years ago in this very hotel. The lobby, when I descend, is a castle, complete with Flemish tapestries and high-gloss Clinique counter, behind which a fashion model in heavy mascara crouches in the deep-knee-bend position of waiting, patiently picking her toes.

In minutes I'm cabbing my way through the steam heat to Larry's discount hotel, which is basic but perfectly decent. In the small greeting area, a row of five receptionists who look like the stunning women vamping it up in those Robert Palmer music videos from the eighties—identical tight black dresses and tight black hair—giggle uniformly and direct me to a unit across the grass courtyard, second floor.

I knock at Larry's door and am greeted by the sound of a key fiddling in the lock from the inside: fiddling, fiddling. Finally the door is swung

open by a giant cleaning lady in a thick coat, her sleeves rolled up to her elbows and suds dripping off her hands, who immediately bows out of the way to give me my first sight of Larry, rising from a chair in the back of the room. But if the cleaning lady's a larger figure than I expected, and more overdressed, Larry is smaller and underdressed. I haven't seen him in years and am surprised by how he's shrunk. He's naked except for a pair of saggy underpants, a boxy pair of sunglasses, and his Businessman's Running Shoes. Not that he'd ever dream of running three steps, but he wouldn't be caught dead without his Businessman's Running Shoes.

"Huwwo, Dan," he says in the monotone he always uses to keep himself from getting too happy or too sad.

"Throw on a robe and I'll hug you," I say.

"Oh, that's an inducement," he deadpans. Larry's emphatically not the hugging type. Nor am I in this case. He looks so terrible that I find myself wanting to keep our cooties very separate.

We're both relieved to shake hands.

But even at arm's length, his diminishment is a shocker. He's slumped to the point of being stooped. He's lost a lot of weight, way down from the 280 pounds he was at his peak, but this isn't the sort of weight a person wants to lose. I clap him on the shoulder and find the wasted shoulder of an old man. He's lost one, maybe two additional teeth in his head—I'm not sure, because he doesn't smile enough for me to count. His sunglasses mask the slight edge of menace he always used to have, making him look almost benign, like a box turtle you could keep for a pet. But his face is bleak—puffy and pinched at the same time. Mostly it's gray: He lacks a blood-cleaning kidney to give him the rosy hue of health. As if to make up for the absence of pink, however, the insides of his arms are the color of Coca-Cola.

"What's with the bruising?" I ask, discreetly wiping my hands.

"Dialysis," he tells me. "My nurses in Florida basically treat me like a pincushion, though you'd think they'd be able to find *this*," he says, revealing an ugly blue knob on his forearm.

"What's *that*?" I ask.

"Fistula," he says. "It's where my surgeons in their wisdom fused my vein and artery to provide better access to my circulatory system."

"Jesus," I say. Because I never expected he'd look this bad. "Nice watch, anyway," I say, referring to the fake Rolex dangling from his skinny wrist like a bracelet.

"Like it? It's yours," he says, shucking it from his wrist.

How could I have forgotten? Larry's generosity is so old-school that it's impossible to compliment anything about him without immediately receiving it as a gift. It's no exaggeration to say he'd give you the shirt off his back. I once made the mistake of complimenting an undershirt and immediately received a polyester wife-beater, still warm from his ribs.

"No thanks, got one," I say, dismayed that I do indeed have a fake Rolex just like his. Bobbsey Twins with my cousin Larry wasn't the look I was going for.

"Suit yourself," he says. "How about a calfskin billfold, I brought some extra ones for gifts, or a leather carrying case, or some cash to help with your flight?"

Larry used to handle money like a gambler, shuffling a wad of crisp bills like a fresh deck of cards. But now he grunts to extract a single bill from his aromatic wallet while the rest fall to the floor, presenting him with the problem of how to bend down to get them.

"No thanks, I'm set," I say, kneeling to retrieve the cash while I take stock of my cousin. This was Larry, the little fatty who used to delight in running up the down escalators? Who used to crack me up by putting his lips right against the grille of a fan and mumbling Clint Eastwood lines through the moving blades? *"Go ahead, make my day."* How did someone of my generation become so hunched and withered? Any doubts I might have had about coming to China have vanished with the sight of him.

"I can't begin to tell you how tired I am," he says, collapsing into his chair and beginning a ten-minute discourse on what end-stage renal disease feels like. For someone in such a state of fatigue, it's as if his mouth operates on a separate generator. I only half listen to the grue-

some account, because I need to preserve my spirit; if I'm going to be of any use to my cousin, I have to stay upbeat, which means being selective about how many depressing details I allow in. I take the opportunity to indulge in a little daydream about being at home with my wife and kids, who'll be starting school tomorrow, fourth and seventh grades. "You have no idea," he concludes ten minutes later, digging both thumbs into his eyes wearily. "*I* had no idea before I got sick. I thought kidney disease was something you could take a pill for. And this Peking Opera doesn't help," he adds, indicating the colorful pageant screeching away on the wall TV. "It's been playing nonstop since it clicked on apparently by itself this morning, and I can't shut it off. (No kidding, have you heard this stuff?" he adds. "I mean, it makes Yoko Ono sound like Frank Sinatra.)"

"Can't you unplug it?" I ask.

"You're welcome to try," he says. "Maybe you'll have better luck than I've had."

He coughs feebly for a while—the remnants of a bronchial infection that came with dialysis, he says—while I find the plug right behind the set and pull it out of the wall.

"Mystery solved," he says, relishing the sudden silence. "By the way, just FYI, I reserve the right to kill myself at any time, Dan. My mutha is dead, my futha is dead, my sister is dead, there's only me left and I don't owe anything to anyone. And just so we're clear, if anyone tries to stop me, I would consider it the most egregious thing you've ever done."

My mind tunes him out, because I'm thinking about why he couldn't find the TV plug—that's not like the Larry I remember. His phlegmatic exterior has always masked a razor-sharp brain, but is something more wrong with him? Is his physical deterioration only half the story? I watch the cleaning lady on her hands and knees in the bathroom, scrubbing the floor around the toilet. She really throws herself into it, a big woman made even bigger by the coat she's bundled up in, a suede-and-sheepskin affair that just about doubles her mass. When I tune back in, Larry's still going: how a transplant is a treatment not a cure, how even the best

outcome means he'll be on expensive antirejection drugs forever, how he won't settle for being an invalid in a chair.

"Larry," I say, "you have to realize this is your depression talking."

"Yeah, well, if it's talking, I'm listening," he says morosely. Then flashes a milky-mild smile that makes him look a little like the Mona Lisa. "Of course, I could run out of cookies at any moment, and then my life will be a moot point," he says, reaching into the suitcase at his feet, where I glimpse several boxes of Girl Scout cookies. "You didn't think I was going to chance eating the native cuisine, did you?" he asks, offering me a Caramel deLite. "So how's your hotel? Classier than this one, I assume."

"Only because the magazine's paying for it," I say. I'm a little embarrassed for my better circumstances, and hope I'm not giving off the scent of chamomile. "It's the same one I stayed in twenty-five years ago, though a lot nicer this time, I have to say."

"That the one where the coffee was so bad?"

"You have an amazing memory, Larry."

"I remember everything you ever told me, Dan. I look up to you, you're my big cousin. Matter of fact, wasn't that where you *shtupped* a stewardess on the rooftop?"

Scrub, scrub, scrub.

"Okay, I can see by your face that was a lifetime ago," he says. "You don't want to be reminded of your divorce days. I just want to show how much you've always meant to me, not that your wife ever needs to know. What happens in Vegas stays in Vegas, as far as I'm concerned. And you can quote me."

"I think you must have misheard me, Larry."

"I don't believe so, Dan. You told me a lot of stuff in those days. But in your defense I ought to say that you were hitting the hooch pretty hard back then, Dan. I'm glad you stopped. What was the final straw, don't mind my asking?"

"Larry, let's try very hard to keep this on you."

"Good idea. And now that we're clear about your colorful past, maybe

it's time I come clean and mention one other little thing I neglected to say until now."

The cleaning lady moves from the toilet to the sink fixtures: *scrub, scrub, scrub.*

"I know transplants are illegal, Larry. You already leveled with me."

"Took me long enough, though. I was pretty nervous, trufe be told."

"I understand. You didn't want me to take it the wrong way."

"I'm glad you accept me with my flaws, Dan."

"I . . . uh . . . do."

"That means a great deal to me. So by the same token, there's one other thing I don't want you to take the wrong way either. You can see how visibly nervous I am all over again."

"Just spit it out," I say. "What am I going to do, bite your head off? I've come all this way to help."

"And you *are* helping, just by being here. I can't tell you what a comfort it is, your presence alone."

"I'm glad, Larry. So?"

"I'm getting married."

"Larry, congratulations," I say, so relieved it wasn't bad news that I have to stop myself from giving him a hug. "Why would I get mad at that? That's wonderful news!"

He looks as pleased as a box turtle given a fly carcass to munch on. "You were right as usual, Dan. I didn't have to be nervous after all. Thank you for supporting me."

"Wow, a lifelong bachelor getting hitched after all these years."

He accelerates his monotone just a bit. "Yes, I'm very excited about her," he continues. "I've never been with someone who shares so many of my values. She doesn't drink, doesn't gamble, doesn't run around. She's basically stable, like I am. It's like we're in sync. I've never felt this way about anyone before."

"I'm thrilled for you, Larry. So when'd you meet her?"

"Well, it's in process," Larry says. "I think it only prudent that I spend a little time with her first."

There's silence for a moment while the only sound is the *scrub, scrub, scrub* of the brush gnawing at the faucet.

"Larry, are you telling me you're meeting her here for the first time? That this was another reason you wanted to come to China?"

"Dan, I can't believe you of all people would expect me to marry someone sight unseen. Plus which, your opinion of her is very important to me, Dan. You've always been an excellent judge of character."

He registers the expression on my face.

"Besides," he says, "don't act like I didn't give you fair warning."

"What are you talking about?"

"On your chairlift, Dan. I distinctly remember you mishearing me."

"Larry, it wasn't the best connection in the world. I could barely make out—"

"When you thought I was feeling merry."

A pause while something irreparable snaps in my brain.

"Larry, *maybe* I half heard you but it certainly didn't register. There was a lot coming at me then."

"I grant you there may have been some psychological blocking on your part—'merry,' 'marry,' plus her name is 'Mary'—it was a lot to take in."

Speech fails me. I sink into a chair.

"Well, anyway," he says, "who the hell cares, as you like to say. Besides which, I wouldn't want to burden an upper-caste person such as yourself with crass commercial concerns, but it would have been fiscally irresponsible of me to shell out for a ticket to come all this way and not get my money's worth, see what I'm saying? Doesn't a twofer sound like a better deal? Get a kidney and throw in a bride for free. One from Column A, one from Column B. (And I trust that's not a racist thing to say, because racist is the last thing I want to be, under the circumstances. I'm a guest of the Chinese, they're not a guest of me. Notice I'm making a concerted effort never to use the word 'Chink' while we're over here.)"

"That's good of you. But, Larry," I say, trying to sound out my words clearly, "you misrepresented the situation."

"I fudged, Dan. Let's not pussyfoot around or make it sound prettier than it was. I fudged, fair and square, but do you honestly think you

would have gotten on that plane if I'd kept you in the loop? It was for your own good, in a way. You would have been riddled with doubt if I hadn't protected you from the trufe."

I look around to turn up the air conditioner but see there isn't one. No wonder I'm sweating through my clothes.

"Don't look at me that way, Dan. Am I commenting on your goatee and earring, distasteful as I may or may not find them? I realize you're a different person from the way we were as kids. Live and let live, that's my motto. We all gotta eat."

"I could get very mad at you now, Larry."

"And I could point out to you, Dan, hopefully not for the first time, not to get mad at the messenger. Would you prefer I continue to spring nuffing but half-trufes on you, so pretty soon you know even *less* whether you're coming or going?"

He's right, I don't want that. I'm having enough trouble telling what I'm doing. Am I daydreaming again, or am I really hearing him say that Mary advertised herself on candeyblossoms.com as "a petite thirty-five-year-old professor of architecture at a prestigious university with great command of the English language and a six-year-old ballerina daughter who's cute as a button"? Is he really telling me that he especially loves the ballerina part because of how much he loves kids, he's got like a dozen godchildren including one from a dean at his college who's a nun, couldn't have her own kids but adopted one from Ecuador, who more or less authorized an all-purpose recommendation letter that he carries on his person everywhere he goes? "This is to certify that Larry Feldman is a highly respected intellectual with advanced degrees in mediation/negotiation and a license to practice the art of real estate in countless American states. Any assistance you extend this VIP will be devoutly appreciated in the highest circles." And that he took as inspiration the notes I forged in high school to get out of detention?

I'm not sure; it's something to that effect. But one thing I *am* sure of is that I didn't come halfway around the world to talk about me. I tell him so.

"You're right, Dan. I'm just saying: You're an inspiration to me. And

just between us, I understand it's stacked against artists in our society; no one can blame a forged signature here and there to help you make your way. (And in case I haven't said this before, thank you for coming on this trip, and please extend my thanks also to your wife, I appreciate her making this economic and emotional sacrifice so that I can hopefully attain just a fraction of the marital bliss with my wife that you no doubt enjoy with yours.)"

So help me I'm spellbound. At a certain point, and it happened several minutes ago, I don't even try to resist. I'm held captive by a snake charmer—perhaps the only one in the world who talks with parentheticals. Yet I must admit there's a certain relief in surrendering to such masterful manipulation. It's like being very tired of holding your head up straight and then deliciously allowing yourself to relax your neck and fall asleep at last. Concessions are made. Forgiveness is found. Maybe this is the sweet submission that members of a cult feel. God help me, I'm joining the cult of Larry.

"Okay," I say, rousing myself to speak after a long silence, "so when do I get to meet the bride?"

"You just did. That's her," he says, raising his chin to the woman scrubbing the sink.

My head snaps upright, straining a muscle in my neck. I try to find an ounce of delicacy.

"But, Larry," I manage to say, "she's not quite the way she described herself."

"Tell me about it. I'm as surprised as you are. She's forty-nine if she's a day, she's built like a linebacker, she said a hundred and twenty pounds, I judge more like one-sixty, *maybe* she teaches electronics as a substitute teacher at a rural high school way the hell out in the sticks somewhere near the border with North Korea. I'm still researching that one." He upends a Coke bottle with Chinese squiggles on it and takes a tiny sip. "Oh, and she doesn't have a six-year-old daughter, cute as a button. She has a twenty-four-year-old mentally endangered son—challenged, threatened, whatever the correct term is. Not that I have anything against retarded people. My beloved sister, Judy, was no great shakes herself in the

gray-matter department, rest her soul, though she was surprisingly adept when it came to crossword puzzles. Being shy was mostly her problem. Retiring. Well, you remember, Dan: Did you ever see her make conversation at a family function, other than the time she was so excited about getting accepted into that special program for epileptics?"

"Wait," I say, trying to shake off the blitz of words. "If Mary's not the way she described herself, isn't the deal off? I mean, truth in advertising, right? Doesn't that nullify the arrangement?"

"Not at all, Dan. I very much respect the fact that she misrepresented herself. It shows a native cunning that I appreciate. Not once in our two years of e-mail correspondence did she tip her hand. Plus which, it's flattering in a way. She made all that up just to impress *me*? Well, pardon me, but I *am* impressed."

"But she lied, Larry!"

"Yes she did, and I'm putting that in the equation, but on the other hand we have all those things I mentioned in common, plus she has an uncle who I gather is some sort of muckety-muck in the government, at least inasmuch as he is able to put me in touch with a clinic where I can get my dialysis, starting tomorrow. Which is not a minor consideration, given my health and also my desire to make a few business deals on the side, if at all possible. He also threw in a taxi driver free of charge for the week, which I think is a nice gesture. So I am very much against rushing to judgment. Who am I to judge a book by its cover? You're an author, Dan, you should know what I'm talking about. How would you like it if everyone judged *your* books by their covers?"

"They *do*!"

"But don't you wish they *didn't*?"

I know there's got to be an answer to this, but for the life of me I can't figure out what it is. I rub my neck, where I strained it. Finally it comes to me, feebly. "Well, it's your call, Larry."

"Yes it is, and I'm glad you remember that," he replies. "Be careful not to prejudge in life, is all I'm saying, Dan. Didn't you once tell off a friend's fiancée on the eve of their wedding, only to regret it when she proved a loyal wife a decade later?"

"I can't believe I've told you my whole life's story."

"You don't want to make that mistake again, Dan, especially with the cross-cultural difference between us and the Chinks. What? What?"

A pause.

"Nothing, Larry. So, do you want to make the introductions or what?"

"Mary?" he calls in the direction of the bathroom. "Mary?"

When she doesn't respond after his second call, he puts frail fingers in his mouth and executes a brutal, cab-hailing whistle. "Mary, put down that brush like I told you and get in here!"

"Yes, ah, Professor?" she says, scurrying in and slipping onto Larry's lap, dwarfing her betrothed so I can't see the face that continues the introductions.

"Dear, this is the man I used to think was James Bond."

"I was so not."

"That's how you appeared to me growing up, Dan, what can I say? The adoring eyes of a younger cousin. You had this savvy fair. I don't know if it was dumb luck or what, but no matter what kind of jam you got yourself in, you always came out smelling like a horse."

We shake hands while I crane around Mary to see Larry beaming in his low-key way. "Ten hours she spent on a train to get here. She wouldn't let me pay for plane fare, bless her heart."

"How do you do," I say, watching in amazement as my hand is encushioned by hers.

"I saved his life after college," comes Larry's matter-of-fact voice from behind Mary. "I already had my own real-estate firm at eighteen, lent him a spare bedroom when he didn't know how he was going to support himself as a writer. Girlfriend was cheating on him, so he got two shrinks and cheated on them by not telling them about each other. For the life of me, I'll never understand why neither of them prescribed Valium so you didn't have to steal mine."

"You knew I was seeing two shrinks?" I say, trying to fetch back my hand.

"Now, as to *why* you needed to cheat on two shrinks, that I wouldn't hazard a guess. I'm a professor of mediation, not a medical specialist.

You'll have to ask one of the doctors in the family if you're interested in getting a handle on that. What is their professional opinion of our venture, by the way? I probably don't want to know, right?"

"Probably not," I say. "They're so against it I call them the Disapproving Docs."

"So tell me."

I shift in my chair, partly out of sympathy for the weight Larry is carrying.

"They're skeptical, to say the least."

"And to say a little more?"

"They disparage the whole enterprise," I say, "but you have to expect that. They reflect the conservative American medical establishment. Their official line is that we're 'irresponsible' for leaving the warm grip of American medicine, even though American medicine is telling you to bide your time for ten years. Want me to continue?"

"Unfortunately, yes."

"Well, to play devil's advocate for a minute, you have to admit they have a point, Larry. What do we know of the cleanliness over here? Of how they track organs? There are so many variables, it's just a shame you couldn't call on Burton for guidance."

Mere mention of the name transforms Larry. Suddenly he looks less like a box turtle than a snapping one, neck recoiled, capable of inflicting real damage. "Dan, that is so far from anything I would do."

"I know, but there's no discounting the fact that Burton is one of America's leading doctors, after all. You sure know how to pick your enemies."

"Any case, whatever you do, do not tell Burton where we are. He would like nuffing better than to put the kibosh on this, just to get back at me."

"I don't think medical professionals operate like that, Larry."

"I hope you're right, Dan, for his sake. Because he *think* he wants me to die of renal failure and just fall off the end of the earth, but he *definitely* wants me to live a long life. He has no *idea* how much he wants me to live a long life."

"What's that supposed to mean?"

"Nuffing, Dan," he says, becoming benign again. "Here, have a peanut butter patty, these ones are my favorite."

"You didn't bring any of the sugar-free chocolate chips, in your condition?"

"Sugar-free is for sissies, Dan."

"Then there's the ethical question," I continue, declining the treat. "All the docs in the family are opposed to 'shopping for body parts,' as they put it, maybe even from a prisoner. What's your position on that anyway?"

"My position? Here's my position: This nonprisoner needs a kidney. Execute someone of my blood type!"

"But seriously—"

"I'm dead serious."

And he is. This is such a horrible thing to hear him say, so against every principle of decency I've been brought up to believe, that all I can do is pretend it came from someone else—I can't see the speaker anyway—and change the topic.

"So aside from Mary being, uh, not petite, what's your assessment of her after a few hours?" I ask him.

"Other than the fact that she lied about her size and her age, which I take as a girl thing, I find myself more comfortable with her than just about any woman at home," comes the voice behind the wall of Mary. "Is she perfect? No. Her English is subpar. She keeps trying to check me for lice, but that might be cultural. Despite her being kind of a clean freak, as you can see, I think we have enormous amounts in common."

"So you like her?"

"I do-uu," he says with surprising ardor, peering at me over his shades and opening his eyes so wide I'm startled by their Paul Newman blueness. No wonder that women have always been eager to help him. "She gets my jokes," he continues. "Don't ask me how, but she laughs at the right time. She insists on hand-washing my socks. It's like being in *Shogun*. If only she'd put out, everything would be great."

"You've come halfway around the world and haven't consummated?"

"Didn't you notice the separate single beds? It's like Donna Reed in here. But we have an awful lot in common. Did I mention that she hand-washes my socks?"

There's a pause during which I'm hoping Larry's regretting his words because of how chauvinistic, politically incorrect, and generally hideous they sound. But apparently he's not regretting them, because toward the end of the pause he cranes his head around to send Mary a lascivious wink.

"Dan made good use of my spare bedroom, I'll tell you that," he says.

"Hey, Larry made good use of it, too," I tell her defensively. "When I came back from a weekend away, the door was busted down and there was a picture of my bed on the front page of the local paper under the headline 'Biggest Bust in Two Years.'"

"Which made us even-steven in the drug department," Larry says. "Dan stole my Valium. I allowed an associate of mine to stash a little dope under his mattress in his absence. Not that I would ever partake myself, Mary. As I may or may not have told you, I never touch the stuff, because: One, I like staying in control. Two, always a bad idea to invade principal. And three, dealing it back in the seventies was strictly business."

I reflect that Larry is pretty straight, when it comes right down to it. No drink, no drugs, no unisex salons. He tried a joint back in 1970, fainted. He doesn't even chew gum—behavior unbefitting a business-man, in his opinion. That's why he always keeps a sharp crease in his pants. Have I even seen him wearing a T-shirt, or shorts for that matter? Of course not. According to Larry, who's gonna respect you if your knees are showing?

Larry turns to me and adds some confidential information. "Best art thief in the business, incidentally."

"Who was?" I ask. "Your 'associate'?"

"Moishe the ringleader," he says. "Moving dope was just a sideline compared to his interest in art. Speaking of which, they've never solved the Gardner Museum heist, you know, Dan."

"I don't *want* to know, okay, Larry? Let's have a rule that you not tell me anything I can't repeat in court, okay? Besides, we've lost our audience."

Mary has slipped back into the bathroom to resume scrubbing, leaving Larry with a frontal sheen of sweat in her absence.

"Did she even understand a word we were saying?" I ask.

"A couple here and there, maybe," he says. In silence we watch Mary as she continues sanitizing.

"Are my eyes getting worse, or is there really a step in the threshold going into the bathroom?" Larry asks.

"That's to keep out evil spirits," I tell him.

"Oh, that's right, I forgot for a minute," he says. "Because evil is so dumb it doesn't know how to crawl up a step."

We continue watching Mary while I refrain from reminding Larry that a sardonic attitude will not help us while we're at the mercy of this splendid nation. "What's with her heavy coat on a day like today?" I ask him.

"It's a gift I sent her last month," he tells me. "Warmest coat L. L. Bean sells. She was thoughtful enough to bring it here so she could model it for me. It's minus-forty degrees where she lives. The North Koreans think they're getting someplace good when they escape their homeland, apparently, but it serves them right. Minus-forty, the same temperature as Moscow, plus it has one of the biggest open mine pits on the planet. Not very appealing. Anyway, the poor dear has to go out in minus-forty-degree weather to send me an e-mail, plus avoid falling into the pit. Even the thought of her going out in that abusive situation makes me shiver."

Larry has always been openhanded to a fault. In this he takes after his father, Sam, the lovable but illiterate garage mechanic, who would stand there between hospitalizations passing out silver dollars to the children. The less he had, the more coins he passed out. Though Larry had numerous bitter issues with his father and would be loath to acknowledge any resemblance to him, he does basically the same thing. The less, the more. During the recession of 1990–91, hard times for his Tuxedo Band-Aids (first aid for black-tie affairs) or whatever product he was pimping back

then, Larry never showed up at a family member's house without some pricey secondhand offering in the trunk of his Studebaker Avanti. He specialized in bulky items: dehumidifiers, microwave ovens, even, during one dubious venture into gaming that I forbade him to tell me about, pinball machines. It isn't exactly a dirty secret per se, but it's worth noting that almost every member of our clan has a pinball machine in his or her cellar, vintage mid-seventies, obtained in ways none of us wants to hear about. Larry never drove up anyone's driveway empty-trunked. Air conditioners, too—something we could certainly use right now in this airless hotel room.

"It must be ninety degrees in here," I point out. "Couldn't she just model the coat for you and then take it off?" I ask.

"It's an honor thing, I gather, some Asian way of displaying loyalty," Larry says, mopping his brow not very effectively with the Coke bottle. "Or subservience or something. You tell me—you're the China hand."

"Larry, I'm not a China hand. I've been here four times total, and the last time I was thrown in jail, for God's sake."

"Mary's got to hear this story," Larry says. "You were clowning around in some forsaken outpost in Tibet, right, drunk on barley beer? Offered to sell some Chinese soldiers a basketball signed by the Dalai Lama, something like that?"

"Larry, do you mind if we don't revisit that adventure? It still gives me hives."

"Did they waterboard you? Mary's gonna love this."

"I think we've established that she doesn't have great command of English, Larry."

"At least tell her about the sadistic soldiers blowing smokes rings in your face."

"Larry, no one in this country wants to hear stories from the past. It's all Great Leaps Forward, haven't you noticed? Besides, she can get the whole traumatic tale off my Web site if she's curious."

"Well, all I can say is, it's beyond me how you'd be willing to come here again. I'm amazed you're not freaked by the Chinese after that, Dan."

"Who says I'm not freaked?" I say. "I thought I was lost to the world, and vowed that if I got out, I'd never step foot in this country again."

Larry takes in this confession with the seriousness it calls for. "I guess bottom line is you want to make sure to avoid a jail cell this time around," he says.

"You could say that, yes."

"Okay, so help me find my trousers. You ready to go?"

"Go where?"

"The airport, I keep telling you. I forgot most of my luggage at the terminal. In the excitement of meeting Mary and so forth, it slipped my mind. Or maybe this is the first time I've told you. See, that's my mental impairment again."

"Larry," I say.

"Yes, Dan."

"What mental impairment?"

Larry looks me in the eyes for perhaps the first time since I entered his room.

"I'm pretty sure I told you about my mental impairment, Dan."

"I'm pretty sure you didn't," I say, looking back in his.

"Well then, there it is again, case in point: my impairment. As you may have noticed, I tend to babble a bit. Misplace things, get confused, what have you. Our task is to determine whether this is the natural result of the dialysis, which scrambles my blood chemistry, or if it has to do with the disability suit."

"Larry," I say.

"Yes, Dan."

"What disability suit?"

"Okay, I'm not going to quibble," Larry says. "Maybe I already told you about it and maybe I didn't, but long story short, what do you think's funding my trip?"

"So wait, I may have heard something about it on the grapevine: Is this the disability suit for getting hit in the head by a falling icicle?"

"No, it is most definitely not," Larry says, offended. "The icicle suit was the one I filed on behalf of my mutha, the settlement of which was

nuffing compared to my own disability suit, for being rear-ended by a truck." His anger settles down a bit. "I can see where it might be tricky to keep them straight, however," he adds generously. "For the duration, if you wish to refer to either as the icicle suit, I have no quarrel. Any case it was a quarter-million-dollar settlement, after lawyers' fees. Sweetest words I ever heard come out of a jury foreman's mouth: 'We find the plaintiff cognitively impaired.' But the downside: Cost me twenty-two IQ points, and Dan, as you know, my claim to fame has always been that I'm the dumbest member of Mensa—I had the lowest IQ you can have and still be a member. But now I can't even seem to locate my toof-brush." He raises his voice. "Mary, do you know what I did with my toi-letry bag?"

On her knees in the bathroom, Mary holds up the bath mat, nod-ding hopefully.

"Never mind, dear, go back to work if that's what you want, or better yet come in here and rub my neck. . . ."

Mary gears up to run toward us while I gird myself for a bear hug.

"Mary, you are in for a treat when I take you home to America," he says. "You may think you've seen good basketball in this country with the Dalai Lama's team, but just wait till you see the Miami Heat. You're gonna meet my friend Shaquille O'Neal. I've had lunch with him half a dozen times, on account of my cousin on the other side of the family is his accountant. We'll get center court seats for all of us together, Dan in the middle 'cause how many people could I ask to delve into his life sav-ings like this, not a peep of complaint—"

Mary is at full gallop. I brace myself just in time for an onslaught of bosom.

"Cuzn Dan!" she cries.

CHAPTER 4

Making Love Out of Nothing at All

You cannot push a cow's head down unless it is drinking water by its own will.

First order of business is getting Larry back on his dialysis routine. No time to waste: Without a working kidney, it's imperative that he be hooked up to a blood-cleaning machine at once to keep him alive till we can locate a replacement kidney. Bright and early next morning, Mary leads Larry off to hook up with her uncle, who's made an appointment for him at a dialysis clinic. This frees me to begin the process of procuring a kidney, but before I can start, I have to do some remedial work—locating not only the luggage but also the passport Larry's managed to misplace, both a drain of precious time when we've allotted ourselves only a week in-country. Yuh-vonne pitches in, taking me to the airport where we find the luggage, manning the phone with her little rhinestone headset from my hotel suite to find the right offices to replace his passport so that he can legally be here.

Noontime finds Yuh-vonne and me sitting on a hard wooden bench with the rest of China, in a gleaming but ill-lit hallway at a police station where we hope to get the forms to get the forms to pay the five-hundred-dollar U.S. penalty and replace his passport. How can the insides of China be so gleaming when the outsides are so dusty? Maybe it has something to do with those brooms everyone is always wielding

that look like something snapped off a tree. It's a mystery that makes my eyes droop, and soon I'm dozing in and out of sleep while Yuh-vonne passes the time by translating aloud from the binder she claims is my fact file.

"'Beautiful lady smooth bottom of he shirt' . . ."

It's an interesting translation.

"'She take fingertips and stroke he belt' . . ."

"Wait a minute, it says this in my fact file?"

"No fact file!" she informs me. "Chinese chicken-choking book!"

So I see. Chinese porn is hidden inside the binder. Should I take umbrage that she's defiling my dossier? Yuh-vonne smiles with her little bitten lips and continues reading.

"'With great skill her fingertips undo the latch on belt, the key on belt'—what you call the handle that attach?" She looks at me brazenly.

"Buckle?" I say.

"Yes, buckle! 'And then she does zippery part'—what called the zippery. . . ?"

"The fly?"

"No fly!" She looks vaguely offended.

I peer down at the page, all those lovely squiggles. "Yes, fly, I'm sorry, that's what we call it. . . ."

Satisfied, Yuh-vonne coyly covers her smile with her hand and continues. "'He gorge is'—how you say, like a desert?"

"Dry? His throat is dry?"

"'Then she put mouth on he . . . deek. . . .'"

Suddenly my cell phone rings. Was I daydreaming just now? I scramble to fetch it and hear a semifamiliar voice.

"Ah, Dan, Professor is frighten."

"What do you mean, Mary? Is he all right? Can you put Professor on the phone?"

"Put. Professor?"

"Yes, can you put him on the phone?"

After a few minutes of negotiation, Larry takes the line. "Larry, are you okay?"

"Not really, Dan. I'm upset, I'm confused, I can't even read the street signs."

"That's because they're in Chinese, Larry. We'll get this all straightened out when we get you a new organ. Where are you? I'll come meet you."

"I have no clue, Dan."

"Okay, can Mary say it to me phonetically?"

Mary gets back on the phone. "Hello, Mary. What is the name of the hospital where you are?"

"Hos-ip-it-al. . . ."

"Yes, the hospital, or clinic, or wherever you are. Its name. What is its name?"

"Okay! Close Beijing."

"Not *in* Beijing"?

"No Beijing—close!"

"What's the name of the town? The name of—"

"Sank you, sank you very much," she says, hanging up.

"Yuh-vonne, I have to go see my cousin," I tell her.

With the aid of a rhinestone hand mirror, she's applying coral-colored lipstick to clash with the highlights in her hair. "He is eunuch?"

"No. What makes you ask that?"

"On phone—you say he need new organ."

"Not that kind. A kidney organ. Can you help me find him?"

"I do. Everything!" she reminds me with a happy smile.

"That's really sweet," I say. "Can you ask our driver if he's willing to go?"

"No ask driver."

"Why not?"

She leans to whisper in my ear. "Maybe he garment spy," she says.

All right, once again: the issue of "government spies." Let's get into this topic a little deeper. Twenty-five years ago, almost everyone in China was a government spy. In fact, it was risible how almost everyone was a government spy. They were paranoid, and with good reason: When Mao formed his first government in 1949, it was later discovered

to be half filled with Soviet spies. And the Soviets were his allies! In Chinese society, spying for the motherland was traditionally considered a sacred duty. Keeping tabs on friend and foe alike was in the air they breathed, and had been for eons. But for a culture that codified its espionage in the sixth century B.C., the cloak-and-dagger stuff was so primitive as to be borderline funny. One evening twenty-five years ago, I came back from a banquet early to use my bathroom and actually caught a sweating hotel clerk with his hands in my luggage, feverishly planting a bugging device. Later he tried to gain my good graces by giving me a bottle of sticky-sweet Shandong wine. I was so taken with his grade school antics that it worked: He *did* gain my good graces, even though from then on, my luggage clicked like a Geiger counter whenever I got near a railway station. I was embarrassed for them, the way one is embarrassed for a slow classmate who so obviously copies from your spelling test that you move your elbow to let him see better.

But then, of course, that slow classmate had the power to lock you up and throw away the key.

Ah, the precious antics of police states . . . comedy on the cusp of terror. Staring into the abyss for three hours, last time I was here, was so nauseating that the only proper response was laughter.

Yuh-vonne leans in again. "Also for secretive purposes, we refer to kidney as other name. Say 'Princess,'" she suggests.

"You really think it's necessary?"

"I think."

Calling Mary back, Yuh-vonne gets directions to the dialysis clinic outside the city limits. We dismiss our limo driver and hop a bus to the burbs, which are distinctly un-Kryptonopolis-like. There are oxcarts and rice paddies and the smell of gunpowder from fireworks going off at random. We take a bumpy taxi ride several hazy blocks to a clinic that looks like a low-level government building, with decals for soda pop on the windows and a junior-size billboard in the courtyard advertising foot powder.

When we finally locate Larry, he's inside a circle of people—slumped forward in the backseat of a minicab parked inside a second inner court-

yard, looking like a guy who's made up his mind to do something everyone else disagrees with. He may be frightened, as Mary diagnosed, but it comes out as stubbornness. He refuses to have his dialysis treatment. Why not? He objects on principle to being ordered around. Even if it's for his own good? He doesn't care. He hates this hospital, he hates this country, and he hates Mary.

"You hate Mary?"

"Probably only temporarily. I've been up since seven o'clock with certain things I said I wanted to do, and Mary, whose real name turns out to be Ma-ah or something like that, she stalled and stalled—first we had to go here, then we had to go there, and then we had to go to a restaurant where I paid for lunch for everyone."

"Who's 'everyone'?"

"These people. The doctor, the translator, and so forth."

"That's who these people are?"

"Yes. I'm too tired to explain. Also the taxi driver and the old man."

"Who's the old man?"

"Dan, you know what? I don't want to make introductions right now. I just want to go back to my hotel."

I turn to nod hello to everyone. They grin at me helplessly, with worry in their eyes. The woman doctor looks concerned and kind. The old man has his chin in his hands and is assessing everything as he steps thoughtfully about, never looking at anything in particular. I take a seat in the taxi, which is rich with a loamy scent, and turn back to Larry, who manages to lift his gaze to me with a pirate glint and say, "On the other hand, I like your girlfriend."

"She's my guide, Larry."

This would be the time for Larry to come up with some sort of crude joke about her guiding me to a rooftop, *shtupping* my money's worth, something like that. What constantly surprises me in these instances, however, is that Larry's not that type of person. Despite his rough appearance, he's made of finer stuff. "I always envied your taste in women," is all he says.

I look over at Yuh-vonne and wonder again whether the T-shirt she's

wearing, with the slogan I AM IN MY PRIME, is the most appropriate choice to wear while visiting police stations this morning. "She's pretty bright," I say.

"She's like the Chinese equivalent of a California girl," he says, warming to the subject. "Not a Valley girl—she seems too articulate—but a starlet, very enthusiastic, someone who—"

"Larry," I interrupt, "if you don't have dialysis, you could die."

"So I die. I don't care anymore. I'm sick of treading water."

"Larry, you haven't treaded water in China. It's different here."

"Dan, all due respect, but water is water, and I can't back down now after saying I wouldn't. It would signal weakness."

A memory comes to me—Larry as the little boy refusing to blow out his birthday candles. He'd sit there with his chunky arms crossed under his pointy birthday cap, insisting that if he blew them out, it would mean that the party was over. And now as an adult, the mix of 100 percent obstinacy and perhaps 60 percent disability is a potent one. Nor is physically forcing him an option: Not only would he be as unmovable as a tree stump, he'd probably punch me in the kidneys. Then we'd have two of us needing new organs.

And so Larry the diva of dialysis sits in the back of his Chinese cablet, choosing instead to relate his first memory.

"Maybe not actually my first," he says, "but top two or three anyway. My mutha says we have to go see the doctor. I don't want to go see the doctor. Okay, we're not going to see the doctor, my mutha says, we're going to see Aunt Esther. Goody, I like Aunt Esther. But after we go see Aunt Esther, guess where we go next? The doctor's. It was a stupid lie, but it opened my eyes."

"Maybe that's when you started taking a different path from your twin," I say. "Judy continued to believe in your mother's system, but you took a more skeptical approach."

"It taught me that if something didn't make sense to me, I'd say no. So when you tell me things, no offense, Dan, no matter how much sense they might make to you, I'm going to go with my gut. Hasn't lied to me yet."

"But right now your gut is injured, Larry!"

"Sorry," he says with a shrug. "My kidney tells me, 'No dialysis to-day.'"

"About that word," I say. "Yuh-vonne thinks it would be better if we don't say 'kidney.' The walls have ears, apparently. She suggests the word 'Princess.'"

"Fine. I need a new Princess. But the old Princess doesn't want dialysis." He coughs into his hand, a surprisingly delicate maneuver. "I am just not in the mood to be exsanguinated."

"Don't be dark, Larry. You're not being exsanguinated, you're having your blood cleansed."

"I thought you'd appreciate the word, though," he says with a hint of pride.

In addition to his personal entourage, we're providing entertainment for a crowd of maybe ten people in the courtyard: three teenage girls, a barefoot man smoking in a wheelchair, a beggar urinating on the clinic steps, and half a dozen faces at various open windows in the whitewashed clinic, all staring at us impassively.

"But you could die without dialysis!" I remind him.

"Actually, I've skipped them before and was surprisingly okay. I figure if I can cut out one every other week, I can save myself a couple hundred bucks a month."

This calculus reminds me of the husband in childbirth class who asked if he could get money back for forgoing the episiotomy. I refrain from telling him so. "And Mary?"

"She can keep the gifts. I'm not asking for them back."

"Have you given her more gifts?"

"Just a used laptop, about a year ago. I couldn't believe how easy it was with PayPal. I wired her three hundred and fifty dollars, she picked up a Dell, I think she said."

"Don't you think that was overly generous of you, before you'd even met?"

"Dan, she had to go out in forty-below weather to e-mail me! Do I want her to freeze, just to talk to me? That's why I brought her my mother's mink coat."

"I thought you brought her the warmest coat that L. L.Bean sells?"

"That was for Labor Day. The mink is for Memorial Day. Or vice versa. Trying to keep those holidays straight is a sucker's game."

"You carried your mother's mink coat over from Florida?"

"I had it compressed. They do a very good job of compressing things like that. It doesn't cut down on the weight, but it takes up surprisingly little space."

"I can't believe you gave her your mother's mink coat when you're not even sure you want to stay with this woman."

"She liked it very much. She was posing for me, I took pictures. It looked almost as good on her as on a stripper of my acquaintance. Nice way to say 'hooker,' incidentally."

It occurs to me that I could learn a thing or two from Larry's open-handedness. But now's not the time to explore this question. Now's the time for a decision.

"Larry, you're not thinking straight."

"Welcome to my world," he says, pointing to his head as though it's a third party to these proceedings. "My question is, am I misoriented permanently from the icicle, or just temporarily from the dialysis? I can only hope it's the former."

"You mean you can only hope it's the latter," I say.

"That's what I said," he says.

I don't bother correcting him that it was his mother the icicle hit. "Let's get him back to his hotel," I tell the crowd. "We can make sure he gets his dialysis tomorrow, hopefully."

The crowd murmurs troubled assent. The kindly woman doctor retreats into the clinic. The translator piles in the front seat of the mini-cab with the driver, and Mary piles in with Larry in back. The tiny car heaves and bounces off. The old man sticks around, still with his chin in his hands and pacing slowly to and fro, looking at nothing but assessing everything.

The smog respires with a life of its own, back and forth, like cloud banks of vaporized Frappuccino, quite tasty.

"So that's my cousin," I tell Yuh-vonne, inviting her to sit next to

me on a cinder-block bench. "What's your honest opinion of everybody?"

The black pupils of her eyes dart from side to side, twitching as in REM sleep. She's hard at work, figuring how much tact to filter in with how much candor.

"Your brother Laurie's accent I can't understand," she says carefully.

"He has traces of a speech impediment left over from having his tonsils taken out too late," I say defensively. "Or maybe they mangled the surgery. Anyway, his tongue sometimes has a habit of staying in the back of his froat."

"He sound a little Chinese," she says.

"Hmmm. And what do you make of his mail-order bride, though Larry doesn't like us to refer to her that way?"

Again with the REM movement. "Ah, she is not good educated."

"No?"

"Because her voice doesn't look beautiful."

"So there's no way she could be a college professor, as she claimed?"

"Definitely not! High school maybe. In the distant countryside. Her education basement is very low."

"I'll level with you, Yuh-vonne. See, I'm not sure I can trust Mary. Maybe she just wants an American husband to get out of the country, take his money, and then ditch him. I need to figure out if she's good for him."

"Ah, maybe just concubine to play with Laurie," she says, "only to play and not be serious, so to catch better opportunity for herself."

"We call that a gold digger, where I come from."

Yuh-vonne thinks a minute, nibbling little dents into her lips. "But maybe Laurie have golden heart," she says at last. "Maybe they have golden heart together. A relationship between human beings is the hardest thing there is."

Which gives me something to think about while the old man paces nearby, his chin in his hands.

"It is hard to find person you can trust," she says at last. "Mary is brave lady. She came to Beijing only to make friends with Laurie. This

take a lot of courage. But as for emotional item, I'm not sure," she says. "Maybe Mary not love Laurie so much."

"Okay, that's what I'm wondering."

"All she worry about is if he dangerous."

"Larry? He wouldn't hurt a fly. Unless maybe you were a cousin who got on his bad side."

"That all she worry about, not how is Laurie doing, only is he dangerous. Also why he never marry before."

"He's come close a couple times, but it never worked out."

"Not because he gayboy?"

"Nah—he likes the ladies, and the ladies like him."

Yuh-vonne nods. "Mary is not stupid, and she is clever. She knows what she wants. Also, all these people around Laurie, they are her peeps, I think. Three to one. Four to one. Who know how many, their purpose only to chase the money."

"You think they're all in collusion?"

"And the taxi driver, too, in my opinion." Yuh-vonne stands and extends a hand to pull me up. "So now we go back to our hotel?"

Despite myself, I love how she calls it "our" hotel. But suddenly the old man takes a step closer and addresses some sentences in Chinese to Yuh-vonne, who nods and says "Are! Are! Are!" like a toy poodle with its vocal cords cut.

"What was that about?" I ask when it's over.

"Ow my God, this man is the uncle," she tells me.

"All this time? While we were talking about Mary?" I ask, as the old man takes a thoughtful step away to give us room to discuss. "Could he understand us speaking in English?"

"Impossible to know," Yuh-vonne says. "He play cards very close to chest. But also maybe he decipher your party language."

"Body language?"

"Maybe?"

"How do you do," I exclaim, grabbing the old man's hand. He smiles wanly, allowing his limp hand to be pumped but still looking at nothing, certainly not at me.

"Sank you very much," he murmurs deferentially.

"Well, time to go back to our hotel!" I announce to everyone—teenage girls, urinating beggar; it's not quite loud enough for the people in the open windows, but I trust they can read my party language.

"Not so fast, homey," Yuh-vonne says. "Uncle say wait here for Laurie."

"Why wait here? Larry went back to the hotel."

"He say Laurie only went for gifts in taxi."

"But that makes no sense! Why would Larry want to get gifts for the clinic he's refusing to have treatment in?"

Yuh-vonne gives a shrug as if to say, He's *your* brother. But he's not, of course. She keeps calling him my brother because she can't fathom why I'd do this for a cousin.

Just then the taxi comes toodling back into the dusty courtyard. Everyone tumbles out but Larry. The taxi driver waddles into the hospital bearing an armload of hastily wrapped presents.

"You got gifts for the clinic you're rejecting?" I ask Larry.

"That's how I am, Dan," Larry explains, patiently cracking his knuckles in the backseat. "I'm a people person. I like to give. Plus, I want to stay on their good side, in case I find myself needing their services at some future date. Just because I'm ill, don't ask me to change how I do business, please."

I switch tactics. "So the old man turns out to be the uncle."

"Yes, and some sort of godfather in the government, I gather. He arranged this clinic. He arranged the taxi. Any case, I suggest we go back to my hotel. I need a pillow very critically."

I turn to Yuh-vonne. "You want to go back to their hotel with them?" I ask her.

"I am at your service night and day," Yuh-vonne confirms.

"Can we squeeze in your taxi?" I ask Larry.

"Why not? Save a few bucks."

This taxi is not like the Red Flag limo with leather seats. It's more like a circus car trying to accommodate a serious number of misfits. We

say good-bye to the uncle and the translator, and soon Larry and I are pressed up together in the ratty backseat, thigh length to thigh length. In all the years we've known each other, this is the closest we've ever been. He radiates an inordinate amount of body heat.

"I like the uncle, he's connected," Larry says. "I'm going to send him a Cross pen-and-pencil set. Something to show honor. If I can work with him, I think we can make a mint together. I can set him up in Vegas, I know croupiers, I know the sheriff, I know the head of the Chamber. Or forget Vegas, I can fix him up with Sheldon Adelson, who's only doing the biggest casino in the world in Macau as we speak. My mutha went to grade school with him back in Roxbury-Dorchester. All we need is one percent of his casino. Is one percent too much to ask? With Mary at my side and the uncle in my pocket, we can score big time."

Yuh-vonne exchanges a few sentences with Mary in the front seat, then clears her throat to get our attention. "Yes, but you see, just now Mary tells me she will leave Laurie," she says.

I'm shocked. "What? You mean for good?" I ask.

"Sorry to inform," Yuh-vonne says. "She do not like fiasco at clinic."

Larry's self-defense mechanisms are more practiced than mine are. "So she leaves," is what he says, cracking his knuckles.

"But . . . but," I sputter. I'm taking this hard. I'm protective of my cousin and don't want to see him left high and dry. But I'm also a cheapskate. "What about the mink coat?" is the first thing I can formulate.

"I'm good for it," Larry says. "I gave it to her with no conditions. It's her property."

"But—"

"She's free to go if she wishes," Larry says. "I make no claim on anyone."

I'm so stunned on his behalf that I feel a little carsick. I look at Yuh-vonne, who looks back at me. We're sad together on either side of Larry, and a little guilty. While she and I were checking out Mary, Mary was checking us out and deciding it wasn't worth it.

We ride in silence for a kilometer or two, bumping. The taxi has no shock absorbers or muffler, and we rattle around noisily. After a while I reach in front and squeeze Mary's right shoulder. This seems to relieve

the tension, reminding her that we're not enemies. She inhales and pats my hand. Yuh-vonne says something to her that sounds to my overeager ears like, *"Watch 'em, guam show."* Is it okay for me to hear English in the sounds she makes? The last thing I want to do is dis these people who're going to such lengths for us. Finally I decide it's just my brain doing the best it can, and I let it be. *"Saudi sandwich way too low,"* Mary responds, shuddering with a couple of small sobs and dabbing at her eyes. I can't tell if I see tears or not. Maybe the way her skin is constructed, it soaks them up before they have a chance to roll down?

"What're you thinking?" I ask Larry.

He shoots me one of his Mona Lisa smiles. "I could clean up in this country with a coupla Midas shops."

When we get to Larry's hotel, Mary's still dabbing at her eyes, but she seems fine. Larry's unhappy but taking the blow in stride.

"Where are we?" Larry asks, standing in front of the lobby. "Oh, I didn't recognize it for a minute. I apologize, everybody."

We clamber upstairs, each according to his or her capabilities. Various people help various people. As we walk down the corridor—Mary who is not Mary, Yuh-vonne who is not Yuh-vonne, my brother Laurie who is actually my cousin Larry, and the taxi driver who for some reason has come with us—I lag behind to examine a trapdoor in the wall that has captured my attention. When I get it open, it reveals a primitive fire extinguisher inside.

"Curious man," Yuh-vonne whispers to me with a lewd wink, "always curious man."

Mary busily fidgets at the room key, an oversize woman always fidgeting with undersize things. Once inside the room, she marches into the bathroom and huffily plucks frilly panties off the shower-curtain rod like Richard Dreyfuss in *The Goodbye Girl.* The taxi driver makes himself at home on Larry's bed, sitting cross-legged on the pillow to work the remote for the TV across the room. Larry plops himself down on the foot of the bed and removes his Businessman's Running Shoes from

his swollen feet. I don't want him to remove his Businessman's Running Shoes. Even less do I want him to remove his Freakishly Thin Business Socks, but that's what he does. Wearing a sphinxlike expression, he rubs his bare toes with both hands. They must be soggy and odoriferous, I think. At this moment I should kick-start a negotiation between the estranged parties, but I'm too busy trying to cover my nose and take tiny surreptitious inhalations, yoga-like.

With me in this handicapped state, Yuh-vonne initiates the conversation. "Mary, do you want to say something to Laurie?" she begins.

Yes, she does. Mary plucks and plucks, Larry rubs and rubs, I cover and cover. With Yuh-vonne interpreting, here's what it is:

"Mary say she feel very sorry, but to be honest she did everything according to her mind. It all just a mistake."

"So she's really leaving?" I blurt, ruining my yoga breath. "Just like that, after corresponding on e-mail for two years?"

My plaintive tone seems to mobilize Larry.

"Did I ever hit her?" he asks, dropping his sphinxlike expression. "I know I was angry today, but I never came close to hitting her. Surely she has to realize that."

"Larry, do you *want* her to stay?" I say.

"I don't want her to *leave*," he says, as if making a great concession. His pride's at stake, and he didn't get where he is in life by begging.

"Okay, now we're getting somewhere!" I say optimistically. I surrender to the situation, uncovering my nose. "Hear that, Mary? Larry doesn't want you to leave."

Mary comes out of the bathroom and wipes her eyes against the black lacy bra in her hands. She turns to Yuh-vonne, snuffling. *What should I do?* is the question she obviously puts to her in Chinese.

Everything's in Yuh-vonne's court for a minute. She launches into heartfelt negotiations with Mary while Larry continues to rub his feet and look indifferent. On the muted TV, a Chinese shopping channel is hawking a lime green Barcalounger knockoff that's the spitting image of the one I'm sitting on. I'm not sure whether I should feel vaguely famous because of this.

"I don't like her," Larry says, rubbing his feet.

"Who? Mary?"

"Mary I like again. And Yuh-vonne I have great respect for."

"Then who don't you like?" I ask.

"The taxi driver," Larry says. "Why does she have to be in on this?"

"The taxi driver's a woman?" I ask.

"That is my judgment, yes," Larry says. "And a very expensive one, too. She charged me eight hundred RMB for the use of her cab today. That's more than a hundred bucks."

"I thought the uncle was picking up the tab," I say.

"As did I."

I look at the cabbie with new respect. "You wouldn't happen to know of any black-market connections for a kidney, would you?" I ask her.

"King tizzy, shoe can go," the cabbie says, waving no.

On TV they're now pitching some kind of bird poison that makes unwanted birds keel over almost immediately. You can rid the whole neighborhood of pesky, noisy birds! At last Yuh-vonne comes out of her huddle with Mary.

"What's the verdict?" I ask.

"Mary say if Larry take dialysis tomorrow, she will stay three days."

Despite himself Larry betrays a look of immense relief. "Deal," he says.

"Our work here is done," I say, standing up. I feel chastened, realizing how tentative the situation is, not just Larry's health but everything. I don't know who anyone is, what anyone knows or doesn't know, when or where the next shoe will drop. "We go to our hotel now."

Yuh-vonne hugs Mary in a mutual ballet move, the women patting each other's shoulders ritualistically. Yuh-vonne kneels to hug Larry, her "Prime" T-shirt riding a third of the way up her bare backside. "Thank you, dear," Larry says to her, and means it.

Yuh-vonne gives him a lingering look of fondness. "I hope you be happy every day," she tells him.

Yuh-vonne wants to collect the headset she left in my hotel suite, and in a few minutes she's back there with me, casually shuffling through my yoga CDs. "Yoga give you the soft bones?" she asks.

Is it a rebuke? A challenge? "No, yoga does not give me the soft bones," I say.

"You mind if I smoke?" she asks.

Ordinarily I would. I would stop her both for general health reasons and because it must be smoke that has stained the backs of her teeth brown, where she's forgotten to whiten them. Also because it's getting late. But right now I'm too fatigued from the day's machinations to object. Besides, it's amazing to see her smoke, and with a rhinestone cigarette holder yet. Blue curlicues waft from her nose like in a movie from the 1940s.

"I am at your service," she reminds me, stroking the back of my head.

"So this means what, exactly?" I say.

She answers the question sideways. "I see fortune-teller," she says, taking her hand away to fetch her iPod from within her purse. "Fortune-teller say I marry two times."

"What happens to the first husband?"

"Die," she says with a smile. If that statement's meant to woo me, it's the strangest woo I've ever heard. She turns on her iPod and holds it up so I can hear the song: "Making Love Out of Nothing at All" by Air Supply.

"We go rooftop now?"

I'm a curious man. But mostly I'm a married man. Bye-bye, Batgirl.

CHAPTER 5

Situation Splendid

A good fortune may forebode a bad luck, which may in turn disguise a good fortune.

Picking up momentum here. We've got Larry lined up for remedial dialysis, check. We've managed to procure a replacement passport, check. Now at last I can get moving on job number one, finding a secondhand kidney. What's at stake is so dead serious that I find it essential to maintain a light touch. "Here, black market, c'mere boy. . . ."

Establishing contact with China's black market is tougher than you might think. Turns out it doesn't advertise in the yellow pages. Nor can you just go out and hail it the way you would a taxi. You can't clap your hands and entice it like a puppy, *Goo' boy, want your belly rubbed?* And maybe you don't want to establish contact with it anyway, given that it might end you up in a jail cell with sadistic Chinese soldiers puffing smoke rings in your face. . . .

So the next-best thing is to reach out to Beijing's international journalists, a loose and backstabbing confederacy, I realize, but I have to start somewhere. Ditching Yuh-vonne and her Happy-Go-Luck services and letting Mary take Larry to his makeup dialysis, I spend a day making discreet inquiries among the fraternity of Western journalists covering China. No dice. I spend another day discreetly calling Chinese reporters on the mastheads of native English-language newspapers. Ad-

ditional no dice. As the days wind down, I find my inquiries becoming less and less discreet. The thin and subtle feelers I put out are turning into large and hairy vines. Eventually the vines turn into a shaggy net that I cast wider and wider. I know I'm supposed to be hush-hush, but on the other hand, as the Red Guards used to be fond of saying while bashing people's heads, you can't make an omelet without breaking some eggs. The net's soon wide as can be, encompassing pretty much everyone I encounter. Private butlers, public bartenders, night watchmen, strip-club bouncers all are left scratching their heads in my wake. "Kidney? What mean 'lightly used kidney'?"

Elevators are a particularly promising venue. Here's how it goes in one of them.

"From Seoul?" I ask a Korean businessman whose robust voice makes him seem wealthy.

"SEOUL, YES!" he shouts. "YES, SEOUL! HA HA HA!"

I never knew I could be so funny by merely stringing two words together. But when I string together a few more, he begins guffawing so volcanically that I fear for the cable lofting us skyward, especially as he starts bouncing around the elevator, feinting jabs at my midsection.

"NO PRELOVED KIDNEY! HA HA HA HA HA! NO PRE-LOVED KIDNEY!"

Here's how it goes in another elevator, with a Caucasian man helping a tiny Chinese baby girl hop across the floor. Something about the way he handles her, as though she were expensive porcelain, tells me he's a new parent.

"Cute baby. You adopting?"

"Yes, just today."

"Congratulations. Where are you from?"

"Spanish."

We watch the little sweetheart for a while. There's a bald spot at the back of her head where her hair has rubbed off in her crib; she probably wasn't moved as often as she should have been in the orphanage. "New life for her, eh?"

"Yes." He pats his heart. "And for us."

I take a breath and consider asking whether the adoption agency would happen to have an extra kidney in the system, before coming to my senses.

"Hey, have a great day," I say. "Good luck with your little charmer."

Obviously I'm getting too close to the line. It even almost-crosses my mind to pass out flyers in Tiananmen Square—figuring I'm giving up on China in a few days anyhow. What're they going to do, detain me for being desperate?

Uh, yes. . . .

That's when I decide I need a breather. It's been three days since the fiasco at the dialysis clinic, and I treat myself to a swim around the perimeter of the hotel's giant kidney-shaped pool—it feels like I'm tracing Larry's organ, writ large—and afterward make for my favorite breakfast buffet on the sixteenth floor. I lift the lids of the silver chafing dishes to ogle the food items, which seem a cross between fifties-style Betty Crocker–type hors d'oeuvres and something from an agricultural country-fair display: demure heart-shaped marshmallows topped with overchewy corn niblets, pizza-type waffle wedges topped with dino-size sausages.

While I'm filling my plate, I'm approached by a waitress I haven't seen before. The nameplate on her olive drab uniform says TRAINEE, but she tells me her real name is Jinghua.

"Jinghua," I say, mauling the pronunciation.

"It mean 'situation splendid.' "

"Jinghua," I try again, but can't get my mouth to do that nasal thing. That mouth thing.

"Give it up," she says, smirking demurely. "Be content at call me Jenny or Jade."

"Jade is nice," I say.

"So you little fairy?"

"Excuse me?"

"You try a little fairy rice?"

"Fairy rice?"

"Sorry for my simple mistake. *Fry* rice. Or try neuter?"

"Noodles?"

"Yes, sorry once more. Noo-dle."

After I settle into my bamboo-and-cane throne, Jade is still with me. She stands in attendance while I sip my surprisingly great orange juice. Then she trips over her own feet just standing there but betrays no embarrassment, no lack of composure. She's like a pony, not quite used to her long legs. I'm charmed.

"What under you hat?" she asks.

"Nothing but hair loss. See?" I show her. She studies for a moment.

"Torrible," she says. "How old you are!"

"Yes, it's true."

"No, that is my question. How old?"

"Oh, me? I'm eighty-four."

She thinks this is wildly funny. I'm becoming legendary throughout the Middle Kingdom for my rarefied sense of humor. "If you could be any age, what would it be?" she asks conversationally.

"I like being eighty-four! It's a great age. What about you?"

"For me, I like you be twenty-five, so be my big brother."

I meant how old would *she* be, but that's okay. I'm pleased with her answer.

"But since you so old, we must content to be father-daughter."

Works for me. She can be the daughter I never had, poised and pretty. It's been twenty-five years since I was last in Beijing, as a foot-loose young man between wives. And how old is Jade? Twenty-four. If any of the women I'd hooked up with last time I was here had gotten pregnant, the child would be Jade's age now. She's a grad student of foreign relations, she tells me, only a part-time waitress, and I immediately feel more at ease with her than I ever did with Yuh-vonne—her frank, guileless face, her teeth that are as white in back as in front. But how can she, like Yuh-vonne, be so free and easy about her American name? Jenny or Jade—how can she allow her identity to be so malleable? A Chinese mystery, one of those enigmas that long ago earned the natives that awful adjective "inscrutable."

But she's giggling at me again, producing cute bubbles in her teeth. "You are much ability to make me laugh," she says.

"What'd I say now?"

"Not say—*do.* You stir coffee with arm of sunglass."

"That's an American thing. All the very important people, the presidents and such, we stir our coffee with our sunglasses. It's like a code, how we recognize each other abroad."

"You are pulling it again, my legs!"

So I am. But in a chaste, fatherly fashion. She's so trusting I wouldn't have it any other way. Her dark eyes are candidly veiled, like seal eyes, peering at me with more openness than I'm used to. Maybe that's what gives her such an air of vulnerability. For me, after being with Yuh-vonne, it's like going from a hot dog to a cream puff, except that Jade is strong as well. She knows who she is. I reach for the clod of preternaturally bright scrambled egg, with a cowlick of parsley on top. And continue making conversation, since she shows no signs of leaving. Her supervisor sees her idling with me but backs away, bowing.

"So, Twenty-four, do you have a big brother or sister in real life?"

"No, Eighty-four. I am only one child."

"Is it lonely for you, to be an only child?"

"Oh, no, I am glad of this. I am number one! I tell my mather, if you have another baby, I will kill it."

"You were joking, surely?"

"No—serious!" She giggles, pleased with herself: "He he he he." I never heard a giggle so literal before, but it works. I would say it sounds scripted, except it's so charming.

"So you are their treasure."

"Treasure, yes. My mather tease me, say she like her dog better than me, but I know is not true. In true, I am responsibility to be best daughter I can, safe and good. If there is tragedy and I am killed, like in earthquick, then they have no one, is torrible!" Her eyes fill with tears. "Such a thing take place sometime and is very torment."

Every now and then, you meet someone like this—someone you feel

should never have to die. How could such adorableness ever die? How could such sparkling innocence be snuffed? I want to protect her from death. I want to take her under my wing and make sure no harm comes to her—no earthquick, no depressionism, none of the things that hurt our children. Of course I can't say any of these things, so I content myself with saying, "Your parents must love you very much."

"I hope that," she says ardently. "So what is your plan in this day?" she asks.

"I don't know. Why?"

"This day is my lucky day, I think," she offers. "Because this day I show you my country to repair my English."

This isn't delivered flirtatiously—just earnestly. Situation splendid.

"You want to show me around? What'll it cost me?"

She doesn't understand. She doesn't want to think ill of me. . . .

"How much to be my guide for a few hours?" I say, tapping my watch and wallet, but this puts a shadow of shock on her face.

"Nothing!" she says. "I want repair my English—"

"Okay, yes, sorry, I'd like that. Maybe tomorrow morning?"

"We take tour. I show you fuck market?"

"Pardon. . . ?"

"Antique and such, also modern product for deep discount?"

"Oh, sure. Folk market sounds good."

"Where we have supper?"

"Supper? I can't take so much of your time."

"I am nothing to do tomorrow except working, sleeping, shopping."

She looks so dejected that I feel like the Spanish father in the elevator, handling his baby with kid gloves.

"We'll play supper by ear," I say. "Where's good to meet tomorrow morning?"

"Outside hotel. Not in lobby. I not tell hotel I doing this."

"Undercover, eh?"

"Double-oh-seven, bang bang!" she snickers, blowing smoke off her fingertips.

"Gotcha, outside the hotel."

I will not—I will not!—pass out flyers in Tiananmen. To distract myself I return to my luxury suite, settle myself among my 100-percent Egyptian cotton linens, and knuckle down to cast my shaggy net wider still. I wish I could use the distinguished mahogany fountain pen provided by the hotel to write letters in longhand to everyone I ever knew in the hemisphere, but I settle for e-mail. Some remedial apologies are top of the list.

> Dear Safrina, First of all I want to apologize for the way I left you waiting at the Singapore airport last time. I know it's nineteen years ago, but I'm trying to make amends for my youth. What can I say? I loved you, but you had too many boyfriends for me to handle. I had to break your heart before you broke mine. Anyway, I find myself in your neck of the woods again and wonder if you might have access to any working kidneys on any of the islands. . . .

> Dear Achara, I'm sure it comes as something of a shock to hear from me again, two decades after our painful falling-out, but I'm writing to ask an unlikely favor. I remember you telling me that your aunt was the queen of Thailand. With the vast connections that must be available to your family, do you know anywhere in Bangkok I could possibly get my hands on . . .

> Corazón! It's way past time that we bury the hatchet. Why point fingers? There was enough blame to go around. I'm not mad anymore and hope you're not either, because I have a dire favor to ask. Manila has become quite the sophisticated medical center this last decade and . . .

Then, speaking of the devil, just after I've pinged this off, Manila pings me back. Not Corazón or any of my other old Asian flames, but a

beachside motel where I earlier made tentative arrangements if our week in Beijing didn't pan out.

> To whom Sir and Madam☺
>
> We look forward where you stay. At your request we have book two ☺ rooms. However we are in perplex about you request for rooms on separate floors for 'breathing room' purpose. Is pity Sir you request ☺ for two floors can not be honored because we are single floor operation. However we can place each room far from the brother room, if suitable, on other side of **Relaxation Yard** which is covered by green plants to make guests feel cleansing and comfortable. . . .

Score! I snag this despite its vaguely prisonlike sound. It's only a contingency anyway. Hopefully, we won't need Manila if China somehow comes through.

One more outgoing e-mail before I get to my in-box: A warm thank-you to Happy-Go-Luck Travel, telling them I won't be needing Yuh-vonne's services any longer and directing them to give her a large tip in farewell. It's in honor of the little teeth prints on her lips, may she be happy every day. But, oh dear: Is Larry's generosity rubbing off on me?

No, it's his pragmatism. I'm purchasing Yuh-vonne's continued silence. The last thing we need is for her to blow the whistle on us.

Nibbling the plunder I pocketed from breakfast, a croissant I'm happy to confirm does not have a 4-H blue ribbon clipped to it, I move on to my incoming. The first is from the Disapproving Docs:

"Dan, we must once again state in the strongest possible terms that we find your actions reckless in the extreme. The very idea of scavenging for a life-saving surgery would almost be laughable if it weren't so naïve. There are simply so many unknowns here that we demand you clear all contacts with us before proceeding. You *have* lined up rock solid contacts, we assume?"

Oh, rock solid, never fear. Into the recycle bin it goes. I open another

e-mail from my one and only contact, the embassy friend of the friend I e-mailed before I left home. Izzy is gone all week, it turns out, but wants to know if we can meet on Friday evening when he gets back. I check my calendar. That would be cutting it close, because it's only two days before our backup flight to Manila. Izzy suggests we meet at his synagogue, some sort of makeshift temple for expat Western Jews apparently, in a space graciously donated by a foreign-language institute. It sounds sufficiently Somerset Maugham–ish to spark my interest, and I tell him yes.

And now the reward for all my hard work: an e-mail from home. Even tapping the name of my youngest stings my heart with yearning.

Dad!!!!!!!!!!!!!!!!! MS.BOULDRY MYNEW TEACHER IS AWESOME!!! !!! These are some words to describe her: funny, creative, smart, childish, helpful, caring, weird, CHATTERBOX!!!!!!!!!!!! and gets disracted really easy!
 dad i love you sincerely,
 Jeremy Roth-Rose

P.S. I think Flight attendants wear to much lipstick, Dont you?

Okay, that's it. I need a blast of family heat. It's 9:00 A.M. here, 9:00 P.M. there on a school night, but they might still be up. I dial.

The incomparable wife: "How's it going, hon?"

Her unworthy husband: "Compared to being on a chairlift with two preadolescents? It's a cinch," I say.

"You staying safe? Boys, try to keep it down when I'm talking to Dad in China—"

"DAD IN CHINA!?" There's the sound of the phone being grabbed, fumbled, moved to the fifty-yard line, intercepted. Touchdown! I manage to ram in the earplugs I've arranged at the ready just in time.

"How's it goin', Pop? You're not getting arrested or anything?"

"Going okay, Spence."

"Not getting gunned down by *Laurence*?" he says with a mock French accent. Our little motif, for some reason.

"*Laurence* keeps missing me so far. What's going on with you?"

"Won a tennis trophy. Wrote a cool poem. I'm well rounded."

"Amazing," I say. "You astound and delight me, big boy."

"Yeah, so I'm feeding the ducks like you asked, and everything's fine, except Mom keeps fast-forwarding the movies through the sex parts just because Jeremy's too young."

"AND I ALREADY KNOW WHAT SEX IS!" adds his exuberant little brother in the background. A statement Spencer cannot let pass unchallenged.

"Okay, Jeremy, what is it?"

"Guys, guys, have a sense of the moment," I say, "this is a phone call from around the globe."

"Well, Mom's saying it's Jeremy's turn. See ya, Dad."

"DAD, HI, I CAME UP WITH SOME INVENTIONS JUST LIKE YOUR COUSIN. READY? BEER POPSICLES!"

"Not bad, Jeremy, I could see that catching—"

"OH, AND HOW ABOUT THIS ONE: CHEESE DOUGH-NUTS! SO NEXT TIME, DAD, COULD YOU TAKE ME TO CHINA WITH YOU, BECAUSE I HAVE LOTS OF IDEAS, AND MAYBE I COULD HELP SAVE YOUR COUSIN, TOO!"

"That's a really nice offer, Jeremy, but I don't think—"

"BUT, DAD, YOUR COUSIN'S NOT REALLY GOING TO DIE, IS HE, DAD? YOU WON'T LET THAT HAPPEN, WILL YOU, DAD?"

"Well, I'm doing my best to—"

"OH, AND, DAD, GUESS WHAT'S THE BEST SOUND IN THE WORLD? THE SOUND OF TEETH CRUNCHING INTO A BAGEL! EVER HEAR THAT, DAD? IT'S SO DELI-CIOUS-SOUNDING! READY, HERE IT IS...."

And then, from halfway around the world, I hear it, clear as a bell, the delicate sound of my son's front teeth breaking the crust of a toasted

bagel. And he's right, it *is* delicious-sounding. It's blessed-sounding. But his quiet, sensual side doesn't fool me for a minute.

"Good night, hon. And, Jeremy, guess what? I figured out what you're gonna be when you grow up."

"WHAT?"

"A wealthy Korean businessman."

"Chutzpah" Is a Jewish Word

Man's schemes are inferior to those made by heaven.

Pine. The minty smell of pine needles . . .

Next afternoon I go back to the discount hotel and find Larry on a chaise in the courtyard, catching some rays. The pleasant scent of piney goodness perfumes the air. In the milky light, Larry's skin looks like drapery that's been stored in the back of a closet for years. He's wearing what looks like a Depression-era bathing suit and his box turtle sunglasses while Mary is giving him a foot rub. I can only imagine the coaxing it's taken from her to get him to take off his Businessman's Running Shoes, but now she's knuckling the tender veal of his insteps while Larry half snores with contentment despite the Peking Opera playing on the portable TV in front of them.

"Pardon me for not getting up," he says, muting the TV without seeming to move a muscle. "I'm exhausted from yesterday's dialysis, which was particularly aggressive. Though you should have seen how glad everyone at the clinic was to have me back. Those gift-wrapped Mao manicure sets were a sound investment, turns out."

Towering over him, Mary is waiting on him hand and foot. "Professor . . . pillow?" she asks, plumping it behind his back while also clicking the sound on again with her own remote.

"Bless your heart, that's ever so much better," he says, using the locutions he picked up from his elderly immigrant parents. He clicks off the sound. She clicks it back on. "So how're you making out?" he asks me.

"The street sweepers are pretty much in agreement that there are no kidneys to be had, but I still have a few construction workers on the case," I tell him. "Meanwhile we're coming down to the wire. If we don't find something in the next forty-eight hours, it's Philippines here we come."

"You're kidding about the street sweepers, right?"

"Only a little," I say. "The bushes are being beaten for you, man."

Click. Counterclick. I still can't locate the source of that subtle piney scent.

"I'm glad to see that Mary has a mind of her own," I add.

"Oh, she has a strong spirit," he says, closing his eyes. "Though I must say I admire the concept more than the execution."

"So how's the courtship going?" I ask.

He starts ticking off on his fingertips. "I know she means well, but I generally like a little more conversation with my partners," he says. "She's surprisingly guarded about herself. Matter fact, it took me two days to get the weather forecast out of her. Plus, she keeps forcing flower tea on me to enhance my yin. Tell me honestly, Dan, do I strike you as someone who wants his yin enhanced? On the other hand, I can blather and blather and she doesn't mind. It's better than being with my therapist."

"You really have a therapist? When'd you decide they weren't all narcs out to bust you?"

He doesn't bother answering me, opening his eyes to squirm upright on the slippery chaise. "In summation, Mary and I have a real rapport," he says, "though it may be a while before she's cooking gefilte fish and stuffed cabbage."

Well, it's obvious *something* is making him feel good. He's smiling more than he has on this entire trip. I can even confirm how many teef he's lost due to kidney disease. Precisely two.

"She seems to like *you* well enough," I note.

"And, Dan, not to sound stuck up, because I'm really not, but she's not the only one," he says, raising his boxy shades to glance at me. "You

should see the receptionists at the front desk making goo-goo eyes whenever I walk by. I mean, when did I suddenly become so attractive to Chinese women? Maybe it's one of those deals where foreign women find dumpy-looking Americans hot because they don't know any better."

"Or maybe you're handsomer than you think, Larry."

"Thanks, but I know what I am. I'm penetrating. I'm pithy. I'm down to earth in a good way—but handsome? No, that's not me."

"Maybe you're handsomer than you *look*," I suggest.

Click. Counterclick.

"That's deep, Dan. I'll think about that. I always think about what you say. But, to be frank, I've never experienced anything like it. It's as if Mary worships the ground I walk on."

"Or maybe she worships your passport."

"*Pffft!*" Mary has opened another Coke can for Larry. The miracle of carbonation seems to catch her by surprise every time.

"That's certainly a possibility," Larry says, taking a sip. "I'm not so vain that I'm not weighing that as an active possibility. In fact, I'd like you to help me weigh that, if you wouldn't mind. I could use an extra set of judgments."

But now, as though she's caught the tenor of our conversation, Mary wants to put in some comments of her own. "Professor no eat!" she tells me, a complaint and a question all at once.

"I'm eating, dear," Larry says. "I'm not eating sea cucumbers, it's true, but I'm eating a balanced diet of shortbread cookies with lemon icing and shortbread cookies dipped in fudge. Maybe it's not your idea of a balanced diet, but I'm a big boy. You don't need to mutha me."

Where have I heard this affectionate brand of squabbling before? It comes to me: in the kitchen of Larry's parents, Rivie and Sam, back in Lynn, Massachusetts—the same mix of exasperated fondness. They would chuckle for the benefit of any onlookers as they sparred.

Click. Counterclick.

I think I figure out where the piney scent is coming from. I'm not positive, but does Mary have one of those Little Tree Air Fresheners hanging around her neck for a pendant?

Scrunching forward so that he resembles the wrinkled old elephant in *Babar,* Larry offers me the box of Girl Scout cookies. Again I decline. But again Larry dislikes having his generosity stymied. "Here, take some cab fare, then. Who knows how much you're putting out racing all over town? Mary, will you give Dan some bills from my wallet? And help yourself to some more while you're at it," he tells her.

She's become very familiar with his wallet in the past two days, I note. I refrain from saying anything. It's his money; he can do what he wants, especially with that quarter-million-dollar icicle/truck settlement.

Larry settles back on his chaise, disappointed that I keep refusing his money. My failure to press the advantages life affords me has always been a source of chagrin to him, a symptom of my white-glove upbringing.

Mary leans forward with her air freshener dangling and starts probing me for hard data about her affianced. After all, it's a two-way street, this marriage thing. She has a checklist to satisfy, too.

"He big-ah boss, yes?"

"I'm not a big boss," says Larry, who seems to have less trouble understanding her than I do, maybe because of his own speech issues. "It's just that she has to know that what I say goes. Like, if I say we go breakfast, we go breakfast. She has to do it my way. I don't think that's unreasonable, do you?"

"He-ah very big professor?" she tries again.

"They don't come any bigger," I confirm. "In fact, forget professor, he's a commissioner! Back in Florida he's like the world commissioner of pool chairs! He's practically chairman of his condo association, and that's one nasty campaign to engage in, am I right, Larry?"

Larry cracks his knuckles. "I'm thinking of maybe running sometime," he allows.

"What'd I tell you?" I crow. "Chairman Larry!"

"Chairman Larry," Mary says, satisfied. She seems to admire the sound of this very much.

"Hope you don't mind a little ribbing," I say to Larry as an aside.

"It's your nickel, you're entitled," he says, cracking his knuckles again, an activity that sounds a little like muffled gunfire.

As if reading my mind, Larry embarks on a fond reminiscence of the weaponry he used to carry. I don't listen to a lot of it, because, again, I don't want to get sucked in. I can be of most assistance to him if I maintain my distance. When I tune back in, he's talking about the gun he used to have that was in the shape of a wallet. If a perp demanded your wallet, you pulled it out like you were complying, and then you shot him dead.

"I really miss my firearms," he says, sighing, as though talking about an offspring who left for college in Hawaii. "I carried a gun for eighteen years. I feel very naked without a weapon. In particular I miss my .25-caliber jet fire Beretta. Very small, fit inside my palm. It was so highly concealable I used to take it to bar mitzvahs and weddings."

"You're telling me you took a revolver to bar mitzvahs and weddings?"

"No, you misheard me."

"Good! For a minute I thought you said—"

"I said I took my *Beretta* to bar mitzvahs and weddings. My *revolver* I reserved for brises."

Picturing Larry in a yarmulke and semiautomatic . . .

Then: Ow my God, yarmulke, it's Friday, I forgot I'm supposed to go to Friday-night Shabbat services. I make my good-byes while I hurriedly gather my stuff.

"I didn't bother making a reservation for you, assuming you wouldn't be interested in going," I tell him.

"Why the hell are *you* going, you don't mind my asking."

"I'm meeting my one contact from home—friend of a friend at the embassy here named Izzy somebody."

"Have you already told me who he is? I can't think of it right now."

"Do you remember the first season of *Survivor*?" I ask him. "That sleazebag Richard Hatch who walked off with a mil?"

"No, but that's okay. I don't do popular culture."

"Anyway, my friend is the federal prosecutor who convicted Hatch afterward for not paying taxes on his winnings," I tell him. "I went to the case. Did a brilliant job. Nailed the guy for procuring a second passport and plotting to skip the country with his Argentine boyfriend."

"And this prosecutor's friend at the embassy can help us how?"

"Not sure yet," I say. "I'm just following any leads I have."

"And how do you happen to be friends with this particular prosecutor?"

I decide not to tell him that it was his connection, in a way. After Larry tried and failed to get me in hot water with the FBI years ago, I bumped into a guy at a party who would have been the one to prosecute me, if the FBI had found me suspicious in any way. The guy and I bonded over dinner, joking about it the rest of the evening, and now we go kayaking together. But why should I bother Larry with details? I can play mysterious, too. I look over his white shoulders and chest, innocent as heavy cream.

"You might want to consider using some kind of sunscreen," I reply.

I hand the cabbie the Chinese directions Izzy faxed me and soon am weaving crosstown. Four dollars or forty-five minutes later, I'm let out in front of an old-fashioned student union—more cement than glass—but the receptionist in the rotunda indicates that the makeshift synagogue is at the other end of campus. Rather than give me directions in Chinese, she takes me by the sleeve and tugs me along through about a hundred yards of corridors into a courtyard, around some statuary, and up three floors of another building. Okay, this is more like it for an expat Jewish service—a couple of threadbare rooms off a college library.

Three senses immediately tell me it's the right place: 1. Sound. "You had your *baby*!" says an Australian-accented, glamorous older woman in leopard-print scarf who's bear-hugging another woman. 2. Sight. A couple of well-dressed gentlemen are pointing at the sky outside the window, quarreling about whether the sun has officially set. 3. Smell. Burning toast. Who overdid the bagels?

Yes, it's my people, all right. I feel like Yuh-vonne throwing her arms wide and saying, *I love you, Jewish!*

I've never gone to services in sandals and panama hat before, but what the hell. No one stands on ceremony when you're on the road. At least I operate as if no one does. If I were going to be self-conscious, I might as well have stayed home.

Izzy is apparently not here yet, but as people trickle in, I mill around making friends among clusters of Western Jews, mostly Americans and English, stationed in Beijing: a short, elegant gent from Baltimore, wearing bow tie and owlish glasses, who turns out to be the dean at this institute; his opera-singer boyfriend, who's on sabbatical here from the Sorbonne; the Beijing bureau chief for an international news service; plus architects, bankers, and so forth. Everyone is witty, affable, competitive. It's like old home week except with an edge, the sort of edge cultivated by brainy people who've cut their teeth in combative academics, sparring for fun but not entirely for fun. I travel from cluster to cluster, meeting an attractive young New York reporter who sizes me up to see if I'm a threat, and a Chicago judge passing through town who knows my lawyer brother-in-law and says to tell him "no hard feelings," which I pretend not to hear, deciding it's the kind of message that will do no one any good. I'm either going to have to tread these shoals very carefully or just shoot the moon.

"A nondenominational service, I take it?" I ask. "Hopefully, not too much responsive reading?"

This line helps me pass muster. The dean with bow tie smiles at me complicatedly.

"Where are you from originally?" I ask a man with the American Foreign Service who wears a black yarmulke with gold Chinese characters.

"I've been away so long I'm not from anywhere anymore," he says—a boast that contains a bit of one-upmanship, I feel. "No one who comes to Beijing now has any idea how it used to be before the reforms," he adds.

"So true," I say, meeting his challenge. "When I was here last in '84, I could never stop and talk to ordinary people in Tiananmen the way I did yesterday."

"You trying to get yourself thrown in jail?" he pursues belligerently.

Another man in steel wire-rims comes to my defense. "He'd have to try harder than that to get thrown in jail; he'd have to unfurl a 'Free Tibet' banner or something."

"Speaking of Tibet, do any of you ever find yourself swayed by the Chinese case for dominion?" I ask.

"I was once shown a three-hundred-year-old document from some Chinese functionary or other," the man in wire-rims replies, "in which he extended sovereignty over Tibet, but that's a little like the governor of Texas saying he extends sovereignty over Mexico. Do they have a case?" he asks rhetorically, adjusting his spectacles. "On the basis of various particulars, you could say so, but it doesn't add up to any compelling narrative."

"Harvard or Princeton?" I ask him.

He adjusts his wire-rims again, too briskly to be nonchalant. "Harvard," he admits sheepishly. "What was the telltale sign?"

"The terminology of that last clause," I say. "The giveaway was the word 'narrative.'"

"It couldn't have been Yale?" he asks.

"Certainly not!" I exclaim, using a mock-aghast tone.

A chuckle circles the group. That clinches it. We're *meshpuchah,* all but a few holdouts. I feel like Schindler at that banquet early in the movie, working the room so that by the time he left he was a pal of all the bigwigs. But I'm still wondering how to make my move. I decide to go for broke.

"So does anyone happen to have a spare kidney lying around?" I ask.

Expressions of amusement and surprise.

"I beg your pardon?" says the black-and-gold-yarmulke man, who still needs warming up.

"I'm in town scoping out a kidney for my cousin," I say. "That's why I've been eyeing your midsection somewhat lasciviously, if you hadn't noticed."

"I had noticed," he says a little icily. "You're kind of cavalier about this, aren't you?"

"The riskier the situation, the more cavalier I try to be," I say. "Keeps me from clutching."

"Maybe clutching's not such a bad thing under the circumstances," he rejoins.

"I don't know, haven't you ever heard the ancient Chinese saying 'When skating on thin ice, flash those blades'?"

"Which dynasty would that be from?" he pursues with tightened lips.

Time for others to step in. "Lighten up, Saul," says the dean with bow tie. "Just because you have the best-looking yarmulke in the room, that doesn't give you the right to foist your opinions on everyone."

But Mr. Black-and-Gold won't let it go. "Have you even bothered to learn a word of the language?" he asks me.

I smile at him. "This may sound weird, but I always try *not* to learn the language of the countries I visit," I say. "I find I can pick up more sensory information without it, like how a blind person develops other skills to compensate. Have to stay more alert to signals from my environment without the crutch of language."

The others rally to my defense. "Why are you on his case, Saul?"

"I'm just against checkbook medical tourism," he declaims flatly. "There are two million people waiting for organs in China. It's repugnant for cowboys to come in and try to jump ahead of them."

"I'll meet your statistic and raise you one," I say. "How's this: Seventeen Americans die each day waiting for an organ of one sort or another."

"I'll leave the American medical community to voice my position," he counters. "I'm sure they have good reasons for loathing the practice."

"Yet even for them it's not cut and dried," I say. "I'll tell you what my cousin's nurses said. When my cousin was still undecided about going abroad, they agreed with the doctors, that he should sit still and be patient. But when my cousin's mind was made up to go, they all said, 'Good for you.'"

"Hmmph!" says Black-and-Gold, half protest and half something else.

"All I'm saying is that under ordinary circumstances I might be tempted to be dogmatic, too," I tell the man. "But when it's your own relative's life on the line, you tend to see a few more shades of gray."

By now the others are nodding so much on my behalf that Black-

and-Gold is finally forced to cut me some slack. "Well, in that case you might want to talk to Antonia over there," he says. "She owns SER Global."

"What's SER Global?"

"Only the principal manufacturer of surgical instruments in the world."

She's the glamorous Aussie who said "You had your *baby*!" when I walked in. She's taking her seat in the front row beside the news bureau chief, who turns out to be her brother. Good, he's already in my posse. But I have to plot my approach judiciously. If I approach her directly, it'll be a one-shot deal and she'll either cooperate or not. But if I give her room to approach me, I lose nothing if she doesn't and still retain the option of pursuing her privately later if need be. Sound like a plan? But how am I going to pull it off?

The service begins. I take my seat dead center, and a guy who looks like he could be named Izzy enters the room to take a seat behind me. We give each other the thumbs-up. It's an energetic ceremony, full of the bellowing of songs and waving of arms to welcome in the Sabbath. The tunes are ones a child might make up in a playground by himself: simple and flowing. The rabbi is an enthusiastic twenty-something woman in Birkenstocks, cracking wise. I find myself thinking that she's an example of someone who should be a little *less* comfortable with public speaking, but then decide that's an uncharitable thought, the result of my being the product of a combative academy myself.

I relax and let my mind wander. Why do I find myself so comfortable in this setting? Maybe it's because for the better part of a week I've been charmed by the Chinese, who seem not so dissimilar to Jews. Think of the areas both specialize in: education, business, and family—not necessarily in that order. Also food. Don't Jews repair to Chinese restaurants on Christmas, when they're in need of emotional comfort? Haven't I noticed that the traditional Chinese moon-cake pastry comes in flavors like those of *hamantaschen*? Also both subsets have been victims of the same prejudice through the ages: that they're gawky, bumbling, industrious—the nerds of their respective continents, who in reality have

proved themselves capable of some of the most nerdless feats on earth. Also they both share some basic ideas of life and death, such as the belief that the physical body should stay intact after death, barring the removal of organs. Which, come to think of it, doesn't bode well for my getting a kidney.

On the plus side, however, is an anachronism they share that may just work in my favor. These, after all, are two of the oldest cultures on the planet, still holding fast to certain values they've upheld since time immemorial. In this cutting-edge city in this postmodern world, I happen to be sitting in one of those pockets where things operate the way they did four thousand years ago: through personal relationships. Seated here, I'm at the intersection point of two ancient tight-knit systems, where Chinese *guanxi* meets Jewish *guanxi*. Could I tap into that somehow to get Larry what he needs?

Not only that, but as I look around at all these brilliant faces, it occurs to me that these are some of the best-connected people in Asia. Could I just stand up and make an appeal right here and now? For inspiration I recall my old college roommate who was enterprising enough to bed Janis Joplin the night she toured campus and used the same spirit years later when he found himself traveling through a faraway city with all the hotels booked up. How'd he find a place to sleep? After leafing through a list of evening events in the local paper, he went to an AA meeting and said, "I'm new to town, can anyone put me up?" *That* girlfriend lasted six months.

I let the idea simmer while my mind wanders some more. The ark is a red and yellow porcelain credenza in which the Torah sits wrapped in . . . a bungee cord? I can't quite make it out from where I'm sitting. People are tapping their feet to these infectious, primitive rhythms. The banker from London, the history professor from Rome, all these high-octane overachievers from the most sophisticated corners of the globe are tapping their toes. My ears perk up at one of the rabbi's remarks: "We have a sub-minyan of lawyers here tonight, so if anyone is in need of expert legal advice . . ."

Okay, good, they're a giving group. But will they lend a hand? There's

a moment to introduce all the children in attendance: Rebecca, Ben, Joshua, Eleena. There's a prayer to ask healing for anyone of our acquaintance who's ill. Several hands pop up around the room, tossing out names to be included. "For Larry Feldman," I say, using my best voice so they're disposed to hear more from me. Okay, hat's in the ring. But now what?

As the service proceeds, I skim along the text and find myself feeling sorry for God. If He exists, as I happen to believe, does He really want to keep being called all-powerful, ever-righteous, Sovereign and Sustaining Ruler, blah blah blah? After all these eons, He must be so divinely fed up with all that fawning. Put yourself in God's shoes. If you were Him, wouldn't you want it spiced up once in a while? We're boring Him to death! Here's the praise I'd want to hear, so here's the praise I put silently forth from my innermost being:

Cool God! O Cool One beyond compare. Blessed be Thou for tossing us a holy bone! You got Larry and me safely to China. We're on the hunt! We're getting closer! O Hipper than Anyone God, Most Happening Dude by far, help me help Larry even more. Give me the goods to enhance my cunning, I pray. If You could guide me as to how to play this group so I can save my cousin, that will be cool beyond counting! Thanks unto Thee for showing me the way, O Coolest God of the cosmos, for revealing unto me my opening and giving me my shot . . . right about now . . . anytime You think it's right. . . .

"You there, in the very fetching panama," the rabbi says.

"Me?" I say, finding myself on my feet. "Oh, yeah, the panama. I figured it would serve as a yarmulke tonight," I say.

"It works. Is that a silk band?" the rabbi asks.

"I doubt it. I picked it up on the street in Ecuador for eight bucks."

"Ecuador? For a panama?"

"Little-known fact: Most panamas come from Ecuador," I say as the intelligent heads nod in receipt of a new fact. How my people love new facts! Information! Data! While they're taking this in, I scramble to collect myself.

"So you're standing," the rabbi observes neutrally. "Does this mean you have a general announcement to make?"

Cool God, here goes nothing, I think, turning to shrug an apology to Izzy in case this backfires. I clear my throat. "*Shabbat shalom,* everyone," I say. "I'm Daniel from Massachusetts. I apologize in advance if this isn't the proper place to say this or if I'm abusing your hospitality, but I'll just be direct: I'm in Beijing on a mission of mercy. My cousin Larry, whom I referenced before, is dying of end-stage renal disease and I've come to Beijing with him to look for a kidney. I realize it's a controversial subject, and the last thing I want is to offend anyone, but we can't afford to dil-lydally. We've had no luck all week and are about to give up on China and leave for Manila in two days, so time is of the essence. If anyone has even a faint lead on how to find a healthy kidney, it would be a mitzvah if you would share it with me after the service."

No one reacts as I sit back down in silence. A deep blush starts in my chest and speeds upward to my scalp. How gauche I am, barging right in and doubtless breaking all kinds of protocol. I've probably embarrassed my host, Izzy, half to death. I don't dare turn around to see the discom-fort I've caused. Cool God, ouch—sorry me so pushy!

The ceremony breaks up shortly afterward, and I'm left alone with my blush burning the tips of my ears. People hurriedly depart to the right and left of me. I turn around slowly to face Izzy, but he's split for a buffet table at the back of the room. Maybe I ought to just liquefy myself and dribble down a drain somewhere. . . .

The pretty journalist from New York approaches me.

"Sorry if I overstepped," I say.

"Hey, 'chutzpah' is a Jewish word," she assures me.

"Yeah, but didn't I just alienate everyone in the room?"

"They're still processing," she says . . . and sure enough, little by little, members start drifting over.

"So how's your brother doing?" one of them asks.

"He's my cousin, and he's dying," I say.

"I have an uncle who's a pulmonary surgeon," someone else volun-teers, "who came here a few years ago to perform a lung transplant."

"Close but no cigar," I say, getting my confidence back. "I hear lungs but no kidney. Do I hear a kidney," I ask, like an auctioneer, the tips of

my ears still burning. "Kidney going once, kidney going twice . . ."

Just then a leopard scarf slides by behind me, close enough to brush my shirt. "Talk to me when you get a chance," the Australian accent says.

Ten minutes later Antonia is giving me her business card and telling me she'll try to call me tomorrow. Of course the transplantation of organs to Westerners is illegal and her company would never put itself in a position to help me directly, she says, but perhaps she can make a few discreet calls on my cousin's behalf.

"It *is* illegal, for sure? That's one of the points we've been unclear about."

"Because the law is more fluid in China than you're used to at home, it's not as black and white," she says, "and it's frequently tailored to meet local conditions. But yes, it is indeed illegal, since they passed a Restriction a while back. Apparently the feeling was that the West was making such a fuss about China's transplant business—questioning whether organs came from political dissidents or religious radicals—that China said, 'All right, then, you can't have any.' And that was that. But here people don't have the same general attitude against it that there is in the West. It's not frowned upon ethically the way it is in much of your United States."

"Well, I'm suspending all ethical considerations because he's my cousin."

Antonia comprehends this implicitly. "Those considerations are fine until it's your flesh and blood, isn't that right?" she says. "So Izzy tells me you're a writer. What sort?"

"I write about my life and the things I see happening around me. You could call me an investigative memoirist, I guess."

"I'll be frank: I'm asking because that concerns me. You're not going to give away any secrets, are you? You could get a lot of people in trouble. . . ."

"No, ma'am, I won't," I say.

She looks me over. "Give me my card back."

Is she rescinding her offer because she doesn't trust me? But no, she only wants to add her cell number.

"Tomorrow," she says. "But no promises."

We hug and part.

Suddenly finding myself superfluous in the room, I try to locate Izzy to say good-bye, but he seems to be successfully avoiding me. Just as I'm at the exit ready to slip unnoticed down the stairs, the dean with the bow tie appears—Alfred somebody—tucking his business card into my breast pocket and telling me to keep in touch.

"I like what your cousin's nurses said," he says. "Did they really wish him well?"

I nod. "There aren't any bad guys in this drama," I say. "People may go about things differently, but everyone wants what's for the best."

He snorts appreciatively, passing me something under his arm like contraband: the black yarmulke with gold Chinese letters. "A little keepsake from one of the guys," he says out of the corner of his mouth, as though we're performing an undercover act. "He says to say you earned it."

An hour later I find Larry in the lobby of his hotel, regaling the Robert Palmer quints, who are spellbound by the unstoppable flood of Larry talk in a tongue they don't speak. "On the other hand, you may be too young to have heard the name Shaquille O'Neal, all those greats," he's saying. "What are you, seventeen years old? Seventeen is good in China, I can see you're responsible citizens. Where I come from, seventeen is the worst. Let me give you an example. I had a friend whose daughter was seventeen. Name of Angela, I called her Angina. My friend asked Angina, theoretically, if she had a classmate in a wheelchair, would she be willing to be friends with her. Angina thought for a minute. 'Sure,' she said, 'because I'm so popular it wouldn't hurt me a bit.'"

"Sorry to interrupt, ladies," I say, pulling Larry aside. They seem disappointed as I escort their star performer to the other side of the room

and give him the good news about Antonia and her connections. Larry's visibly unimpressed—after a lifetime of disappointments, he's learned to keep his emotions monochromatic—but does allow how excited he is that Mary has hand-washed his socks for him again while I was gone.

"By the way," he says, "just FYI: I don't do sunscreen, like you mentioned before you left. I consider it sissyish. Please don't embarrass me like that in front of Mary again. I'm a big boy."

I look him over. "That may be what you are most of the time," I say, "but what you are the rest of the time, Commissioner, is a pain in the ass."

Larry considers this. "That's probably an accurate assessment," he says.

CHAPTER 7

Good Luck, We Trick You

One cannot refuse to eat just because there is a chance of being choked.

Next morning, fuck market. I figure I can cheer up Larry if I grab him a Cartier knockoff for five bucks that would cost someone five grand on South Beach. Outside the hotel Jade comes hopping up to me waving both hands. I almost don't recognize her in jeans and blouse instead of her olive drab uniform. "Excuse me, Eighty-four, but this moment the staff comes out," she explains as she pulls me down the street away from the hotel entrance.

"Oh, that's right, Twenty-four, you're moonlighting on the sly?"

"Double agent, license to kill," she snickers. "Martini shaken, not stirred."

I love that she can make fun of all the spying silliness. Situation splendid.

"Heat so hot you shirt is wet already," she notes. "You are very *schvitz*."

"It's hot, all right. Where'd you pick up the slang?"

"I jabber on Internet so make this day worthwhile for you."

The market, when we get there, respires the electrifying odor of garlic and incense. We are jostled by local vendors with beaten-up toenails and Westerners whose toenails look as if they've never done an honest day's work in their lives. Merchants and customers alike use finger symbols

to signify numbers, a kind of bartering sign language I don't remember from last time I was here. It's pleasant to be under the wing of my young protector. "Be wary of pickypocks," Jade warns, and she shows me how to discern between antiques that are genuinely old and those manufactured two weeks ago. She scratches the surface of an ancient-seeming jewelry box where particles of sand have been glued to make it seem as weathered as something from the Ming dynasty, and sure enough there's a shiny staple underneath. I'm impressed: The art of instant Minging manifests an ingenuity that's almost worth the price. But Jade is embarrassed about her countrymen's duplicity.

"Don't worry, we have fibbing in our country, too," I assure her. "We even have our own finger gesture to symbolize it." I demonstrate crossed fingers. "It means the person is faking."

Jade is confused—she thought crossed fingers meant hoping for good luck. I've never thought of it before, but I tell her that the gesture actually means both—faking and hoping. What an odd combination. Jade crosses her thin fingers. "Good luck, I trick you," she says, grasping the double concept right away.

I don't actually mind losing money at this sort of bazaar, because there's some justice in having Westerners spread the wealth like this— paying a few extra dollars for an imitation Cartier helps make up for the ways we've always exploited the Chinese, sort of individualized reparations. But Jade seems determined to get me my money's worth. At a stall with yellowing, chipped animal bones, I eye an eagle skull with a black beak. Jade confirms that the dried cartilage is real. But what's this other beauty?

"Walf. Small walf," Jade says. "Not find this on Canal Street!"

She decides I'll never fully grasp the Chinese soul until I own a small Chinese wolf skull, and to negotiate with the vendor she uses a range of lovely sounds my brain scrambles helplessly to make sense of. *"Boozy boozy Negev Desert!"* she scolds with finger upraised. *"Who has chiggers? She! She! She!"* she laughs, putting her hand on his forearm as they chortle together, all part of a prescribed game. She cajoles most artfully, tugging on his sleeve, swinging her hips coquettishly, calling him uncle—

and periodically accusing him of trying to pass counterfeit bills. "But not too crispy to travel?" she asks me after winning the sale for two dollars. It's just coming to me that she means "brittle" when my cell phone rings.

"What'd you lose now?" I ask, but it's not Larry—it's the Australian accent of Antonia, telling me she reached someone, something, somewhere. . . ?

"Listen, Antonia, there's a crowd around me, can you hold on while I go someplace that's quieter?"

But there is no quiet place in the market. Jade leads me to the back of a booth away from the main foot traffic, yet even here my English attracts a small crowd, including three schoolboys with their arms affectionately around one another's necks. While I cover my ears from the ambient noise, Antonia tells me she's learned that kidney transplants have indeed been drastically reduced because of the Restriction, but that if I can promise confidentiality, there's a surgeon out in the city of Shi a few hours west of Beijing who may still have access to some.

"How can he skirt the law? Will it be a healthy organ?"

"My understanding is that this Dr. X is so highly placed, if he wants an organ—which will be immaculately screened—he knows how to make the authorities look the other way. But time is of the essence. If you can get there by this evening, he'll be able to meet you. Don't fool around with trains; just take a taxi and go. The fare will cost maybe eight or nine hundred RMBs—less than two hundred dollars."

"Is it safe?"

"Safe?"

"I mean, if they catch us, will they lock us up to make an example?"

"I know what 'safe' means, I'm just framing my answer," Antonia replies. There's the wail of a siren from her end as a police car hurtles by. "I can't say anything for sure," she informs me after it passes. "Nothing is guaranteed. But I'll tell you that if I were desperate to save a family member, this is the place I would go."

That does it for me. I agree to run it by Larry and, if he's good to go, to get started immediately.

"When you can commit a hundred percent to getting out there to-day, call me back and I'll confirm with my contact," Antonia says. "I have an hour and a half before my flight."

"Where you off to?"

"Conference in London. I'm almost at the airport now. I won't be able to hear you in a few minutes, but I'll keep my cell on vibrate."

"Antonia, you're an angel. . . ."

"Just call me back within ten minutes so I can let my contact know. Then, when you procure a cab, have the cabbie call the surgeon's secretary so he can get directions. Here's the number. . . ."

"Thank you, thank you. When I woke Larry last night to tell him there was a ray of hope, he nearly wept with gratitude," I say. Am I laying it on too thick? He might have wept—if I'd actually wakened him, and if he were that kind of person. The main thing I want Antonia to know is how much her efforts are appreciated.

"I want to make very clear that I'm not guaranteeing anything, and I'm formally absolving myself of all responsibility for your actions. But good luck. And Daniel?"

"Yes?"

"Be careful. . . ."

Hanging up, I look at Jade. Her seal eyes allow no light to escape. She's heard everything, understood everything. She's my instant ally as I dial Larry and get his okay, call Antonia back with our commitment. As we rush to the market exit, Jade asks me something only an ally could.

"This lady you speak with, she is someone we can trust?"

"I think so. I met her at a Jewish synagogue last night."

"You are Jew?"

I flag a cab. "Yes."

She stops me and lifts my hat. "But where you horn?"

"Only about half of us have horns these days," I say, ushering her inside the cab. "It's part of a PR push. So where shall I drop you?"

Jade waves her hands no as we begin flying through the traffic. "Of course I halp you in this task," she says.

"Don't be ridiculous," I say. "Shi is hours away. I don't even know what time we'll be back tonight."

"Don't ridiculous *you*," she says adamantly. "This my country. You are guest. I only worry how you manage in Shi?"

"Don't know yet," I say. "We'll play it by ear."

"Your ear not get tired from playing it so much?"

I lean to give her a kiss on the cheek. She recoils slightly until she understands it's just the cheek. Now she's happy again. I'm happy because I really can use her help. Her face looks American to me right now as we rush to Larry's hotel. I see my face in the reflection of her sunglasses, and it looks Chinese. Everybody looks like everybody, I conclude sagely. It's the wisdom that comes when things start clicking into place.

As arranged, Larry and Mary are sitting by the sidewalk in front of their hotel. Larry taps Mary's elbow to help him up, a gesture I remember his parents making to each other back in Lynn, oddly touching in its familiarity. Larry's ragged, drained face brightens at the sight of Jade.

"Where'd you find this one?" Larry asks. "They keep getting better and better."

"She was my breakfast waitress."

"Must have been some breakfast," he says dryly.

But now there's a new development. Mary takes this moment to announce that she's going home!

"I thought the day after tomorrow," Larry says in shock.

"Train in two hours," Mary says.

Larry's stunned. Why didn't she tell him before now? But events are in motion, and there's no time for explanations or elaborate farewells, no time even for Mary to wince when we embrace good-bye and the Little Tree Air Freshener squeezes into her bosom. Larry is shell-shocked as I guide him into the backseat of the cab and slide in after him. Jade takes the front. "Nice a meet you," Mary calls, blowing us a kiss as we screech off down the block.

"I thought the day after tomorrow" is all Larry can say.

Is the romance over? Is that the end of the Larry-Mary show? Larry is too stunned to respond, and Jade and I can only raise eyebrows.

————

Here we begin the most harrowing cab ride of our lives to date. Yes, we're in a rush to meet Dr. X, the mystery surgeon, in the far-off city of Shi before nightfall, but the cabdriver doesn't need that excuse to dart and weave between diesel trucks with only inches to spare. He likes multitasking—he munches on a hairy chicken claw with one hand while jerking the wheel with the other—so I hand him my cell phone with the surgeon's secretary predialed for him. "Are! Are! Are!" he says, writing down directions on a Mickey Mouse pad he has taped to the front of his broken speedometer dial.

Traffic leaving the city is frantic, but despite this our driver appears to nod off, while still managing to munch on the chicken claw. Before long he slams the brakes so hard I drill my forehead against the empty kidney-bean can soldered to the back of the front seat that serves as an ashtray. His hands, with yellowish nails that extend a half inch beyond his fingertips, are looped through the steering wheel, and he's waving his index finger as though conducting an orchestra of fleas.

"Does he know where he's going?" I ask Jade.

"Oh, yes, very skillful driver," Jade says.

Coulda fooled me. He ducks under an underpass so low that the antenna scrapes the cement ceiling, then emerges from the other side to shoot across four lanes of traffic without once checking his mirrors. For all this activity, he looks half asleep, slumped over the wheel, with a nasty habit of drooping his head every four or five seconds. It's exactly how I'd look if I hadn't slept in two days.

"Can you tell him to slow down?" I ask Jade. This works for the short term, but in a minute he resumes dipping in and out of the break-down lane, which also contains bicycle riders, shards of truck parts, and workers pushing shopping carts loaded with twenty-foot pipes. After an oncoming bus swerves to avoid hitting us, I notice that Larry doesn't look well. He hasn't said a word since Mary left, concentrating instead on studying receipts from his wallet. This is the self-defense clicking

in again, how he's maneuvered a difficult life, but I'm not sure denial is healthy just now.

"I think you miss Mary," I suggest.

"I do!" he says, releasing air out of his face like punctured bubble wrap. "I'm the first to admit it. I haven't been without her the whole time I've been here. She's taken care of everything. Maybe it's a moot point, but I have a lot of sympathy for her. Her life has not been easy, by a long shot. Why can't we pool our resources and make a go of it together? Or is it too late? I don't even know if she left for good or if I'll ever see her again. . . ."

His eyes are closed, and he's resting his head on the side window while excavating a boil on his chin. You've got to be feeling pretty low to keep your eyes closed while you do that.

"Maybe I'm mistaken, but I see great devotion in her. To use a strange word. I mean, she's not gorgeous, but I pick up a lot of sweetness in her. She sat by my side throughout my entire dialysis yesterday, rubbing my back. If I got taken, I'm going to be hurt beyond belief."

"What would it mean to be 'taken,' exactly?" I ask.

He digs a moment more. "I'm not sure," he says finally. "I don't want to sound evasive, it's just that I'm not sure." The boil done, Larry starts making sounds as though he's gargling, but with a dry throat.

A flock of guinea hens scamper across the highway. Some of them make it. The feathers of the rest fill the air like a series of pillow bombs.

"How'd her husband die, anyway?" I ask.

"Car accident."

"Sorry I asked," I say.

"Believe me, so am I."

The driver waits with uncharacteristic patience for a truck to pass us before veering into the speeding lane. But oops, it's a double truck that swipes us, tearing off our sideview mirror. There are no seat belts in back, only a hanging strap, which I access. Larry doesn't bother. At one point I ask Jade why the driver is going east when before he was going north?

"He not sure. He only know by sun," she says.

We're in the countryside now, passing sunflower fields. "This could be north Florida," Larry notes from time to time, trying to find references to home to help him deal with his homesickness. "This could be North Carolina."

I'm grateful that this is a highway and not a crooked back street, but we're tacking and snaking as though it *were* a crooked back street. It's like driving slalom on the autobahn, with the occasional trash can or patio chair strewn here and there, kind of brilliant in its own way, though I'm not sure I know what I mean by that. Suddenly there's a pause in the action.

"Is it me, or did we just stop in the median and the driver got out?" Larry asks.

"He has to go peewee," Jade informs us.

"Good to know I'm not demented," Larry remarks. "Merely imperiled."

The driver comes back minus his chicken claw and resumes driving. I work to keep Larry talking. I hint that he might want to talk about why he never got married. One great thing about Larry, even when he's feeling poorly, you never have to coax; he comes out and gives you all he's got. Complete mini-sagas—beginning, middle, and end all wrapped up with a bow.

"Ten-second story," he says. "I'm fussy, simple as that. Never met the right girl. Well, strike that. There was one with . . . I don't want to mention her name, but it didn't work out with Chelsea—oops, guess I said it after all. That's the misorientation speaking, whatever you want to call it. Who'd want me now anyway, in my state? What am I going to do, chase 'em with a cane? Those days are behind me."

Okay, it's a little shorter than I was hoping, but it does seem to warm him up a bit. I hint that he might want to tell the story about why he initially decided to find a mail-order bride, even though he doesn't like referring to her as that.

"A lot of people in my coin-trading discussion group asked me the same question," he says. "Here's why. Because go to another temple

mixer, meet another seventy-year-old overweight real-estate broker? No thanks. How I found Mary was on a Web site I already gave you the name of—it's not coming to me at the moment—which they claim has forty-nine thousand women, which took me the better part of a week to check out. I checked out the men, too, just to see what I was up against. What a bunch of losers: potbellies, the works. There's some guy with a big toofy grin saying he's an astronaut from New Jersey. If he's an astronaut, I'm a stud muffin. I myself was quite forthright: didn't mention my illness but was otherwise quite honest."

Seems like quite an omission, but . . . must be a boy thing. "But then Mary turned out to be lacking in some of the essentials," I skip ahead, to keep his rally going, such as it is. He's looking so poorly that I'm grasping at straws.

"Sadly, yes," he says. "Though I do want to correct the record on one point, if I may. Mary's son is not mentally endangered. I misunderstood. He's actually a very capable young man. He just graduated university, where he was captain of his basketball team, and just got his first engineering job. Mary is very proud of him. I don't know how I got that wrong, and I apologize for it. Oh, I miss Mary ever so much."

Gets me every time: this tough guy using Edith Wharton language. But he's backsliding now, so to cheer him up or give him perspective, whichever comes first, I segue to the subject of . . . our relationship. "Larry, not counting our recent estrangement, why do you suppose we've basically always gotten along?"

"No big mystery, Dan. We're straight with each other. Not overly straight, not straitjacket straight, but straight enough so it works. Plus, look at this, you're giving me a fake Cartier from the marketplace. Thank you, Dan. You can never have too much of a good thing. And just to show you how much I appreciate it, I'm going to put the Cartier on my left wrist to go with the Rolex on my right. The Chinese will think it's a new status thing."

From here it's a natural step for him to talk about our childhoods. How we did this together. How we did that together. His memories are much more vivid than mine: None of it sounds even vaguely familiar

to me. Two or three hours go by, and the deeper into the countryside we drive, the less familiar his memories sound. The pump of Larry is primed, and he's talking a blue streak; I couldn't shut him up if I tried. How at my house he was always nervous around the dinner table because everyone used big words all the time. How our housemaid frightened him—he wasn't sure how he was supposed to act around her. How one time my mother took him to the train station to go home and she saw he was craving an issue of *Popular Science* on the rack and she bought it for him, even though he begged her not to because it cost so much—seventy-five cents.

The sagas are flying. But then the world he's talking about becomes distinctly alien. How his father, Sam, the lovable but illiterate garage mechanic, used to beat him with a belt. How a respected great-uncle manhandled him sexually. What? This isn't even the same orbit of planets on which I was raised. I can't accept that. Great-Uncle Auguste, the hero who fought in the French Resistance, abused him as a little boy? Larry isn't really saying that, is he? Not in so many words, maybe, but he gives me to understand that we view the world from very different starting points. There in the backseat of this tiny rattrap cab, with no seat belts and an empty can of kidney beans for an ashtray, Larry tells tales that make me think I've never known my cousin at all, never known the universe we supposedly shared.

As if to mirror my dismay, the air outside's gotten worse. Dense, chewy ribbons of smog have spread themselves over the sunflower fields like shrouds of mutant spiderweb filament. They've moved the smokestacks out of Beijing into outlying regions as part of the plan to sanitize the city's image for the Olympics, and we're now in the thick of it. Raw, unscrubbed black smoke tumbles into an already filthy sky, making the air so bad that cars put on their headlights in the afternoon light and you can hear the particulates hissing around like drizzle. Nor does it help that car exhaust is leaking into the cab through the floorboards. We're awash in bad air, inside and out.

But a little reality check. I must have misheard him before. Auguste, who had that beautiful library of rare French books in leather jackets—a

child molester? Could that possibly be true? Could the fact be that all the children in the family were protected from Auguste, but no one protected Larry? That he was expendable, his ass didn't count for much?

"This could be Georgia now," he says. "Look at that red soil."

I tune out for a while, won't allow myself to take in any more. I watch two grandmothers hobble along the median strip, holding hands. I watch a mattress lashed to a highway sign nodding in the wind. The pollution's bothering my eyes, making me blink twice as much as usual. Eventually a question is directed to me.

"Dan, do you remember my bar mitzvah?"

"I only remember you saying in your bar mitzvah speech that you wanted to grow up to become a munitions dealer," I say.

"That was more for shock value than anything else, though it did seem like a pretty sweet life," Larry says. "But do you remember what happened afterward? After the ceremony when everyone moved into the banquet hall to have lunch, you stayed behind and started making speeches into the podium microphone that you assumed was dead. You didn't know it was being broadcast live into the banquet hall—"

"Yeah, a vague memory."

"Everybody thought it was actually pretty funny, except for one person—your futha was fuming around till he found you and kicked you out. Long story short, you were wandering around the parking lot with no lunch."

"Wait a minute, didn't you come out and find me after a while?"

"I brought you a plate of dessert, so you wouldn't go hungry."

"Do you remember what I said into the microphone?"

"No," Larry answers, "but I do remember that the dessert was strawberry shortcake."

This actually puts a lump in my throat. I know it's a cliché, but the lump is real: It's hard to swallow for a second. The image of a thirteen-year-old bringing his fifteen-year-old cousin a piece of strawberry shortcake in the parking lot. What a sweetheart.

"You were one of the only people I wanted there," Larry tells me. "I desperately wanted to emulate you."

I sway and jostle as the cab swerves back and forth.

"That's why I say, whatever you think is best about my treatment, Dan, that's what I'll do. You make the decisions. I won't impede you. I put myself in your hands."

Before I can react, he interrupts me.

"No, wait, I just remembered what it was you were saying into the microphone," Larry says, "but it's gone again. Sorry."

The car stops. "We are at hospital," Jade says, hopping out.

It's late afternoon, and we're in the middle of a provincial capital of nine million that few Americans have heard of. Gray, gritty: "Could be Baltimore after a brush fire," Larry says, coughing. "If I lived here, I would take up smoking as a defense."

Indeed, the pollution is worse than anything I've ever seen. The low-grade, high-sulfur coal that produces most Chinese electricity mixes with the humidity in the air to produce a kind of atmospheric sulfuric acid. My eyes sting. I get out and snap some pictures to try to capture the soupy mix. Two guards come over but withdraw when Jade assures them we're guests of Dr. X. Like every other skyscraper in this fast-growing country, the hospital itself seems to arise out of the soil like a giant mushroom: First there's dusty, hard-packed earth, then there's a gleaming steel edifice. Across the parking lot struts a hearty young pocketbook-toting administrator who speaks blessedly good English.

"Glad you made it in one pieces," Cherry says after introducing herself as the hospital translator/coordinator. "Sorry to say, Dr. X has already left for the evening; he had appointment with delegation from Zambia. But we are prepared to do preliminary procedure and attend all you questions, if you kindly follow me."

Inside the hospital it's quiet. Ghostly patients shuffle about in blue-and-white-striped PJs that look like what Yankee uniforms would look like if Yankees never got honest-to-goodness smudges by sliding into home plate but just hung out at second base for two years collecting dinge. Limbo dinge. Cherry leads us to a waiting room off the main lobby

called the Family Crush Room, where a delegation of extremely polite medical residents awaits us. The men have pimples, the women sit with their legs open on the yellow plastic couches, a sight that both cheers and terrifies me; perhaps they've delayed their social skills because they've been so busy cramming in arcane medical knowledge?

"You must have a gazillion question," Cherry says.

Larry raises a hand. "Where is the little boys' room?"

I help him to a bathroom that has extra-fancy bidets with automatic drying features on one side, but on the other loose rocks around the shower stall to keep water in. It's like we're in a time bubble somewhere between Stone Age and Space Age. When we're all reassembled in the Family Crush Room, Cherry reinvites our questions while a nurse draws a blood sample from Larry's arm and the residents take scrupulous notes.

"Have you had Western patients before for kidney replacement?" I ask.

"Oh, yes, many-many from Middle East: businessman, tycoon, such and such."

"What about Westerners from, like, the West?"

"Just last year before Restriction, a seventy-five-year-old who was also from Florida like you," Cherry says.

"What a coincidence," Larry says, "Not only do we come from the same state, but I *feel* seventy-five."

"But after surgery, eighteen!" Cherry says. We all laugh. Beneath his hangdog expression, Larry has a million-dollar smile when he lays it on.

"I've never had anyone in America get my vein on the first try," Larry says, amazed as the nurse deftly holds two Q-tips to his vein for a minute, making it stop bleeding without a bandage. "This is certainly a positive sign."

"Oh, yes, everything positive," Cherry confirms. "Flying color for everyone!"

"I know there are a lot of variables," Larry says with a beam that everyone in the room mirrors, "and I won't hold anyone to anything that would hold water in a court of law, not that I'm even thinking that direc-

tion, but can you give some sense of how much this might set me back cash-wise, because I am not a rich man, despite my esteemed title of professor."

Despite our best efforts, we cannot get the barest glimpse of how much a transplant might cost or when it might become available. The attempt goes on long enough for a couple of patients' relatives to come into the room, slip off their shoes, stretch out barefoot on a plastic couch, and fall asleep. The one thing Cherry is unreserved about is that the hospital's track record with this surgery is exceptional. "Hundred percent success rate so far."

"Is that possible?" I ask, skeptical. It hurts my eyes to widen them.

"Oh, yes, we do over four hundred surgery last year, not so many this year because of Restriction, but many notable patients, including Saudi prince two months ago, Korean diplomat, also a very famous Chinese film star, but it is pity she is gone."

"Well, that seventy-five-year-old from Florida, for instance," I ask. "Would it be terribly unethical to give an idea of what he paid?"

"Oh, not the sort of question at this juncture," Cherry says. "But in this particular field of organ transplants, we are considered one of finest hospital in all region."

"Really?" I ask. "By whom?"

"This is the track record," she says matter-of-factly. "First job now is to see about the patient's condition. Already I can report from blood tests, he is viable candidate for surgery. During last hour I have been in consult with Dr. X over phone, and he say all system go. Hip hooray! So later when Dr. X assess situation with own eyes, then we discuss financial arrangement, so forth so on."

"Cherry, this is a city of nine million people," Larry interrupts, cutting to the chase. "I assume you have some good food here?"

"Oh, yes, we are renown for our fried scorpion dumplings."

"What I'm really asking is if you have any fast-food franchises?"

In a minute the whole group of us has piled into a cab, and we are on our way downtown to a local Kentucky Fried Chicken. Larry is so buoyed by the prospect of an American meal, and a captive audience,

that he takes the opportunity to unburden himself on various subjects: the American moon landing (never happened), health clubs (he'd visit them if they had couches to lie on), how to solve the organ-donation problem. On this last he suggests two options: (1) adopt the Spanish approach and make donating the default, so if you don't officially opt out, you're automatically an organ donor. With the proper incentives, "lifetime movie passes or what have you," the problem of kidney donations would be licked within five years. And (2) make motorcycle helmets optional.

Two traffic jams later, our high-spirited group wades through a grove of eighty bicycles to gain entry to a KFC, the hottest spot in town. We wait in line to get served, and just as we're about to order, a group of secretaries nonchalantly cuts in front and beats us to it. No one seems perturbed, not even Larry, who's soon tucking into his mashed potatoes, reviving even more with tender memories of his first job ever at a KFC in Everett, Mass.

"This was a part-time job?" Cherry asks. She puts a small chicken wing in her mouth and doesn't take it out until everything that's edible is gone and the bones are whistle clean. Despite her elegance and efficiency, she eats KFC the way the Chinese used to eat chicken twenty-five years ago, except for spitting the remains on the floor.

"Goodness gracious yes, I was all of fifteen at the time," Larry replies.

I don't remember him being underage, but I do recollect—and I assume it's a good part of the tenderness he's manifesting—that it was the locus of his first lawsuit. Slipping on water from a defective freezer case, he managed to spill hot chicken oil on his forearm and ended up suing the establishment, inaugurating him into a lifetime of litigation that has been a lucrative sideline ever since. "How much did you clear on that first one?" I ask him.

"Around nine hundred dollars, as I recall. Not bad for a fourteen-year-old in the sixties."

"I thought you said you were fifteen."

"I'm cognitively impaired," Larry shoots back. "I'm fuzzy on my details, but on my general outline? A hundred percent."

"Like our hospital record!" Cherry says.

Neither of these boasts does much to allay my qualms, so I privately put the overriding question to Larry. Check in at this hospital or bounce to the Philippines?

"It's really all the same to me," he says. "The motel you found in the Philippines is thirty-five dollars a day, and my room in Beijing is forty-four dollars, so it's a difference of nine. I can't go wrong either way."

This strikes me as an imperfect way to choose life-and-death medical care, so while Larry begins regaling the table with a description of how good American coleslaw tastes—and what a travesty it is that Chinese KFC swaps it out for bamboo shoots and lotus roots—I go to join Cherry at the communal washbasin outside the bathrooms, where she's rinsing her hands.

"Sorry for being pushy about this," I begin.

"No problem, I will talk hard balls to you."

"Great, because we're at a crucial juncture right now. We have to make a decision tonight whether to cancel our flight to the Philippines tomorrow and entrust you with his survival."

"But impossible to know answers to your questions," she says. "Every case different. The first important thing is healthy for Larry."

"Agreed, but is it at least possible to tell me if the price here is roughly comparable to the price in the Philippines? Because the only hard figure we've been able to get is that it's around eighty-five thousand dollars in the Philippines. Is that ballpark?"

"Maybe ballpark," Cherry says.

"Okay, thank you. Can you also give me an idea of where the kidneys come from? Because we hear all kinds of things in the West about prisoners and religious sects and—"

Cherry cuts me off with a general answer about the condition of the kidneys, which, she assures me, will be top-notch. Dr. X is renowned for this sort of transplant. Medical colleagues all over the Third World send him their relatives to do.

"Am I answer all your question?" she asks pleasantly. "Need more to pump my info?"

"Well, the other main thing I need to know is, is it legal?" I demand.

"Hard to say that, because Chinese people don't really know laws. But if doctors can get, is okay."

I look over at Larry, who appears to be demonstrating how he couldn't eat lotus roots even if he wanted to, "given what condition my teef are in." Reading my cousin's lips is not an ability I ever planned on developing.

"So what I'm sort of gathering," I say to Cherry, "is that it's official policy not to do transplants for Westerners—"

"But only true so-so."

I incorporate her interruption. "Which only true so-so. Maybe it's what's known as a Beautiful Law, so-called because they look good on paper but there's no enforcement?"

"Could be," Cherry says. "No one on the outside really knows, that's the thing, all secret. You part of secret now, too."

"So it's sort of an open secret, but no one knows the details. Made trickier by the fact that the central government makes the laws, but it's up to the locals to carry them out."

"So not very transparent situation," Cherry confirms. "Also liquid all the time."

"Okay. So even though it's officially illegal to traffic organs to Westerners, if a well-placed surgeon has a way of procuring an organ for a Westerner, he's not questioned."

"Yes, of curse," she says kindly.

"And Larry and I won't land ourselves in jail?"

"Jail? No, I don't think so."

"You don't *think* so?"

"Of curse not," she clarifies patiently. "Rest easy. You are in good hands."

Well, all right then, that's what I wanted to hear. I'm partial to those five words. We are in good hands. It's such a human expression, so reassuring on a primitive, tactile level, that I surrender. We don't know the cost, we don't know the time frame, but in the end it comes down to

hands, and something about Cherry's makes me trust them. Competent, strong, maybe even wise hands. It's a leap of faith, but here we go, crossing the Rubicon, making the emotional commitment to put our fate in the hands of this capable young lady. Larry is in my hands, and I am in Cherry's hands, and Cherry is in Dr. X's hands, like a series of nesting dolls with Mama Mao at the end.

Our business concluded, I duck into the bathroom to rinse my contacts, and while I'm doing so, the right one shreds in my fingers. The pollution's eaten it away. My teeth taste granular; when I blow my nose, it feels like the Great Wall. Also, I make out a smudge mark in the middle of my forehead like it's the beginning of Lent, only I got this from banging into the cab's ashtray. Scrubbing it off, I wonder how many hours I've been wearing this mark of penitence, and no one thought to tell me?

I emerge from the bathroom to a blurry scene. With only one contact lens, I can't immediately locate our party near the windows. Then I spot Jade, a figure of clarity in a fuzzy, fast-moving space. Seeing me emerge safely from the bathroom and begin to pick my way across the noisy room, she raises her hand in a victory salute to me. I can't quite make it out, but is she, are her...?

Yes. Those thin fingers are crossed.

CHAPTER 8

Anaerobic Memories

Once on a tiger's back, it is hard to alight.

So we're moving our little opera to the city of Shi. We're canceling the Philippines and committing ourselves to Cherry and Company. One little glitch: Before we can install Larry in this hospital, we have to return Jade to BJ, check out of our hotels there, then scoot on back. Should be a snap—in our minds we've already moved.

Round-trip, however, is going to require two separate journeys.

Our faithful cabbie's waiting outside the hospital when our party returns from KFC. He's used the hour to play games on his cell phone rather than catch up on sleep. Making our farewells, Jade, Larry, and I exit the city the same way we entered, via a series of medieval ramps and pulleys, but things look different this time. When we arrived in sunlight, Shi appeared bleak and grimy, a grim town of harsh angles. But with darkness it's transformed itself into a neon wonderland: sprays and spoutings of illuminated fluorescents. Sidewalk trees, storefronts, and a bonanza of billboards are adazzle with flashing bulbs. I can't say for sure, because my one remaining contact lens is smeary, but there even seems to be a nighttime amusement area not far from the hospital, where a series of colored fountains provides a blinking liquid backdrop to a promenade on which couples seem to be . . . figure-skating? Whirling each other round and round?

I'm a sucker for neon, especially when it's in a language I can't decipher, and am cheered by its fluid warmth. But a few blocks on, Larry thinks he reads messages in the garish squiggles.

"Did you notice all the massage parlors in this town, Dan?"

"Where?"

"There! There! We just passed another one! You're going to have a good time in this town."

It's like a Rorschach test, I think. He's managing to read into these foreign graphics every kind of fantasy vision. And just like Larry to use such a grandmotherly word as "parlor." Well, I suppose there's something to it. If I squint, I can see some of those letters looking vaguely like a woman's legs. Or hips. Wiggling hips, because the neon's moving. Wait a minute—those are breasts being advertised there! The target of neon squirts and spumes. Larry's right: There are massage parlors all over the joint! With real-life hostesses in ankle-length gowns beckoning real-life customers, all washed in vivid, reflected color.

"Let's just call it Massage Central," Larry suggests. "The real city name is too hard to pronounce anyway."

Larry is still coming off the high of mealtime. The attention of so many female medical residents at dinner has apparently made him feel munificent toward womankind. He directs his attention to Jade in the front seat. "What do you do, dear? Dan tells me you're a grad student. What are you studying?"

"Foreign relations."

"From what I can see, I'd say you're already very successful at foreign relations," he tells her. "As Dan may have already told you, I am a professor. Here I'm just a poor schmuck of a patient, but at home, if I ever manage to get back there, they call me sir."

"What you professor of?"

"Customarily I teach negotiation, which I can tell Dan thinks is just a fancy term for haggling. I also teach mediation from time to time and as such am called upon to mediate complex legal cases. High-status people from the top echelons of society come to me for advice."

"Is that true?" I ask.

"Moderately," he says. "Have you ever been to America, dear?"

"I have never been on a plane," she offers.

The more we drive, the more Larry's good mood drains off. Soon munificence gives up the ghost. He has cycled through many moods in the hours since Mary left, trying to find equilibrium, and now he has to add fatigue to the mix, as well as nervousness about moving into the darker reaches of China. He's finally allowing it to hit him that Mary's gone.

"I don't feel very well," he says, commencing a series of wet hiccups. "Usually I would go to bed after exerting myself as I have today. I don't take a car ride like this ordinarily."

"No one takes a car ride like this ordinarily," I say.

It's rush hour now, so the breakdown lane also contains shards of cinder block, wrecked dishwashers, and the occasional vehicle driving the wrong way. We seem to have mistakenly gotten onto a secondary truck route, a dusty road with a red light every half mile or so, squashingly full of thirty-six-wheelers, none of which keeps our driver from nodding off for four and five seconds at a stretch. In order to find the correct highway, for a time we're the ones driving the wrong way in the breakdown lane. Eventually we find the right road, but this presents us with a new issue.

"May I ask why they're erecting *tents* in the breakdown lane, with women standing by them waving flags?" Larry asks.

"Overnight restaurants," Jade says. "Not very clean."

"Do tell," Larry says, bringing his palm to his brow. He now has a migraine on top of everything else. "You have no idea how bad this feels," he reports. "Everything itches. Feel right here," he says, offering the raised scar on his forearm, the fistula.

I make a conscious decision to suspend my policy of not touching him in order to put my index fingertip on the glazed lump. I get a buzz like a soft version of those shockers you conceal in your palm.

"Aches like hell," he says.

Jade frowns with sympathy for his pain. "Larry is biting bullets," she says, reaching around and taking his hand.

"I've had a lot of bad moments in my life, but this is the worst I've ever felt," he says, chewing on a handful of anti-nausea pills. "This has me thrown, I have to say. This is the most nervous I've ever been."

"Look, all you have to do is get through tomorrow and you'll be in one of the best hospitals in China," I remind him. "Movie stars. Saudi royalty. Maybe they'll fix you up with some Chinese herbs."

"No thanks. I'm a purist: straight pharmaceuticals for me." His effort at a smile dies on his face. Between the driving conditions and being abandoned by Mary, he's not far from having a panic attack.

"More and more bullets he bites," Jade says, squeezing his hand.

"Oh, I miss my mutha. I miss my sister," he says, rocking with anxiety.

To take his mind off the present situation and remind him what he's accomplished in life, I try to get him talking again. "Jade, this is a guy with a heart a mile wide. Wait till you hear his saga about how he saved his twin sister from epilepsy."

"I don't know if I can rise to the occasion," he says, taking little sips of air.

"Give us a treat, champ," I say. "I've never actually heard the whole thing from soup to nuts."

With a valiant effort, Larry lifts himself from his hunched position and begins to speak.

"The year is 2002. Judy has had epilepsy since she was born, sedatives to keep her down and amphetamines to bring her back up. As a result she never developed any interpersonal skills and limited herself to working more or less full-time at the DMV, then coming back to my condo, where she lived, then locking the door and chatting by phone with our mutha until she fell asleep in front of the TV. Three shows: *I Love Lucy. The Price Is Right. Little House on the Prairie.* Occasionally she would break routine and go to dinner with some old people who considered her 'pretty.'"

"Really?" I ask. It slips out, interrupting the narrative.

"After a certain age, anyone under forty looks okay," Larry explains.

This strikes me as profound enough for me to shut up. But not for long. "What'd she spend her salary on?"

"Bathing suits, mostly. She found a shop that had bathing suits marked medium that were really extra-large. But she kept buying them, pretending she was a medium and therefore could keep on eating her fruit-and-nut chocolate bars. Only fruit she ever ate, incidentally. I think the store knew what they were doing and mislabeled all their ugliest stuff they couldn't get rid of."

"What'd she need bathing suits for anyway, when she had a water phobia?"

"Exactly," Larry says. "So there we were living in Florida with all its physicians, and our mutha, Rivie, living outside Boston, the medical capital of the country with an arsenal of Harvard-trained doctors, and nuffing was being done. I decided I was going to do something about it. I got on the horn in my condo—nice two-bedroom with private balcony overlooking mini–golf course; I'm still upset that you never visited, Dan—and I did nuffing for two days but make phone calls. Long story short, eventually I'm in touch with a Dr. Finkelstein at NIH, Finkelsteiner, something like that. He finds Judy's case interesting over the phone, would like to see her in D.C. in three to four months. Much too long. I call Cousin Burton—"

"Wait, you call *Cousin Burton*?"

"Dan, you gonna let me tell my saga? Burton was a good guy then," Larry says with a mild expression, as serenely unconflicted as Mona Lisa. "By the way, thank you for not objecting to my going in and out of present tense. It makes the telling easier, plus my mind is misoriented. I don't always remember what's past and what's now."

"You're welcome. Good to resume?"

"Good to resume. Long story short, when Finkleheimer gets a call from Burton, we're good to go in ten days. But now of course Judy doesn't want to proceed. Trufe is, she's used to her disease, she's fond of her disease, her disease serves her. She doesn't have to apply herself. I say, 'Judy cut the crap. I know you're scared, but we're going.' Soon as she sees the place, twelve-hundred-acre campus, she does a hundred-and-eighty-degree change. Plus, she'll be the star there. She likes nuffing better than to be the star of her little medical dramas. That makes her special. In no

other arena in life is Judy special except through her medical condition. Bottom line, she goes. Comes time for the surgery, she's in ten, twelve hours. Chatting the whole time. Most of the surgery, they're mapping her brain. Only ten, fifteen minutes of actual cutting."

Larry starts looking out the window, counting the restaurants in the breakdown lane. The babbling has helped: He's seeming somewhat revived . . . but the story's left hanging.

"And?" I say.

"And what?"

"And what was the outcome?"

"Oh! Never had another seizure. From the day of the surgery on. And by the way, just for the record, I appreciate how no one in the family ever referred to us as Punch and Judy, at least to the best of my knowledge, despite our occasional knock-down-drag-outs. That goes to the family's credit, which is a very short category in my mind, but give the devil his due."

"So, Larry, stay on track here. You changed your sister's life!"

"But not necessarily for the better," he's quick to point out. "Because suddenly after the operation, she had no crutch. Her epilepsy had been the central component of her life around which everything else was structured. Everyone started telling her, 'Oh, Judy, now you can go get your driver's license, you don't have to work at the DMV, maybe you can even get a boyfriend.' All this terrified Judy. She didn't want any of it. She just wanted to be babied by our mutha."

"And then your mutha, I mean mother, dies."

"Exactly. And no one came to the funeral, which I can never, ever, ever forgive the family for. That goes deep, Dan."

"But, Larry, you could never decide on a date for the funeral. If you'd just chosen a date, I'm sure everyone would have come."

"That remains to be seen, which it never will, will it? I'm still too upset to talk about it. Getting back on track, as you say, things took a downturn after our mutha's death. Judy's worked by this time nineteen and a half years, she quits six months before she would have qualified for pension. That would have given her a measure of independence, which

was the last thing she wanted. She took to chatting with our deceased mutha on the phone and falling asleep in a chair, since our mutha had died lying down and Judy didn't want the same thing to happen to her. Long story short, one day after a four-day weekend with no activity from her locked room, I grow suspicious. I punch the door down with my shoulder and find her expired in her La-Z-Boy, pills all over her lap, dressed in a black Speedo."

"Why a black Speedo?"

"Trying to be the alluring dame in death she never was in life? Beats me. But I can tell you that she did not look good at all. In fact, I almost vomited. Never saw her in it before, I would have told her to throw it out. Judy did not exercise. At the end she weighed, I'm guessing two seventy-five, may she rest in peace."

I don't bother letting a silence surround this thought. I'm too mad at Judy for not donating her kidney to her twin.

"But you did what you could. Larry, you did a heroic thing."

"Thank you, Dan. I rarely hear words like that. My need for external validation is bottomless—that's why I got the three radio ham licenses, three state real-estate brokerage licenses, a pilot's license, and I took the commercial airline pilot's license test just to see how I'd do and got a ninety-two, which isn't great for a professional pilot but not bad for a civilian—"

"Hush, Larry. Settle down. I'm giving you those words. You did good."

Pause. He inhales a tiny space for himself. "Thank you, Dan," he says. I hear his breathing become less raggedy, time it against my own. He is settling down.

The driving continues without letup. Jade in the front seat has her head tilted back, letting all this talk flow through her. It's a comfort to me that she's here for moral support. Larry sighs a few times to himself, then speaks again with a memorial tone.

"She was the most unhappy person I ever knew, Judy was," he says. "She was unhappy not having her seizures. She missed them and what they did for her. And she was selfish, insofar as letting her kidney die

with her instead of giving it to me. Yet I don't blame her, poor thing. I blame her mental state. And I miss her. I still wake up and forget that she's dead sometimes. I wake up and think I have to tell her something, but then I remember that she's dead. And I think about my dad. Him I remember is dead."

"Hush, Larry. . . ."

"I got a short straw when I drew my dad. You know his sole advice to me when I tried to play Little League baseball? 'Never swing, maybe you'll get a walk.' That was basically his attitude. Don't try, maybe you'll get by. If that isn't the most pathetic advice a father ever imparted to a son, I don't know what is."

His words are beyond bitter—they're just sad. "Hush, Larry," I say . . . but he can't stop.

"He never gave me any help in any way. So when my students want my help, I go out of my way to do everything I can. Black, white, Chinese, it doesn't matter. That's why I'm glad I teach at a second-tier school. Harvard students don't need my help."

"So something good came of your relationship. You were able to see him for what he was and rise above—"

"Sam I always saw for who he was. Maybe that's why I always called him 'Sam' and never 'Dad.' From the age of four, I knew this was a very limited person. Sam came from an immigrant family, all he was was basically a manservant to his older brother, Irving, who owned the garage Sam worked in and who treated him badly. Gave him a hundred dollars a week and a box of chocolates for New Year's. And Sam went along with it, thinking that was his function in life, to prop up his older brother and be subservient. One of my first memories was my mutha yelling 'Yoohoo, Irving, see? I'm putting a dime here, only taking a warm Coke from the rack, not one of the cold ones from the cooler.' I was only four, but I knew this was not right."

He hardly draws a breath. These words are coming without air going in or out. The memories are so deep that the words are anaerobic.

"Sam never let anyone read in the house, you know why? Because he himself couldn't read. He had the opportunity to learn many times, but

he never bothered to. That's what I don't forgive. He didn't have to be that way. He chose to be that way. The last time he tried to beat me with his belt, I was twelve. I said, 'Do it! Do it in front of all these people!' I was scared of a lot of people, but never of him. He never earned my fear."

"Do you have any happy stories about your father?"

"I'll try, see where they take us. Here goes: Low as my futha's branch of the family was, there were a few sparks of glory. One of the cousins, Max, grew up to become professor emeritus of Harvard. Another cousin, Benny, started a famous perfume empire. Another cousin, Lenny, grew up to become the legendary Leonard Bernstein, maybe you've heard the name, though he was considered such an obnoxious little prick at fourteen that he got his face punched in and was thrown down some stairs. They still laugh at that one in that branch of Sam's family, at the expression on little Lenny's bloody face, obnoxious little know-it-all."

Larry takes time out to swipe his nose with a hankie that may have been starched once, years ago. "There, was that happy? I can't even tell anymore," he says. "But you'll notice that I use curse words very seldom, if you call 'prick' a curse word, so I guess all this is dredging up some pretty emotional material for me."

"Umm, I've heard happier," I admit. "Any others? What about the Little League you mentioned? Wasn't your father a sponsor or something?"

"To a degree," Larry says. "What happened was, Sam never did anything with me, but one day he gets the idea in his head that he wants to sponsor a Little League team. This enabled him to have the words 'Sam Feldman and Son' printed on the backs of our Cleveland Indians shirts and watch us parade around the field, making him inordinately proud even though there was no such entity as Sam Feldman and Son. He took pictures, you wouldn't believe how many. But because he was a sponsor, I had to join the team. Hated every minute of it. I couldn't bat and I couldn't catch. Though there was one bright spot: The catcher grew up to become the drummer for the band Boston, which got pretty big in the late seventies, used to get me free tickets, which I'd scalp, made a little pocket change."

"What about fishing?" I ask. "Didn't you two like to go deep-sea fishing together?"

"True to an extent," Larry concedes. "One thing we bofe loved to do was fish. So one day Sam tells me he's going to take me out in a half-share boat out of Gloucester, that's two of us and two rented out to some strangers. I'm a little kid, I'm looking forward to it. We get up early, before the sun's up, drive to Gloucester, he's got to go to breakfast at his favorite diner where he always goes, sits there telling his jokes, they don't want to hear them again, but Sam doesn't care, finally breakfast is over, we go to the pier, sign says boat left half an hour ago."

I'm silent. I don't know what to say. So Larry says it for me.

"A professor," he says. "It's hard for me to believe how far I've come sometimes. I haul out my CV sometimes and say, 'Who's that?' It's pretty impressive, I have to say. Problem is, I still see myself as my futha's son."

"You *are* your father's son," I say. "But you're also more. You have to accept yourself as the accomplished grown-up you've become. You have to let go of the way he used to see you. It's no longer valid."

"It was never valid."

"But to the extent that it was, you have to surrender the old picture you have of yourself."

"I don't do surrender, Dan."

"Maybe that should be next on your to-do list. Saves a lot of wear and tear."

Larry thinks about this as we find ourselves inside a traffic jam, locked among massive smoke-belching trucks. A tiny old lady on a bicycle weaves in front of us with a fishing pole in her teeth.

"Thank you for helping me, Dan. In case I haven't told you. I'll make it up to you."

"You don't have to, cuz."

"But I want to prove I'm not a *schnorrer,* taking more than I'm entitled to."

"Larry, you know what this sounds like? This sounds like your mother yelling, 'Yoo-hoo, Irving, I'm only taking a warm Coke.' Larry: Take everything you need. You're entitled."

"Thank you, Dan. Oh, that calms me down. Oh, you have no idea. You're like my consigliere. I still want to figure out what it was you said into the mike at my bar mitzvah, I'm getting compulsive now, I know it's in my mind somewhere—"

"Shh, now," says Jade, reaching back and taking his hand again. And like that he closes his eyes and falls asleep. Maybe it's the visual overload, maybe it's the sleep deprivation or the heat, but he's been laboring through his moods at such a dizzying rate, from despair to pirate cheer, struggling to keep himself afloat, that he's worn himself out. Like magic, the talking ceases.

Jade and I look in each other's eyes. We're each a little shy at having witnessed these words of his.

"Torrible," she says quietly.

"Yes, it is," I say. With blurry vision I look at the diminished hulk of Larry, not snoring, barely breathing. I look back in Jade's eyes that emit no light, infinitely grateful she's shared this ride with us.

"Do you have anything to snack on?" I ask her quietly. "Mooncakes?"

"I am very very sick of mooncakes in my entire life," she replies. "Please I give you some jum?"

"Okay, but only if you promise never to pronounce it 'jum.'"

Studiously to herself she practices her hard *g* while she unsnaps her purse and takes out a piece of Trident, extending it to me gingerly, like feeding a deer through the fence at a petting zoo. "Sugarless, good strawberry!" she says, but she says it quietly, with sadness.

We watch our charge dozing, almost like he's our child, our brutal spawn, something we're caring for together, a tender beast hiccupping in his sleep, adjusting his position every now and then to alleviate his back spasm.

"Were you able to understand most of what he was saying?" I ask her.

"Some of it. When he is talking, I am thinking of my futha," she says—it's peculiar how her Chinese accent sounds like Larry's speech impediment; his is a handicap and hers is an intonation, but it all levels out—"he always say, '*Do not pity! Be strong!*'"

Her eyes bulge for a second, turn shiny. With a little darting gesture, she reaches back into her purse for a tissue and apologetically dabs her eyes. "Sorry," she says. "Miss my parents."

I pat her hand, let it go.

"Were they affectionate with you when you were growing up? You know, stroke you and sing you songs? Affectionate?"

"You spell?"

"A-f-f-e-c—"

Slowly she spells it out in the air, and then quickly her face lights up, before dimming again. "No, is different in China. My futha no show affectionate, only this: '*Stahdy! Stahdy hart!*'"

She mimics her father's harsh voice so well I can hear it—his worry for her, his dreams for her. For a minute I even think I glimpse Larry's father, Sam, on her features, but it goes away as swiftly as it comes.

"He wants you to study hard and make something of yourself."

"Yes."

"Do your parents ever tell you they love you?"

"No!" She's taken aback. "In China not considered polite."

"What about your grandparents?"

"*No!*" She's even more scandalized by this thought. If she didn't trust me as a friend, I think this question would be giving her doubts about me. "But in their heart, very deep, no words for it." She is dabbing again. "My futha—"

"Yes?"

"He says I am naïve."

The word comes out perfectly pronounced. Naïve.

"Of course you're naïve," I say. "If naïve means tending to feel simply for people, and to simply forgive, I'm naïve too, in that sense. Just so long as you don't let people take advantage of you, it's a blessing to be naïve. It's something you should try to always be."

She nods, naïvely, dabbing her eyes. We nod back and forth, with great naïveté that we wish to hold on to. It is almost like a vow between this Chinese daughter and her adopted American father. Again I feel

this impulse to protect her, to safeguard the passage of moods on her face like the phases of the moon in fast motion. Together we look over the brute slumped in the seat, a spot of moisture locked into the corner of his twitching eyeball.

"I am in torment about Larry tears," she says.

"Me, too," I say.

CHAPTER 9

The Kidnap Cabbie

The one who strikes first will gain control of others.

Every time I see the vamp quints, the team of beautiful receptionists at Larry's discount hotel, I hear the songs from those old Robert Palmer videos. "Simply Irresistible." "Addicted to Love." Next morning when Jade picks me up and together we go to collect him, Jade stays in the reception area to scrutinize the bill while I go up to Larry's room with a roll of yellow tape to fix his suitcase that's falling apart. Involuntarily, my nostrils sniff the air in his room—an unlikely odor of cardamom and rifle grease. "You having intestinal trouble, on top of everything else?" I ask.

"I've gone over it and over it and can't figure out what gave it to me. Was it the Lemon Chalet Creme cookies I had for breakfast? One of them had like a black spot on it. Something in the batter?"

I see a glass of germ-sweating, bacteria-festering tap water next to his bed.

"Uh, Larry, I think I may have an idea why. . . ."

His jumbo suitcase is bursting, but I set to work binding it back and forth and up and down. Presto, we're good to go. But then: "Larry, what's that crate over there?"

"That's my porcelain tea set," he explains. "I have innumerable god-

children at home, and I need to bring things to them. They're a big re-
sponsibility."

"Larry, that's going to be a bitch to tote around."

"The other ones aren't as big," he says.

"What 'other ones'?"

He points to three other crates behind the sofa. He's wrong—they're
bigger. "Sixty bucks for each tea set," he says. "You know how hard that
was to pass up?"

The elevator's on the fritz, so I lug each crate down the stairs one
after the other and line them up on the blazing sidewalk of the court-
yard outside the reception office. When all four are lined up, the hotel
manager, a slick-haired sharpie who apparently feels he knows how to
deal with this customer, comes out clucking.

"Larry, Larry, Larry," he says, "what are we going to do with you? You
have to consolidate."

The manager produces a large cardboard box, and I go to work pack-
ing the various tea sets into it when Jade intervenes. "Not too crispy to
carry?" she asks. "Please give me cell phone to ask my mather's advice."

"Uh-oh, did you give me back my cell phone, Dan?" Larry asks, fan-
ning his face with a fat wad of Chinese money, gangster style.

"I never had your cell phone," I say.

"Uh-oh," Larry says. "I know I had it earlier this morning, when I
was talking to Mary."

"You were talking to Mary this morning?" I ask.

"Yes, didn't I tell you? I reached her at her uncle's, and the first thing
out of her mouth is she loves me and wants to visit me when I get in-
stalled in the hospital."

Jade and I look at each other in the heat. "Larry, that's great news!"
I say.

Larry starts wheezing through his nose, a sort of nose hiccups,
whether out of excitement or his condition, I'm not sure. But we're still
minus a cell phone. The vamp quints are happy to turn the courtyard
upside down, looking behind flowerpots and inside drainpipes.

"Call the cell-phone number," the hotel manager suggests, and soon

there's a faint ringing from inside the suitcase I bound with yellow tape.

"Does anyone have scissors?" I inquire. One of the quints produces a cigarette lighter, pale flame flickering in the sunshine. "No, I mean the kind that *cut*?"

Snip, snip, snip. I take out everything from Larry's suitcase, all the clip-on neckties, the three-piece suits made in Albania, the corn-and-callus cushions, everything packed in with funereal precision. And this: hard copies of all my books as well as CDs of my aunt the harpsichordist soloing at Boston's Jordan Hall. "I'm proud of my family," he says defiantly when he spies my dumbfounded look. "The few who aren't trying to screw me over."

"That doesn't mean you have to cart our products all over Asia," I say. "They're not even my paperback editions."

He sends me a helpless look, which I translate as: These were the ones on sale. He doesn't even have to say it. He couldn't anyway, because the nose hiccups have gotten worse.

No sooner do we find the cell phone among his antifungals than Larry wonders where his MasterCard is. "Could it be in *your* bag?" he asks.

I don't see how, but I open mine, too, just in case. Not there, of course, but Larry gets a gander at the title of one of the books I'm carrying—*Middlesex*—and pops a devilish gleam.

"Never off duty, are you?" he says to me admiringly.

"Did you check your back pockets?" I ask, patting him down. Frisking my cousin on his diminished, no-longer-round rear end is not something that a month ago I ever imagined I'd be doing.

Sure enough, there's the MasterCard, bright and shiny.

"Tea sets too crispy," Jade announces, clicking shut Larry's cell phone. "My mather says I will arrange a shipping company to send them to Larry direct."

We give Larry's address in America to Jade and make her promise to forward the bill to us at the hospital. Larry insists that we hold on to one crate of teacups for safekeeping. "I can't afford not to get at least one set out of this," he says.

I use a few of the luxury hotel's washcloths I seem to have taken with me to wrap his tea-set pieces, along with my wolf skull, then seal the suitcase up tight.

"Game on," the hotel manager says, sending one of the vamp quints off on a bicycle to fetch a taxi, the black bobbin of her hairdo bouncing over the potholes.

"Good man," I tell the manager. "I don't know how we can repay all your kindness."

"When Larry send me forty hot coeds to rent rooms for exchange program, that will be payment enough," he says.

"Larry worked out a deal with you?"

"Why do you think I'm doing this?" he says with a chortle, rubbing his fingertips together. I can't believe he actually says that, and out of the side of his mouth yet. Isn't that the sort of thing you're supposed to keep to yourself? Okay, so they're not all helping us out of the goodness of their hearts. Jade and I exchange a smile anyway, part of our pact to retain naïveté.

The taxi's here, but by the time I've loaded it with our belongings, Larry is entertaining the vamp quints again. "Does the name Red Auerbach mean anything to you?" he asks.

"Larry, you don't have to pile it on so deep," I tell him. "They already like you enough! Can't you see how they're twittering?"

"Beneath my somewhat brash exterior, I'm a very insecure person," he says.

"If it doesn't work out with Mary, I'm sure any one of these ladies would be happy to run off with you to your condo in Pembroke Pines. Don't say it—I know you're devoted to Mary. But hey, you want to seal the deal, watch this: Ladies, not that you know what this means, but Larry here is a charter member of Mensa, the brain club in America."

"IQ of one thirty-one," Larry protests with genuine modesty. "That means I'm the dumbest member, with the absolute lowest number they'll accept. And now of course my disability cost me twenty-two points."

"What is with you, cuz? I try to talk you up, and you cut my legs out from under me!"

"I don't like to boast about my real accomplishments, only my pseudo ones."

Shrugging the way an ancestor must have shrugged on the streets of Minsk three generations ago, he hobbles to the street, an old man in sunglasses, so pathetic that I take his elbow—chicken bones held together by a rubber band. *Get used to it,* I tell myself.

Jade accompanies us in the cab to a madhouse scene outside the train station. I remember being here twenty-five years ago, and the pushing and shoving has only increased with the millions of new people since then.

"Very exotic, looks like China," Larry observes.

Jade's in front pulling several suitcases on wheels, and I'm behind her doing the same, and Larry's way behind, stepping gingerly around the crumbling tiles of the plaza, when the cabbie we just left comes running up with a handful of bills. "Larry drop these!" Jade says, counting two thousand RMB and buttoning them into Larry's breast pocket. I'm glad she doesn't refer to him as Professor. Not that Larry doesn't more or less deserve the title, but every time someone says it, I feel like I'm one of the con-man duo on Huck Finn's raft. I couldn't bear for Jade to fall for it.

"The cabbie won't even take a tip," Larry notes. "I like these people."

They must like us, too, because in a minute a new cabbie with a cute dimple approaches and calls us "friend," telling Jade that he lives in Shi and will take us there for a discount price.

"Another car ride on that road? Never," Larry says, but Jade intervenes with some good sense. "You no have train ticket reserved," she points out. "Maybe you don't make train till much later? Also, maybe it so crowded you have to stand? Also, train station in Shi very far from hospital. You have to wait another taxi there. Maybe is better drive?"

"Up to you," I tell Larry. "At least this cabbie looks more awake than yesterday's."

"Let's do it," Larry decides. The new cabbie with the cute dimple relieves Jade of her suitcases, and we follow him through the throng, getting sprayed by a street cleaner, me twisting my ankle but willing the pain away, looking in vain for a handicap ramp for our suitcases, another four blocks of broken tiles and sand before we come to the man's under-size taxi.

"I think is safe," Jade tells me when we're loaded up and ready to go.

"'*Think*'?" I say, chuckling at her wit. "What's he gonna do, kidnap us?"

"Yes, I think not. I write down his number in case to call police." She scribbles down his license on her small palm.

I look at her for what may be the last time, with no words to express my gratitude. "*Jo yee, jo jang,*" I say, trying to remember the friendship toast from twenty-five years ago. "*Yo yee* or *yay yee,* something like that—"

"Give it up." Jade smirks with a shove to my shoulder.

This is farewell. I give her a chaste hug.

"Sorry I am sweaty," she says.

"It's the humanity," I say, meaning "humidity." I'm losing my English in the onslaught of so much Chinese.

"I hope you live," she says, apparently without irony. My heart tugs as we drive away.

In the backseat, Larry and I are wet with perspiration, giving each other as much berth as possible. Both of us are a little out of breath, but Larry is already on to the next chapter of his life. "Better exhaust system than yesterday's taxi," he diagnoses. "I think the problem yesterday was there was a loose fitting where the muffler met the tailpipe. You know how many Packards I worked on when I was twelve? I was given a Coke for each muffler I changed."

I can't figure out which is worse—a morose Larry when he's down or a garrulous Larry when he's up. Also I'm a little heartsick at splitting from my adopted daughter. But at least this taxi ride seems to be better than yesterday's, and we're making better progress, too. Before an

hour's up, we're in an unfamiliar landscape of cornfields and irrigation machinery. We're not weaving nearly as much, either. "I paid him a little extra to not cut between trucks," Larry explains.

Something about my hesitation makes him look at me.

"What?" he says.

"Nothing. It's nice that you're so generous with everyone. It's just . . ."

"What?"

"I'd just start conserving money if I were you; we still don't know how much the surgery's going to cost. But hey, it's your call. I'm not going to tell you how to spend your quarter mil."

Something about *his* hesitation makes me look at *him*.

"You do still have a quarter mil, don't you?" I ask.

"Life," Larry says with a shrug.

"Yes, go on. . . ."

"Life costs money," he amplifies, "especially when you have a fiancée with champagne tastes, not that she isn't worth every penny."

I brace myself. "Larry, how much do you have left?"

"A little under sixty," he says.

"Bullshit!" I explode. "The icicle/truck settlement was for two-fifty, after lawyers!"

"Shhh."

"*Shhh?* What do you mean, *shhh?* Either you have it or you don't."

"I did have two-fifty, but it's been going fast. Most of it already went to living expenses. The market is down. This trip is not cheap. Plus, the first thing I did with my winnings was pay off people I owed, which you have to admit attests to my decency as a human being, despite my image as a miscreant, which I cultivate, no question, it's an ingrained habit. Bottom line, I've got maybe one-twenty left," Larry concludes.

So that's what *shhh* means. It means he has twice what he lets on. But it also means he has to husband his money carefully. This trip may not work, after all. If we don't succeed in getting a new kidney, Larry will be too ill to make any more money.

"Okay," I say, recalculating. "That doesn't change the basic equation. It was still a good move for you to come to China, assuming the kidney

comes in around eighty-five. Let's do the numbers again. How much does a kidney transplant cost in the U.S.?"

"Two-fifty, vicinity. But insurance covers it at home."

"But you have to wait ten years at home, which you aren't willing to do. Plus, you mostly get a cadaver kidney at home, and here you get a live one. So it's worth it to pay out of pocket here, right?"

"Look at that, a Russian gas station. Probably twenty percent water," Larry says.

"*Right?*" I persist.

"That seems logical, yes," Larry says.

"Plus, here they're more experienced at the surgery, since they do so many more of them than at home."

"Correct."

"So it seems to me that you may be misoriented, but you got yourself to the right place. As long as you watch your pennies."

Larry starts cracking his knuckles, a sign he's feeling pressured. "I get it," he says. "I have to preserve my nest egg. I'll do my best."

Progress. Hard won. I allow myself a moment of relief before attending to more pressing matters, like why we don't recognize any landmarks whatsoever on our drive. Are we sure our cabbie understood our destination correctly? I tap the little plastic partition behind the cabbie's head that insufficiently seals us off from him.

"Uh, hello, friend? We going Shi?"

"Friend, yes," he assures us, nodding his dimpled cheeks up and down.

"Let's just hope he's not planning to cut our throats," Larry suggests. "Jade didn't sound all that sure on the kidnapping front."

"We don't understand this culture very well," I remind him. "Let's not second-guess what people mean every minute. Besides, they don't kidnap people in China, as a general rule. That's not their style."

We go a few more miles in silence and pass a series of water tanks I'm sure we would have remembered from yesterday, if we'd seen them. I crack my knuckles—which I almost never do.

"What I don't like," Larry says after another minute, "is that this cab-

bie found us, we didn't find him. Could be he saw my two luxury watches at the train station and figured I was worth trying to take down."

He slides the bands of his watches around so they double as brass knuckles. "They'll do in a pinch," he says.

We stare at the faulty partition between the cabbie and us while I smell a hint of cardamom and rifle grease again.

"I saw the video of Danny Pearl's last moments," Larry says out of nowhere. "Do yourself a favor. Don't see it."

We sit in nervous silence for a few unfamiliar miles more, wheezing through our noses.

"Seriously, Dan, this could be worse than your being thrown in a Chinese jail cell."

"It wasn't really a cell, it was more like a little barracks room with bars, if you must know. But I really don't want to think about it right—"

"Do you bear any scars on your body?"

"It wasn't a Jack Bauer kind of deal," I say, "it was—"

"More psychological torture," Larry deduces. He scratches his butt discreetly for a while before taking another tack. "So what were you doing here anyway twenty-five years ago? Being like a freelance foreign correspondent?"

"That sounds more glamorous than it was," I say. "Mostly I was getting away from my divorce."

"Didn't you teach the natives how to dance or something?"

He's distracting me, I suddenly realize. He's trying to help me like I was trying to help him yesterday, when he was the one feeling worse. He's throwing me a lifeline, and you know what? I'll take it.

"The year was 1984," I begin, a little timidly. "The streets of Beijing were colorless and without music. No one seemed to have radios or record players. At least I never saw or heard any. The government was just starting to allow Western music in a few select venues. One of these venues was a banquet for some visiting American journalists. A film crew from the Ministry of Education followed us around recording our every move, presumably to broadcast nationwide for training purposes, teaching the masses how to catch up on certain officially sanctioned Western

customs. The crew followed me behind the bar, where I demonstrated how to pour a Perfect Manhattan, which I freely confess was long on bourbon. They followed me to the dance floor, where, after a sufficient number of Perfect Manhattans, I was induced to demonstrate the Jerk. Long story short, as some people like to say, I may no longer be one of the worst dancers on the planet. Scary thought, but there may be a few million Chinese doin' the Dan."

"Ha ha, good one," says Larry.

"Ha ha, thank you," I say bashfully. Because Larry's trick of distraction has actually worked. I feel better. I'm back to normal, acknowledging that there's probably nothing awry with this cab ride. I just tend to get paranoid in this sort of situation. I'm the guy, after all, who carried the personal telephone number of notorious Lebanese kidnapper Abu Nidal in my wallet when I traveled through most of the eighties, courtesy of my Lebanese hairstylist, who promised that if I got kidnapped, that number would connect me with the chief honcho, who could spring me.

Without warning, our cabbie peels out onto a dirt road and starts signaling to another cab that pulls in right behind us.

"What just happened?" I say in alarm. "Did we just land ourselves in trouble?"

"I'm not sure what to make of it," Larry says, deeply unstartled but with steel in his voice. "Can you get the number off his license plate?"

I try to turn in the backseat, but I haven't done yoga the whole time I've been in China and am too stiff to move sufficiently.

"Write this down," Larry instructs. "C56488."

"You got the plate? Then why'd you ask me?"

"Double-checking."

Larry shouts through the faulty partition to the cabbie, eighteen inches away, as though he's hard of hearing. "WE GO SHI, YES?"

"Friend, yes, friend," says the cabbie, checking his rearview every couple of seconds for the shadow cab. He reaches into the dusty storage area beneath the dash and brings out a cell phone from among the loose papers there. His dimple's vanished as he makes a call with one hand and starts conspiring with the person on the other end.

I'm sweating a new kind of sweat now, colder than the one back in Beijing. It's as though my cranium has sprung a leak; the fluid seeps down to my armpits, where it drips into a bottomless space. Shouldn't my shirt soak up the sweat? But it drips, drips, into a measureless void. Where's my sense of humor? But I can find nothing remotely amusing about this situation. In preparation for anything, I stash my passport and wallet in a buttoned pants pocket, adjust *my* fake Rolex so it doubles as brass knuckles. Larry takes out a ballpoint pen and clicks it a few times, making sure the point is exposed. "In the event of a situation, I'm using this to go for his eyes," he says.

I keep staring at the faulty partition between us and the front. It's meant to protect the cabbie, but it comes only halfway up. In a pinch I could get my hands through to throttle the cabbie. But my mind is lagging. I keep wondering why anyone would install such a half-assed partition? I flash on the image of a bridge near my house that became such a favorite of suicide jumpers that they finally put up a fence. Only trouble was, there were ten-foot-wide gaps in the fence every thirty feet. Wouldn't you think the line between life-and-death predicaments would be more foolproof?

We gravel on in silence for a few more minutes while I laggingly think about fences, suicide, murder. I call Cherry's hospital office and leave a message on her machine, trying not to let panic creep into my voice. I text-message my wife at home: "Kidnap cab? C56488." At a stop sign, the shadow cab pulls up to us. Two burly guys measure us with their eyes. Do they want to take us on? Too bad Larry doesn't have his beloved firearms with him. He does look pretty ferocious in his box-turtle sunglasses, like a Miami tough guy—so long as they don't know how sick he is. Without being invited to, I reach into his satchel for an extra pair of box-turtle shades and put them on, too.

"I don't think we're being unduly paranoid, do you?" I ask him.

"Better more duly than less duly," he says, clicking his ballpoint calmly.

His voice is so serene that I can't help but be flooded with admiration. How many degrees of impassive Larry's face is capable of! If some-

one had told me ten days ago that I'd be spending this kind of time studying my cousin's face like it was a da Vinci, I don't know what I'd have thought. But I let Larry take charge. He's better at distracting me than I am at distracting him, clicking his ballpoint pen in readiness, rotating his feet in their Businessman's Running Shoes, which I realize now could double as ballbusters.

"Ever watch *Sopranos* reruns, Dan?" he asks.

"I thought you didn't do popular culture," I point out.

"HBO!" he says, as if it's understood those initials are above the fray. "The reruns hold up surprisingly well. Nevertheless, the premise is still implausible. They make Tony out to be some New Age gangster with higher qualities: loyalty to his children or whatever? No, I'm sorry. I've been around these people, and let me tell you: Tony is a street thug. No redeeming qualities whatsoever. No higher education. No advanced degrees. He kills people for disrespecting. What, he couldn't just beat them up? Especially since the guy has an IQ of a hundred and thirty-six—check it out, fifth season—that's five points higher than me in my prime. He should know better. (That said, however, I must admit that I like Tony's house very much. Very tasteful. In most areas he's a very confused guy, but I have to hand it to his home decorator.)"

I try to meet Larry halfway in the coolness department, even though it's all bluff on my part. "Larry, now's as good a time as any to ask about something that happened once when we were kids on the Red Line and those guys wanted to mix it up with us, remember? I was kind of anxious, but you wanted to fight?"

"I remember," he says, flexing his hands with his improvised brass knuckles.

"Was I being a wuss?"

"One time doesn't make anyone a wuss," he assures me. "You had a sheltered upbringing. You didn't understand that it's better to just get hit a few times than spend your life fearing being hit."

"Really? That strikes me as profound," I say.

"Okay, you want me to talk about fistfights," he says. And he's right: I do want him to talk about fistfights. He's diagnosed my anxiety accu-

rately—hell, he probably diagnosed it decades ago—and knows I need him to fill me in on everything I've missed in my coddled existence and have to catch up on double-quick.

"The first thing to know is that every fight is different," he says. "And none are like Muhammad Ali in the ring. Most are scuffles with very few clean punches. But the secret to all fistfights is the element of surprise. You know how I'd handle it if I were to get in a fight now, in my condition? I'd pretend to be hurt and cower, then as soon as he didn't expect it, I'd punch his lights out. Surprise is key."

Okay, this is helpful. Hearing Larry's lethargic, even-keeled voice with all its various speech impediments is keeping me calm.

"Larry, another incident," I say. "Remember that time we were trying to park in South Boston one night and that black guy stole my space and you told me to stay in the car, but I got out and started walking over to talk about it. He smiled and adjusted his posture so subtly that suddenly I got the feeling he was packing heat. Or whatever you call it. And I got back in the car. Was I right to get back in?"

"You were wrong not to stay in the car in the first place."

"All right, good," I say, nodding my head. "So let me ask another question. That slick hotel manager back in Beijing. Nice guy, right, even though he had ulterior motives for helping pack you up?"

"Guy was a huckster," Larry says. "I saw the way he was eyeing my tea sets. If they arrive with so much as one swizzle stick missing, I'm all over him with the authorities."

I yawn, suddenly exhausted with insight. "I didn't sleep well last night," I say. "The phone kept ringing."

Larry looks at me as though I'm mentally endangered, then enunciates carefully, "Hookers. They rent a room in the hotel and then call all the other rooms, one after the other, hoping to get lucky."

So help me, the guy is brilliant. His talk is aimed with dead-eye accuracy to simultaneously comfort and toughen me up. Feeble, ill, and homesick as he is, he's taking care of his older cousin.

"So . . . ah, hookers, Larry? Do you really know them socially?"

"Mostly they're sad people who can't find a better way of life," he

confirms. "On the other hand, a lot of regular women don't even charge, and that's sadder. And on an additional hand, if someone wants to give me one for my birfday, I won't object." He registers my appreciative expression. "I can see you're soaking this up," he says. "So I'm going to resume by thanking you again for the fake Cartier watch, and I'm going to tell you why it's important. It's a power prop to go along with my other power props that tell the world I'm a success."

"Power props?"

"When I was first starting out, I got myself invited to the Cosmos Club off Dupont Circle in D.C.," he says. "One of the most exclusive clubs in the world. Teddy Roosevelt's still trying to become a member, ha ha. Long story short, I was invited for dinner when I was eighteen. Not worth going into details, but I managed to scoop up a dozen matchbooks, knowing they'd come in handy someday. Sure enough, three years later I'm entering into negotiations with a hotshot lawyer who pulls out an expensive cigar. I'm there with a light, after which I place down the matchbook facing the guy. Guy reads the inscription, Cosmos Club. 'What can I do for you, sir?' the lawyer asks."

"You were pretty savvy for being so young," I put in.

"Nah, way too obvious. You know what I would do differently today? Place down the matchbook facing *myself*. So you catching on?" Larry asks. "It's not like you don't know this stuff abstractly, it's just that you never had it spelled out for you in the context of real life. Let me give you another example."

And so forth. Somehow, before I know it, we're at the hospital. I've gotten both more worldly and more world-weary with each tale. The shadow cab has drifted away. How many pounds have I lost, in sweat and anxiety? I'll never know. Nor do either of us know if the whole scare was a false alarm. Maybe they took stock of us back at the stop sign and felt they'd get too scratched up? Maybe our cabbie became mesmerized by all of Larry's gobbledygook and dropped the ball? We'll never know. Anyway, a couple of exhausted men in box-turtle sunglasses and Rolex brass knuckles are finally delivered to the hospital entrance, safe and sound. I'm only too happy to pay the cabbie in full, even tipping

him twenty RMB for not kidnapping us. Ciao, ciao. "Oh, and I'll take a receipt, please."

Stepping out of the cab, I thank Cool God that the scare is over. But when I look back at Larry, expecting to see a similar relief on his face, I see nothing but a blank stare, slack and emotionless. For him, looking up at the eleven floors of this great, grim hospital, the Giant Mushroom of Hope and Dread, the real scares are just beginning.

Welcome to the Super 2

Without rice, even the cleverest housewife cannot cook.

Suddenly silent. The glass doors of the hospital close behind us to seal out all sound. No honking, no jostling. All is shiny emptiness, a great big McSpace Age lobby that is eerily vacant except for a couple of severe-looking, vaguely threatening Arab men who saunter through, holding hands. Relatives of patients? From far off I hear the sound of . . . a badminton birdie being hit? Larry and I walk toward the elevator bank, followed by a maid who soundlessly polishes off our footsteps so no dust remains on the glittering marble.

On the ninth floor, still ghostly quiet, there are a few patients sitting around on windowsills and wearing colostomy bags. In their Yankee uniforms with limbo dinge, they're from no country but the Land of Weary. We make it to the nurses' station and say we are looking for Cherry. When she arrives, toting her ever-present pocketbook, she escorts us to Larry's new home: a double-room suite with twin beds, fridge, and flat-screen TV. I plug everything in and feel the room buzz to life.

"Did we miss lunch?" Larry inquires.

"No lunch," Cherry replies.

"Are we too early for dinner? I finished my last Girl Scout cookie twenty-four hours ago."

"No dinner."

Turns out they don't serve food in this hospital. Families have to bring their own. There are no plates for patients to eat on. Or glasses to drink from. Or towels. Or soap.

"Or toilet paper," Larry calls out from the bathroom.

"Is Dr. X around?" I ask. "I'd feel better if we could talk to him directly."

"He at conference, back at end of week."

In his absence, preliminary tests are taken by two of the medical residents we met last night: a gangly man who suffers from acute self-consciousness and an ungainly woman who could profit from a little *more* self-consciousness. Have they never schooled female residents to sit with their legs closed? The poor woman looks like she's struggled over every hill she's ever come across and reminds me of someone I can't put my finger on. One good sign, however—and I'm desperate for good signs—is that she's very adept at spinning a purple pen around in her hands. Great manual dexterity.

I offload all of Larry's stuff in his room, his suitcases and crate of teacups, and help him get organized. "Also, you should give me your passport for safekeeping," I say.

"I'm a big boy, I'll keep it with me."

"Larry, we went to a lot of trouble and expense to get a replacement. We can't afford to lose it again."

"More important, we can't afford to lose my self-respect," he says, reaching down to retie his shoe slowly enough that finally I just do it for him. "So that's the way it's going to be."

His obstinacy is a healthy sign, I decide. I'll choose my battles. "Fine," I say, making a mental note to steal it later if it comes to that, "but where will you keep it so you don't lose it?"

"In my slacks."

Slacks? Why not just call them chinos, britches, knickerbockers? What generation is he *from*?

"Better yet, I'll keep it in this Kleenex box with my glasses and wallet. Since I apparently won't be wearing trousers."

Jodhpurs, lederhosen, pantaloons?

He changes into a hospital robe.

The compressor of the fridge starts making prudish squawking noises. Larry turns up the volume of the flat-screen TV on the only station he can find that's broadcasting in English: Al Jazeera.

"Is there a way to shut off the music?" I ask, because a lullaby-type tune warbles softly from invisible ceiling speakers. *The itsy-bitsy spider climbed up the water spout.* . . .

"And the A/C?" Larry asks. "I'm not accustomed to the arctic blast."

"By the by," Cherry says, not hearing us, "we need two thousand RMB to start account rolling. For diagnostic workup, such and such."

Apparently everything's done in cash on the barrelhead. Before we can get under way, we have to open our wallets and fork over almost all the bills we have on hand. Next they want to see the medications he's on. Larry rummages until he finds two leather satchels and empties their contents onto the glass tabletop. Seventeen plastic vials in all. The residents start giggling.

"You take these every day?" Cherry translates, clucking with dismay.

"Two and sometimes three times a day," Larry answers.

The residents' amusement turns to disbelief as they turn the vials around and around, as if inspecting cucumbers too rotten to buy. "But these pills do not work," Cherry says. "Blood pressure is two-fifty over two hundred," she says.

Larry shrugs. "I'm just showing you the cards I'm holding," he says.

The residents confer until they reach a decision. All medications from home will be stored in a safe place where Larry will have no access to them. "First thing first, we remove pills, then see how your condition is," Cherry says.

"Cold turkey?" Larry asks. "What about my antidepressionists? You sure that's safe?"

"First thing first," Cherry says. "We must bring down blood pressure, also resume dialysis starting tomorrow. As needed, we give you clam pill to keep you clam."

Before undressing, Larry empties the contents of his shirt pocket. Two pairs of reading glasses, two pairs of shades. A handful of American change. Business cards from the crew of the plane he took here from Florida. Tube of toothache gel. While I unpack Larry and get him settled in—he won't part with his Businessman's Running Shoes, a concession they allow him—a woman comes into the room and gives Larry a Chinese-looking haircut. A man comes in and takes Larry's picture. Larry morosely pays each visitor, though each puts him to some discomfort. "Is all this really necessary?" Larry asks when yet another man comes in to sell him a bunch of plastic clothespins.

"It up to you," Cherry says. Apparently none of the visitors are connected to the hospital in any way. They're free agents from the street, peddling their goods up and down the corridor just as they do on the sidewalk outside.

The compressor of the fridge heaves one last squawk and shudders to a stop. The Al Jazeera news anchor is issuing a statement denying reports that they recently broadcast a beheading on live TV. *Down came the rain and washed the spider out.* "Can we get another couple of blankets in here?" Larry asks, shivering in his paper-thin hospital gown.

"Again it up to you," Cherry says—meaning that the hospital won't provide another one but we're free to buy one elsewhere. Since no more peddlers seem to be coming by—did the word go out that Larry's wised up?—I conclude it's left to me to provide. I stash my suitcase here for the time being and set off to hunt and gather.

"See you soon," I say, squeezing his shoulder. It feels abrupt, but I'd better get some nourishment in him before he keels over.

At the elevator bank, I have time to examine the hospital a little more carefully. For a structure built just two years ago, it looks roughly used—like so many things in this country, subject to instant antiquing. It seems antiseptically clean, but on closer inspection it looks Minged up—mildewing in easy-to-reach places, its plaster wizened twenty minutes after application. Brand-new walls have scuff marks as though they've been

around fifty years, the putty gouged out in places, the paint moldering. Right before my eyes, this ultramodern hospital shows signs of dissolving back to the sand from which it sprang. Is this why the Chinese language has no past or future tense—both are here now, in the crumbling present?

Yet another in a series of Inscrutables. The word's less offensive as a noun, for some reason, less patronizing and pat.

"You still here?" Cherry says, passing through the elevator bank a few minutes later on her way to the stairwell. "I forgot tell you, elevator only go up."

Outside in the smogosphere, I have a chance to list the other Inscrutables I can't get my mind around.

INSCRUTABLES . . . ITEMIZED

Inscrutable of the stockings: Why do the Chinese of both sexes wear ankle stockings, even with sandals? It offends every fashion sense. . . .

Inscrutable of the bus squat: How can people stay so long in the age-old Chinese position of waiting, snoozing on their heels for hours if need be, waiting for a bus that may never come?

Inscrutable of the One-Child Policy: Where are the pregnant people? They're almost as invisible as members of my own generation. Intellectually I grasp the concept that the government must limit population growth, but how can a people who've had extended families for eons put up with a policy that mandates only one child per family, and thus no siblings, aunts, or uncles?

Inscrutable of the gradual stairs: When did the Chinese devise this method of pitching their stairs so much more gradually than Western ones? I'm forced to take them one at a time, slowing me down when I'm in a mad rush to go nowhere, as usual. . . .

Inscrutable of the cab honking: What are those cabs trying to

say as they each honk an average of sixteen times per minute?
Do they really think they're going to change my mind if they're
driving on a one-way street in the opposite direction from where
I'm walking, that I'll say, "Oh, you're honking so well I guess I'll
go your way instead?"

Nevertheless, I'm acclimating. Now that I'm going to be living with
it awhile, I have to admit that the pollution here truly is breathtaking.
Beijing's vaporized Frappuccino was impressive, but this is something
to stand in awe of. Championship-level pollution. Olympic-stature pol-
lution. An ivory-gray effluvium stops your vision after two blocks out
or five stories up. What's worth seeing beyond that anyhow? Probably
just more power pollution. It's amazing how quickly you adjust to not
being able to make out the tops of buildings. The pollution is more than
a by-product; it's a being in its own right: a living, heaving conscious-
ness—like walking around with an old lady attached, her toothless gums
clamped around your nose. Inspiring, in a way: Breathers feel, "If I can
do this, I can do anything." So I will adapt, too. My old-fashioned al-
lergenic American prissiness is a thing of the past. I'm tubercular with
confidence, convinced we're going to succeed in our mission.

I'll figure out my lodging later; right now I'm taking in the city. It
occurs to me that Shi may be a glossy city, Shi may even be a spotless city,
but our section is neither—sort of like the outer reaches of Queens. Un-
like Beijing, all tricked out for the Olympics, Shi is old-time China. The
taxis are not on their first coat of paint, as in Beijing. The bikes are not
the streamlined kind you see in BJ; they're the kind your mother had in
junior high, with three gears and rusty chains. The residents are not yet
self-conscious about grooming themselves in public. On the other hand,
there are plenty of places to relieve yourself. Ducking behind a cluster
of weeds wouldn't be out of character almost anyplace in this section of
Shi. Helps keep down the dust, too.

And the smell! The smell is another presence, like the pollution,
an entity that lives its life while you live yours. In the dull smogshine,
the smell is like dried seaweed packed into the tops of your sinuses with

wooden chopsticks. Seaweed with a hint of old cat urine to it. Except it's not cats. Time to admit: It's human beings. Billions of human beings.

And the traffic! If the traffic getting to Shi was somehow brilliant, here in the city's center it's genius. Watching safely from the sidelines allows me to view it objectively, enough to drop all preconceptions of what traffic should look like. I know I've seen this kind of organized disorder before, but where? With starlings swarming ahead of a thunderstorm? With amoebas seen through a microscope, clumping together, then flowing forth again to ooze against its limitations?

No. What it's really like: pedestrian traffic. After all, if a person is strolling on a crowded sidewalk and something catches her fancy in a shop window, she'd think nothing of stopping, backing up a little, making her way over against the current of people. Nobody would get mad if she veered at a right angle or lunged ahead if the shop looked like it was about to close. So it is with the car traffic here. They're not drivers, they're motorized pedestrians.

Once you crack the code, even the gridlock makes sense. It's less a vehicular traffic jam than a jam of people who happen to be in cars. People jockeying for position, nudging their way across the flow, pressing forward or backward by small degrees. And for all that, there are very few accidents, just as you rarely see pedestrians getting into accidents with one another. Drivers are so free to drive as they like that they're free to avoid crashing, too. At home we're in our straight and narrow lanes, so when an accident looms, our options are straight and narrow as well. We can steer to avoid it, but we're so stiffened by habit that we lack flexibility. When a Chinese collision looms, the drivers are more creative in their escape tactics, even if that involves a sidewalk or two. Freeform driving allows for freeform avoidance.

It occurs to me that the way we got Larry to where he is now has worked a lot like this Chinese traffic. We're adapting to the native credo: Stay loose. Find your own way. Don't merely think outside the box; bust the box down, baby!

Lifting my hand in a flood of taxicabs, I'm instantly engulfed. To test their skill, I refrain from moving my feet until the last minute to see

how close they land. The one closest to my toes happens to be a pedicab, like a rickshaw on a bike, so I climb aboard. Here's the conversation the pedicabbie and I have on the way to the supermarket.

Hey, how's it going?

Not bad, you?

Can't complain.

So where do you want to go?

Anywhere I can get some groceries and housewares.

Hmmm, not sure what you mean.

How about you just pedal around a bit and I bet we come across it.

Okay, but aren't you worried about getting wet? It's starting to drizzle.

Nah, I'll be fine. Ho, those folks are coming out of that building with grocery bags. Can you pull over?

The preceding was conducted entirely in party language, not a word exchanged. And that Foreign Service guy at the Beijing temple thought I needed to speak Chinese. . . .

TOP TEN SIGNS YOU'RE IN A CHINESE SUPERMARKET

10. Chicken bones on the broken-tile floor.
9. Where the broken-tile floor is still underwater because of last week's rainstorm, you're walking on wooden pallets.
8. Parents hold their baby daughter over a wastebasket so she can pee.
7. The rolls of toilet paper on sale are so insubstantial they could handle two toilet incidents, tops.
6. In the bathroom someone blows his nose directly into the toilet while someone else, ow my God, did he just spit in his palms to rinse his face?
5. You take an elevator to the housewares department, but others push in before you can exit, and:
4. At least two of the others are smoking, and:
3. The other six are coughing with open mouths.

2. Since people keep cutting into the checkout line, it takes longer
 to pay than to shop.
1. But it's worth it, because the soup you carry out in a plastic bag
 has an entire chicken foot in it—a hairy, liquid-bleached claw of
 your very own!

Larry's horrified by the soup but pleased with the junk food, when
I get back.

"Umm, Pringles, good," he grunts—a caveman sound—and proceeds
to leave a crunch zone of chips on the floor in a circle around him. But
what's this? The Mao playing cards I bought at the market with Jade,
along with some of my toiletries, are all over the room. What's going on?
Where's the suitcase I left in the corner?

"Oh, I couldn't figure out who that belonged to," Larry says, devour-
ing the Ring Dings. "I put out everything with my stuff."

Sure enough, all of our grooming products are mixed together on
various surfaces around the room. His Fixodent with my sunscreen. His
shoe spray with my Rogaine. His Bengay—isn't Bengay for really, really
old folks?

I go into housekeeping mode, filling up his larder. A Larry-type
word, I realize. I lay out the provisions I've gathered, each one a distinct
and hard-won victory. Pink polyester blanket. Two green plastic plates,
bowls, cups. Vegetable peeler to skin questionable foodstuffs. It was easy
to pick out foods he'd like: the worse, the better. Snickers. Twinkies.
He's on a restricted diet, can't eat fruit or veggies, and studiously avoids
the fried tofu and potato dumplings I got myself. Soon we're both eating
our supper and watching a TV movie on a Chinese station. A young Mao
and his pals are on the march—the equivalent of our cowboy shows, with
flat Mao caps instead of ten-gallon hats. You know it's Mao because of
the telltale wart; if they ever airbrush it out, China will have lost its soul.
Before long the news comes on, showing the occasional U.S. government
official looking like a windup doll: cotton-white hair and seashell-pink
skin.

"So how was your first day in the hands of the Chinese medical establishment?" I ask.

"Astonishingly good," Larry says, firing a shot of eyedrops into each eye. "They put me on a handful of traditional Chinese medicines derived from the root of the rhubarb plant, which has been used for thousands of years because of its ability to suppress inflammation."

"Since when did you go to medical school?" I ask, impressed.

"Sorry," he says. "I've had a crash course the last couple years. I'll put it in layman's terms. Apparently, because of poor economic conditions these past decades, China had limited ability to do transplants or even dialysis until relatively recently. In its place, herbal therapies were used to treat patients like me with renal failure, with the common ingredient being the rhubarb root, given either orally, by injection, or by enema. To the latter, I say thanks but no thanks."

It's nice to see glimpses of the old Larry on top of his game. But I thought he wanted to stick with straight pharmaceuticals?

"I'm arcing," he says with a shrug. "What can I tell you? You take the boy out of his condo and things change. At least I haven't developed a hankering for bear bile, which is used by ninety-five percent of Chinese hospitals. But I can tell you that all the nurses on this floor know my medical history backwards and forwards. Plus, not once this whole afternoon has anyone missed my vein. All in all, I feel in much more capable hands than I do at home. If you were to ask my verdict after one day, I'd say American medicine has a lot to learn from these people."

He takes time out from his little speech to sip his Fanta through a miniature straw. "By the way, not to complain, but next time could you pick me up some Raisinets, please? It's how I get my fiber."

"Wow," I say. I sit back and look at him in wonderment. Go the soft speakers, *Twinkle, twinkle, little star* . . .

"Oh, say, and if you pass some Barbasol, can you pick me up a little—unscented, for extra-sensitive skin?"

"Sure, but you're sort of on vacation here, Larry. You don't need to be so scrupulous about shaving every day."

"It's one of my cardinal rules—to project a professional image, no matter where I am," he says. "One last thing and we're done: You're getting your camera back tomorrow."

"My camera? Did I lose it? Ow my God, did I leave it in the cab?"

"Relax," Larry says, lifting one cheek to release a purring noise from his posterior and flicking back the Mao movie all in one move, a pretty athletic maneuver, given the variables. "While you were out, Cherry said he called the hospital to say he found it behind the backseat."

"Who did? The kidnap cabbie?"

"If that's what you insist on calling him. I'm not convinced that's what he was. On reflection, he may have been sharing the route with his friends in that other cab, but they decided against it when we made a fuss. Maybe that's what all the 'friend' talk was about. What do we know?"

"But he has my camera?" I ask. "It must have fallen out when I was stashing my passport."

"Said he's sorry, but he can't drop it off till tomorrow. Has to go back to Beijing to get another round of passengers. So much for him being a kidnapper."

He's right: I was foolish to think we were being kidnapped. But here's the thing: I give myself full permission to play the fool when I travel. The way I see it, if you can't be willing to do that, why venture out of bed? Besides, I want to seize this clearheaded mood of Larry's to ascertain some basics about his condition.

"So just to fill me in on some fundamentals," I say, "do you have one working kidney or none?"

"None."

"And when they get you a transplant, presumably you'll be all right with only one?"

He's plainly bored by my questions, making no effort to suppress a yawn. "As long as I avoid tackle football," he says, lifting the other cheek.

"Do they take out the old ones or what?"

The blankness of his Mona Lisa smile makes it clear he'd like to

watch TV in peace. "They don't bother. They just push everything aside and plug in the new one."

"There's room?"

"If not, they'll take out the gallbladder or something."

"Is nothing nonnegotiable in this world of ours?"

Larry does little to help me expand the discourse or make me feel at home in his strange, pastry-smelling proximity. Instead he anticipates my next question to cut me off at the pass.

"Relatively simple operation, easier than for the donor, apparently. So long as they don't drop it in with chopsticks, I have no complaints."

From the hallway outside the room comes the squeak of nurses' shoes skittering by, the scuff of patients' slippers shuffling sadly behind their silent IV cranes. At street level a truck passes by sounding like a helicopter, its engine so defective we can make out its *whop-whop-whop* through our single pane picture window nine stories up. On TV they're advertising a beauty cream you rub on top of your breasts to enlarge your bosom. Flat-chested women wearing expressions of scowling depriva-tion have no luck flagging down taxis, while a full-figured gal wearing an expression of satisfied happiness has great luck. What's her secret? We see her in the privacy of her boudoir, where she's applying beauty cream to the top of her chest. The beauty cream draws fat cells, represented as fizzy bubbles, up up up from the abdomen, where they do no good, to settle in the pleasing bosom area. And that's all there is to it. A twofer: The fat cells leave an area where they're not wanted and congregate in an area where they *are* wanted. Why didn't Larry think of that? Now the formerly flat-chested women are able to snag all the taxis they could ever need!

"Anything else I can get you tonight?" I ask. "Shall I see if I can hunt down some Halloween candy, Alka-Seltzer, anything?"

"It's getting late," Larry says, peering at each wrist in turn, where his watches were before he misplaced them again. "Hadn't you better find yourself a hotel room or something?"

———

Kind of embarrassing, to be invited out of the hospital room by the pa-
tient. It reminds me of the time my mother in the nursing home said she
was seeing too much of me. But anyway, I'm a free man in China, free
to hump my suitcase down eight flights of stairs to the lobby, empty as
always except for a couple of stern Middle Eastern–looking men idling
through, carrying badminton rackets. Outside, the sidewalk culture is
booming in all its low-tech multiplicity. Residents unfold their sling
chairs to watch TV, play cards, weld auto parts, scissor noodles, get a
trim around the ears, practice calligraphy with fat water-filled brushes
on the asphalt, or enjoy what appears to be the exquisite bliss of ventilat-
ing their socks. The air is by turns delicious and putrid.

When I get to the lodging Cherry has recommended, I find it a very
proper hotel in a sylvan glade. Quiet, safe, and utterly unacceptable. I
want noise, strife, peril! Now that my expense account has expired, I also
want one with little Styrofoam cups for coffee instead of exquisite china
with lids. I want fake wood laminate and cheap broadloom to cover a
multitude of sins. I want to feel I've come down in the world, meeting
life on its terms, on the road! Of all the hotels I pass, my first choice is a
clean Chinese chain hotel on a busy intersection smack-dab on the main
drag, except it's just beginning to be built and looks like it won't be ready
for six months. But wait, there's a light on in the lobby. . . .

"I'd like a window facing the street," I tell the front desk.

They just dug the foundation a week ago, and already the second floor's
ready to rent while they work on the rest night and day. With its immacu-
late glass-and-tile lobby, it's less a Mini-Mushroom than a Sino-ized Su-
per 8; I immediately dub it the Super 2, because it's about one-quarter as
fancy. It's also old-school enough that I receive a carbon-paper receipt for
my deposit and a quizzical look when I ask about gym facilities. Perfect.
The stern receptionist with an incongruous jabot indicates that I'm the
first Westerner to stay there, then asks if I'd like to buy a flashlight in case
of power outage. She's having a special on matching chrome sets: two for
about a buck. What do I look like—someone who can't pass up a sale?

"Hello, room," I say, making friends as I enter. It's always been my
habit to speak immediately to my hotel rooms, knowing from long expe-

rience that the first impression a room gets of you is the most important. "I'll be your new roommate. If any state spies want to nab me for illegal transplants, I'd appreciate it if you'd trip them up long enough for me to make my getaway...."

It's hot yet drafty. I remove everything from my pockets and drape my shorts over the chair, checking the coins out of habit from when I had a penny collection as a kid—you never know when a 1909 VDB-S Lincoln might turn up. Opening the window wide, I get a full blast of the Chinese night music: car engines like tractor motors, the screech of bicycle brakes like just-run-over puppies, the deep plaintive call of street vendors like mating bullfrogs ("*Brown cowwwww-uh? Brown cowwwww-uh?*"), the up-close stuttering of pneumatic hammers in the hotel. All the commotion is a comfort somehow. Maybe because it's nice to visit a culture that's growing and isn't so obviously hurtling down the tubes. Although it's not really fair that some cabbies use siren-type air horns.

I park my laptop in front of the window and hook in. Immediately after the cascade of Microsoft tones, a riff that doesn't seem at all discordant with the Chinese street melodies, I send Cherry an e-mail telling her where I've landed. "Ping!" comes her response at once, telling me that the kidnap cabbie will meet me in the lobby with my camera at 9:00 A.M. sharp. I'm uneasy—a feeling exacerbated by the money-saving, low-wattage bulbs throughout the room. Then "Ping!"—I have a new e-mail ... from Jade.

> HI 84~~~ Is everything ok? i am miss larry and you.. i am really concern about the health of larry. will you stay in Shi long enough for me see you? my father can lend me his railway pass.. Mahybe i am free the next Wenday afternoon. today i am very sad because of missing ~ by the way tell me the name of that girl who take us to KFC. Cherry? I forgot.ok.see you next week. ~~~24

I'm hot yet cold. Fatigued yet jumpy. Hopeful for Larry's future yet fearful. Happy for the letter from Jade yet apprehensive about meeting

the kidnap cabbie in the morning. To soothe my rattled nerves, I turn on the bed lamp to read myself to sleep, but it's no brighter than a refrigerator bulb, and I soon give up.

"Damn dim bulb!" I say aloud, turning out the light. I'm sounding more Chinese every day.

CHAPTER 11

Return of the Kidnap Cabbie

Do not remove a fly from your friend's head with a hatchet.

One thing you can say about kidnap cabbies: They tend to be punctual. The stroke of nine next morning finds two individuals tentatively approaching each other in the lobby of the Super 2: an American wearing a meek expression signifying, "Are you the one who almost took away my freedom to see my little boys for the rest of their childhood?" and a Chinese wearing a meek expression signifying, "Are you the one who was mewling in the backseat for no apparent reason?"

I remember the cute dimples. "Friend," he keeps saying. Okay, he doesn't have to rub it in. I get it: His friends in the other cab were supposed to drive us to Shi while he went back to BJ to pick up more passengers. I'm a fool—but at least a fool with his throat uncut. We shake hands exuberantly. I also shake hands with the smiling, dimply woman at his side, who seems to be his wife. What, did they get a family rate on dimples? I can tell by the interesting sounds he makes through puckered lips (*"Oleo merger, catch a kitchen can"*) that he's pleased by the chrome flashlights I give him. He can tell by my no doubt equally intriguing sounds that I'm pleased not to be sitting on the floor of a closet with my hands tied behind my back with plastic twine. We go outside, and his wife snaps a picture of us in front of his little cab. She tells me how much

she likes the picture (*"Knee-bash, knee-bash! Sammy's dagger so delayed!"*) before handing it to me: The strain shows like gnarled rope on my face. Is it significant that his eyes are closed? I find myself wanting to speak the toast that is on the tip of my tongue. Long live the friendship between the Chinese and American peoples! But it won't come: *"Wong we..."* We shake hands again all around, and then before toodling off, he remembers to give me one more item he found in the backseat: the distinguished mahogany fountain pen I lifted from my luxury hotel in Beijing.

Oops...

What sort of mood will Larry be in this morning? Truculent? Tearful? Or merely mistrustful? I brace myself for the worst, only to enter his room and discover that he's radiant! Why wouldn't he be? He's watching TV while up to his elbows in a bucket of hot wings.

"Catered by KFC!" he trills. "Apparently they deliver for orders over five bucks. Want some?" he asks, offering me a plastic take-out cup that's more gravy than mashed potatoes. "It's a little herbier than at home, and the Coke tastes a little cough-syrupy, but at least I'm eating," he says.

"You're not dying to give the local dishes a try?" I tease.

"Dan, back in Beijing I asked Mary to translate the room-service menu, and you know what one of the dishes was called? 'Dog Won't Eat It.' Okay? Even the Chinese call it that. Case closed."

A questionable lullaby warbles from the softspeakers: *You're a grand old flag, you're a high-flying flag.* The A/C is off, and the temperature is to his liking: semi-sweltering. The room's loamy with the scent of Larry.

"Uh-oh, here we go again," he says, pushing himself to a more upright sitting position as a gaggle of eight nurses comes giggling in and surrounds Larry in his bed, posing for pictures. "They're taking turns by floor," Larry says, his arms around them. "This is the sixth floor, by my count. They've been doing it all morning. Apparently I'm some kind of celebrity in here. It's a fantasy beyond belief."

One for the family album: Larry in his hospital gown and shades, sitting atop the blankets like an underworld kingpin, hugging the prettiest

nurses west of Shanghai. When at last they leave, the reenergized patient turns onto his side and begins pontificating again, a real blue-streak special. Unfortunately, I haven't mentally cranked up for the onslaught this morning and don't tune in, but a stray story line filters through, each worth a Movie of the Week: something about a pusher named Midget who used to be chased all over the globe by a ruthless bounty hunter, but now Midget's son is in trouble with the law and Midget's hired his old enemy to find his son so together they can help him; something about fixing up ex-Senator Barry Goldwater with a runway model from Milan, and too bad Goldwater kicked the bucket, because he owed Larry big time; at the end of which he says, "Good morning, Dan. As you can see, good food always makes me feel better. I'm feeling so good I even like this new gown with tiny blue sailboats. Makes me feel like a little boy."

"Good morning," I reply, even though now I mostly want to go back to the Super 2 and sleep.

Cherry enters the room for a brief check-in. "Patient good today," she says. "Better than so-so."

I smile sympathetically, because I can only imagine what she's been through with him while I was gone, but I have to keep bugging her: "In terms of our anonymity," I ask, "is it okay that Larry's becoming such a mascot in here?"

"Is okay," she assures me.

"But what about leaks to the authorities? If so many people in the hospital are in on the secret, isn't there a bigger chance someone will tip off the local police?"

"Is not like that."

"What *is* it like? That's what I'm trying to figure out."

"In China we have an old sentence, 'Take the dead horse to the live horse.' This is what we try to do with Larry."

"I have no idea what that even—"

"You the one need a clam pill, not Larry," she admonishes with a smile. "Everything clicking like clockwork. Larry a fighter!" she says. "He will punch butt all over town."

Momentarily alone with Larry, I settle sleepily into the plastic couch in front of the overloud Al Jazeera. "So they make a convert of you yet?" I say, watching an avuncular news anchor narrating a documentary on the American invasion of Iraq to the film sound track of *Apocalypse Now.*

"Actually, despite my being a capitalist fundamentalist, I have to admit they're more balanced than some stations I could name," he says. "If I didn't know they were commie, I'd think it was Walter Cronkite talking."

He's having his pre-dialysis blood pressure read again by the ungainly resident from the other night who looks like she was picked on in high school. Larry's flirting with her, making the requisite joke about how if there's a spike in the reading, it's her fault. She can't understand a word but giggles anyway.

"I swear I'm getting the VIP treatment," he tells me. "Back in the States, it's always 'Buy me, buy me.' Here it's 'Let *us* help *you.*' Whole different mind-set. I tried to give the janitor a tip, and he wouldn't hear of it. Watch this, bet this resident won't take a tip either. . . ."

I redirect. "What accounts for your VIP treatment, do you suppose?" I ask.

"Could have something to do with meeting Dr. X last night."

"You met Dr. X?" I say, jumping to my feet. "I thought he was gone till the end of the week!?"

"Oh, didn't I tell you? He came in at ten P.M., after you left. Dressed very sharp. I'd say basically American style with an Asian twist. Power tie. Power cuff links. He said I have a lot of influential friends in China. That's apparently what's motivating him. Not money so much as doing right by our impressive contacts."

"Antonia!" I breathe. She actually called in a favor for someone she met only once? I'm humbled.

"She must have some kind of muscle, because he said he got a great number of calls and e-mails from people in very high places. And already this morning I was bustled through a battery of tests, no waiting, just wheeled right through."

"Larry, this is great news!"

His burp sounds like a question mark. "You think so? I do, too," he says, mopping up the last of some egg yolk with a porous tablet of KFC sausage. "He said he wanted to make me aware of how complicated the situation is, what a ton of red tape he has to jump through to get an exception to the new laws. The gist is, he's still able to get a few kidneys, not like a year ago when he personally did a hundred and fifty kidneys, but a few. Long story short: Said he doesn't want to boast, but he's the right person to pull this off, if anyone can."

"Larry, this is fantastic."

The resident removes an IV and instructs him to raise the arm.

"See what a good clotter I am?" he boasts, as no red appears. "Always been an excellent clotter."

"So was all this conversation with Dr. X through an interpreter, or does he speak—"

"Speaks impeccable."

"Larry, this is better than I dared hope."

"I think so, too. He said in America you have to wait for a kidney that's been sitting in a jar two weeks. Here I get one fresh out of the donor, pop it in with five minutes' notice. So I'm sitting right here, docile as a lamb."

"Right," I say.

As the resident prepares to leave, Larry tells her, "All right, sweetheart, stay out of trouble," and gives her a buffalo nickel, which she seems to prize. I suddenly realize who she reminds me of—just as suddenly shove the image of Larry's dead twin, Judy, out of my mind.

"Any mention of the surgery's price?" I ask.

"That we didn't discuss," Larry says. "Nor when it might happen. I didn't want to push the envelope. I figure this first meeting let's keep everything friendly, I can always put the hammer to him later."

"Let's let it be, then. Don't breathe another word about it."

"As you wish, Mr. Bond. I defer to your judgment."

"And don't mention that you've never actually met Antonia."

"Roger that. But to expand upon your original question, his English is sometimes good and sometimes not. He's spent significant time in Great Britain. He has a daughter who's in college in Miami, but when I asked him which college, he didn't seem to understand."

"But Miami's gold, right? You'll be able to repay him with Miami."

"Of course. That's where I have the most connections. I'll take her to the Rusty Pelican—my accountant knows the owner—I'll give her the name of my lawyer who's on the traffic commission in case she has any parking tickets. I mean, of all the places for his pride and joy to be, she's in my city. He seemed to understand I can take care of her. It's all about relationships. . . ."

"Larry, I think we made the right decision not going to the Philippines."

"I know, plus they just blew up a shopping mall there this morning. I saw it on Al Jazeera."

"Not only that, they're illegalizing kidney transplants for foreigners, just like here, but punishable by twenty years in jail and a forty-eight-thousand-dollar fine."

"I love how you don't plan things, Dan."

"You, too, Larry."

WHY I'M MORE AND MORE FOND OF CHINA

After we go our separate ways—Larry to dialysis and me to some city errands—I wade through various crowds, leaving behind people deconstructing my passage. Even if it's a gang of teenage punks trying to act disaffected, all is hubbub behind me as they diligently process my greeting: "Hello, how you."

If it's a gang of college girls, they're polite, but afterward they cover their mouths and giggle, thinking they're out of earshot just because our backs are turned.

When I pass a little park, I see a young tree propping up an

older tree, and I understand that it was planted specifically to do that, and:

That reminds me of Larry's story about his father, Sam, working for his older brother, Irving, and how it was traditional in old Russian-Jewish families for the younger brother to serve and prop up the elder, and:

This makes me feel that the world is connected in all sorts of ways I can't even fathom.

Every now and then, I can hear the sound of old China, a tinkling of old-fashioned bicycle bells, reminding me that on my last visit I brought bells back for the children next door, and for a couple of years I had the sound of China in my neighborhood at home, and:

This makes me doubly homesick, in a lovely way, for a China that no longer exists and for the neighborhood children who are now grown up.

I feel I can't get lost. No matter how far I wander, I always have the landmark of the eleven-story hospital, with its two arms outstretched and a water tank like a nurse's cap on top. And when that's obscured by smog, I can't get lost anyway. What a rush, to feel unlosable!

Fireworks are likely to occur anytime, because someone's always celebrating something. Could be a wedding or just a job promotion, but they ignite out of nowhere with a sound like two tons of pebbles cascading out the back of a dump truck.

When all is said and done, people here seem happy. At least that's the conclusion I come to after hearing so many of them, including policemen, humming quiet tunes to themselves on the street. Can we say the same about Queens?

When I return, it's dusk. Back in the hospital, I confront the usual emptiness in the lobby, punctuated by far-off badminton sounds. But the Giant Mushroom has aged forty years in the hours I was gone. New blotches and stains. Those hairline cracks in the crown moldings weren't there before,

were they? That gummy decay around the doorframes? And Larry looks Minged up—smudged and tattered, caved in on himself. I'm horrified to watch him in his sleep, like an emperor from the 1500s in a state of active decomposition. No wonder he's doing everything in his power to get off dialysis—in the hours since I've seen him, they've taken out all his blood, scrubbed it clean, and put it back. The procedure leaves him ruined.

Tiptoeing in his half-darkened room, I silently lay out my care package: Sponges. Napkins. Dishwashing soap. Silverware. But the silverware clinks.

"Sam?" Larry mumbles.

"It's me, Larry. Go back to sleep," I say, unbagging hand soap, straws, shampoo.

"Who?"

"Me, Dan, your cousin."

"Oh, hi, Dan. I'm sorry. I didn't. Where am I?"

"You're in the hospital, in China."

"I'm sorry. China?"

"Yes, don't you remember?" I say, opening the bathroom cabinet and laying in toothpaste. "We came to China, and we found a hospital to get you a new kidney."

He takes this in.

"What time is it?"

"Eight."

"A.M. or P.M.?"

"P.M."

"Oh. For a minute there, I thought I had to call Judy and tell her where I was. I'm very."

"You're in a safe place, Larry."

"I'm a little. Can you tell me something? Judy. Is she alive or dead?"

"I'm sorry, Larry. Judy died a couple of years ago."

"Okay, that's what I. I just."

"I know, it's very misorienting. You've had dialysis this afternoon."

"And my mutha? No, wait. She's gone, too?"

"Yes. I'm sorry."

"It's the dialysis. When I wake up, sometimes I don't remember, and then I have to mourn for them all over again."

"That must be horrible."

"The one person I never wonder about is my futha, because he was dead to me so long ago. Oh, I'm doozy."

"Don't try to sit up, Larry," I say, straightening his pillow so he can lie back down.

"Dialysis always leaves me weak, but this one was a whopper. I think the dialysis here must be more aggressive than at home."

"That's entirely possible, Larry."

"I was dreaming about my futha. As you know, I had a very faulty bonding with Sam. He resented everything I could do that he couldn't. When we were in South Miami once, he laughed because I couldn't read the signs all in Spanish. 'Now you know what I go through,' he said."

"But you had a dream about him?"

He doesn't answer for a minute, lies there sweating in the half dark. *Out came the sun and dried up all the rain,* comes the tune from the invisible softspeakers.

"We were fishing, I think. Because one thing we bofe loved to do was fish."

He coughs sadly for a minute, without sentimentality.

"No, he was dropping me off at school. Second grade. In second grade I just wanted to go home. I just cried and cried to go home. I was worse than Judy."

He breathes, head sunken on his chest.

"Did you know I had to repeat fourth grade?" he asks. "This for a kid with an IQ of one thirty-one."

"Because you were too busy rebelling from your teachers?"

"I know where you're coming from with that question, but no. It was because I was so shy. I was so short on self-confidence that when the teachers called on me, I'd always say I didn't know, just because I wanted them to get to the next person as quickly as they could."

"I didn't know that, Larry. You were always filled with such bravado."

"At sixteen I dropped out of school, but I didn't get a job at Irving's

garage, like everyone told me to. I made it my business to enroll myself in a private school that I researched myself. Within a day I knew I had made the right choice."

"How'd you pay for it?"

"With my winnings from KFC."

I want to say, "No wonder you're so devoted to them," but I restrain myself. Instead I say, "Larry, that was nothing less than heroic. You altered your circumstances. What's that old expression? You picked yourself up by your bootstraps."

"I did."

"You could have withdrawn from the world. But you found something in yourself to hoist yourself up. It's like how you cured Judy's epilepsy. These are heroic actions, Larry. Why do you never give yourself credit for them?"

"That's a good question. I'm confused about that."

"Why do you think?"

"I'm too busy giving myself kudos for the things I oughtn't, and not for the things I ought?"

So help me, I love the quaint language coming out of this miscreant's mouth. The truth is, and he doesn't want this to get around, but he isn't a miscreant at all. He's a gentleman, checkered like all gentlemen, with a gentleman's checkered heart.

"I'm hard on myself," he says. "I don't want to be selfish."

"It's not being selfish to give yourself credit, Larry. There ought to be a better word. It's being self-generous."

I can feel him struggling with this concept in the tropical dark.

"So when are you going to claim your right to take the coldest Coke in the cooler?" I ask.

"I don't know. I got my pilot's license just to see if I could do it, and even then I still had my self-doubts. I do this, I do that—"

"May I make a suggestion?"

"As you wish."

"Yoo-hoo, you're doing another heroic thing, by finding your way to this hospital room. Maybe that ought to do it."

"What do you mean?"

"I mean, the American medical establishment in its wisdom counseled you to be a good little Do Bee for ten years and make no fuss—"

"That's the U.S. policy for how to help its citizens—"

"And instead, you took charge of your destiny and joined the army of half a million Americans last year who got off their asses and are doing something! Whether you succeed in saving your own life or not, that ought to convince you of your self-worth."

Down came the rain and washed the spider out. . . .

"Think about it, will you, Larry?"

"I do, Dan. I always think about what you say."

From nine floors below, a fleet of police cars sounds like an armada of rowboats with outboard motors. The fridge makes a ghastly noise as it shudders to a stop. Larry flinches.

"Did I ever tell you about the time I saw the apparition?" he asks out of nowhere.

"What operation?"

"Not operation: *apparition*. Remind me to tell you that saga sometime."

"We've got time now."

He points to his ear and shakes his head no.

"No one's gonna overhear. Or understand."

Still he shakes his head no. "I lived through the Nixon years. I make a policy of not trusting."

I close the door. And lock it. Now he's ready.

"Dan, you know me well enough to know I'm not exactly touchy-feely. But when I was ten one summer day, I was helping my neighbor Frankie DelSesto on his newspaper route. Nice kid, grew up to tour with Aerosmith, in charge of selling their souvenirs. Any case, we were just turning back from the beach when I saw a ten-foot-tall Jesus Christ on a rooftop. He had an intricately carved staff, a full beard, and a long deep brown luxurious robe. Instantly I knew it was Jesus. I have no idea how I knew it was Jesus and not Moses, given my heritage, but there wasn't even a question. It was Jesus. He knew my name though he didn't speak;

it was thought transference. What I got was a wonderful feeling of abso-
lute peace—nonverbal absolute peace. 'What's the message?' I wanted to
know. 'Everything's A-OK,' he said, without words. It wasn't a question
of him trying to convert me or anything, he just wanted to reassure me.
There was an awareness of me and what I needed. I loved it at first, but
the next day, when I tried to make sense of it, I didn't like it one bit. I
was a reality-based kid. It was too scary. I never spoke about it for years.
Finally I asked a psychology major, did that make me insane? He said,
'No, you are not insane.' I thought that was a pretty strong statement."

"Jesus said, 'Everything's going to be A-OK'?" I ask.

"No. 'Everything's A-OK.' Like it's A-OK right now and always will
be. Eternally."

"For the record," I say, "I don't think you're insane either. So where
do you want to go with this?"

"It's just to say," Larry says, struggling, "sometimes I have feelings.
Premonitions, call it what you will. And I have a very bad feeling about
this surgery."

"Larry, you need to rest. Post-dialysis is no time to make sweeping
statements."

"No, Dan, I'm in my right mind. I know it's bad luck or whatever to
speak ill of it, but I think something bad is going to happen. I am *not* go-
ing to be all right. Even if a kidney comes through and they put it in, the
surgeon's going to botch something and I'm not going to make it."

"Larry—"

"I'm just informing you, Dan. Please take it seriously. Contrary to
what Jesus, or whoever he was, was telling me when I was ten, I do *not*
have the feeling that everything is A-OK. Never has been and certainly
isn't now."

I don't know what to say. I feel like my brain has been scrambled by
dialysis, too. But it's vital to keep up an optimistic façade in front of him.
Two nurses walk past in the hallway, conversing. *"Quizzical gums he has!
Major social craze!"*

"Ow, the light hurts my eyes," he tells me. Even with everything
turned off in the room, too much light seeps in through the gauze cur-

tains from the floodlights outside for his sensitive, post-dialysis eyes. I help him put on his box-turtle shades, glad to be distracted from thoughts of his demise. But still the floodlights bother him. I remove the sheets from the spare twin bed and rig two squishy chairs by balancing one on top of the other and—another thing I never thought I'd be doing for my cousin—climb up to tie a series of knots in the sheets around the curtain rod. Being on my tiptoes on such an unstable surface against a thin picture window nine floors above the ground serves to keep me from dwelling on his premonition.

"Better?" I ask, panting, when I come back down.

"Thank you, Dan."

"Does that closet light bother you as well?" I ask, because one of the Freakishly Thin Business Socks lovingly laundered by Mary is keeping the closet door ajar a crack.

"I use it so I don't get nervous in the dark."

"But isn't it too bright? The light slants right into your eyes. I can turn on the bulb in the other room instead, if you like, and let the light peep under the door."

"I don't want to trouble you."

I show him how little trouble it is.

"That's good," he says.

"You should be snug as a bug in a rug," I say, tucking him in.

"Why are you doing this, Dan?"

"It's going to be too bright otherwise."

"No, I mean . . . all this."

I look over this relic of a man, trying to grasp that he's the same person as the chunky little boy who used to run up the down escalators. How much of that boy is left to save? The nurses pass by again, on their way back to their station. *"Sheer drizzle spice, steak on top!"*

"Y'know, I don't know why, exactly, but I'll tell you something," I say. "Every now and then, I get your mother's face in the back of my mind, saying, 'Thank you, Danny. Thank you for taking care of my little boy.'"

"That's nice," Larry says.

"But as for the other reasons, can I get back to you? Honestly, I'm still working on it."

WHY I'M MORE AND MORE FREAKED BY CHINA

Now that I've left Larry's room, I can admit that his premonition rattled me. He's right about so many things. Will he be right about the surgery, too?

The lights are out in the stairwell, and as I blindly feel my way down eight pitch-black flights of stairs, I wonder if Larry's not the only one with brain damage.

When I reach the street, the city's inflamed in a firestorm of neon. Swirling dragons. Flaming serpents. It looks as if a demon magician has touched it with an evil wand.

The darkness here's more diabolical than the darkness at home. As I walk alone down a spooky alleyway, bike riders fly out of the murk like bats on wheels, squealing *"Go back to quack-a-doe!"*

The air, when all is said and done, is no laughing matter. It's totalitarian pollution, a one-party blanket of smog so supersaturated that it can't absorb the smoke from the sidewalk barbecues, much less the blue plumes from firecrackers that erupt out of nowhere, veiling all.

I'm lost. Even though the arms of the hospital are more or less visible through the haze, tonight they spread like the wings of a malevolent owl, leading me nowhere I want to follow.

I'm wet, or about to be. In a spot not far from the hospital, a promenade functions as a nighttime amusement area for adults, between fake volcanic rocks and a patio for old-timers to do their tai chi. But as I'm venturing closer, a fountain of colored water erupts from the rocks, drenching me head to toe.

Wet and lost as I am, I understand that these old-timers were my first enemies. Delicately doing tai chi between the fountains,

these are the infamous Red Chinese of my childhood, the ones we were told were sadistically brainwashing American POWs in secret North Korean camps. And here I've put myself at their mercy, surrounded by them on all sides. . . .

The next group is even worse. After so many days of not seeing people my age, I run into a whole brigade of them on a terrace by the promenade, and it hits me that they're the original Red Guards who committed some of the worst atrocities of the twentieth century. While we student activists were making hay at home with a pretend revolution, our counterparts in China were making real hay, forcing millions out of the cities to reap grain in the countryside, butchering intellectuals and raping ballerinas and turning themselves into the human equivalent of swirling dragons and flaming serpents.

And what're they doing on this sweltering September night? Waltzing. After all the carnage they wrought, they're waltzing to old songs from the 1930s playing on an ancient gramophone. "When I Grow Too Old to Dream." "The Touch of Your Hand." "Falling in Love with Love." Lit up in the smoglight, their eyes red in the glow of firecrackers, they turn gracefully clockwise, changing steps to turn counterclockwise. How can they be dancing, after all they've done, like Nazis doing a jig on the graves of their victims? But they're sad-looking, and their waltz is sad. Wreathed in smoke, they sense that I'm of their generation. They beckon to me: "Join us!"

Never have I felt more a stranger. I withdraw into the shadows.

CHAPTER 12

Shabbos Duck

When the map is unrolled, the dagger is revealed.

Next morning there's a dead body on the sidewalk. Outside a bakery where I've gone to grab breakfast, the baker lies faceup on the asphalt, still wearing his white chef's hat. He's a big, florid man; it's inscrutable that he used to have energy enough to keep his bulk upright—and that suddenly he doesn't. Two women stand above him, waving their arms and making their pocketbooks swing. A police officer also stands over the chef, his car parked casually in the middle of the street. The tableau would have been unthinkable only a moment ago; now it's as banal as dirt.

Then we onlookers, being not dead, go about our business, as the Vermont poet said. Life goes on: The take-out window ten feet away doesn't even suspend its business, cash bills handed in, steamed buns handed out. I order a half dozen little pastries with almonds stuck in sweet white goo. A treat: If this is a bad omen of some sort, all the more reason to make sure I keep my spirits up. . . .

Returning to the Super 2, I arrange to keep getting Internet in my room. The unfriendly receptionist in her flounce is never happy to see me, nor

is the Internet an easy concept to express to her in party language, but eventually we work it out.

"So it's all set for me keep accessing from my room?"

"Okay-okay," she answers with a forced smile.

"I steal Tsingtao shot glass with lukewarm coffee from lobby, okay?"

"Okay-okay."

"I go upstairs cry my heart out, okay?"

"Okay-okay."

Sometimes the only way to make sense of your surroundings is to reach out to a far-off source. So now in my little Super 2 roomette, with paint droplets from the construction floating down and hardening on the outsides of my windows, I spend the day deep-Googling. I learn that Shi is an industrial city with little charm, known predominantly for two things: exceptional hospitals and a plethora of massage parlors. The first fact I've gathered by now, but the massage parlors are like nothing I've ever seen. Some of the Web sites offer virtual tours of their palatial interiors: fantasy temples with saltwater grottoes, saunas decorated with ceramic parrots and ceramic eagles, complete with discreetly bowing hostesses giving the revolving doors a little spin to help you through. . . .

Larry's right. Massage Central is where I've landed us.

And other facts. (It's laughably easy to get information, despite there being an estimated thirty thousand Keystone Kops devoted to blocking Web sites seemingly at random.) Those fountains of last night that I found so alien, they were nothing worse than replicas of Old Faithful in honor of the U.S. of A., going off every quarter hour with a big blast at midnight. Also, sixteen of the world's twenty most polluted cities are Chinese, and Shi is among the top performers.

Yet for all its flaws, there's something about this land that makes people want to waltz. As I munch on cold shrimp and celery cubes left over from breakfast, I recall one of the only times I've ever waltzed in my life, twenty-five years ago, when I was taking an overnight steam train through Shandong province, and at a rural station the woman I was traveling with started waltzing me beside the track. The fields around us were filled with peasants sleeping in the open air, with a small fire at

the entrance to each family's field of crops, but dozens of them roused themselves to stand and watch the strange sight of us dancing under the moonlight. Does something similar motivate the Red Guards to waltz? The haunting vision of last night is still fresh in my mind, those revolutionaries waltzing to old American favorites from a time before they were born. . . .

By late afternoon, when I get to the hospital, I'm determined to figure out where the badminton noise is coming from. Before even checking in on Larry, I walk down the halls past the Family Crush Room, turn left at Sufferers Locker Room, and enter a wing I haven't been to before. The badminton sounds grow louder, and soon I find an empty corridor where two ferocious Arabs in long robes are lunging for a birdie. I'm impressed: all that fierce heft in service of a corrugated plastic birdie. They're really throwing themselves into it, their grandstanding cutthroat but silent, so hushed that the only sound is their bare feet making quick grippy noises on the glittering marble floor.

I whistle in admiration after a particularly savage smash shot hits one of the guy's kaffiyehs. The ice is broken.

"You belong to America?" the smasher asks.

I admit it. Even though I know it's stupid to do so when in dicey territory, I'm never able to pretend I'm Canadian. "I do belong to America. You?"

"Saudi Arabia," says the smasher.

"Yemen," says the smashee.

Our conversation draws visitors from a communal kitchenette off the hallway. Five men slip out to join us, reticent and stern. One of them, a lanky young fellow in Western clothes, sips judiciously from an Oodles of Noodles steaming from the microwave. "You here for a liver?" he asks me.

"Kidney," I say. "For my cousin."

"Me also," he says, giving me a fist bump. "Kidney ny father."

"Liver for my brother," says the Yemenite smashee. "Lung for his uncle," he adds, since the Saudi smasher is too intent on his serve to speak for himself.

It really is a medical mecca for Middle Easterners. I'm introduced to an Egyptian with lovable brown eyes who owns a chain of stalls in a Cairo marketplace. He's here while his nephew awaits a heart transplant. A Moroccan wearing an iPod that is more advanced than anything I've seen in America awaits a pancreas for his uncle. The lanky fellow is named Abu, and he's the scion of a sporting-goods empire in Pakistan, responsible for all the badminton paraphernalia. There's no royalty in residence, apparently, but these gentlemen are commercial royalty—rich and well connected enough to have found their way here, all speaking better English than the Chinese do. They tell me that instead of putting themselves in hotels, they've purchased nearby apartments to live in while they wait for the transplants to take place. I try to keep it straight. Egypt/heart/nephew, Yemen/liver/brother, Morocco/pancreas/uncle. All males, naturally. Do the women in these lands not require transplants, or simply not merit the expense? The only women are the wives and mothers in shawls and trinkets who shuffle soundlessly about, obsequious as servants. Except for being the recipients of an occasional tongue-lashing, they're not spoken to, thanked, or otherwise acknowledged.

And no Westerners, of course.

"We are friends?" I venture.

"Oh, yes, no problem." Big pat on the back from Abu, who all but says, "We are family of patients together!" But he doesn't need to say it. We're in neutral territory facing the ultimate common adversary. The usual rules are suspended. We even find it possible to chitchat about the state of the world—stuff that's easy to agree on. For ten or fifteen minutes, we swap geopolitical truisms, and then it's time to ask the question that's preying on my mind.

"So how long you been waiting?" I ask.

"Two for me. Two also for him."

"Two weeks? That's not so bad," I say, doing some rough calculations. At this rate I'll be able to see my family again before the weather turns colder.

"Not weeks, *months,*" says Abu.

"*Months?* You've been here two months already?"

"Two, maybe three months more," comes my reply.

Wait—maybe five months altogether? I run some more numbers in my head. That would bring us to Christmas. Be without my family all autumn? Not see Spencer starting drum lessons? Not see Jeremy rehearse his role of Tiny Tim?

Untenable. Gotta go.

"Pound it," Abu says, giving me another fist bump before I race off to the elevator bank. "Keep it real."

Maybe five months? At the rate he's going, I doubt that Larry will be alive in five months. I need to hunt down the truth behind these terrible numbers. Cherry's at the nurses' station down the hall from Larry's door, jumbo pocketbook in hand, conferring with the resident who looks like Judy. I pull her aside.

"Cherry, you and I need to talk hard balls," I say. "I've been speaking to some of the Middle Easterners—"

She cuts me off. "Every case different," she reminds me. "They have no Restriction, therefore less hazard, less hurry."

"Is it possible we might have to stay here four or five months?"

Giggling is the last thing I'd expect at this juncture, but giggling is what Cherry gives me, her hand in front of her mouth, modestly covering her teeth. "Oh, no," she says. "You special guests with many friends on Chinese soil. Big *guanxi,* not little *guanxi.* Don't have to wait so long."

"Then how long? Larry's weaker every day."

"So I think we give you the answer to this question other day."

"Really? I don't recollect getting an answer."

"That answer is we do not know."

"Oh, yeah, *that* answer I remember. But can I at least set up a meeting with Dr. X to discuss the time frame, and also the price, because Larry is not a rich man. . . ?"

"He on the fly, very difficult to catch. You may try his secretary on floor four."

"May I try her now?"

"She also difficult to catch: in, out, everywhere. Also, this afterhour."

"It's only ten to five."

"Yes, but this Chinese time. Maybe she gone already. In China if you want to be sure, better choice to see early morning, say six A.M."

Suddenly it hits me. Ow my God, is Cherry not to be trusted? Her evasiveness may or may not be legitimate, but is there something else going on? Is she keeping us in the dark on purpose, the better to keep tabs on us? Is that what the pocketbook's about—it contains secret files on us?

And just as suddenly she seems to sense that I'm onto her. Her face widens into an extra-sweet smile as she tosses her hair.

"Hey, tonight Friday, big hoedown party night, could be? You want take Larry to restaurant? Par-tay! Par-tay!"

I'm thrown. Perhaps I'm meant to be thrown.

"What do you mean, outside the hospital?"

"Good for patient morale," she says.

"But—"

"Larry say he like Peking duck," she says sweetly. "Very good restaurant for just such a treat around the corner."

"But . . . is he okay to go? I mean, how could we even get him down all the stairs from the ninth floor?"

She finds me amusing. I'm the one who called her from the backseat of the kidnap cabbie, after all. Oh, it pains me to recollect the message I left on her answering machine. I blush anew as she chuckles at me.

"Elevator not *still* broke, Daniel. Only one day broke. How you think your brother get to dialysis on sixth floor?"

My cousin, I want to say. But there's so much going on in my brain, trying to figure out whether I'm being paranoid again, that for once I hold my tongue.

I open the door to Larry's room, and there he is already dressed for dinner in heavy trousers, short-sleeved business shirt, and wool sport coat. So wait—Cherry suggested Peking duck to him *before* I grew suspi-

cious? Maybe she *didn't* make this offer to throw me off the scent? The truth, once again, is that I can't tell friend from foe. Perhaps she's no more a spy than our poor cabbie was a kidnapper? I'm on the other side of the planet, after all, where upside down is right side up. I don't know my ass from my elbow.

I turn to Larry, about to say, *You're not going to be too warm in that outfit?*—but for the second time in as many minutes I keep it to myself. Larry has his own truth, as Cherry has hers, maybe even as the Red Guards have theirs. Doesn't mean I have to be happy about it, though.

No question: Larry is failing. Walking down the corridor with me, on the way to dinner, he takes tentative baby steps. Descending eight floors by elevator leaves him breathless. By the time we make it across the cavernous lobby downstairs, he's perspiring so much from the effort that he takes off his sport coat and asks me to hold it. He grips my shoulder to negotiate the curb by the sidewalk. I'm not prepared to hold his hand, but I do take his upper arm when crossing the street and can't help noticing that the skin up there is pudgy soft, just like when he was a kid.

"Slow down," he says. "If I don't concentrate on standing upright, I'll fall over."

I surprise myself by not being impatient. It's actually interesting to go at his pace; he points out things I wouldn't have noticed at my usual speed. "Someone could make a fortune installing banisters in this country," he says, noting the lack of railings everywhere. "We can't go more than five yards without the walkway changing." He's right: The ground surface that passes for sidewalk goes from pebbles to puddles to rutted tar. It's like my finding it advantageous to not speak the language—his perceptions are sharpened to compensate for his shortcomings. Two handicapped men in China, with only our wits to get us through.

"Eight A.M.," he says. But my brain's so busy working overtime that I've misheard him. What he actually says is "ATM"—pointing out a cash machine I hadn't noticed before.

"It's a good one," he says, trying it out. "I'm going for broke."

Unlike most of the ATMs I've been trying up till now, this machine's not on the blink, and Larry is able to make repeated withdrawals. He's already gotten seventy-five hundred RMB, about a thousand dollars in small bills. "This is better than Atlantic City," he says buoyantly, playing it like a slot machine until his pockets are bulging.

Approaching the restaurant, the sidewalk path is so narrow and dark—lit only by passing headlights—that we shuffle single file. The mud is slippery from a shower earlier today and feels ancient in its slickness. As for the air quality? "If I were flying in fog this thick, I'd use instruments," Larry notes.

In the gloom an excitable old man is playing "Danny Boy" on a violin, almost jittering with energy. Beyond him a line of street hawkers affords Larry an opportunity to teach me the art of bargaining.

"NO TOURIST PRICES," he says to the first hawker he encounters. Larry's stiffened for the confrontation, wrapped so tight he could be mummified. "WE'RE NOT STUPID WESTERNERS. WE'RE NOT WHATEVER YOU THINK WE ARE."

"Go easy," I tell him. "I don't think they follow—"

"He knows more than he's letting on," Larry says.

"Good-friend price," says the hawker, who wears a flowing Fu Manchu and is smiling with a kind of joy to be in our company.

"I'M NOT YOUR GOOD FRIEND," Larry says. "I'M A BLACK-BELT NEGOTIATOR. Now watch this," he tells me, "it's called lowballing. He wants sixty-eight RMB for the lighter, right? That's only about eight dollars American, if my calculations serve. But does he think I'm a *schmeggege*? Instead of coming in at sixty-four, I shock him into a whole new stage of negotiations. FOUR!" he barks.

The hawker looks deeply disappointed in us. "No four. Forty-eight," he says.

"FOUR!" Larry barks again. "Another tactic I use," he continues, "is to offer to buy in quantity. Ask for a half dozen of anything, suddenly they're interested. SIX FOR EIGHT!" he barks.

The hawker looks as though he's reached his tongue into the most

fragrant of honey pots only to be stung by a bee. "No six for eight!" he says. "Forty-two each!"

This goes on for another minute while the crowd watches raptly to the tune of "Danny Boy" and the hawker seems alternately joyous and bee-stung.

"Finally, don't be afraid to walk away empty-handed," Larry counsels, walking away empty-handed. As my hunched-over cousin crosses the street, I pick up four lighters for twenty RMB, to the delight of all.

I'm chuckling to myself when I catch up to him. What a *schmeggege,* whatever that is! And suddenly the *schmeggege* saves my life—pulling me back from a cab that comes as close as a bull in a bullfight. Weak and misoriented as he is, he yanks me out of harm's way while I'm crossing the street. I didn't bother checking both ways, too busy feeling superior. . . .

Entering the crimson restaurant, Larry and I spontaneously start to cough from the spice in the air. But soon our lungs adjust, and after being cut ahead of in line twice, we're seated next to a table of four businessmen. From their overrelaxed manner, I can tell they've put a few away and will be smoking like chimneys before long. I request a table far from everybody, a window seat facing the dark street, all by itself. But no sooner have we settled in than the empty table next to us is taken by a man who begins smoking like a chimney.

"You know, we haven't spent this much time together since we were kids," Larry says conversationally, settling himself with a groan of relief. "Have you noticed we're starting to look alike? We're walking around with the same watch, the same kind of camera; even our expressions are practically identical."

The way I see it, it's not that we're alike as much as he's in culture shock, casting about to make connections with anything remotely familiar. It's how he handles his homesickness. The food on the waiter's tray reminds him of something his mother might have had in the old coun-

try: like kasha that hasn't been cooked right, like chicken soup except that shrimp heads are trying to mate on the surface.

"By the way, just so there won't be any misunderstandings later, this is on me," Larry says, studying the menu in Chinese.

"Don't worry about it, I got it," I say.

"I'm not worried, I'm paying," he says.

"You paid the last several times," I point out.

"That's a reasonable thing to say, but no," he says.

"Larry, I *want* to pay."

"You want to? That's a nice impulse. Just understand it's my treat. Accept it."

I do so, but with a certain unease. It's not merely politeness on my part. It's not merely that it reminds me of his father giving away silver dollars he didn't have. It's also that Larry and I have a history of him paying for my meals, and they haven't ended up well. Every time he wanted to interest me in gold coins just before the price of gold plummeted, or a Boston condo as the real-estate bubble was on the point of bursting, he would take me to lunch and insist on paying. I'd save thirty bucks on the bill and end up thousands in the hole.

The waitress arrives with a free hors d'oeuvre plate of little watermelon cubes. "Another spellbinder," Larry remarks. "This country has the best-looking women I've ever seen. I find ninety percent of them attractive and twenty-five percent of them gorgeous." He puts down the menu and addresses her. "I WANT TO ORDER PIZZA WITH EXTRA ONIONS, MUSHROOMS, WHAT I CALL TACO BEEF, BUT REALLY ANY BEEF WILL DO, PEPPERONI—"

"Larry—"

"Am I talking too fast again? I never remember to slow down."

"Larry, there's no such thing as pizza here, much less taco beef. Besides, I thought you were cool with Peking duck."

"You win," he says, showing me the whites of his palms in submission.

"Peking duck for two," I tell the waitress. "And two middle Cokes."

"Duck not ready for half a clock," she warns us.

That's fine. This will give me a chance to ask Larry something I've been wondering about for a while. But first Larry has to slip the waitress a bill that amounts to 100 percent of what the entire meal's going to come to.

"YOU'RE PRETTY AS A PINUP," he tells her.

She preens.

"Doesn't speak a lick of English, but all girls know the word 'pretty,'" Larry says, giving her another 100-percent tip. Twice the price of the meal.

"Larry, you've got to preserve your capital. . . ."

"She's working hard, she deserves it."

"But, Larry, they don't even tip at the *end* of meals in this country."

"That's not my fault."

Fine. I concede again. It's a series of mutual compromises. He's sampling the native cuisine. I can let him tip to his heart's content.

"So, Larry, I've always wanted to ask you this. I'm only asking now because you're plying me with duck. But are you mobbed up?"

This question seems to please him and make him tight-lipped at the same time. He pops a Beano, then reaches over to snag one of the watermelon cubes, each with its own plastic dragon toothpick. "I don't want this to go wide, but yes," he says, and launches into a blue streak of mini-sagas that he says must be off the record. Most of it's too complicated for me to follow anyway. All I get are some choice names and phrases: "A-hundred-and-fifty-percent financing." "Disappeared in '92." "Unfortunately also deceased." "Political asylum for Russian girlfriend." "Embezzled billions, but they could only get him for making free calls from pay phones." It's a lot of generalized innuendo, and the only way to keep my head from spinning is not to follow too closely. Still, is it possible he knows the people who offed Jeffrey Dahmer in prison?

"But better than the mob," he says, coming out of deep background, "are my connections with the MM."

"You mean the Motor Men?"

Larry shushes me and turns stiffly in his cushioned seat to see who might have overheard. "The mob's easy to infiltrate. The MM's twice as

hard, but this has to be even deeper background, because these guys lack any sense of humor whatsoever."

So here's a disguised account of what he tells me about the MM.

"In Miami, a few miles south of my domicile," he begins, "there's an allergist I grew up with who found himself with a client who it turns out is a member of the MM. This client had a stuffed-up nose, couldn't figure out what the problem was. Milton diagnoses the problem as being the fault of a cat living in the MM's clubhouse. Client gets rid of the cat, presto, problem solved, client's so grateful he starts referring Milton to other members who also turn out to have allergy problems. Who knew the MM had such sensitive nasal issues? Soon Milton finds himself in a pickle. What's he gonna do with patients who are basically hard-core criminals—find the nerve to throw them out? Soon there are six or seven members of the MM as clients, including the leader of the local clubhouse we'll call Killer. They're filling up his waiting room in their chains and leathers, and for some reason they took a shine to Milton, started offering him some of their whores that he regularly declined. But Milton's basically a sissy who got a kick out of this proximity to real life and bragged about it to me on one occasion. Not really bragging. Allergist bragging. Any case, I had a problem with a tenant I was sleeping with. She couldn't make rent because she was in debt for cocaine for two grand that some black guy in Overtown had advanced her. He didn't want the money. Pretty little red head, he wanted to pimp her out. She didn't know what to do so came crying to me. I checked her out, spoke to her sister, who's a petroleum engineer in Sioux City, tells me she's basically a good girl but she's in over her head. So I said, 'Tammy, don't worry, I'll take care of it.' Had Milton set up a meeting between me and Killer. I lay out the situation, they agree to pay the pimp a visit, I'll drive."

Here Larry interrupts himself to wet his whistle. "Dear, could I bother you to remind you about those middle Cokes?" he asks the waitress in a normal tone, as casually as though she were working the pub at his condo club. "Actually, bring the whole bottle," he corrects.

Larry gazes out the window at the black night. "I must say the local truckers have remarkably bad aim. They hardly ever hit the bicycles," he

says, and no sooner are the words out of his mouth than down one goes. Not a serious accident. The bicyclist brushes herself off and shakes her fist at the truck that winged her.

"Not to take anything from the guy in the famous Tiananmen Square photo, standing up to the tank," Larry says. "But it does give you perspective to be here. Face-offs like that are an everyday occurrence. It's called traffic."

"Let's get back to the story," I propose.

"This next part involves a knife," he warns me.

"How big a knife?"

"Here to here," he says, opening his arms exactly as wide as our restaurant table.

"Basically like a saber?"

"That's your word," Larry says. "Whose saga is this, yours or mine? When it's your turn, you can use all the clichés you wish, but right now I've got the floor. You ready?"

"Shoot," I say.

"So we drive to Overtown. I stay in the car. Ten, fifteen minutes tops, they come back down and say it's all set, he's moving to his mutha's in Chicago in the morning. Tammy's off the hook. What they did was take a knife to his balls. They show me the knife, it's as aforementioned. They place it against his balls and give him a little cut, just enough so he has to go to the hospital for a couple of stitches. Careful to break only one toof when they put a gun in his mouth. 'Notice we're not wearing masks,' they tell the pimp. 'That's because we want you to remember our faces. In fact, every night before you go to sleep for the rest of your life, we want you to remember our faces. See? Ramon here's got a scar on his chin. And see, I've got a cute little button nose? My mother used to call me Button-Nose. But you can't call me Button-Nose. You can't call me shit. All you can do is remember our faces and pray that nuffing bad better happen to Tammy. Because if anything ever does, even if she takes a tumble getting on a bus, we're gonna assume you caused it and come after you. You're her insurance company. You better hope she has a nice long life.' "

End of saga. Larry starts counting the broken eggshells overflowing the ashtray from the previous diner's meal.

"So what happened?" I ask.

"I told you, he moved in with his mutha! Weren't you listening?" Larry conceals his annoyance by stretching across the table to spear another watermelon cube.

"No, I mean, to Tammy."

"Overdosed sixteen months later. Died with the needle in her arm. Too bad, sweet kid, just a little confused." He signals the waitress sidling by with ten soup bowls stacked in her embrace. "Any chance of our getting that Sprite, dear?" he asks with a winning smile.

"And what happened to Killer?"

"Serving twelve to fifteen for possession of kidney porn," he says.

"Kidney, did you say?"

"Kiddie, kiddie, get your ears checked, Dan," Larry advises.

"Well, anyway, that's an amazing story," I say.

"So am I sorry I took the action I did?" Larry asks rhetorically. "No. *I did the right thing.* Plus, I dated the sister in Sioux City for like six months. Amazing oral technician. Treated it like a French horn. You think it would be rude to ask our waitress for more pineapple?"

"You mean watermelon?"

"Sure, I'm not picky."

Just in time the duck is wheeled over, looking like it was pulled out of a pond of brown glaze and had its throat sliced two minutes ago, about the time in the story when the saber was put to the guy's balls. A man in white flips the duck back side up. He resembles a surgeon, but he's a duck slicer wearing a surgical mask as he carves so adroitly. Snip, carve, slash. Such a pro you can't even make out his breath moving through the mouth gauze. Two male waiters prepare the table, but one makes the mistake of reaching to ready Larry for his meal. Larry smacks the man's hand away and gives him a dirty look.

And so the meal begins.

———

And then the meal's done. The duck's hit the spot. Larry has pushed back his chair and is applying Blistex to his lips with a sigh of satisfaction. Without meaning to, Larry has proved to me that he has a better palate than I do—discerning breast skin as having a different flavor from thigh skin. Additionally, he's used his utensil with great skill—the KFC spork that he apparently plans to carry everywhere, like an all-purpose Swiss Army knife. As for me, I'm still trying to process things.

"Why are you staring at me like that?" he asks me, whittling at one of the holes in his teeth with the plastic dragon toothpick.

"It's just hard to imagine anyone in our family being connected with either the mob or the MM," I reply. "See, look, now you've got me calling them by their initials. I don't want to call them by their initials. I want to call them by their real blood-and-gore name—"

"Call them what you wish," Larry says. "All I can tell you is, time comes, they're gonna have Burton's ass on a stick."

"Whoa!" I say, pushing my chair back and holding up my arm like a traffic cop. "What are you talking about here?"

Larry takes off his sunglasses and gives me a Mona Lisa expression that says, *I have no expression whatsoever.* "Dan, you're my cousin, and besides that you're more or less my friend, so I'm going to do you a favor and say, 'No comment.'"

I re-strain the muscle in my neck. Now it's officially a crick. "I thought the fatwa was over, Larry. Larry?"

"You're absolutely right, it *was* over," he says, taking a tissue that serves as napkin to pat the drops of sweat that constellate his brow. "Then it became under again."

"But you said it was done!"

"If you recall, I didn't say it was done. What I precisely said was it was behind us, and it *is* behind us. Specifically, it's behind Burton, not to get too anatomical."

"But, Larry, here we are in China on a whole new page. What did Burton ever do to you that was so unforgiveable you can't let it go?"

The Mona Lisa smile means he means business. "Dan, believe me

when I tell you, you don't want to know. Suffice it to say he stabbed me in the back, trying to swindle my mutha."

"But if you don't tell me, how can I judge it for myself?"

"Who's asking you to? I know what I know. That's good enough for me."

He spears another watermelon cube and sucks it thoughtfully for a minute. A cab races by the window. *More more more more,* goes its horn.

"Okay, bottom-line reason, sparing you the details? He said I owed him money, I said I paid him back. To teach me a lesson, he demanded a mortgage on my mutha's house, saying it'll be a learning experience for me, a growth experience. Long story short: My mutha died the worst kind of death, thinking she had lost her house and that Judy and I were left homeless. We were with her day and night at the hospital at the end, and she thought the only reasonable explanation was that she had lost everything to Burton and we had no home to go to. Yes, she was delusional, and we tried to convince her otherwise, but she was set on it, and she died in agony. She died sick with worry, and for this I blame Burton. For this he deserves everything coming to him. That's why it's not over."

"But Burton didn't get the house," I protest.

"Doesn't change anything. He tried."

"But you've got to keep things in balance," I say. "Didn't you tell me a couple of days ago that you wouldn't have been able to arrange the cure for Judy's epilepsy if it hadn't been for Burton?"

"Absolutely. He was an angel."

"Then why—"

"That was then. This is now."

I can feel my face doing funny things. It's as though my eyebrows are trying to convince him out of it by sheer force of contortion. My neck muscle is seizing up. "But the FBI interviewed you last time, when they advised him to go to a motel for two weeks. You'll be the first person they suspect."

Now the Mona Lisa smile deepens a bit, so the toothpick can reach

some deeper recess. "Let's just say I have made arrangements," he says. "To be dispatched upon my death."

"You're kidding me. Tell me you're kidding me."

"No, that's the beauty part, because as soon as I'm dead, presto, the plan goes into effect. They can't come back at me. Pretty sweet, huh? So in a way I hope Burton *does* find out where I'm going to have my surgery and *does* manage to squash it, because it'll be his ass."

I'm squinting through the smoke from tables everywhere, blinking much more than I want to. "So I'm assuming this is still a wake-up call rather than a *fatwa* fatwa, as you said. And Burton will survive it, right?"

"Yes. Whether he'll want to, that's a different question. Put it this way: It'll be a learning experience for him. Like he prescribed for me. A growth experience. He thinks he rules the world. He'll find out that he's not even an ant in the real world."

I've never heard such contempt packed into a single word as what he does with "ant." He extracts his toothpick and points it at me.

"And you know the part I love best, Dan? That he thinks he's safe. Oh, I relish that. This is my masterwork. I want to be remembered for this."

"But, Larry, you don't think something more moderate might be in order? Like challenge Burton in a court of law?"

"I'm not interested in paperwork. This is poetic justice. He screwed me up the ass, I'm returning the favor. And in front of his wife. That's the part Killer especially liked. When Killer heard about my mutha on her deathbed, he said he couldn't wait to take care of it personally. He was very attached to his mutha, too, apparently. Well, I already alluded to that. She called him 'Button-Nose.'"

Larry's eyes are dancing. Even the thought of the deed makes his eyes sparkle with happy menace. I haven't seen him this animated since he was ten, doing his favorite trick of speaking Clint Eastwood lines into the fan: *"I tried being reasonable, I didn't like it."*

I look around the crimson restaurant, aghast. My eyes search out a TV for distraction. On the screen above the waiters' station, they're

running a show about pandas. What is it with this country and pandas? Everywhere you look, pandas chewing on celery stalks, pandas batting one another playfully in the balls, pandas in positions that in any other species would be called obscene. They even have an expression for someone with droopy eyes: "panda eyes." Enough with the pandas already. I make one last effort at denying Larry's news.

"You're gaming me, right? You're hoping I get back to Burton with this so he freaks out all over again, even though in reality there's nothing to it."

"Oh, I like that version," Larry says. "That adds a nice little bit of surrealism that even I couldn't have dreamed up."

"But that's the truth, right? You never really issued the first fatwa against him. You were just blowing smoke to shake him up. You'd never do something like that to your own cousin, or anyone else for that matter. You just said it so he'd get anxious, and that would be punishment enough right there."

"Good. Keep your head in the sand. That's the version we'll go with."

"Because you've got the golden heart, even for people who cross you. I mean, you're someone I've known my whole life, you're not . . . evil . . . are you?"

"No, I like the first scenario. We'll leave it at that. Why spoil a nice Friday-night duck feast. Good Shabbos, by the way. We ought to make this Peking duck a Friday-night tradition."

The denial is over. I'm at one of the next stages of grief—depression—and am surprised at how weak and supplicating my voice comes out. "I really thought the feud was dead."

"Not dead. Dormant. But I do have some good news."

"What's that?"

"I've refined it somewhat. I now want the act recorded on film so it can be posted on YouTube."

"Larry, I've got to tell you this is making me physically ill."

"Don't worry. It's less than a grand. Killer gave me a discount—"

"I don't mean how much you've had to shell out, Larry! I mean the idea of you doing bodily injury to a relative. To anyone!"

When have I ever seen eyes so merry with deadliness? And then it comes to me. At his father's funeral. There was a man no one recognized at graveside. He stood right beside the casket, waiting patiently for it to be lowered. And when it was set into the ground, he was the first person to pick up the shovel and perform the traditional rite of casting dirt upon the grave. Only he did it with too much gusto. It's meant to be symbolic, a reluctant drizzle of soil, but this grunting stranger heaved five, ten, twenty-five shovelfuls: He didn't stop till his shirt was soaked through. It was only after the ceremony that it occurred to me he must have been someone with whom Sam had had a blood feud. Decades earlier, perhaps, the man must have vowed, "I'll toss dirt on your grave!"

Who knows, maybe it was what kept the guy alive all those years. Maybe Sam, too.

Primitive business, this vengeance thing. People took their restitution seriously back in the shtetl.

Larry's watching me, an enigmatic smile playing on his lips. He looks more like Mona Lisa than the original Mona Lisa does, so that I understand something about Leonardo's model that I didn't understand before. She's more than enigmatic. She's a schemer. Behind that famously mysterious smile, she's plotting to violate her cousin. And make another cousin an unwitting accessory.

"So come to think of it, Dan, you're doing a twofer too, just like me," he says.

"How's that?"

"You thought you were coming to China just to save one cousin. But if you save me, you save Burton, too, at least for the time being. Two for the price of one. . . ."

Chapter 13

Dear Florida Power & Light

Even a hare will bite when it is cornered.

Sept. 19. Dear Florida Power & Light:
It has come to my attention that despite my entreaties
you still have not turned my power back on in my condo,
due to you thought I had not paid my bill. The check is in
the mail. Please reinstate the above stated relief henceforth.
Sincerely, Larry Feldman.

Five days have passed. I'm at a new stage of grief—stupefaction—
after Larry's announcement, trying to fathom how I managed to land
myself in an episode of *The Sopranos in Asia.* (This week's episode: Is
Dan saving the life of a monster?) Larry's dominion over me is total: I've
been horrified into a state of submission. Between the bombshell that
he hasn't rescinded his fatwa and the realization that I'm now for all
intents and purposes an accessory, my mental state is disabled; I'm good
for nothing more than being Larry's manservant. He dictates, I type:

Sept. 19. Dear Mary:
Here I am in the hospital with nothing to do but wait.
Feel like a prisoner, but even more painful is not being able

to communicate with you. Is there any chance of your coming
back to me fairly soon? Of course I will pay all your expenses
and then some. Please let me know how much money you
need and I will have Dan dispatch it. All my love, Larry.

One thing's clear: Larry's in his element, reigning supreme. Divulg-
ing his fatwa seems to have freed his creative energies, which are fur-
ther fueled by infusions of imitation Do-Si-Do peanut butter sandwich
cookies I managed to find in a local grocery store. His blood pressure
is down to 190 over 120 and his mood bullish, his body weak but his
drive ascendant. In his box-turtle shades and Businessman's Running
Shoes, conducting business through me from atop his thin-as-silk hos-
pital sheets, he's the ayatollah of the ninth floor. Since he ordered the
A/C to be shut down, I'm wilting in the heat of central China's late-
September furnace, so disenfranchised I'm not even allowed to correct
his grammar.

Sept. 20. Dear Netflix:
 You must have me mixed up with another Larry Feldman. I
sent back all boxed sets of "Dirty Harry" eight or ten months
ago. If you insist on charging me for someone else's blunder,
I will have no choice but to desist being a customer of yours
and/or institute legal recrimination with no ado.

Sept. 21. Dear Nuvention Clearing House:
 Thank you for your encouraging words. I do in fact have
a new invention and one I think you can market to great
advantage. Enclosed you will find the business plan for my
latest proposal, as well as a personal check to cover the cost
of registration. It is my belief that Fortune Rubbers, novelty
condoms printed with Chinese cookie-style fortunes, could
really strike pay dirt with the gay demographic as well as
normal people.

Sometimes I can't even tell which letters I'm writing for him and which I'm inventing, for sanity's sake. Other times I forget where I am, sweating in the room where I've again risked life and limb to jury-rig extra sheets in the windows against the glare of smogshine that hurts his eyes. In the dim light punctuated by the Arabic gutturals from Al Jazeera that susurrate night and day, I muddle my Middle East geography and half think I'm hiding out with the Taliban in some Afghani cave. Only the periodic flocking of Chinese nurse-groupies relieves the desert mirage. ("Lar-ry! Lar-ry!" they chant when he makes an appearance in the hallway to hobble to the weight scale. He flashes them a V like Winston Churchill in his dotage.) That and the regular appearance of the KFC man, who has a double row of teeth like the keyboard of a harpsichord and who performs a high five with the patient each time he delivers a catered meal of Double Crunch with Honey BBQ sauce.

Artie to Larry: "Professor, look, both you same size now!"

Larry to Artie: "Yes, and that's for the first time since my bar mitzvah, I believe. Look at Dan, he's so skinny his shorts are falling off his hips."

Or did I make that up? Daydreaming has become my only escape, a life-saving pressure valve that allows my brain to, among other things, revert to a time when the whole clan got along: Sam passing out silver dollars, Little Larry showing off his collection of switchblades, Burton patting him on the head, saying, "Aww, isn't that cute."

Sept. 23. Dear Florida Power & Light:
 Know by these presents that I had 45 pounds of expensive beluga caviar in my freezer. If even one ounce of it is ruined due to you shut off the juice, this is to inform that I intend to seek financial relief in the amount of no less than $85,000.

Meanwhile the personal fusion between us, master and man, no longer even frightens me. I just accept it. That we're indistinguishable from each other, one creature with borderline psychopathic tendencies,

is accepted without qualm by the cashier's office downstairs whenever I go to make a deposit of Larry's money into his ever-ravenous account. When I borrow his camera's memory card to back up his pictures into my camera, as he instructs, it feels like I'm being force-fed a brain implant. Entering his e-mail account to do his correspondence, I feel like I'm leaping into Larry's body, like Patrick Swayze using Whoopi's in *Ghost*. Is the merger almost done? Huwwo, have I really adopted his speech impediment as my own? I'm his lackey, what he might inexcusably call his personal coolie, captive to the mini-sagas that I can no longer orchestrate and which are more than ever like papal bulls, standing fully formed on their own outside the normal rules of discourse.

LARRY ON HIS OWN ETHNIC GROUP

Rarely met a Jew I didn't respect. I didn't say like, I said respect. Certain family members excepted. Oh, and except in Vegas, which is populated mostly by irrespectable Jews and irrespectable Italians, bofe wearing Hawaiian shirts.

LARRY ON SOLVING THE MIDDLE EAST CRISIS

While we're on the subject, I may as well give you my suggestion for achieving peace in the Middle East. If I were the negotiator, first thing I'd do would be greatly expand the city of Jerusalem. Ninety percent of the old city goes to the Jews. Ninety percent of the new city goes to the Palestinians. The new stuff can be a pile of dirt, they just need to claim some land, and the Israelis should be responsible for developing it for them. They want a homeland, let's create it for them. It's called Enlarging the Pie.

LARRY ON PRIVATELY TUTORING HIS STUDENTS

Just because I take my teaching seriously, does that mean I don't avail myself of the opportunities that present themselves to Privately Tutor my students? I anticipated your curiosity on this point. And the answer is: I'm not beneath it. I mean, I don't make a practice of it, but on occasion, especially with ones from Puerto Rico. For some reason they're the ones who always come up to you after the first class to invite you to their rooms for extra help. The five roommates, each one cuter than the last, they know to clear out.

On and on go the disquisitions, as relentless as the clouds of ivory-gray smog through the hospital window, velvety and choking. I am so powerless that when I occasionally make a sound of protest, I'm shot down with no attempt to control the sarcasm from on high.

Me: You want me to write *another* letter to Mary's uncle buttering him up about chinesepridemall.com?

Larry: Yes, Dan, *unless you're suffering writer's block again.*

Me: But if I may, Chinese pride, Emerald Isle pride, all these Web sites you've concocted—do you actually believe in any of these things?

Larry: What do my beliefs have to do with it? This is business. Do I believe in Eskimo pride, just because I own a Web site called igloopower.com? Theoretically, sure, why not, but it's not something I'm emotionally invested in. Am I invested in gay pride? I don't want to mislead you, so I'll have to admit: not that much. Nuffing against them, even though I once got stuck behind a gay-pride parade for four hours and had to wonder, do faggots have to be *that* proud? But Chinese pride could be the biggest haul of all, now that I've been here and see what these people require. Mary's uncle is a man I feel I could work with. He doesn't say a lot, but he knows where the bodies are buried.

Meanwhile the dictation goes on at any hour, recording the devolution of our life here.

Sept. 25. Dear Colleagues & Godchildren:

A major development took place yesterday that I am most unhappy about. I left the hospital on my own accord for a little stroll but apparently the powers that be thought I was trying to escape and they have insisted that my subordinate Dan pretty much move into the spare room of my suite to keep watch over me. It is true that I did fall in the street and sustained some fairly impressive scabs on my elbows and knees but I am irked that Dan has to now be here even more with me, taking up the good couch and watching every single thing I do with that upper caste accent of his, not that he can

help it. If any or all of you would like to write the hospital to petition on my behalf I will not stop you.

Yes, it's true, I am his hostage, as he is mine. I haven't checked out of the Super 2, but I spend more time in the hospital suite than anywhere else, frequently crashing on the couch in his spare room, just as I did after college. My life is all Larry, all the time: smelling Larry in my clothes, dreaming Larry in my sleep. By night our heads rest against opposite sides of the same hospital wall, completing the mind meld. By day I sit in my molded-plastic school chair and type.

Sept. 26. Dear Candey Blossoms Candidate AZ418B:
Please be advised that I do not now nor ever did in the past request a romantic dalliance with you. You sound like a nice girl but I am satisfied with the one I got. Plus you are Korean and I am specializing in China right now, even though you point out rather convincingly that Koreans have more advanced fashion sense than China girls. I thank you for your consideration, but please no more mash notes.

As for the elephant in the room, we make no further reference to it. The fatwa's just there, lighting Larry up from the inside. In odd moments when I believe he's sleeping I steal a glimpse at the Internet to try to gain perspective on the issue, Googling the history of the Motor Men and/or digging up strangely pertinent definitions.

cozen \KUZ-un\, transitive verb:
1. To cheat; to defraud; to deceive, usually by petty tricks.
Perhaps derives from Early Modern French cousiner, "to defraud; literally to treat as if a cousin (hence to claim to be a cousin in order to defraud)."

So much have I become his Mini-Me that I find myself thinking, Maybe there *is* something sweet about the life of a munitions dealer.

After all, isn't that the profession Rimbaud entered after resigning from poetry at age nineteen—how bad could it be? Larry's shuffling walk, his stumbling gait, I now view as languid. Even the fatwa now makes a kind of mad sense to me. Larry's not an evil monster. He's merely concocted the perfect payback for his disadvantaged life. And it *is* perfect. Burton was the first golden boy of the overprivileged generation from which Larry was excluded. By screwing Burton, he's in effect screwing this whole generation of rich snots, including me.

And by roping me in, he's made me a party to my own screwing.

Only one thing is going to snap me out of this—seeing Jade hop two-footed out of her bullet train from Beijing to visit us.

"Hey there, 24."

"Hello, 84."

I'm touched by her smallness when we hug on the platform. Pulling away, I'm amazed by all I'd forgotten or hadn't sufficiently noticed: those oblong nostrils, the bubbles in her teeth that keep re-creating themselves. She has a delightful thing she does with her tongue when she speaks. Sometimes it licks her bottom lip so it's as glossy as lipstick, other times it curls beneath her back teeth in an almost impish manner. How had I overlooked this before?

And she's so happy! "I nudge you," she says, pushing my shoulder slightly.

"I nudge you, too," I say, returning the endearment or whatever it's supposed to be. This makes her happier still, her face both familiar and new, and so animated I can barely keep up with it. But then one last fleeting hug as her face takes a sudden downturn.

"Worried about you and Larry so much!"

So we're off.

In the cab from the train station, I have a silent conversation. *Cool God! You who maketh Situations Splendid! Thank You for the women You always*

send my way. Where would we men be without them? Women arranged for me to find this hospital, women have been caring for Larry in this hospital, women do everything but pack my lunch and give me milk money! How in the world did You engineer them so fierce and loving? I even got e-mails in the last few days from my old Asian flames, Corazón and Company, who forgive me, of all things . . . asking what they can do to help! O Lordy Lord I long to praise, who chilleth out the passions of crazy lovers in due time and restoreth order between cousins, where would we be without You?

Per Jade's request we go directly to see Larry. I usher her into our sheet-darkened cave, kicking Ring Ding wrappers out of the way, closing the door to the bathroom so no vagabond scents might offend her quivering oblongs. Just having someone in my corner to objectify things rouses me from the stupor I've been in since the Shabbos Duck. I reclaim myself.

The deposed ayatollah is snoring. Jade looks him over fondly, fretfully, maternally—the hulk reduced to a fetal figure under a blanket that shudders with his breathing.

"You really stay here now?" she whispers. "I thought you joshing me."

"Oh, ain't no joshing matter."

"Why he keep cell phone in Kleenex box?"

"So he won't lose it, along with his important documents."

"Why instruction papers taped all over walls?"

"To remind him where the Kleenex box is."

Jade assesses the situation with a gravity I haven't seen before. "*Oy vay,*" she concludes. "What Dr. X say about situation?"

"We haven't been able to see him."

"*Ma?!*" she cries, a hoarse whisper. "But this is the deal, you are here for Dr. X."

"We're just playing by their rules."

Jade takes note of my helpless grimace, makes a decision. "No matter," she declares. "We find Dr. X now, get the fresh scoop."

Instantly Larry wakes up. "I'm coming," he says.

"The patient spying on us!" Jade giggles, giving him a kiss on his cheek. "You overhear all our state secrets."

"Huwwo, Jade, huwwo, Dan," he says. Just by the pitch he uses, I can tell, mercifully, that we're back to our original dynamics. His reign of terror's over.

"But we have no appointment," I note.

"We hunt him down!" Jade says.

Larry and I exchange a wary look, the first eyeball contact we've had in a week. Why hadn't we thought of that?

"By the way, Dan, you don't have to worry about my conduct," he says as Jade and I help him put on his Sunday best. "I've mastered a blend just for situations like these—a unique mix of obsequiousness and assertiveness that I think you'll appreciate."

"Better to err on the side of shutting up," I caution him. Sorry if that came out unkindly, but I've just come off a dark week, and with so much at stake in this meeting, we can't afford to have anyone rock the boat.

"Aye-aye, Cap'n," he replies good-naturedly. "It's doubtful you'll hear peep one from me."

I'm not letting him off the hook. "Whatever you do," I say, ducking into the bathroom to prepare, "just don't pitch him any inventions."

"Scout's honor," Larry says. He flashes me a smile meant to be charming.

On the fourth floor, Jade and I support a formally clad Larry by either elbow as we find a wall directory behind glass. Jade runs her finger down a list of Chinese names, and we travel through a maze of corridors until we locate the corresponding office number. The light under his door indicates that Dr. X is in. Larry stops me from knocking so he can push three mini Dove chocolates into his mouth. "Energy," he explains.

"You sure you're okay to do this?" I ask.

"Give me thirty seconds," he says, pushing in three more. Finally: "Let's do it."

Just as I'm about to knock, though, another delay. Larry is looking at me as though a turkey just flew out of my nose.

"You took your earring out," he says.

"You noticed."

"I do have my 'on' days, Dan."

"And let me tell you I never take out my earring for anyone," I admit. "Not to interview heads of state, not to speak to a convention of shrinks, never. But just this once, I want to make sure there are no glitches."

"I appreciate it," Larry says. "This is a very straight individual we're dealing with."

Does Larry also notice that I've gargled with Listerine and scrubbed my nails? I haven't taken this many precautions since the reunion with the kidnap cabbie. But after all, what if Dr. X receives a phone call from a certain medical colleague at Harvard—who doesn't realize how he's cooking his own goose—and deems it inadvisable to proceed? I need all the credibility I can get.

Larry and I both take a deep breath. Only Jade is completely composed, a blank slate.

We knock.

And are admitted into a plush office. Two walls are lined with ceramic eagles and parrots. In between the sculptures are expensive unopened bottles of imported scotch—more showpieces. The rest of the walls are taken up with photos of Dr. X smiling suavely with various sheiks and international CEOs. But in person Dr. X doesn't smile as suavely. In fact, he doesn't smile at all. He looks like a stern older brother of the pleasant man in the photos.

"Your country give us many problems," Dr. X begins after ushering us to our seats.

I gulp.

"So many bad words, rumors about what we doing. They call us murderer! Say we kill students for kidneys! Members of Falun Gong outlaw sect. We never kill these person. Only murderer-criminals who deserve be killed!"

This is not going well. I look at Jade but get nothing back. Do I see a chastened look on Larry's face? But he's impossible to read as well. There are plastic potted plants in all four corners of the room, looking rather proud of being plastic. A slight smell of toilet lingers in the air.

"China is not so bad," Dr. X continues in a scolding tone. "I am not a member of the Party, but I believe that for Chinese our system is the best. Not absolute freedom like you have, but little by little. We have over two-thousand-year history. Give China time. Maybe fifty, one hundred years we be like you. But not now. You want us implode like Soviet Union? No, slowly, slowly is the ticket, also quietly, quietly." He takes off his orange-tinted Bono glasses and tosses them on his desk." You understand?"

I understand. I cannot tell whether Larry understands. As for Jade— I've never seen her so unreadable. Her eyes trap the light to reveal zero.

"And don't take picture of me with cell-phone camera when you pretend you text-messaging! No tricks like those, I not born yesterday. . . ."

"No, certainly not," I say.

"Last year simple," Dr. X continues, putting his glasses back on. "I do more than hundred and fifty kidneys, important people all over world. When I do them, they become lifelong friends. They help me. One hand wash other. You understand?"

In case I didn't, there's a photo of Dr. X shaking hands and exchanging toothy grins with a famous sixties American radical I almost recognize. I can't quite remember: What did the radical do to get on Nixon's enemy list? And where've I seen those ceramic parrots before?

"This year very difficult. That is why number-one importance is silence. I do not tell government I work on Westerner. I perform in secret. If government know I need kidney for Westerner, they take knife to my program, shut down hospital. So number one is silence. You must protect my program."

"I will tell the truth," I say.

This is a tactical error for which I'm immediately taken to task.

"No truth, no lies. Just silence. Otherwise I not able to get permit to help foreigners, not just your cousin, everyone."

"No, of course not, I understand."

"Only silence . . ."

As though in response, the room falls into a hush. Just as the doctor ordered. I can make out the ticking from an antique grandfather clock in the corner, doubtless the gift of a grateful tycoon somewhere. Tick-tick . . . tock . . .

Am I not dressed properly? It's well and good that I took out my earring, but the rest of my business attire is hardly up to snuff. Untucked shirt, goatee that hasn't been groomed since I arrived in China, hat that isn't quite as white as it was before encountering this air. . . . No wonder Dr. X is directing all his comments to Larry and his Albanian threads. Every time the doctor is forced to swing his head in my direction, he keeps his eyes closed. At least we're both two-fisted in the fake-power-prop department. . . .

Tick-tick . . . tock . . .

There's a sound to my left, a bullfrog warming up, tones so low I almost don't recognize them for a minute. Then I realize they're emanating from Larry's throat.

"I couldn't help noticing there's no security on your office door," he says.

"Why need security?" Dr. X says irritably. "We have guards at front door, many guards strolling grounds—"

"Why is because anyone already inside the hospital can access your sanctum with impunity," Larry informs him expressionlessly. "What you need . . ."

To my horror, Larry regales Dr. X with a description of his "mock security system," an ornate wall plate studded with plastic buttons: black, yellow, red. "But no wires, no fuse, no circuitry," Larry informs him. "Besides being a plain wall plate, ninety-nine cents at most hardware stores, with about sixteen cents of added decoration, it's nuffing."

Dr. X contemplates the notion for a long minute. "It's nuffing?" he echoes.

"That's the beauty part," Larry says. "It doesn't send out a silent alarm to notify the police. Doesn't set off a siren to scare the neighbors. It does nuffing but let the perp imagine the worst."

I shoot Larry a warning look meant to signify, *What happened to Scout's*

honor? He shoots one back that signifies, *What do Scouts know about building rapport?* . . . and resumes maintaining his deadpan gaze.

Dr. X pushes out his chair an inch. "I hook up how?"

"Self-sticking adhesive on the back."

Dr. X loosens the muscles of his face, and for the first time I can see that it would be a pleasant face—that is, if we were on the same team as those well-nourished CEOs. "How many I can buy?"

"No need," Larry says. "Once you give the word, I can have four dozen speeding their way to you, free of charge."

Larry allows a small smile to squat on his lips. Dr. X does the same, filling the smile with the filter end of a Benson & Hedges cigarette that Larry leans to light, after which he leaves the Cosmos Club matchbook on the desk facing himself, so Dr. X has to strain a little to read it.

"I like the way this man think," Dr. X says to no one in particular, exhaling yellow smoke, perusing the matchbook, exhaling smoke that's even yellower a second time. "So to matter at hand. I need best kidney for this situation, suitable and young. I have already potential donor being check for disease, AIDS and so forth."

"So wait," I say cautiously. "Does this mean we're moving forward?"

"I help you because you are friend of friend, but you keep secret top priority. I like Americans, but please, no more Americans! You getting last kidney in China."

I mask my excitement by skimming my eyes over the medical tomes lined up impressively in the bookcase behind Dr. X's head. A video titled *Carnivore Babes* is in among the tomes, making no effort to disguise itself. Jade maintains her blankness while her pupils make tiny flickering motions as though observing a Ping-Pong match under a microscope.

"We are peppering very many documents for permission to go through," Dr. X continues. "Need strict order from high court. Paperwork in process for donor to sign, also his family, everyone be on same page, no coercion."

I look over at Jade, who betrays not so much as a blink. I don't need to look at Larry. I can hear the knuckles being cracked beneath his poker face.

I can hardly contain myself. "You pepper all the documents you need," I say. "So do you mind if I ask who the donor is?"

"Bad-bad criminal," Dr. X says. "Thirty-one years of age and already kill many people. Break in woman's house, kill woman's father, then decide he want no witness so come back and kill woman and woman's baby. Very bad man!" he says with surprising vehemence. "I would kill him hundred times!"

Tick-tick . . . tock . . .

After a heated pause during which the toilet smell grows a little sharper, Larry and I choose the same second to both blurt out questions. I let him go first.

"Any way I can try out the kidney for a few weeks and get my money back if it doesn't work?" Larry asks.

"Ho ho," Dr. X says. "Like take for test drive!" Dr. X seems to enjoy the question. I'm the only one in the room, besides Larry, who knows that Larry isn't joking.

My turn. "Any way I can see the operation?"

"*See,* how you mean?"

I mime adjusting the focus on a pair of binoculars. "See? Be in operating room to watch."

Dr. X reacts as if I've uttered an ageless witticism. "Oh ho, equally funny. Not even in your country. Not anywhere in world. Surgeon get nervous, slash by mistake, bloody mess everywhere! Oh ho ho!" Dr. X says, leaning back to put his polished loafers on the desk. His eyes are more or less open when he swings his head in my direction. "You not such lousy fellows, you two!"

Even the grandfather clock seems to be enjoying our presence now. The glaze on the ceramic eagles, also the grins of the sheiks, seems to glint along with the bottles of show-off scotch. Besides me, Larry's the only one in the room who knows I'm not joking.

I seize the opportunity to abet the surgeon's good spirits with a measured amount of flattery.

"You are a young man to be in such a position of responsibility."

"Only look young, perhaps!"

"Oh ho ho," I say. "At the top of your game. And you have traveled the world, I see from the photos."

"Oh, yes. I have been to your country six time. Conferences in Boston, Chicago, D.C., New York, Miami—"

"Miami," Larry says.

"My daughter goes to school in Miami," Dr. X says.

Larry's knuckle-cracking goes into double time.

"You know, of course," I say, "that your patient, Larry, is a professor who lives just outside the Miami city limits. He is in a position to provide help for your daughter."

"Oh, sank you," Dr. X says, crushing out his cigarette eagerly in the soil of a plastic geranium.

"Whatever she needs," Larry adds. "Jobs, references, apartments. I used to own a building not far from the water. Four apartments. They told me I needed to abide by rent control. I gutted the first three floors, made one jumbo apartment. Guess what? Bye-bye rent control!"

I glare at Larry. "But of course there will be rent control for your daughter," I say.

"Goes without saying," Larry says, glaring back at me. "This building wasn't even in Miami, it was in Boston."

"Whatever she needs," I repeat. "And I myself live only a plane ride away!"

"Only a plane ride!" Dr. X is delighted by this.

"So we must host you the next time you come to visit your daughter. Larry can show you the best spots for food."

"Oh, sank you very much."

"You like sea cucumber?" I ask the surgeon. "Larry is something of an aficionado when it comes to sea cucumber. He knows the best restaurants for sea cucumber in all of Miami!"

"Oh ho ho," Dr. X says cheerily. He actually rubs his hands together.

Larry's not one to be outdone, unless it's in his strategic interest to be so. "And of course you know that Miami is one of the major sea-cruise capitals of the world," he adds.

"Yes?" Dr. X asks, anticipating happy tidings so acutely that he raises his eyebrows with pleasure. Handsome, handsome man, I decide.

"Yes. To look at my corn-fed appearance, you might think I've never ventured beyond the Bible Belt. Maybe just to Montreal to buy knockoff meds. But how wrong you'd be. I don't think even Dan knows this about me, but I have taken numerous deep-discounted, spare-no-luxury cruises out of Miami, courtesy of one of my ex-students from Puerto Rico who now functions as a flack for one of the major liners."

"I like cruise very much," Dr. X says, wide-eyed. "To where they go?"

"They're so cheap I don't even ask where," Larry replies. "She gets me special deals to the tune of two hundred and forty-five dollars per person including port charges for a week in a penthouse suite, outside balcony, marble tub with Jacuzzi, freebie shrimp cocktail at any hour, all the chocolate strawberries you can eat. Good for your head, all this luxury? Put it this way. For two forty-five, that's the cost of a single psychiatric appointment, and which do you think will make you feel better about yourself? Bottom line: Anyone I say, she can set up with identical privileges."

"Ooohhh," Dr. X says, nearly speechless. "You are fortunate man in your connection, I see."

"Not really," Larry replies flatly. "She wasn't anyone I even cared for, particularly. (By this I mean I never felt moved to Privately Tutor her. Very light-skinned, but still not my type. All I did was give her a ten-day extension, and she considers herself forever in my debt.)"

"But I share your zest for foreign experience," Dr. X says.

"Oh, I see what you're driving at," Larry corrects himself. "No, no zest, not for me, not really. Travel makes me depressionistic. Matter fact, after I get home from this trip, if I ever step more than ten yards from my condo again, please shoot me."

Tick-tick . . . tock. Jade's eyes are as dark as marbles.

"Hold everything," Larry suddenly says. "I may have misspoken. There actually may be a twelve-dollar port charge I didn't report in the Bahamas."

"Twelve dollar I can manage!" Dr. X chortles, coming around the desk to clap Larry on the shoulder. "I like the way you operate, Larry. Good head on you shoulder!"

"The appreciation is mutual," Larry replies without emotion, discreetly shrugging out from under Dr. X's hand. "And meantime we will keep your secret very silent," he says.

"Yes, first thing is silence. . . ."

"If asked, Dan here will find a way to disguise all the pertinent facts," Larry says.

"Disguise very important," Dr. X says. "Sometime matter of life and death."

"Dan's very strong in that department," Larry says, opening up a second line of assault while I adopt an expression of deep modesty. "Every manner of persuasion. You should have seen the masterful way he talked his way out of things when we were kids."

"Yes, me, too," Dr. X says, chortling at the memory. "In Cultural Revolution, I pretend my family all a bunch of poor peasant!"

"That truly is amusing," Larry says with an unamused expression.

"Just a bunch of hilly-billy dirt farmer!" Dr. X says. He is doubling over with laughter. "Rural weed pokers, even with advance degree!"

"Dan, too," Larry continues, killing two birds with one stone—making points with Dr. X while taking potshots at me. "During his hitchhiking days, he used to convince his drivers they wanted to go where he was going, not where they were going, even if it was miles out of their way. Did you know he was voted Con Man Who Will Sell the Brooklyn Bridge by his senior class in high school?"

"Well, I was also voted Best Actor, because I wanted to channel my abilities into something artistically acceptable," I say, firing Larry a cautionary look.

"Didn't I tell you? My cousin!" Larry says, beaming at me proudly but also with more than a little malice.

Dr. X stops his wheezing to look me over admiringly: my ratty sandals, my filthy white hat. "Yes, that truly impressive," he says.

"A total bunco artist!" Larry brags.

I cross my legs and clear my throat and do everything but kick Larry under the table to let him know it's time to start wrapping up.

Larry ignores me.

"All the best writers are like that," Larry expands. "Faulkner was considered a total goldbricker by his townsfolk. Frank McCourt, the review of 'Tis in his hometown Limerick paper was headlined "Tisn't.'"

Now I *do* kick Larry while Dr. X rocks with hilarity at this new information. Down below, where I meet Larry while pretending to adjust my Velcro sandal, I mutter, "How the fuck are you in possession of these facts?"

"Hey, I read the funny pages like everyone else," he mutters back, before bobbing above the table again. When I ascend, Dr. X is scribbling his personal cell-phone number on a business card, just in time to present it to me with both hands and the slightest of bows.

"Sank you," I say, giving him mine, not quite so impressively. But he seems to enjoy the splotches on my well-traveled card, perhaps figuring that an organic business card goes with my getup.

"Perhaps at our next meeting, I will tell you details about my latest breakthrough," Larry tells Dr. X. "A UFO hotline so people who think they've seen a flying saucer won't feel so alone. They get a friendly voice on the other end of the line taking down their information with the respect they may or may not deserve."

"UFO! I am UFO buff, big time! Tell me details now!" Dr. X begs.

Larry sadly shakes his head no. "1-800-I SAW UFO, is all for now," he says.

Dr. X is jittering with so much excitement I half expect him to haul out a violin and start playing "Danny Boy." Instead he comes around from behind his desk and urgently starts rubbing both of Larry's shoulders. "I love UFO! UFO give me chance to sharpen party-host abilities, entertain my friends at soirees with many creepy tales!"

"I look forward to telling you more after the surgery," Larry says indifferently.

"Me as well!" Dr. X confirms, rubbing both of Larry's shoulders energetically. "So now we have to wait for surgery, but not so long," he says.

"I hope so, because Larry is visibly weaker than when we got here," I say. "As you know, he took a fall recently—"

"We are aware of these developments. We monitor closely," Dr. X says, handing me a camera and gesturing Larry and Jade to clump together with him for a group photo.

"How long do you estimate before surgery?" I say, focusing.

"When get order from high court, perhaps one week, two weeks," Dr. X says, directing a few phrases to Jade in Chinese while composing his all-purpose professional smile for the portrait. "Usually many months, but since you special friends, I insist to get done sooner. Shhh, secret . . ."

Two weeks!? How did we just blast past the Badminton Boys from the Middle East? I contain my excitement. I contain my guilt. But what can I tell you—I'm an American: How I channel my guilt is to ask for *more*.

"If it can be done any sooner, we'd appreciate it. . . ."

"Sooner the better," Dr. X says. "I know you must be eager to get home to your two little boys."

Click! Dr. X posing with his suave international smile. Jade staring into the flash so no light escapes her eyes. Larry looking as happy as a mug shot. *Carnivore Babes* barely managing to fit inside the frame.

"Yes," I say slowly. "Of course. How'd you know I have two—"

No time to finish my question. Everyone is already shuffling to the door. Pocketing his Cosmos Club matchbook, Larry glides languidly out of the office arm in arm with Dr. X. Jade and I follow in stately fashion, like the parents after a wedding ceremony. We finally managed to get our least-marriageable daughter hitched. . . .

CHAPTER 14

Long, Long Live!

Those who have free seats at a play hiss first.

"Can you believe it?" I explode once our taxi is safely speeding off. "We're on our way to a healthy kidney!"

"Where!? *Now?!*" Jade asks.

"No, right now we're taking what's called a joyride," I explain from the front passenger seat. "We're celebrating the meeting with Dr. X by driving—anywhere, fast—doesn't even matter where. Whee!"

"Joy die!" Jade says. "Whee!"

No whee from Larry. Of the three passengers in the cab, only Larry isn't happy, protecting himself from happiness lest it turn on him, like a high-schooler going to the prom but sitting on his carnation accidentally on purpose.

"This good development," Jade confirms as neon lights flash past outside. "Everything coming up like roses."

"So the surgeon definitely means what he says?" I ask Jade. "We can count on him?"

"Oh, yes," Jade says cheerfully. "In my judgment he kill prisoner in two weeks."

That's putting it a bit starkly, but it damages my mood only slightly. It's the equivalent of seeing a baby calf frolicking in a field and realizing

it's this evening's veal piccata. I'm not quite ready to resume humming "Danny Boy" till I square away a few things.

"And we're sure it's a real criminal and not someone who voted against the mah-jongg commissioner or something?" I ask.

"Of course that," Jade says. "You see how much passion Dr. X was. Chinese generally hide their feelings. But he turn red, voice shake with anger. 'Kill hundred time!' Only because it is bad-bad criminal."

"What'd he say to you in Chinese when I was taking your picture?"

"He ask me, 'He really the cousin?' He want to make sure you are not journalist wanting story, or maybe double-oh-seven, like me!"

"Oh, right, I forgot you're Mata Hari," I say. "But seriously, how careful do we have to be about that stuff? I've gotten a strange vibe from Cherry."

"Cherry, no!" Jade scoffs. "In my opinion always good to keep eyes open. But Cherry I believe no threat."

This completes my good humor. I'm in a triumphant mood that nothing can wreck. Yes, the triumph has a twist to it: a bit of heartlessness mixed in with my high spirits, knowing that someone else is to die for Larry to live. But I'm relieved that the donor is a bad-bad criminal . . . and I'm fairly confident that the recipient is not a bad-bad criminal . . . so it's a trade-off, the survivor's dilemma. We pass the Red Guards waltzing on the terrace near the Old Faithful fountains, but we're going so fast that my shiver's only momentary.

Mostly what I am is ravenous. "What say we celebrate by chowing down," I suggest. "Where shall we eat? Larry, your choice."

Maybe he feels the mix of emotions, too? He's acting more than usually subdued, sitting like a lump of concrete in the back with Jade. Or maybe it's just his baseline moroseness. "Let's have a change of pace," he says without enthusiasm. "I'm in the mood for something authentic. How about Friday's?"

"You mean the New York chain? They have a franchise here?"

"I saw a flyer when I went for my stroll the other day," he says. "Good to get a little variety in my diet."

I turn to the cabbie beside me in the front. Aside from being a speedy

driver, she's what you'd call a full-figured gal: a Chinese Queen Latifah, complete with freckles and a chesty laugh from smoking or just exuberant living. "You know Friday's?" I ask her. "We go Friday's?"

"Friday's!" she whoops, picking up on my mood. "We go Friday's!"

"Friday's!" I whoop back at her. After weeks of Chinese food, the prospect of bloodred American beef at a New York–style restaurant is making me drool. "Friday's, yeehaw!"

"Friday's, yahoo!" she bellows.

"I'm trying to remember an old expression," I tell her. "*Yong yay, mong mee* or *mong may*, something like that. . . ."

"Give it up!" laughs Jade from the backseat.

And suddenly it comes to me. In a flash, I've got it back, fully formed. I try it tentatively at first, sounding it out:

"*Jong may yo yee wan-su-aee.*"

The cabbie's the first to hear it. "*Wan-su-aee?*" she asks, her freckles blinking at me.

"Yes," I say. "They used to compliment my pronunciation, twenty-five years ago." I try it out again, a little more confidently. "*Jong may yo yee wan-su-aee.*"

The cabbie looks startled, then very happy. "*Jong may yo yee wan-su-aee,*" she confirms.

"Yes," I say, "long live the friendship between the Chinese and American peoples!"

Jade in the back is bouncing up and down in her seat. "*Jong may yo yee wan-su-aee,*" she booms.

"Long live!" cries the cabby, honking her horn and weaving in and out of traffic. "Long, long live!"

It's mine again, in a flash. "Unbelievable!" I say. "It just came back to me!"

The cabbie's as excited as I am, exulting something similar. "La-la believable!" she shouts, beeping the horn in jubilation. "*Jong may yo yee wan-su-aee!*"

———

Our joyride delivers us to Friday's—which turns out to be half American chain restaurant knockoff, half traditional Chinese kitchen. Jade's never been inside an American eatery before, and she looks amazed. Is it the concept of silverware? Or the photo of the monster mushroom-bacon burger on the plastic menu, along with the Chinese specialties? I feel guilty even considering a burger, as though I'd be doing my stomach no favor after weeks of lighter Chinese fare.

"I want cock no ice," Jade orders sweetly.

"Make that three Cokes no ice," I amend. But am overruled by Larry, halfheartedly trying not to be a party pooper.

"No soft drink for you, dear," he tells Jade. "You're getting a genuine American cocktail."

To the waitress he says, "ONE COCK FOR DAN," not noticing that he's adopted Jade's pronunciation. "ONE STRAWBERRY SCHNAPPS FOR THE LADY, WITH A COUPLE OF EXTRA CHERRIES ON TOP. SAME FOR ME," he adds, explaining, "I need to live a little."

His words contain so little life, however, that when the drinks come, about thirty seconds later, I try to lift his spirits by pointing my index finger at him in victory.

"You're getting your Princess!" I tell him. "Your Princess, a kidney!"

He doesn't seem to grasp my meaning and grasps my finger instead, not letting go.

"You're getting your surgery within two weeks," I say, lifting my glass. "Toast to Chairman Larry!"

"To a soon surgery!" Jade echoes. She takes her first sip of schnapps, which, by evidence of her face, is a revelation.

"Let the record show that I continue to have a very bad premonition about it, however," Larry reminds me.

"Nothing can wreck my mood right now," I tell Larry. "Not even having my pointer finger mauled by you."

He seems embarrassed that he's still grasping my finger, lets it go, and takes his first cautious sip of his drink, coughing at its strength. "Do

you think Dr. X took it all in?" he asks. "Those references to Paul Volcker may have been a little much."

"What references to Paul Volcker?"

"I feel confident he got my gist, though," he says. "And just so you know, that was a conscious decision on my part not to tell him about all the nineteen-year-old girls from Appalachia who board those cruise ships five to a room in the hope of bagging someone good. I calculated it would be overkill. Because forget coeds—a girl from the mountains will commit acts at sea she wouldn't dream of doing ashore. Are you kidding? With an American professor in a balcony penthouse? I make out like a bandit."

"So everything's great," I say. "Why the long face? You having second thoughts about your donor?"

"I'm delighted with my donor," he says. "What's not to like? He's thirty-one."

Count on Larry to cut to the chase. He's right—the donor's youth is a plus. I guess it's too much to expect moral hair-splitting from Larry; I should just be relieved he didn't try to make a deal for the other kidneys—the six kidneys of the donor's murder victims—for him to scalp outside Dolphin Stadium.

Rather than lightening his mood, however, the schnapps seems to be readying him for his next set of problems.

"I couldn't help noticing there was no mention of price," he says. "Did he say how much discount he was willing to give us?"

"I didn't hear the word 'discount' at all," I say.

"I continue to have the feeling I'm being set up for a stupendous fall." He fixes his cinder-block gaze on his drink, takes another sip. Meanwhile Jade's exploring the miracle of her American cocktail, like a hummingbird at a feeder of sugar water. "Unless my ears deceived me," Larry says, "I'm pretty certain he said he would try to keep expenses down."

"I didn't hear that either, but let's hope so."

"Well, let's do more than hope," Larry says, leveling a placid gaze on me, "because it's only fair to tell you that I won't go through with this if the price is too high."

I assume he's kidding. "That raises an interesting question, though," I say. "What price do you put on saving your own life? Is fifty grand appropriate for an extra few decades? Is sixty? Seventy?"

"If it doesn't come in under fifty, I'm jumping ship," Larry declares.

I give it a beat. "Sure you will," I say, laughing. I examine his face for any sign of levity and start to get a sour feeling.

"I'm serious, Dan. I'm very concerned about cost. I can always start over again and negotiate a better deal in some other country."

I have to be mishearing him. I look helplessly at Jade. "Take it easy on that drink," I advise her, because she goes back for additional sips every few seconds, less like a hummingbird now than one of those plastic bird toys that clips to the rim of a glass and ducks its beak up and down, up and down.

Back to looking at Larry. I'm hoping the intervening seconds will have erased his dangerous thought process.

"You're not telling me," I say slowly, rationing out my words, "that after coming all this way, after all the people who've put themselves on the line for us, that you'll leave everyone hanging if the price comes in too high."

"You're the one who's always telling me to watch my pennies," he says. "And I agree: A penny over fifty and I'm on the next plane outta here."

After a while I exhale. "You know what?" I say. "I'm going to pretend you're not here, that you're back in the hospital suite, not really saying what you're saying."

It works, temporarily. It's like holding my breath and ducking under the water to swim away from a sea monster. I turn my attention to Jade, who's counting the beads of condensation on the outside of her glass. A harelipped boy wanders by hawking pink balloons. I startle to see three Westerners across the room, just as the natives always startle when they see me. They're our mirror image: two women and a man, and they're all laughing together, the best of friends. The man and I raise glasses to each other. This whole scene could be jolly if there weren't a death-radiating killjoy breathing moistly at my elbow.

We order some standard American dishes. Jade is inspecting the rice inside the salt shaker, holding it upside down without realizing it's emptying onto her place mat. Wearing an expression that makes me suspect that the strawberry schnapps has loosened her tongue, she raises her hand with an important announcement.

"Yes, you with the bubbles in your teeth."

"I don't care for McDonna," she says.

"Really!" I say, scandalized to my core. "Well! And what is it exactly you don't like about Madonna?"

"She too sexy in a bad way."

"Okay, I'll accept that as the statement of a tipsy, tipsy woman. Any Americans you *do* happen to favor?"

She picks up her swizzle stick with two hands and begins to turn it like a tiny corncob, nibbling its maraschino cherry all around. "I like Benjamin Franklin very much. He is like chairman of American history."

"Okay, one vote for Ben Franklin," I say, opening my large illustrated menu for the first time, even though we've already ordered. "You know what I've been meaning to ask you, though? Where's the 'chicken without sexual life'? I used to love that twenty-five years ago."

"They rename. Now call 'spring chicken.'"

"Tell me it ain't so! What about 'bean curd made by pockmarked woman'?"

"Now call 'stir-fried tofu in hot sauce.'"

"Is nothing sacred? Why would they mess with a proven crowd-pleaser?"

Jade skillfully gnaws around the cherry until there's only a spot of red left. "It so Olympic tourist don't get wrong idea. All menus scrubbed clean of so-so names."

Larry watches over us judgmentally, severe as a Spanish duenna, cracking his knuckles. I know the warning signs for when to desist, and the echo of distant ballistics is one of them. But I don't care if his disgruntlement is ethical, intestinal, or whatever. Let him stew. Serves him right.

"So," I ask Jade, running my finger down the menu. "You like the cow stomach?"

"It is very milled," she says, meaning "mild." I'm not clear whether this is a good thing or bad, in her book.

"What about pig's heart fried with pickled peppers or pig's intestines sautéed with black bean sauce?"

"I like," she says.

All this organ talk is driving Larry deeper into his funk, which is fine by me. "How's about kidney?"

"Um, good roasted!" she says enthusiastically.

"Which one's best: the black kidney in this picture or the redder one?"

"I like everything in the menu," she says. "The bitter pig's nails. The spicy chicken's ear. The stewed soft turtle feet."

"And what's this beautiful item on the back page?"

"I do not know how to speak this," Jade says after a short struggle. "Maybe it is like floor of dog? No, not dog. My error. Collie, floor of collie—"

"Collie-floor?"

"Cauliflower!" she exults. She takes another hit of her strawberry schnapps, then guffaws with a new thought. "So now we know what you think is beautiful: cauliflower!"

I decide to see if I can get Jade to open up in a new way. "Well, there are all kinds of beautiful. For instance, cauliflower's not beautiful," I say, "in quite the way you are."

As if struck in the face by a flower, Jade swiftly lowers her gaze to her drink.

"What, you don't think you're beautiful?" I pursue.

Jade breathes strangely, something between a gasp and a sigh. Her eyes look porous, like charcoal.

"Come on," I coax.

She takes one last long draw on her straw and—open sesame!—gives us all she's got, a blue streak special complete with parentheticals she must have picked up from some rhetorical master somewhere.

"Only middle level," she says. "Okay, maybe upper middle. (But not like Koreans in magazine, so stylish! I do not prejudice against Koreans, for they are a mother lode of TV stars.)"

I ask how she compares to, say, Cherry.

"Cherry is very pleasant, capable person," she says. "Definitely not spy, in my belief. But Cherry does not always smell, is her only problem. I always try to smell. Wait, do I say this right? Smeil. Yes, smile."

The food arrives. Larry takes one bite of his baby back ribs but loses interest and gestures that we should help ourselves from his plate. Jade turns her fork and spoon upside down to use as chopsticks for her mac 'n' cheese and keeps chattering.

"Mao is genius, I think. If she come back now, not dead, she be very happy, because we Chinese are so strong and so rich! (Oh, sorry for saying 'she.' In China we have no different word for the man and woman. It all one word. So I say 'he, she'—sorry!)"

"And would Ms. Mao allow Tibet to go free?" I ask, taking my knife to stab! stab! stab! through the bright glaze of Larry's baby backs.

"Of course no, for it belong to us!" Jade exclaims, also gorging herself from my cousin's plate, her face burning bright from this carnivore's feast. "It's not I *think*, it's I *know*: a fact. I am feeling strongly about this! I stick to my gun!"

"Just one big happy family, eh?" I ask, savoring Larry's bloody sauce, stuck to my front teeth.

"Is true, Chinese people are like my friendly relatives," she says. "I call any old man 'uncle' or old lady 'grandmother,' because we are one family. It too bad you have nothing like this in your country! Are you sad?"

But in fact I'm not sad. It's been a great day. We've established a rough timetable for Larry's surgery. We're on track for a new Princess. Larry's wrapped Dr. X around his little finger. I've gotten out from under Larry's thumb. My banquet toast of twenty-five years ago has come back to me intact. Nothing can wreck my mood: not even the news that it's time to take Jade back to the train station.

"But so soon?" I protest. "The round-trip is longer than the time you stayed!"

"I schlep again soon. Bullet train so fast I come and go many quickies!" She looks around bewildered. "So where is evidence for this meal?"

I hold up the bill. She tries to snatch it but misses.

"My treat," I say.

"Nice thought, but don't even think it," Larry says, snagging it from my fingers like one of those frogs with a lightning-fast tongue. It's the first thing he's said in an hour.

At the station I'm still not sad. I'll see Jade again soon. Larry will somehow come around to springing for the surgery, whatever the cost. Everything seems doable, even the notion of transplanting a living organ from one human body into another. What's the big deal? You slice it out of one person and you stitch it into another person. "Danny Boy" seems the right thing to hum as Larry and I walk Jade to her track.

"Thank you again," I tell her.

"Don't always say 'sank you,'" she says with impatience. "Normally in my country, if you are friends or you are family, you do not say."

"Oh, it's understood, like 'I love you,'" I say.

"Yes, too stupid to say."

I stand corrected. Not to say reprimanded. But nothing can wreck my mood. I push her shoulder slightly. "I nudge you," I say.

"Exactly!" she says, looking pleased as she pushes my shoulder slightly back. Emboldened suddenly, she reaches her fingertips to my chin. "I do?" she asks, touching my goatee experimentally. It's the first time she's dared to touch my face, but she must feel safe, because we're well chaperoned by our Spanish duenna. "So like wire," she says and shivers slightly. "I think this night I will have sweet dreams," she says.

I do not answer this. It's in my wedding vows.

From an invisible distance, trains chug, firecrackers ignite.

Down the lonely platform, we see a fuzzy figure all by herself, swaggering under many pieces of luggage. The poor thing must have missed her train or be lost or something. But now the figure is waving, making noises, all but yodeling to us. Let's listen:

"Larry-Mary! Mary-Larry!"

I rub my eyes. Am I dreaming? Swaying under her baggage, sweating like a rhino in Larry's mother's fur coat, it's Mary, returned from her open pit of a city near the Korean border, back to her beloved. "I bring you mashed!" she says, waving a bag of KFC.

"Huwwo, Mary," Larry says evenly as he accepts a hug without emotion. "I thought not till next week. Any case, thank you for coming."

We wave Jade off on her train. We bring Mary back with us in a cab. One woman out, one woman in.

"Danny Boy" dies in my throat. I was wrong. There *was* something that could wreck my mood.

CHAPTER 15

Knock-Knock-Knock

Quarreling is like cutting water with a sword.

So now we are three again. A new three. Group dynamics have changed. The Gang of Two rules the suite.

The only way a truce can work is for Larry and me to give each other as wide a berth as possible. Immediately we set up some house rules. The door between our two rooms is to remain closed. He seals his and Mary's room so it can stay tropically heated; I allow mine to cool at night by keeping my windows open. When we need to initiate communication, we'll use the phone. Or at the very least knock. Larry accepts the conditions, but not happily.

"You make me sound like a manipulator even to myself, Dan, as though I planned this arrangement. Did I ask for Mary and you and me to end up in the same cell block? Go home if you want. Leave me to my own devices. I don't care. I'm a big boy. I can take care of myself."

The preceding was for rhetorical purposes only; we both understand the situation. Luckily, there are still reserves of goodwill that we can draw upon, and the door clicks cordially between us. All that can be heard is the sound of the lullaby piped in overhead through the soft-speakers. *Three blind mice, three blind mice . . .*

No, actually that's not the only sound that can be heard. The passage

of hours, then days, brings further intimacies, as I discover to my chagrin that I can't avoid overhearing the housekeeping between them.

"I'll brush my hair myself, Mary.... Because I like brushing my hair, that's why...."

See how they run, see how they run ...

Mealtimes are always interesting. The din from Chez Larry-Mary usually begins with the popping open of a Coke can, punctuated by celestial screeches from Mary when she gets ambushed each time by a burst of fizz in her face. Then even happier sounds as she drops two or three artificial sweeteners into her brew and savors the result. "Goooooooooood...." Then domestic tranquillity, for a while, as they settle into their meal and work out mutual misunderstandings in their own way.

Mary: "What is?"

Larry: "McFish of some sort, except the KFC variety. Can you hand me my Blistex ... no, not my reading glasses ... thank you...."

Silence. Contrapuntal chewing.

"Mary, can you open another Coke for me? ... I would happily do it myself, Mary, if I were strong enough.... Thank you, Mary.... On the subject of fish, can you ask the nurse what kind of fish this medicine comes from? I can see from the illustration on the box it's supposed to swim in water, but—"

"Fish."

"I know that, but what *sort* of fish?"

Mary goes into a hubbub with the nurse, while the refrigerator squawks, coughs, and recovers—to come up with this answer:

"Fish-fish."

When I go to the bathroom, I tiptoe through their tropical room and glimpse them like any normal couple: he hunched in hospital robe and Businessman's Running Shoes, going through his closet, she sprawled in fur coat and hairnet, devotedly cracking pistachio nuts for him. Overheard in passing, a disquisition on his wardrobe, snatched midstreak:

Bought this jacket at a Hadassah thrift store sale in Hallandale, Florida. Fifty cents. It's thirty dollars in the catalog. Keeps the rain off, more or less. Now this clip-on bow tie I found at a Cub Scout bake sale in—

Sometimes they bicker, but usually they both show an impressive amount of patience for each other, watching the Chinese weather channel for hours in harmonious silence. After which conversation resumes in respectful tones.

"Storm predicted."

"Ummm, storm!"

"You like your food?"

"Hot."

"I know it's hot, Mary. Hot wings means hot. I like it, too."

And so forth. I don't know how he's pulled it off. Right here in the middle of the East Asian landmass, a configuration of lofty mountain ranges and vast areas of inhospitable terrain, Larry's managed to re-create the dinner-table conversations between Sam and Rivie in Lynn, Massachusetts, circa 1962.

Meanwhile we seem to be getting the runaround from Cherry. Two weeks come and go like nothing, and still there's no sign of a kidney. I decide against hounding Dr. X but think there should be some sort of progress report. "You sure the dead horse is coming to the live horse?" I ask Cherry.

"I am sure. Maybe off by just one-two weeks, because first week of October is national holiday, or some screwup possible, quite minor."

"And it's not going to leak out to the authorities?"

"Chill, Daniel. Do not ransack yourself."

Agreed: I should not ransack myself. It's high time to get the silence and space I need. Fortunately, to this end, the elevator goes both up and down.

"Hello, Saudi Arabia," I say to my friends in long robes, whom I haven't seen in weeks.

"Hello, America," they say to me. "Bush still suck, eh?"

"Big time."

"Beeg time, beeg time." They parse my words.

As usual, the women of the second floor are invisible—the Pakistani wives in blue shawls, the Egyptian mothers in head scarves and beads,

the Yemenite sisters with wide belts and swaying hips. It's the men who speak loudly, gesture broadly, pop their pecs before serving the birdie. But you get the feeling it's the women behind the scenes who are conducting life, quietly making it all happen.

Abu, my Pakistani friend, has apparently been celebrating his birthday for three days. "Twenty-six years of age!" he boasts, accepting a soup bowl of cake that his mother offers with lowered eyes. "New cake every day!"

After receiving a short scolding from her son about too much frosting, the mother mutely sidles off to resume prayers on her little mat.

"Tomorrow we cut the cake again, four days!" he promises me.

"I'll be here," I say.

"So now I show you better exercise?" Abu asks me.

"Depends what you have in mind," I say.

"You are familiar with the Vespa motor phenomenon?"

"Minimally."

"Come with me."

And for the next three hours, he rides me around on the back of his Vespa motor phenomenon, showing me a city I didn't know existed. Muslim restaurants. Breweries and textile factories. Massage parlors conducted by blind men, who're alleged to have more sensitive fingertips. Massage parlors that specialize in foot rubs with flaming glass cups placed against the soles to stimulate circulation. Massage parlors that—

"Why does your hat not fly off?" Abu calls to me from the front.

"It's well trained. It knows it won't get dessert tonight if it misbehaves," I call back.

Laughing, Abu guns it. Last stop is an antique skyscraper hotel with a crenellated castle roof, glimpsed between cloud banks of smog. Abu instructs me to walk through the lobby as though we own the place, straight to the elevator, up to the top floor where there's a stuffy old gym, 1920s vintage. A small swimming pool whose green water looks like it hasn't been rippled since talkies were invented. A wooden contraption with rollers to wring the water from bathing suits. A machine you stand in that's supposed to cook the pounds off, probably banned in the United

States a century ago. And a stationary bike that feels like you're riding a manual typewriter. But it works. The whole place is like an aboveground dungeon, with tiny windows of leaded glass through which I can see the city operating below like a toy-train village with thousands of whirring parts, all its flywheels and cogs clicking in sync. When the windows are cranked shut, it's as if a mute button has been pushed. Blessed silence reigns: no more raucously melodious street cries, no more unstoppable firecrackers. Best of all, no more Larry-Mary noise. The only sound is Abu expertly penetrating the green water as he practices his half gainers from the diving board, slick and quiet as a coin entering a pay phone. It's enough to bring me back the next afternoon, and the next. Every silent hour I spend up here, daydreaming to my heart's content, is one I don't spend with the non-silent hyphenate next door.

Then one night a phone call I wasn't expecting.

"Huwwo?"

"Huwwo."

"Huwwo?"

"Yes, is this Larry?"

"Yes, Dan, what do you need?"

"I don't need anything. You just called me."

"No, *you* just called *me*."

Beat, garbled.

"Oh, I'm sorry, Dan, Mary is telling me that she called you. She just woke me up and handed the phone to me."

"Well, why did Mary call?"

"I'll ask her. Mary, why did you call Dan and hand the phone to me? . . . Not *yes,* Mary. That's not an answer to why did you call . . ."

"Larry—"

"Not *sure,* Mary. Not *uh-huh,* Mary. Why. Did. You. Call. Dan."

"Larry, does Mary need something from me?"

"I know he's my cousin, Mary. Mary, stop! I don't *want* a pedicure! [*Garbled*] Because I don't *care* for a pedicure, Mary, it's as simple as that."

"Larry, listen, why don't you call me back when you get this straight-ened—"

"I *am* being patient, Mary. Do you hear me raising my voice, Mary? Do you see me raising my fist?"

"Larry, it's four in the morning. Can we maybe resume this an-other—"

"DAN!? DAN!?"

"Yes, Mary," I say as Mary takes the phone, "there's no need to shout."

"DAN!? LARRY NOT MARRY ME!"

"He's not marrying you, Mary?"

"NOT MARRY ME AT ALL!"

"Okay, Mary, let's talk about this in the morn—"

[*Click.*]

Knock-knock. In the morning I go to Larry's room, and we do talk about it—a powwow between distant allies who have no particular warmth to pool but do have business to conduct. Then again, Larry's room has a *lot* of warmth to pool.

"So the bridesmaids' dresses are on hold?" I ask, fanning myself with both hands, kicking pistachio shells out of the way as I sit on the molded-plastic school chair.

"Don't get me wrong. Compatibility remains high," Larry says in a monotone that's more mono than usual. "As a matter of fact, I believe I may be falling for her, somewhat violently. Just look at her preparing my pistachios. She lines up the piles so all I have to do is delve. I'd like nuff-ing better than to do right by her, marriage-wise. It's only the trust issue I'm continuing to monitor."

"Anything in particular bothering you?"

"Not to the best of my knowledge," he says, squirting back a blast of nasal spray and blinking at me blankly.

"But I mean, you wanted to talk—"

"Oh, I see," he says, his concentration coming back. "Yes, in that case,

one thing. As you may or may not know, Mary is very diligently studying the English workbooks I got her. But the other day I offered to buy her English-language CDs that she could play on her computer at home, and she told me she didn't have a computer."

"I fail to see the signifi—"

"Dan, don't you remember? I sent her three hundred and fifty dollars to buy a used laptop a year ago. It was one of the first transactions between us, and she was most appreciative."

"Oh," I say, my heart sinking. "I see. So you're saying—"

"That she pocketed my money."

Why do I feel my heart aching? Not because I like Mary so much, but because Larry was so happy with her for a time. I could count the missing teeth in his smile! Wouldn't it have been great if she and Larry could wander off into the sunset together, arm in arm? The Larry-Mary military-industrial complex forever?

"I'd like to work things out between us, but only if I conclude she's not using me to ride my passport to the promised land. And for my part, I want to make sure I'm falling for her for the right reasons, not only for the way she tends to my laundry needs, though she continues to do that like nobody's business, including my most intimate apparel."

"But if she does your knickers while taking *you* to the cleaners, that doesn't seem to be a very good trade, Larry."

"But I'm impaired! I'm not sure I can trust my judgment. Am I genuinely fond of her, or am I only rescuing her to assuage the guilt I feel for letting Judy slip away?"

I don't know: The whole Judy question is a difficult one for me. As is the question of how comfortable Mary has become with me—comfortable enough to sit there wearing pantyhose with no skirt so I can't help seeing that her panties are valentine red. A new tune warbles forth from the softspeakers: *Jack and Jill went up the hill to fetch a pail of water....*

"Is she still giving your credit card a good workout?" I ask.

"I don't mind her using my credit card. In fact, I encourage it."

"Because it'll atrophy if it isn't exercised daily?"

"Ha ha, good one," he says without smiling.

I look at Mary dividing the pistachios into various piles for Larry to enjoy. "Larry, I have to tell you, all you're saying sends up red flags to me. Did it ever occur to you that she might have stolen your passport that first week, sold it to the black market, or worse?"

"What, identity theft? No, I have to admit that never occurred to me, but it's not that far-fetch—"

He interrupts himself. "Mary, that's more than enough piles, thank you. Could you call the nurses' station and ask them to send us a fan? I want to make Dan as comfortable as I can. A fan, a fan?" He makes whirring motions with both arms until Mary grasps what he means and tentatively picks up the phone.

"Another thing," Larry says to me. "For the first time, she appealed to me directly for money, sixty-six dollars U.S. That rounds out to five hundred RMB."

"Did she ask for sixty-six dollars or five hundred RMB?" I ask.

"Sixty-six dollars. Sounds smaller that way," Larry says. "Clever girl."

Meanwhile clever girl is talking to the nurses' station. "Call . . . fan. Call . . . fan," she's saying into the receiver. With her other hand, she undoes the top of her fur coat to let a little air in.

"What's with the crucifix, by the way?" I ask Larry, seeing it glinting there in the opening. "It's more chic than an air freshener, I'll give you that, but did she become Catholic all of a sudden?"

"As far as I can make out, it's more a good-luck token than a fashion statement," Larry explains unhelpfully. Mary gives up on the phone and sets herself to new, non-pistachio-related business.

"So how'd you respond to her appeal?" I ask him.

"I gave her half. I gave her sixty-six dollars," Larry says with satisfaction. "Two can play this game."

"Larry," I say, "that's whole. Sixty-six is whole."

Larry thinks about this. I expect him to say, "Oh, sorry, my head." Which would worry me enough. But instead he says something that worries me more. He says, "Look how she's going after my blackheads now. *Bofe* shoulders. Try getting an American girl to do that."

"Larry," I say, gripping him on his soft arm, "I need you to know this.

My jury's really out on this person. Starting with the fact that she's not who she said she was."

"Few of us are."

"But think about it. Maybe all we need to know about her is that she claimed she was five foot two?"

"Or maybe that she keeps taking a ten-hour train ride to save me airfare?"

"Or maybe that she said she was fluent in English?"

"But she bought me bananas the other day," Larry counters. "Not that I could stomach them, but still it was a nice gesture, I felt."

"Hmmm," I say, holding up my hands as if weighing two sides of a difficult equation. "Bananas, fraud; fraud, bananas."

"Her language *is* improving," Larry says.

"I'll take your word for it," I say.

"She's sacrificed a lot for me, being here so many days."

"And been well compensated for it."

"She's willing to look after me all my life."

"Which you hopefully won't need, since getting you back on your feet was the idea for coming here. Larry, her name's not even Mary, maybe that's the long and short of it."

Mary doesn't even look up at the sound of the familiar syllables. I feel like we're conducting a test for a deaf person in an old movie.

"Do you think maybe she's retarded?" Larry asks me then. "Maybe that's where I got the erroneous idea that her son was retarded, because I'm pretty sure the word 'retarded' was in there somewhere in our early negotiations."

I reflect on the acrylic sweater that Mary recently bought me with Larry's credit card, of questionable use in this stifling heat. "It's an attractive supposition, but I don't think—"

"Fan!" Mary announces with sudden impatience. "I get now me!"

The second she's out the door, Larry begins pointing to the corner behind the dresser. "The stash is over there," he says with no emotion.

"Stash? Oh, come on, Larry, we're not in *enough* danger without you deal—"

"Not that kind of stash," he says. "Mary's stash. Look."

I've seen animal stashes before, where squirrels stockpile parts of nuts along with stray twigs and bottle caps, and that's what this shopping bag of hospital throwaways resembles. Gauze pads. Rubber bands. Shower-curtain rings.

"I don't know what to think," Larry says with some embarrassment, as if the quality control is far below his standards. "It's like we're on the same page about so many things, but then I see her hoarding these things away."

"Could she possibly be hoarding them for *you*?"

"Except I'm not in the habit of using Tampax," he points out. "Plus, there's the issue of the phone bill. . . ." Larry hands me a receipt that totals four hundred dollars for the past two weeks.

"Just from the phone in our suite?" I say, pocketing the bill in disbelief.

Suddenly Larry seems to sag, jellying down in defeat. "I've had it with this country," he says. "I'm so sick of the pillows, they're like beanbags full of I don't know what, kidney beans maybe, that crackle under my ear."

"Really? I kinda like 'em."

"I have no doubt you *do*. I *don't*. You have the security of the upper middle caste, so temporary squalor may not bother you, but it does bother me. I just want to go home. Everyone sounds like Desi Arnaz. When I want something, they say uh-huh, uh-huh, and nuffing happens. I try to tell myself it's not so different here, but then I see something like hospital administrators in a conference room Dancercising with Chinese fans, and it throws me. I don't want to sound ungrateful, Dan, it's just that I come from America, the toilet-paper capital of the world, and here I have to mime to wipe my ass—"

"I brought us some new rolls this morning," I remind him.

"Gee, just when I was getting used to using the paper money," he says. "But seriously, the M&M's don't taste the same, nuffing's the same, everything tastes like China. And you know why everyone squats in this country, Dan, instead of sitting? I finally figured out why. It's because

every single spot has been peed on. Think about it: For thousands of years, millions of people have finally managed to hit every inch. And have you noticed how everyone keeps saying, 'nigga nigga nigga—'"

"That's just a filler-type word, Larry. It's the equivalent of our 'mm-hmm.'"

"I'm not judging, Dan. I'm just saying it offends me. I'm doing my best not to say 'Chink,' and this is how they repay me, by getting to say *that*?"

"Okay," I say, "but to be fair, none of this is Mary's fault."

"It's all part of my horrible China experience," Larry says. "Plus which, I can't get a word out of Mary about her family. I don't know if they're a bunch of opium addicts or what. And her health is iffy. Apparently she's had swelling of the ankles for two years, but she won't let me get anyone in the hospital to look at them. So what it all boils down to, I can't trust my database of emotions anymore. You're supposed to be my sous-chef or whatever the term is—what do *you* think?"

A pause while I get to watch Larry clean the inside of his ears with a piece of hardworking tissue paper before depositing it in the orangey remains of his McFish chowder. Motorcycles pass by on the street nine stories below, sounding like a parade of broken lawn mowers.

What I think is, Mary's come back with a fan. Against all odds, she's not carrying a vacuum cleaner trailing a river of lint, or a stovepipe ripped out of some peasant's hut, or a diseased dachshund she's planning to cook. She's bringing in a real live fan, and she's plugging it into a real live socket. That goes in the credit column. But what I also think is that there's this thing Mary does with her mouth that's not pretty, like she's getting ready to spit pig's knuckles out on a tablecloth. I also think that every time we've shared a taxi, she makes Larry slide across the backseat, instead of letting him sit where it's easiest for him and going around herself to the opposite door. I also think that from the beginning she's always gotten us lost in this, her country; that she smells like she's been sneaking into Larry's Aqua Velva aftershave; that she talks on the phone to people in low tones, and when, to be conversational, I ask what she's talking about she says, "Talking bout."

And she looks like she's lying.

"Well?" Larry says.

Okay, what I *really* think is twofold. Number one, I think I ought to investigate candeyblossoms.com myself. Because in case Mary isn't going to pan out, I could better advise Larry if I have a sense of the field out there.

Larry agrees. "Take it out for a spin. Try running Shi and see what you come up with. Just make sure you limit your search to ages twenty-five to thirty, or you'll be completely overrun. Oh, and be advised that in their profiles read 'mistakes' as 'kids.' If they say they've made three mistakes in life: three kids."

I log on. I'm not going to lead any of the women on or set up a date; that would be worse than viewing time-sharing solicitations solely to collect the free gifts. It's unethical to waste people's time. But there's nothing wrong with swapping a little screen info for educational purposes, is there?

Then, with a click of the mouse, there they are—like when my childhood pet hamster produced babies—a sudden rush of vulnerable bodies: so many candey blossoms that they threaten to litter my hard drive. Is that what they are, these Third World brides, just so much helpless brood? Or are they sophisticated young ladies availing themselves of modern technology? It's an exploitative situation to be sure, but don't both parties get something out of the deal?

Enough so that it's worth a try, I guess. . . .

"Hi, Zhang," I type. "Can you tell me a little more about yourself? Would you say you're a giving person? Are you kind to those less fortunate than yourself? Have you ever had nursing experience? Hope to hear from you soon!"

I can't bear to stay on longer than a few minutes but leave the Web site open on my laptop, like leaving a fishing line dangling in the water.

The other thing I think, number two, is that I should ask Jade about the trust issue. This is something I won't tell Larry about—it would only

launch us into a proxy war, Larry and I sparring through our women: Mary versus Jade in a mud-wrestling pit. So I say nothing, wait till I'm alone that evening, and make the call from the second floor, where the Badminton Boys are going at it with macho brilliance.

"So what's your opinion of Mary's employment history?" I ask Jade. I've reached her on her cell at a girlfriend's harmonica recital, and she's speaking in a hushed voice, as I am.

"I cannot say, really," Jade says.

"I know, but do you think she's capable of holding down any sort of school job at all?"

"Yes, a little unbelievable, I think. And to take so many days away to be with Larry? I have a bad feeling about that."

"Me, too."

"Good chance she is lying," Jade says, becoming more direct. "Some Chinese ladies want to cheat money from foreign, it's torrible. As women Chinese citizens, we lose our Chinese face. I want to say sorry for that."

"Ah, well, it's not your fault—"

"So I think I can spy for you," she says quietly.

"Spy for me? You mean like bang, bang, your fantasy career?"

"I can try," Jade says. "Be private eye, find out what I can about Mary. I will call her school and say I am poor student, looking to speak Mary to ask job."

"You cauliflower!" I cry. "You'd do that for us? And what do you think about the phone bill she's run up?"

"This you not tell me about yet."

"Four hundred dollars from our suite, just for the past two weeks."

I hear Jade suck back her teeth bubbles with a sharp intake of breath. "How big the bill is!" she exclaims. "She must be call at least two hour each day, maybe when Larry is snoring. Who she can call for? May be another man?"

Whoa, really? A plastic birdie ricochets off the wall onto my head. Handing it back to Abu with a wink gives me time to assess this suggestion. "Another man?"

"Such a bill is too big if you call your relative. Only to lover we say so

many words. But this is only my guess, not a fact. We can ask hospital for detail of the bill, see which phone numbers?"

"Got it right here," I say, scanning the bill quickly. "There's one main number that keeps popping up, to 04317137130. Do you want to call the number and see—"

"—if she lying wholesale," Jade completes my thought.

"Bang, bang!" I say. I'm thrilled to have my own personal spy but am held back by one qualm.

"Before we jump the gun, though, are we sure we want to intrude?" I ask. "I mean, maybe Mary will turn out to be okay even if she does have ulterior motives. People are complex! So what if she met him only to make a better life for herself? Isn't that a legitimate thing to want to do, as long as she genuinely cares for my cousin, which she seems to do?"

"No," Jade declares. "The large heart of Larry, she will hurt it, definitely I think."

It couldn't be any plainer. Maybe it's time I stop giving everyone the benefit of the doubt and just accept that life is sometimes as clear-cut as a badminton game: The birdie lands either fair or foul.

"Well, anyway, your pronouns are coming along nicely," I tell her.

"I am learning the difference between man and woman," she says with a catch in her voice.

"Uh-huh," I say.

And that's all I say.

Later that night, just as I'm crawling onto my couch to sleep, there are three loud knocks. I open the door to Larry's room. But the Larry-Mary conglomerate is fast asleep. I'm back on the couch twenty seconds later when there are another three knocks. It's my laptop, receiving nibbles from the Web site I forgot I left open: instant chat invitations. Barbi is thirty, from the suburbs, drinks occasionally, smokes not at all. But huwwo, what's this? Is that a whip she's holding? No, a microphone cord. Sure enough, one of her passions is karaoke—not as piquant as S&M, perhaps, but I'm not privy to Larry's requirements. KNOCK-KNOCK-KNOCK: My, my, now here's ShiJen, a nimble little typist. Her messages come racing in one after the other. Insistent, too. "U there? U

want talk? U busy chatting? U find someone else?" Then KNOCK-
KNOCK-KNOCK: Messages from more women come tumbling in un-
summoned, one on top of the last, no waiting in line but cutting in front
of one another to pound the door down. KNOCK-KNOCK-KNOCK:
It's "Hiedi," snuggling with about thirteen teddy bears. I decide not to
care that she misspells her own name. KNOCK-KNOCK-KNOCK:
It's Kate with an eye patch, no stated religion. Her bio is rather touching
in its brevity: "Well. jst simple lady hoping for love jst ask
me what u want to know. . . ." KNOCK-KNOCK-KNOCK—

Ah, the world's needs. When do they *not* threaten to drown us all?

CHAPTER 16

Thousand-Year-Old Panda

A fall into a ditch makes you wiser.

CRAAAAACCCK! A peal of thunder. Thank heaven, a storm's on its way—only a tempest could break this infernal heat wave. I'm sweating in my skyscraper gym with leaded windows closed, relishing the solitude as I ride my manual typewriter of a bike while Abu sluggishly practices his half gainers. Bring on the rain!

But the afternoon remains oppressively bright. I resume the thought sequence I was in the middle of before the thunder hit: wondering if Burton's guilty. Did he do anything to deserve Larry's fatwa? And would he really try to stop this operation if he could, in the misguided belief that it would end his troubles with Larry? I'm not in a position to judge, but I do know that Burton's always been honorable in his dealings with me. He's been nothing but upstanding, loyal, and generous. Also, Burton has devoted his life to healing thousands of brain ailments and is beloved by his community at Harvard and an army of patients. But then again, I've always known Larry to be honorable, too, in his fashion. He made a point of always paying back my loans promptly and in full. Except that one time he didn't. I wouldn't say he stiffed me; I'd say he didn't pay me back promptly and in full. It's possible he figured he paid me back in other ways. For the condo he convinced me to buy as an in-

vestment, I had trouble evicting a certain tenant who didn't pay rent for almost a year. Larry took it upon himself to call the tenant a name to her truck-driver son, for which Larry received and returned several body blows. Perhaps in his mind this was worth the grand he owed me? We never discussed it in so many words, but when I asked for my grand back, that's when he ratted me out to the FBI. Maybe there was a similar misunderstanding with Burton? Or maybe Larry resents Burton because he helped so much with Judy's epilepsy; Larry's constitutionally incapable of not biting the hand that feeds him? Who's to say? As in most family feuds, there are few truths we could take to the bank. A homegrown Inscrutable.

Bzzzz, bzzzzz! It sounds like a bumblebee caught between windowpanes, but it's my cell phone vibrating angrily on mute. I let my wheels coast to a stop, lazily pick up the phone, and get an earful of screaming.

"DAN, LARRY HORT!"

I reel back from Mary's voice as from a blast of ammonia.

"LARRY BLOOD!" she screams again, telling me that Larry has escaped the hospital again, only to take another spill.

CRRAAAAAACK!—another thunder blast. The atmosphere feels electrically charged, and when I crank open the leaded window, I see that the afternoon has blackened, at the mercy of a crackling downpour. Down below, the toy-train village of Shi looks defenseless, honking furiously to itself in a state of paralysis, its cogs gummed up by the rain. My cousin's lying in a street out there somewhere, and in a minute Abu and I have gained the front sidewalk, observing the bottleneck.

"A cab will be quickest, see you later," I yell to Abu, jumping into the backseat of a gaily decorated vehicle. But it's a police car: Two frightened-looking officers gape at me from the front seat. "Sorry!" I say, jumping out again.

"Take this," Abu says, holding out the key to his Vespa. "It will be quicker for only one."

In a minute I'm racing through wet side streets, away from the bottleneck. It's all clamoring chaos: Sirens wail, strobe lights flash from the tops of ambulances as their drivers shout for right-of-way. Larry couldn't have gotten more than a few

blocks from the hospital, I figure; maybe he was heading for a familiar landmark. The duck restaurant! I'm like the worst or best of the Chinese drivers I've been marveling at all these weeks, weaving the wrong way down a one-way sidewalk. Half a block from the duck restaurant, around the corner from the hospital, I locate Larry lying in his hospital gown in the middle of the street, flailing like a beetle on its back. Everywhere I turn, Mary's in my way, blithering idiotically. I place her aside and approach. Not knowing friend from foe, Larry stabs me with his KFC spork. I kneel in a puddle to subdue him, slosh the rain out of his eyes, peer directly into his face till he recognizes me.

"Huwwo, Dan, thank you for coming," he says, like he's hosting a craps game in the back of a strip club and is pleased I'm able to make it. "You look buff. Been working out?"

"Larry, what the hell's going on?"

"I've been up since four trying to figure out exactly that. I'm quite baffled. What a night," he says. "My back is in spasm. . . ."

I use the momentary calm to coax him up. Mistake: It sends him into another frenzy, waving with his plastic weapon, clawing at my legs with his Businessman's Running Shoes. A piece of paper's in motion—the nun's letter from back home. "Help! Someone!" he calls as traffic honks and weaves around us. "VIP in need!"

"Settle down!" I shout, using my weight now to keep him in place. A couple of soldiers approach with faces so blank they're scary. "No, no, we've got it," I call to them, blocking their approach. They hesitate, unsure whether to take offense or back off. Soon they're gone.

"Larry," I say sternly, "it's dangerous to make a scene like this—"

CRAAAAAACK! The storm's right on top of us now. The duck restaurant chooses this moment to begin broadcasting Peking Opera from its sidewalk speakers.

"I'm leaving," he says through gritted teeth. "I can make my own way to the airport."

With an adrenaline boost, he manages to wiggle out of my grasp, stands bare-assed with tubes coming out of him, the back of his hospital gown soiled.

"Larry, didn't you put yourself in my hands when we got to this city?"

"Sue me," he says. "If it's one thing I've learned in life, it's—"

He interrupts himself to spit out a tooth. Now there's even less of him to save;

nevertheless, his body seems to be cooperating. His blood's scabbing up, the color of root beer; his legs are allowing me to assist him down the sidewalk in a daze.

"Larry, promise me you'll never pull a stunt like this again. Do you know how many germs you could catch outside the hospital in your state?"

"You know how many germs I could catch inside?"

I'm trying to keep him on his feet, hobbling him toward the hospital. His blood, his Brylcreem, it's all over me.

"Larry, why do you keep fighting me every step of the way?"

"All due respect, you've exceeded your authority, it's my call, case closed. What do you care anyway? I'm not trying to cheat you out of a dime."

All the ancient paranoias bubbling forth from a bloody mouth, the Old World recriminations

" . . . your girlfriend Jade . . . your boyfriend that raghead . . . gooks and dinks . . ."

I shake him, not lightly. "Larry, it's time to show a little gratitude to everyone who's put themselves on the line for you."

"I disagree."

"It's not a matter of disagreeing, Larry."

"I disagree, that's all," he says. "I'm doing what you said in the microphone."

I stop.

"What mike? When? At your bar mitzvah? I thought you didn't remember what I said."

"You said fuck everyone there, they were just a bunch of hypocrites and goody-goodies, and you didn't want anything to do with them. That's what I'm saying, too. Fuck 'em all."

I blink at him, aghast. "You think this is junior high, Larry? You're rebelling against the teachers? This is China with world-class surgeons!" I yell. "We've come halfway around the world and jumped in front of God knows how many people to get you a kidney, and you're fucking up the whole thing!"

"No offense, Dan, but you don't know what it's like being me, putting up with what I've had to put up with."

"Larry, better people than you and me are dying all around the world right now because they don't have the money or the energy to find a kidney, and you dare say fuck 'em all? You know what you are, Larry—you're an ingrate!"

"Fuck everyone, Dan. I'm just repeating your words."

"Larry!" I cry, disgusted. "I was fifteen years old, for God's sake! I grew up! The rest of the world is not the enemy! Yes, life dealt you a bad hand! Get over it! You're being given a second chance here!"

"Easy for you to say, Dan. You had all the privileges."

"You're right!" I say. "I did have all the privileges. That's part of the reason I came here with you, to even the score a bit. But you know what? It was a mistake."

We're at the hospital, and I push away the doorman who wants to give me a hand. Mary's trailing us weeping hysterically, flailing her arms and shaking more raindrops.

"Keep fighting everyone," I say to Larry. "Keep your precious feud with Burton. I don't care anymore. Mary, get a wheelchair for him or don't, I'm done with this fool's errand. It's a lost cause and has been from the beginning."

I leave Mary and Larry in the lobby and split.

Whoa, *serious* daydream. I must be in *major* need of escape. . . .

What actually happens is nothing so dramatic. Nor does it need to be dramatic to set me off by this point. All it would take by now is for Larry to look at me sideways and I'd be ready to bail. Larry falls on the street again, that's all: I get a call in my gym from Mary and agree to meet her at the hospital while he gets cleaned up. But it's the last straw for me. Abu drives me back in the oppressive brightness—the storm seems to have avoided us—and in a few minutes I'm in the Family Crush Room off the lobby, on the phone with the airlines to schedule my flight home. I'm disgusted with myself as much as with Larry, for my obscene sense of entitlement—that I can just arrive here with nothing and expect a whole country full of people to stop what they're doing and fetch me a kidney. What a spoiled American. Talk about a sense of privilege. Give me a kidney, world! And to think a kidney would fix him in the first place. Larry's a mess. The truth is, there's very little left of him to save. Not enough for me to bother. I'm washing my hands of the whole thing.

I'm on hold when Mary finds me. My first impulse is to hit her.

"And you!" I say. "Great help you've been. Why didn't you stop him from leaving the hospital?"

"Dan, I cannot do! He big boy, do what he want."

I'm ranting. "Mary, he's not worth it! Why would you even want him for a husband?"

And then, it's the last thing I expect, but Mary is angry, too—every bit as much as I am.

"What *you*!" she yells, rounding on me. "You do this for nice China adventure. You tell friends you big hero, you save cousin's life, but you telephony."

"Oh, I telephony now," I snicker. I'm bullying her with my language, trying to intimidate her into shutting up. "What're you trying to say—that I'm a phony? Yeah, that hurts, coming from the person who steals medical gauze from the hospital—"

"It poor where I come from, you no understand—"

"Who lies about working in some godforsaken school—"

"I *do* working in school—mechanical draw! Good job, no computer skill but T square, hold head up high—"

"Yeah, then why didn't you tell us the truth?"

"Because you will laugh like always laughing at Larry, big joke, ha ha, even sick, even mix up. But you send spy on me, call supervisor and get me in trouble—"

"Oh, like you didn't deserve it, poor you who makes secret telephone calls to another man. Yes, hello," I say to the airline, off hold at last. "I'd like to make a reservation, Beijing to New York, if you have a seat for tomorrow—"

Mary lurches forward suddenly and smacks the cell phone out of my hands. It hits the floor hard and shatters against the tiles.

"That my son I telephone call!" she screams. "He lose job, very frighten, you not know because you safe American. But it hard to live for people! Not everyone fly around world, say give me this, give me that! That my son I telephone call!"

When did she learn to speak this well? Despite myself, I'm impressed

with her vocabulary. She really has picked up a lot of language the past few weeks, studying her manuals.

But she's not finished with me, coming up so close that I'm almost physically threatened for a second. "Why you no give kidney?"

"What?"

"Why *you* no give kidney to Larry?"

Suddenly I feel ridiculous, holding my hand out like I was still gripping the phone. I kneel to pick up the casing, stand unsteadily. "It's doubtful our DNA—"

"See you phony? You not even take test to try."

She's right. I've never really considered offering my own.

"You take big trip, go everywhere outside, but never go *inside,* never go *here.*"

She pokes me in my lower abdomen. I'm shocked by the contact. It's a sensitive spot.

"Ouch, my kidney—"

"That not even right place!" she scoffs. "You not even know! Kidney in back, that where they take it, put new one in front, right here."

She prods me again, same spot. "You worse than Larry," she says. "Larry is what he is, but at least he not pretend he big hero. . . ."

I'm withering under the truth of her attack but try to fight back. "What about you?" I say, trying to match her volume. "Why don't you give him *yours?*"

Mary steps back, shows her teeth in a smile or a grimace, I can't tell. "Larry no want me to, say too risky," she says. "But you his cousin, Dan, in family of doctors, no excuse. . . ."

I'm speechless. I can mount no defense as she softens her tone.

"Why you think we all have two?" she asks me. "One is extra, for giving."

It strikes me as startlingly true, the obviousness of it. I don't know what to say.

"How can you leave your Larry, Dan? He say you good man, you kind man. "

"He does not."

"He say you kindest man in world. "

"Bullshit. "

She clutches me by both shoulders, resolutely. "He says you his big brother, that you only family left. . . ."

I charge into Larry's room, where the nurses are cleaning his surface wounds. "What do you mean I'm kind?" I demand.

"To me you are."

"Fuck that. If I'm so kind, why'd you never ask for a kidney from me?"

"I would never presume."

"And Mary?"

"I would have declined if she offered. She has no health insurance where she comes from, deficient medical care, she can't put herself at risk. Matter of fact, I should forbid it in writing, in case she gets any crazy ideas."

He looks around for a pen, but the Kleenex box with all his worldly goods is nowhere to be found. That's okay, he's made his wishes known. Cherry is here to witness his decision, should it ever come up again.

"But you'll notice that I'm a fair negotiator," he says. "I'm not making this veto without giving you something in return. So tell you what, I'll yield on the question of surrender."

"What do you mean, surrender?"

"White flag, peace pipe, laying down of arms. No more fighting you—I swear on my mutha's grave."

The decision made, he gives himself up to exhaustion, a kind of self-liberation. The act of capitulation is so enormous to him that it amounts to a kind of deliverance; he can't keep himself from making sounds of re-lief as I discuss the situation with Cherry. The whole time she and I are talking, Larry drops his own comments in: "I'll let you people decide." "Whatever you say." "I defer to you." "I won't stop you." "I'll let you talk in peace."

With a wink to me, Cherry leaves the suite. Mary is off nursing her

pride somewhere. At last Larry and I are alone. His surrender proclamation's so monumental to him that he still feels he needs to explain himself.

"All my life I just wanted to assert my independence."

"I know you did, cuz."

He looks a thousand years old, like a thousand-year-old panda, so weary of the world and its nonsense. No, he looks worse than that: What he looks like is just another patient, biding his time in a dirty Yankee uniform.

"That's why I kept leaving the hospital," he says. "It was me demonstrating that I could make my own way."

"I understand, Larry. You don't have to explain."

"When I'm having a fear reaction, that may be the only thing I can do. I don't know what else there is *to* do. But I agree it would be ironic if we were to come all this way for a kidney, only to be struck dead by a Chinese bus."

"It would be more than ironic, Larry, it would be dumb as hell."

"Look at the abrasions on my arms," he says, clucking at himself as if at the foolishness of a minor who's seen the error of his ways. "We'll have to get me healed up."

"We will, Larry, we'll get you good as new. It's just . . . we have it within our grasp now, and you don't want to pay."

"I'll try to pay."

"You mean that?"

"I hope so, Dan. I hope it doesn't come in too high, but I'll do my best to pay."

"You won't go back on this, Larry? Because I can't babysit you 24/7. I've got my own babies at home that I've put on hold for you."

"It's done, Dan." He breathes peacefully.

I believe him. Because, like everything else about Larry, it's contagious: I find myself in surrender mode, too. In the semi-dark of the hospital room, with the sheets draped up and surrounded by pistachio shells, I sit by his bedside in silence. On the TV variety show flickering in the background, a Chinese Jackie Gleason is trying to talk on a red-

hot telephone. There's lots of canned laughter at low volume, but we've learned to tune it out.

"Thank you, Dan. I don't know if I've told you this before, but thank you a hundred times."

"Friends and family, you don't need to say, Larry. It's understood."

"I'm sorry, Dan."

"There's nothing to be sorry about. You're doing the best you can."

"No. I mean . . . for everything. Getting sick and being such a bother. I never meant for this to happen. I always thought I was going to make a million dollars and be in a position to take care of everyone else in the family, not have someone in the family take care of me."

"You just rest, Larry. You've lined up a great surgeon, and I'm going to be with you every step of the way."

He lies there, the vein in his neck pulsing so delicately as the Chinese Gleason keeps almost scalding his mouth on the red-hot phone. Now there really is a thunderstorm outside, not a false alarm but the real thing. It's drenching our windows, and I'm glad we're safe inside our cave.

"You know one thing I don't get, Dan?"

"What's that?"

"Why you agreed to come here in the first place, after what I tried to do to you with the FBI."

"Water under the bridge, Larry. C'mon, it's a no-brainer. Your cousin's sick and you have the power to do something about it? Then what's the question? You do it."

He shakes his head, beyond him. "I guess you're better in the forgiveness department than I am."

"You kidding? I hold grudges worse than anyone. I'm just being . . . unpiglike. I've got a good life—how could I not help? And stop looking at me that way."

"What way?"

"With stars in your eyes. Save it for Chinese mothers who find it in them to forgive Red Guards for stabbing their babies. For people who really *do* donate their kidneys to save their cousins. What I'm do-

ing should be standard operating procedure. It's like you saying that being an organ donor should be our default. Same deal with helping each other—helping should be our default. If I *hadn't* lifted a finger, *then* you could ask me why."

He takes this in quietly, as the rainstorm drums against our window. "Funniest thing," he says. "When I was outside before, freaked by all the signs as usual, I realized that I'm as lost in China as my futha was lost in America. Now I know what he must have felt like, not being able to read the language."

The Chinese Gleason dumps the phone in a bucket of ice water and smiles with relief.

"I'm telling you, if I come to terms with my futha, that will be an added bonus of this trip, even if I don't get a kidney. Imagine: a reconciliation, after he's been dead twenty years."

"Better late than never," I say.

Outside, the lightning flashes, the thunder booms. On TV a new act: A policeman in a girdle and wig cries as he tries to explain something to a judge. Soon all the girdle-and-wig-wearing policemen in the courtroom are crying. The flood level rises to their knees.

"Know what I think, Dan?" Larry says.

"What's that?"

He looks at me with panda eyes. "I think you're sort of a black sheep yourself. Not in the traditional sense, maybe, but—"

"Baaa," I say, silencing him. "And you know what *I* think?" I say.

"What?

"I think I came here because I love you."

"I understand."

"I never said that to you before, and I don't even think I knew it before this moment, but that's why I'm here."

"I appreciate that. Thank you."

That's all. Only time we ever broach the subject. Mary's right: I cannot leave my Larry. I don't know how long it'll take or what it'll cost, but we'll see it through together. Side by side in the semi-dark, with the flood of tears in the courtroom rising to hip level, we wait.

CHAPTER 17

Fate Make Us Together

Govern a family as you would cook a small fish—very gently.

The thunderstorm seems to have chased summer out, and the October air is clear and cold. The call could come at any moment—we're poised to spring into action—but the passage of time has actually made us less clutchy, curing us somewhat of our frantic American impatience. A kind of temporary peace has settled in. In our newfound forbearance, Mary's fur coat makes sense all at once; I never understood that it could get chilly here. Even the acrylic sweater she gave me comes in handy; I wear it every day. Gone is the totalitarian pollution—there are gaps in the one-party smog—which I was actually getting fond of. That luscious ivory-gray smoke, with its tinge of fish stink, it's become part of me, and me of it: We've been respiring together, China and me. Larry and I have been in Shi five weeks, in China a total of six, and without warning we're witness to a lovely succession of serene, cloudless days, so clean we can see the tops of buildings at last. There they are, the uppermost windows with the shades wide open. It's like having been held captive by someone who finally decides to be your friend and whips off his mask so you can see that his eyes are startling blue—like Larry's!

For Larry has undergone a transformation, too. In the past six weeks, he's been yanked away from everything safe and reliable in his life and

been exposed to trauma and fear. Broken down to his core, it's like he's been depatterned so he could be reprogrammed. Long story short: He's sampling parts of chicken that have not once in their lives been encased by KFC Styrofoam.

"Even if I don't care for the food, it's always arranged nicely," he concedes.

But he *is* caring for the food! He's switched loyalties from KFC mashed potatoes to Chinese sticky rice and has developed a hankering for Chinese eggplant. He even shows remarkable aptitude for chopsticks.

"Hey, you're okay with those things," I say.

"You eat enough takeout, eventually you pick up chopsticks," he says.

Of course, "remarkable" is a relative term. Truth to tell, he uses chopsticks like a toddler uses paintbrushes: one in each hand, and both operating independently of each other.

But there's no gainsaying his palate, which continues to prove far better than mine. We play a blindfolded tofu-testing game, and he blows me away. He's letting down his guard in other areas, too. He relaxes enough to skip shaving on the days he's scheduled for dialysis, figuring that the procedure is draining enough without his needing to get groomed for it. (To pick up the slack, I've taken to shaving more frequently, in case Dr. X decides to bestow a kidney on someone with a more reputable-looking companion.) Larry has also stopped begrudging me the time I spend with the Badminton Boys, even though he still contends they represent the competition ("kidneys don't grow on trees," he says, and he's right). It's all part of the general world change brought in by autumn. Fewer firecrackers are being sounded, as China gets back to business after its holiday season has passed. The dewy, stalwart Jade comes and goes several times with quickie visits, making sure all's running smoothly for us. No more beaten-up toenails are on view, because everyone is thickly shod. Summer's over.

Meanwhile, in what may constitute the greatest change of all, Mary is adding what Larry insists on calling a womanly touch to our cave: arranging his clothes according to season, sweeping his discarded pis-

tachio shells into corners, even bringing a pet into our lives, sort of—thumbtacking onto the wall a scroll that features a goldfish that's way too big for its bowl. It looks like it barely has room to turn around, but Mary says proudly, "We make nice home for him . . . and we, too!"

Yes, her English is improving. She immerses herself in her workbooks and now understands perhaps every fourth or fifth word Larry says. It's not perfect—she's still capable of breaking into squalls of laughter when asked how her parents passed away—but there's enough common language between them that they can have a conversation like the following:

"Larry, you like so many food! Lunch and every day dinner, many!"

"I even eat the soup you got me, despite the floaters."

Mary is proud of herself. "I order! Me!" But mostly she is proud of her beau, beaming over him like a mother panda at her cub. "Big apple-tite!"

Larry chuffs on orange soda going down the wrong way. "You should have known me in my prime, Mary. I could walk into any McDonald's in Florida and eat two helpings of their apple pie."

"Two?"

"Two!"

They smile and take each other's hands, smiling happily.

"She's also opening up about her family," Larry reports. "Mary, tell Dan what you told me this morning about your son's girlfriend."

"Morning."

"Tell Dan. What you told me. About the girlfriend."

Mary wears her getting-ready-to-spit-out-pig's-knuckles expression. Then her face brightens unexpectedly. "I-ah like my son girlfriend. She has degree in ah engineer. But I not ready. Ah. To be. Grandmutha!"

"Hear that?" Larry says proudly. "She's even picking up my speech impediment!"

Great: a new generation of Chinese speaking Larryspeak. Like a new generation of Chinese dancers dancin' the Dan.

"Good for you, Mary," Larry says. "Tell Dan the other thing you told me this morning. About fate."

"Fit?"

"Fate, remember Mary?"

Blank face, hard-to-describe mouth expression.

"Any case," Larry says, "this morning Mary tells me, 'Fate make us together.' Isn't that nice? I thought that was a very thoughtful concept."

But it's not as simple as that. Mary's also learning enough language to express her discontent about certain issues. "Ah, ah," she begins, marshaling her English, "I wish to do for Larry," she says. "Do more."

"I know you do, and that's nice, but no," Larry says. "Enough is enough. There are some things that are just too intimate."

"What does she want to do, Larry, you don't mind my asking?"

Larry looks discomfited, like he's just been told he's wearing someone else's jockstrap by mistake. "Sing to me."

"And why won't you let her, exactly?"

The jockstrap is chafing. "My mutha sang to me, she's the only one."

Well, this *is* personal. I stay out of it, looking down at the pistachio shells in the corner.

"I want please you. I study . . . hard!" Mary tries again, her voice breaking. "Now I want sing!"

"And I appreciate that," Larry says, squeezing her hand.

"I go back my home if no let me sing you."

I lift my head. This is not the statement of someone who's entirely out for her own aims.

Larry studies the proposition on the table so starkly before him.

"You win," he says.

"You do it?" Mary asks. "You let me?"

"I said you win. I'll win the next battle."

"Yay-yay," Mary mouths silently, ardently. She turns Larry's hand in hers, lifts and kisses it with her eyes closed. And it's like a snapshot that makes history the instant it's taken. In that simple gesture, my heart warms to her at last. Click. Open and shut. Case closed.

"That was easy," I say to him.

"I don't have any fight left in me," Larry says. "I just shut up and do what everyone tells me."

"That's the best news I've heard all month."

"Surrender is becoming second nature."

Me, too, I think, carrying his kidney-shaped bedpan to the toilet without cringing—though I don't say such a thing aloud. Couldn't if I tried. He's off and running again, not letting anyone get a word in edgewise. "I even feel like accepting myself more, too—and note please that I'm saying this *before* my surgery, so it's not like I'm getting some mystical infusion of wisdom from the donor's kidney—"

"Shhh," I say, hushing him so we can hear what's beginning to happen: Mary singing a little country tune, standing still in the middle of our cave, almost too big for *her* bowl.

And Larry listens from his bed with his eyes closed, in pain or pleasure, it's impossible to tell, but just maybe it's *not* pain.

"You know, Dan," he says, signaling me to come closer and keeping his voice low, "in my earliest phone conversations with Mary, two years ago, she was so ashamed she couldn't speak English that she would try to sing to me. I would cut her off at the pass, of course, but she did manage to get in an occasional note here and there."

I look at Mary's face as she warbles, the muscles of her throat working with so much sincerity it's almost frightening. "Why didn't you tell me that detail at the get-go?" I ask. "I would have softened to her then and there."

"That's why," he says. "I needed you to stay objective."

"Not too dumb, Feldman."

"And I still do, Dan," he says. "I still need you to keep your eyes open. It's not over till the fat lady sings."

Well, perhaps not the best image for him to use right here. The fact is, the fat lady *is* singing, and it's putting another lump in my throat. Must be something in the air. . . .

Meanwhile *my* voice. My Chinese accent is coming along nicely. "Damn dim bulb!" has become my all-purpose curse phrase of choice. Hot water running out? "Damn dim bulb." Phone on the blink? "Damn dim bulb."

Also, when I find myself wading through a gang of card sharks playing Chinese blackjack on the sidewalk, I provide my own running commentary so they don't have to: *"Oh, look you at the crazyheart American Cowboy! He wear socks! Isn't that beyond the humor? Instead of normal ankle stockings. And look, he drink water from a bottle he carry slung around shoulder. What a crack-up and hot card! What madcap business of monkeys will him think of next? No wonder we giggle on top of giggle as he pass. He may as well be of clown hat! But look you, now him writes in pad with characters that are not Chinese! Is there no tomfoolery this screwballs will not perform to keep us up-stitched?"*

Funny thing is, they seem to grasp my self-parody instinctively. They get what I'm doing and clap me on the back as I walk through.

But whether the Disapproving Docs appreciate what I'm up to is more questionable. When I get a fresh e-mail from the Docs ("once again we must remind you that we are not willing to clean up any mess of your devising, if such a situation presents itself"), I use the opportunity of a return e-mail to perfect my Chinese accent.

"Greeting to you, dear doctors! Hello and hope this mail meet you in a perfect condition. I am happy to inform about our receive a winning organ for our dear relative Larry. Presently we locate in ASIA CHINA for transplant project of our own effort. But we do not forget your past help despite that it failed somehow. Even offer to clean mess of our devising! But no mess, sank you very much. In fact, because he is lucky number xxx transplant of season, Larry has win lottery bigtime, and we want include you in total sum payout. Please contact our secretary name MR MARY so he send you million-dollar Cheque to cover all you concern, however failed. And remember alway, the Cheque she in the mail."

As for other accents, the Chinese people continue to sound more like Larry and he like them. Or maybe he sounds more like Ali Baba unreeling his narratives from dusk till dawn, or dawn till dusk, whichever applies. It all evens out. Who's keeping score? For that matter, I continue to lose any ability to see a difference in the way people look. The Chinese look American, the Americans look Chinese, together we all look Arabian. And why not? Why should we be just us and they be just them? We are invincibly interchangeable. Artie the KFC delivery-man,

who now spends his off-duty hours sitting on the foot of Larry's bed listening to the lullaby of Larry's Ali Baba tales, has come to look so much like my old pal Miles back home that one time I feel like saying, "C'mon, Miles, are you putting me on? Have you just applied a little Chinese makeup and snuck over here to check out what's happening?" Another time I'm watching Chinese TV and an interview comes on with Jackie Chan, and I say to myself, "Wow, nice to see an American face once in a while."

Of course, none of this means we can't still be competitive with one another. I've entered the Badminton Boys' round-robin tourney and been steadily working my way up the ranks till I'm contending for the semifinal doubles playoff. It's Pakistan and America versus Saudi Arabia and Qatar, cutthroat but quiet in the little hallway.

Cherry looks on approvingly. "Very springy, Daniel. You reminding me of Israeli patient last year."

"You had a patient from Israel?" I say, almost losing a lob in my surprise. "How'd he get along with . . . everyone?"

"He faced with same difficulty as everyone, so became brother to brother," she says. And I can believe it. The Giant Mushroom is sort of a no-man's-land, an island of neutrality in a world of shooting, machine-gunning, bombing—we can hear it through the windows. . . .

Oh, wait, this is a nation at peace, for the time being. Must be the sound of hammering, drilling, digging. All around the hospital are the sparks of welders, the roll of cement tumblers, the spray of pressure hoses. One wing of the hospital is demolished overnight. A new wing appears in two days. All is aswirl with change except in our ninth-floor cave where we're suspended, waiting out our time as the dynasties inexorably rise and fall through the Shang, the Qin, the Shun, the I Ching. . . . Who knows how many eras are passing or even where we are? I could be in China, for all I know.

Time at its most basic consists of waiting, and wait I do, either in my half of the cave or back at the Super 2, waiting till nightfall to emerge, like the fair ladies of old China who wouldn't go out in the sun lest it ruin their porcelain complexions. I have everything I need in my room:

yoga CDs, scallion bread, chocolate, Bengay I borrowed from Larry that really helps my strained neck. The concerned housemaid knocks and knocks until I finally open up. "Clean you room?"

"I no need," I say, waving my hand no.

"I no need?" she says, furrowing her brow.

"I'm happy as a clam in here," I say. For I truly am. Two-week-old water stains dating from the time of the Ten Kingdoms? I won't look at 'em. Annoying little alarm that goes off every time I open the hall door? I'll keep the hall door shut. Other than Larry-Mary, I deal with very few people in the world besides my strapping housemaid, with blue stitches in her chin. For a while I feared they were whiskers, but she shows me close up that they're the ends of blue threads. Did her husband bust her one? Another Inscrutable. I'll never get to the bottom of it. More like my den mother than my housemaid, she took me under her wing weeks ago, one time hemming the waistline of my pants, which had gotten two inches too big, another time showing me a photo album of her husband and son. This time she snaps the skin-thin green rubber glove off her hand and roughly rubs my bare knee to indicate that it's too cold to wear shorts.

"I know, but I'm hot!" I say. "I'm on fire because we're getting Larry the last kidney in China. Now all we need is for it to happen—with no mishap!"

But she's tricked me, taken advantage of my loquaciousness to sneak past me into my room with her vacuum cleaner, which is missing its wide-mouth nozzle attachment. Back and forth she goes, up and down, with just the naked end of the pipe—inch by inch to catch a stray crumb or chase down a thread, leaving a network of graceful squiggles on the carpet. Was this how Chinese calligraphy was born in eons past, I amuse myself wondering—from a deficient vacuum-cleaning system on a wall-to-wall?

But Dr. X was right. I do miss my boys. I've been putting off calling home, saving it for a treat. Usually, when I've called around the globe

before, the connection has been more crystal clear than the one through the wall to Larry's room, but this time it's distant, faded like a coloring book left in the windshield of the family car. Plus, the voices on the other end seem a little more matter-of-fact than is my liking.

"How's everything, Spence my man?"

"Fine, except when we play Scrabble, Mom keeps insisting that 'bizou' isn't a word, and I'm *positive* it is! Just because it isn't in the dictionary only proves what a stupid dictionary it is, because I'm *positive*."

"'Bizou,' huh?"

"When I said 'slopey' was a word, I wasn't positive, but with 'bizou' I'm *positive,* I *know* I've heard that word."

"No doubt you have."

"And don't say that just to appease me, Dad, like how you agreed when I said we should send Jeremy to live in another family. And while we're on the subject? Jeremy keeps saying he's deeper than me just because he cries at *American Idol,* but I don't think that makes him deep. I think that makes him temperamental."

"I KNOW WHAT TEMPERAMENTAL MEANS!" comes a voice from another phone line being picked up.

"Jeremy, I'm having a private talk with your brother. Can you wait your turn, please?"

[*Click.*]

"Spencer, you still there?"

"I'm here."

"Can you speak up? It's a little—"

"I *am* speaking up."

"You know, whatever your brother is or isn't doesn't take away anything from you," I say. "You're two different individuals, with two different needs and wants, like . . . um, like . . ."

"Like you and Larry," he says.

"Yeah, like me and *Laurence,*" I say with a mock French accent—but he doesn't remember the reference. How has our little motif bitten the dust in just a few weeks of neglect? How fragile *are* our connections? While I was throwing my net vines wide here, were they withering at

home? Uneasy, I change the subject. "So what's the deal, no new awards to report? What happened, you fall off the wagon again?"

"Demon rum, gets me every time. But seriously, Dad, I have a serious request to make. Did you mean it back on the chairlift when you said Mom could be hell on wheels?"

"Of course not, honey. We were just fooling around. What'd you think?"

"I think we all should be kinder with each other, all the time."

"Even when everyone knows we're just fooling around?"

"Yes, because people are very hurtable, Dad."

I'm silent from my side of the world. For some reason I think about how kind everyone in China has been to me the past six weeks—even the dry cleaner across the street. When the band was coming off my panama, the lady in the dry-cleaning shop stood there stitching it back on for fifteen minutes, and when I displayed my wallet to pay her, she wrinkled her nose at me and pushed me out the door.

"Sold," I tell him. "Kindness it shall be."

"Thanks, Dad."

"Thank you, Spence. You're a wonderful young man."

"Well, I've got a pretty good vocabulary, anyway, I guess. . . ."

Then it's his little brother's turn. "Hi, Dad."

"Wow, Jeremy, you sound subdued."

"That's 'cause I hate my brother."

"Wow, for real you do?"

"For real. I wish he weren't even living here."

"Sounds pretty bad. If he didn't live there, how long d'you think before you'd miss him?"

Jeremy calculates. "At least two hours," he says vehemently.

"Well, I can only pray that your relationship will survive," I say. "Tell me what else is new. How're your inventions?"

"I don't make them up anymore, that was stupid. . . . OH, BUT, DAD! DAD!" he says, exploding into capital letters at last. "I MADE TWENTY BUCKEROOS AT MY LEMONADE STAND YES-TERDAY!"

"Jeremy—how much of that is exaggerating?"

Spencer picks up another line. "It's true, Dad. For once he's not lying. One guy gave him like sixteen dollars for a single cup."

"Thanks, Spence. Can you let me resume talking to Jeremy privately now?"

[Click.]

"Uh, Jeremy. What else did the guy want from you?"

"Nothing, Dad!" He's back to lowercase letters, less enthusiastic, bordering on annoyed. "Why are you so suspicious, Dad? It's like you hate America! You think everyone's out to abuse us."

"Okay, so long as you keep the lemonade stand on our property."

"I do, Dad! What do you think, I'm a friggin' idiot?"

"Jeremy, when'd you start using language like that?"

"Dad, it's just, remember how I always used to say that if you were my age, you'd be my best friend?"

"Yeah, I love that."

"Well, I still think that, but you force me to use extreme language. You have to understand, things aren't like that in America anymore. Maybe you've been gone so long you don't remember."

"I have to agree with him, Dad," Spencer says, picking up his line again to add his two cents. "Not everyone goes around molesting everyone all the time. That's a pretty dark worldview, Dad. You shouldn't believe everything you read in the papers over there. Maybe the Chinese have brainwashed you by now."

"Spence, are you off the computer yet?" Jeremy asks.

"Give me five more minutes, Jeremy, and it's yours."

"Guys?" I say, trying to break in. "It's fading out here, guys, can you speak up?"

"*Three* more minutes?" Jeremy begs.

"Four."

"Oh, thank you, Spencer, thank you, thank you, thank you—"

"Hey, Spence?" I interrupt. "I was in the middle of a conversation with Jeremy, and then I want to speak to Mom—"

[Click.]

[Click.]
I've lost them both. Guess they're used to my being away by now.

And so I walk. Each night I sneak out before my den mother can see—
except that she always sees, mutely racing up to me to straighten my shirt
and primp my hat before pinching my cheek good-bye—and rack up ten
or twelve miles walking. It's not to alleviate loneliness; I feel at home
here. Nor is it to kill time; time's not my enemy. It's merely walking,
walking without firecrackers, walking for hours without heat or sorrow,
walking over potholes like a mule bred to be sure-footed—no more ankle
twisting—walking past shut-down warehouses with people shouting in-
side with words that sound like me talking to myself in my dreams, or
like commentary from a Bizarro local travel channel:

*Under cover of nightfall, the crazyheart American Cowboy emerge from his
lair. Here he go now, blinking at dusky moon. What the devil he up to? Ah, now
we see, he want prowl space-age nightclub. See how blue smoke explode in face, how
mighty bass make Cowboy hat vibrate. Cowboy amazed when bartender juggle
Hennessy bottles behind back and over head. Cowboy unshamed when open bath-
room door and find it janitor closet. Cowboy flattered when two women ask to dance.
They not dancing the Dan, he happy to see. They want be Cowgirls, he think, but
white high heels too big for feet—look like white rain boots for little girls to splash
in puddle. Splash! Splash! Cowboy splash, too! Having fun! Women think funny!
Then women think weird. Cowboy feelings hurt. Cowgirls lead Cowboy to back
room, where help him play electronical darts. For hundred RMB. What the hell,
Cowboy play. Cowboy get bull's-eye. To celebrate they want sell him clove-scented
cigarettes, also hundred RMB. Many RMB later, Cowboy leave. Take off sweating
sucker hat. Regard how hair is thinning. Let this be lesson!*

Yes, lessons are learned, even as mysteries are solved. Not that the
mysteries are such big deals, but solving a few does make me feel that
China is not impossible to understand, that there are reasons for things
being how they are. China is scrutable!

INSCRUTABLES . . . SCRUTED!

Inscrutable of the stockings: Because the Chinese live closer to the soil than we do. Even in the cities, mud cakes and flying dust are a part of daily existence. Ankle stockings are merely a matter of keeping the dirt at bay.

Inscrutable of the bus squat: It's not avoiding pee, as Larry thought—it's patience. Or strike that, it's sufferance, long-suffering patience, the best way to wait for a bus that may never come. Not knowing if and when the Princess will ever come, I myself find it restful to hunker down like this sometimes, and a good stretch, too.

Inscrutable of the gradual stairs: It's to keep the population sedate! American steps are pitched steep to reflect, or augment, our rush. Here the effect is calming, making you either patient or docile, depending on your point of view. Maybe Chinese history can be measured in the pitch of their stairs, I think, taking them three at a time.

Inscrutable of the lullaby music: Same deal. I've been noticing watered-down American lullabies everywhere lately, as hold music on phones, as background Muzak in hotel elevators. For a mighty nation, China sure does like to infantilize its subjects.

Inscrutable of the cab honking: It's taken me a while to crack the code, but the Queen Latifah cabbie was my Rosetta Stone, her "long, long live" honking enabling me to extrapolate what other honking means. Sometimes it's instructional: You're driving the wrong way. Other times it's argumentative: You may not think you need a cab, but I'm here to convince you otherwise. Usually it's celebratory, though, honking for the sheer vitality of it, an expression of cabbiness the same way duck honking is an expression of duckiness.

Or maybe I'm reading too much into it. I'm a quack, after all, just here for a tiny while, with training in absolutely nothing. But I'll be damned if things don't seem fraught on these night walks, scrutable yet

infinitely unknowable at the same time. An older bus driver is watching me from his elevated seat as he waits for the light to change. It takes him just a glance to get all the information he needs to know who I am and what I'm about. How I instinctively turn my shoulders a centimeter to indicate that I won't be trying to cross the street in front of him—our subtle animal intentions on display every second no matter what we do. And I'm doing the same with him: reading, analyzing, deciding. What a miracle it is to see a person. You can decode his whole history and the history of his race in an instant's expression and bearing. The exposure nearly makes me giddy. And yet at the same time, our knowledge of one another is infinitesimally small. Haven't I just scratched the surface with Larry?

For the mysteries go on and on. The mystery of the dead chef on the sidewalk, of *any* dead body anywhere, is one I hope not to solve for a long time, and certainly not on this journey. Nor have all my doubts been laid to rest; new ones are surfacing all the time. China's still a repressive, centralized society, trained to think in lockstep—I see it every time a cabbie resists having the destination changed mid-ride, every time a waiter refuses to modify an item on a menu—and these are the people I'm expecting to bend the rules for an illegal kidney? In one TV music video, a man's chasing his girlfriend headlong down the street, but at a crosswalk he halts and waits until the lights indicate it's okay to resume his chase. These are the folks I'm banking on to break the law for us?

The doubts keep pace with the mysteries; the best I can hope for is to maintain some sort of balance. All in all, along with the climate change, I find myself graced with a second wind: I have new patience for Larry, new regard for the place I've landed. I've been living nearly two months among people I was brought up to fear, and I have experienced nothing but generosity and compassion everywhere I turn. If it weren't for sorely missing my wife and sons, I'd be content to stay here indefinitely. In fact, there are moments when I find myself almost dreading the day the kidney comes through. I want nothing more than for the scallion bread to keep supplying me my daily nutrition; for Jade to keep hopping two-footed off her bullet train on her quickie visits from Beijing; for the

badminton tournament in no-man's-land to go on and on; for Chinese calligraphy to keep being scripted onto my carpet with a naked vacuum pipe, up and down and sideways; for the hammering and drilling and bass playing at nightclubs to continue so loud it makes the hair on my bare legs quiver—country on the move!—and for everyone's cooties to keep gloriously commingling. Despite the perils and unknowns—maybe *because* of the perils and unknowns—I want to be nowhere else than right here, doing what I'm doing. Is it okay to be happy being here, doing this? Falling in love with China?

Because I am.

CHAPTER 18

The Last Kidney in China

The longer the night lasts, the more our dreams will be.

It's 10:00 P.M., and Mary and I are singing Peking Opera in Larry's hospital room. She's performing the male roles, and I'm doing the females in falsetto, with much ritualized stomping of feet and syncopated banging of bedpans. Still wiped out from this morning's dialysis, Larry lies before us on the bed with his eyes closed, showing all the appreciation of a corpse. I do believe, however, that down at frog-decibel level, he may be chuckling in time with the music. It wouldn't be too much to shoot for a grin, would it—one of Larry's old-time razzle-dazzlers? "Ha ha, good one," that's what I'm aiming to hear, like a grand-slam home run, despite a few missing teeth in the bleachers.

And then at 10:01 P.M., the call comes. It's Cherry on the phone.

"Now is the time," she says. "Approval has been granted."

Whoa, team. I hush Mary in the background and collect myself. "Have all the papers gone through, the signatures from all the parties?"

"All yes, but no time for small talk," Cherry says. "Tell Larry surgery in two hour, preparation begins right away."

It's day forty-two in Shi, our forty-ninth day in China, and we can barely believe it. We're so pumped—we're like hostages suddenly being

told they're about to be set free—we go into double time, hurriedly getting things in order as a swarm of white-clad people enter our space and scurry about efficiently. We've been poised to go for so many weeks that we're almost exploding out of the gate. Mary sweeps the latest pistachio shells out of the way so that when the time comes, Larry can be wheeled out smoothly. Larry fumbles with his shoelaces, but he's so flustered he's tying them into knots. I take over removing his Businessman's Running Shoes, freeing him to keep up a running monologue as the Judy-lookalike resident shaves his lower abdomen and crotch.

"I'm not optimistic about this operation," he says. "I know the stats are on my side, but my hunches are usually good, and I don't think I'll make it. There's going to be a complication, and I won't pull through. And I'm surprisingly okay with it. My choice to come to China was a sound one. I'm just so tired, tired isn't the word for it. I can't fight for my life anymore. Whatever happens, happens. I want to be cremated, just so you know—my ashes buried with my mutha, my futha, and Judy. And to remind you, even if I come out of it and by some miracle it's a success, I reserve the right to kill myself."

I'm paying as much attention to these pronouncements as I usually do, preoccupied by glancing sidelong at his crotch. First time I've ever seen it. Is that what it boils down to, the nest of his manhood? This tender package, this shy sac, beneath all the hurly-burly of his life? It seems so private and quaint, after all the histrionics of his existence. Eventually I tune back in and find the words he needs to hear.

"Well, I have a great feeling about this," I reassure him. "Everything's fallen into place for us. This is just the endgame of a very fortunate series of events."

But no sooner are the words out of my mouth than I'm seized with a huge charley horse in my thigh. I rarely get charley horses, but this one clutches me for nearly a minute, making me squeeze the bedside for support.

"Dan bad?" Mary asks.

I concentrate on breathing oxygen down to the spasm. Serves me

right for sounding overoptimistic. "Give me a sec," I say at last. Just as an e-mail comes in. It's the Disapproving Docs demanding an update, "or we cannot vouch for the consequences."

The phone rings. It's Cherry again. "Oh, and Daniel, we now have a price for you," she says.

"Go ahead," I say, breathing through my spasm.

"Dr. X give you half-price special, like what he give Chinese citizen. Thirty-two thousand American dollar."

"I see," I say, not letting the figure sink in right away, not tipping my hand about how pleased its initial sound makes me.

"You can get this now?" Cherry asks.

"Right now, in the middle of the night?" I ask.

"Yes, please, before operation. Is midmorning U.S.A., banks open."

"Yes, but it may take a while to go through."

"You tell them to wire and show us document, is okay."

My spasm subsides as I prepare to tell Larry the news. He's lying on his bed with his bare feet pointed at me. In most countries this is an insult, but I don't mind. "Ready for the number, Larry? Thirty-two."

He seems obscurely gladdened by this, taking the figure in stride. "That includes everything?" he asks tonelessly. "CAT scans, recovery time, post-op care?"

"Thirty-two for everything, Larry. And that's for a team of four surgeons and an anesthesiologist. I was gearing up to convince you to spring for sixty or eighty."

"Which I may or may not have done."

"Don't I know it."

"And that's their asking price," Larry says. "I bet I can talk them down to twenty-five—"

"Don't get ahead of yourself," I caution him. "Thirty-two's an unbelievable price, considering it costs eight times that much at home for a cadaver kidney—"

"I know, it's excellent—"

"I can't believe it!" I crow, finally letting the figure sink in. "Thirty-two! Larry, we're gonna save your life!"

"Yes," he says, thoughtfully picking at a hangnail on his big toe. "It may well be. . . ."

But not ten seconds elapse before he's on to a new subject, slowly excavating his Kleenex storage box. "Next order of business, here's my passport for safekeeping," he says, withdrawing the small navy blue booklet and handing it over. He starts plucking cards and papers from his wallet, then lays it belly-up so its contents are exposed.

"Just take the whole wallet, take whatever you need, keep records or not, it doesn't matter. Reimburse yourself for any hospital payments you've paid, buy yourself some good things. I know I'm setting you loose with free money in a city with massage parlors on every corner, but you deserve it, give her a kiss for me."

"Larry, I'm happily—"

"Did I say you weren't?"

"But all joking aside, you're okay with handing over your stuff? Not losing self-respect?"

"That's a girlie thing," Larry says dismissively. "But you'll need my all-purpose password for my various accounts. Ready? 1909VDB-S."

"Wait a minute, I know that code," I say. "It's from the first Lincoln-head penny, designed in 1909 by Victor David Brenner—"

"That's right, and the S was from the San Francisco mint, the rarest of them all."

"So wait," I say as a vague recollection comes to me. "Did you have a penny collection when you were a kid, too?"

"Dan, you been undergoing dialysis, too? Your memory's not so great. We *bofe* had them," he says. "I wanted to have one like my big cousin had. You honestly don't remember?"

"I remember *mine*. I never had the 1909 VDB-S, of course. That was the holy grail, but I had a 1943 zinc penny I was pretty proud of—"

"Who do you think traded it to you?" Larry says. "I only got the new Lincoln memorial in exchange, but I didn't mind."

"Larry, did I . . . cheat you?" I ask. "A Lincoln memorial in exchange for a '43 zinc?"

"In mint condition, but I wanted you to have it," Larry says.

Suddenly I have access to a whole chronology of memories about Larry as a kid that I didn't have until this moment. A sweet little Larry being generous to a fault. A sweet little Larry being a good sport about being taken advantage of. A little-less-sweet Larry never wearing gloves in winter, to toughen himself up. A lot-less-sweet Larry being an ace shot with a peashooter. A tough-talking Larry standing up to bullies. A problem-student Larry bringing cherry bombs to school—and defying his teachers to send him home for it. There may also have been something about a scuffle with a guidance counselor, but I can't stand to think of it, because it's dawning on me that I may have had something to do with this timeline. Could I have contributed, even in a minor way, to his unsweetening?

And always, Larry loving Girl Scout cookies—which is at least one memory I can do something about, right here and now.

"Here, want one? I say, holding out a Caramel deLite. "For courage?"

"Too sugary," he says, taking a flaky dry Chinese pastry instead.

I don't know what to say, so I get busy with my hospital duties.

10:14 P.M. I scramble to make calls to Larry's bankers and lawyers, fax a letter giving his broker the hospital's routing number.

10:17 P.M. Get verbal confirmation that thirty-two thousand American dollars are winging their way to China.

10:21 P.M. At Larry's request I reach his lawyer at her vacation ranch in Wyoming, ask her to fax Larry's living will.

10:22 P.M. Do we know where our donor is? Is he having his final dinner?

10:23 P.M. We receive a fax with written confirmation that money is in transit. Show this to Cherry.

10:29 P.M. Larry says, "Why do I feel I'm about to flunk my final pilot's test?"

10:31 P.M. Larry says, "I'm not deluding myself about what a long shot this is."

10:26 P.M. Do we know where our donor is? Is he is being walked from his final holding cell?

10:35 P.M. "Everything clicking like clockwork," Cherry reports. "Organ on its way."

"The donor, too, or just the kidney?" I ask.

Cherry and the Judy look-alike exchange a giggle. "Just the kidney, really," Cherry says.

10:37 P.M. KNOCK-KNOCK-KNOCK. It's the waifs from candeyblossoms.com. I'm pretty sure I canceled the account, but I guess they've found new ways to get around it.

10:37 P.M. Just as I'm closing my laptop so there'll be no more interference, I receive another e-mail from the Disapproving Docs, saying that unless I assure them that Cousin Burton's life is not in danger, they retain the option of reporting us to the FBI.

10:38 P.M. The computer is successfully shut down.

10:39 P.M. My cell phone rings. It's Jeremy with a new bagel he wants me to listen to, but I don't have time right now and have to cut it short. What's he doing home on a school day anyway? Is he faking sick again?

10:40 P.M. A visibly nervous Larry asks Cherry if she can sit on his bed with him.

"This may come as a shock," he tells her, "but my self-assurance fails me in certain situations, and this may be one of them."

"Yes, of course," Cherry says, seating herself and taking his hand.

10:40 P.M. I think about how much gentler "yes, of course" is than the French *"mais oui,"* which always carries a hint of exasperation in it. I think about how I've seen no exasperation among the Chinese these entire two months. I think that twenty-five years ago the Chinese appeared brutal to me, with policemen pulling citizens by their hair, but that this time the Chinese have the face of Cherry, the face of Jade.

10:41 P.M. I recover a repressed memory that I did in fact take a semester of French in college. Yuh-vonne's fact file was correct! It was on the pass-fail system, as I recall, and I didn't exactly distinguish myself. . . .

10:42 P.M. Still holding Larry's hand, Cherry takes a phone call and then says, "Sorry to report we need more cash money for antirejection medicine. Ten thousand RMB."

"But Larry's account is maxed out till tomorrow," I tell her.

"Must find a way," she says.

10:43 P.M. I race out of the hospital with my own MasterCard, which I hope still has enough credit on it to fulfill the hospital's request. As I'm racing back with a giant wad of cash in my pocket, I glimpse oily roasted peanuts through the window of a nearby market. And I haven't had a bite to eat since this morning.

10:48 P.M. Large paper bag of peanuts in tow, I race back into the hospital, just as a dusty ambulance is pulling up the entranceway.

10:48 P.M. Meet the surgeons coming up the elevator from their basement dorm room. They're in their early thirties, wearing blue jeans, just waking up from an evening nap in preparation for the midnight surgery. They won't let me take their picture, and they let me know that Dr. X is meditating before procedure and cannot be disturbed.

10:49 P.M. I'm greeted by Mary outside our room, waving her hands and cheering, "Yay-yay Larry!"

10:50 P.M. "I'm a creative type," Larry is saying to the Judy look-alike, who is swabbing his tummy with alcohol and painting arrows. Or maybe what he's saying is "I'm afraid of heights." With all the extra bodies in here, the acoustics aren't great right now.

10:51 P.M. While Larry drinks something that will empty his bowels, Cherry walks me down to the cashier on the fifth floor to deposit the latest money into Larry's account. At this hour the place is even more deserted than usual, but Cherry keeps ringing the bell until the cashier shows up and runs my ten thousand RMB through her handy counterfeit-checking machine. A line more or less forms behind me. Someone tries to cut in front of me, but I block him from doing so. Cashier says something that makes the crowd laugh.

"What'd she say?" I ask Cherry.

"She make little joke," Cherry informs me. Instant Inscrutable. I could live here thirty years and never plumb the depths of that one.

10:53 P.M. In the elevator going back up, I ask Cherry: "What'd you mean before when you said, 'Just the kidney, really'?"

"I mean donor is brain-dead, freshly executed, but still alive on life support. Body with kidney coming in ambulance."

I stop eating peanuts mid-munch. "I just saw an ambulance pull in when I went out for money," I say. "Could that have been him?"

"Doubtful," she says thoughtfully. "He come in regional ambulance, probably dusty."

"This one was dusty."

"Okay, that is him."

10:53 P.M. Now we know where our donor is. The dead horse has indeed come to the live horse—but only because the Chinese government has put the dead horse to death.

10:54 P.M. On way back to Larry's room, I stop in Abu's hallway to give everyone the news. As usual, the competition's deadly quiet, but it stops for the minute it takes them to partake of some of my peanuts, a silent moment we share on Larry's behalf, no less reverential for being full of munching mouths.

10:56 P.M. On my return I see that Larry is wearing a black and gold yarmulke.

"Don't worry, it's only a loaner," he tells me. "I need all the luck I can get."

10:56 P.M. Downstairs, the donor's body is being wheeled through the lobby, elevated to the top floor, where it's placed in an operating room next to the one where Larry will be.

"Two rooms side by side," Cherry informs me amiably. "One to remove, one to receive."

10:59 P.M. Larry's transferred from his bed to the gurney in preparation for the trip to the elevator while Cherry escorts Mary and me as closest kin, sort of, to the tenth-floor "Conversation Room," where the anesthesiologist produces a form to sign. Cherry reels off the list of possible "sad effects": heart attack, throat damage, on and on. I sign as Mary rubs her crucifix anxiously.

"You don't know what you're missing," I tell the anesthesiologist who declines my peanuts.

11:06 P.M. When I get back to Larry's room, he's entertaining the Judy look-alike with a brand-new mini-saga:

"Does the name Rockefeller mean anything to you? Bunch of robber

barons from the 1890s. But Jay Rockefeller is senator from West Virginia, one of the smartest men in Congress. Way back, doing graduate work at Harvard, he ended up renting the downstairs of my Aunt Esther's house, fairly homey two-family structure on Sacramento Street. One day Jay's car doesn't work. Esther calls my futha for help, Sam knows where to get a good used battery, needs five bucks to pay the guy, but Jay has already taken a cab to go about his day. Sam pays for the battery, installs it, car runs fine, Jay's ever so grateful. But he's never around when Sam is. And Sam doesn't want the five bucks back anyway. For the rest of his life, Sam gets to tell people that a Rockefeller owes him five bucks."

"Hey, Larry," I say, standing in the doorway. "That's a good memory of your dad!"

"So it is," he says, marveling. "How do you like that—better late than never."

And with a wink good-bye to the Judy look-alike, he's wheeled out of our cave.

11:18 P.M. We're waiting at the elevator bank, where Larry resumes being negatively vigilant, as though making up for the momentary lapse. "None of which diminishes the fact that I continue to feel I'm going to expire of kiddie failure right on the operating table."

"Everything's A-OK," I say.

Larry looks at me with preternatural patience. "No, Dan, nuffing is," he says, "but *that's* A-OK."

"C'mon, trouper," I say. "Can you rally?"

"I'm a pro, Dan. What am I supposed to do: stop living just because I'm dying?" He picks up his cell phone.

"Who're you calling?"

"My broker, Dan. Buying puts on China Life Insurance. It's called hedging my bets. (What don't you get? If I die on the operating table, it doesn't bode well for the way the Chinese perform kidney transplants in general, and presumably the insurance company that banks on people living a long time will underperform over time. Stock goes down, put goes up, ergo the estate of the deceased makes money. Am I missing something?)"

I look at him, admiring, while his broker's office puts him on hold.

"You punch butt, Feldman," I say.

"I know. Not bad for a chronic depressionist. If it weren't for my gallows humor, I'd have been a goner long ago."

Nor does he quiet down in the elevator. Still on hold when the elevator doors open, he continues blabbing to the surgeons inside, who're now dressed in white. Their surgical masks make them look like the duck slicers at the restaurant where Larry and I had our Shabbos dinner a lifetime ago. I only hope they're as skillful.

"Goody luck, goody luck!" Mary cries as Larry's wheeled in. We can't go upstairs to surgery with him, but he wouldn't permit a lingering good-bye anyway. He's too busy giving the surgeons his personal theory on the stock market.

"People say, 'How can you speculate? You don't have enough money to speculate.' I say, 'I don't have enough money to speculate. *That's* why I speculate.'"

Larry and I make eye contact for half a second as the elevator doors close. "Yes, I'd like to place an order for one thousand—"

The doors seal shut.

Mary and I slap high five, then come together in a hug.

Outside, under the dusty stars, or maybe they're cinders, Cherry stands with Mary and me. She purses her lips and nods at me as though the fate of the world is in balance. "Now in a way is out of our hands," she says.

"Cherry," I say, laying my palm on her shoulder, "if I haven't already told you this, then let me say it for the first time. You're a doll."

"Is nussing," she says.

"Is summsing," I say.

The operation is slated to take three hours, up to six if there are complications. Mary and Cherry decide to go out and find a cake to buy. I decide to go back up to our cave. Larry's tropical half looks as if a war front has moved through, and I prop open the door to my half so a cool front can move through as well. The temperature between our two

spaces is evening out, all the molecules flowing back and forth freely. I decide to do a little housecleaning, start putting things back in the wallet he plucked apart. It's like viewing the interior of his life: gift cards from Sharper Image and other defunct stores, laminated photos of all his godchildren—little towheaded rowdies flaunting their baby teeth, as well as sullen teenagers who probably dig their wack-job godfather despite themselves. I reach for a fake Caramel deLite for comfort. Here are photos of Mary that Larry took when she was modeling her L. L. Bean coat his first night in Beijing. She looks amazingly good in them—sending him a sultry look over her shoulder—almost glamorous. Is this the way Larry sees her, like a movie star, almost?

I take another Caramel deLite—not bad, caramel sprinkled with toasted coconut—and sit on his bed to sort through wads of loose, sandy documents. Here's the nun's VIP letter he's been toting around, the all-purpose talisman putty-soft with misuse, not quite grammatical, and with a couple of phrases he was probably too embarrassed to read aloud to me: ". . . diamond in the rough . . . please treat with respect. . . ." But it's an obvious forgery, or worse than a forgery. Down below, where time and rain have gotten to it, the smudgy signature reads "Larry Feldman." Was it muddleheadedness that made him sign his own name, or a strange kind of integrity? For all his sketchy ways, does it go against his nature to lie? I check this tenuous insight against a photo of Larry on his recently reissued passport. Is this possibly the face of a man who's fundamentally honest with himself and others if and when he can be? But how old and sick he looks! How puffed out and entirely devoid of hope! I'm startled by what I haven't admitted to myself before now: He looks like a man at death's door.

I stuff my face with Caramel deLites.

Around the room, remnants of Larry wink at me morbidly. There on the bureau is the all-purpose spork he's carried with him these many weeks. Will Larry be okay in surgery without it? He's so fragile, couldn't he use every good luck charm he can get? And there parked so neatly in the open closet are his Businessman's Running Shoes; it pains me to see that he abdicated them at last. Will he be okay without his rubber-stiff

self-reliance? Why are we toying with the autonomy he so painstakingly assembled in his life? I wonder why I quoted his Jesus line back to him: "Everything's A-OK." But is it really?

Ouch, I get an echo of the charley horse, stand from the bed to try to release it. It fades somewhat, and I limp to his suitcases stacked in the corner. There on top is my wolf skull that's gotten mixed in with his things. I unwrap the washcloth, and it's intact, thank goodness—those luxury washcloths really did the job. The scent of chamomile wafts back to me from what seems like years before. But have the washcloths protected his tea set, individually wrapped in the crate beneath? I unwrap a teacup—jagged shards. I unwrap a saucer—in pieces, as are all the items, one after the other, not a single item unsmashed. Why is this always Larry's luck? Why do I come out unscratched and Larry takes the fall? Jade was right, as usual: They *were* too crispy to travel. Now the question is, was Larry?

Without warning, the charley horse slides to my gut.

I upend the crate so all the rubble of shattered china pours into the waste barrel, chips and flakes and then the trailings of dust. How can this be anything but a bad omen? Another spasm passes through me—a kind of couvade, suffering for Larry's suffering, or maybe an anxiety attack. I close my eyes and am dizzy for a minute, ransacked by images of kidney beans behind my eyelids. Kidney bean pie. Kidney bean salad. WARNING! RED KIDNEY BEAN POISONING! Raw kidney beans contain as many as seventy thousand units of toxin, and as few as four beans can bring on symptoms of extreme vomiting, which may be life-threatening.

Larry, Larry, my sweet little cousin, fighting for his life . . .

Visions of chewing pig kidneys. On the podium at Larry's bar mitzvah, spitting kidney beans at the congregation. The words "kidnap cabbie" speed by so fast they condense into the word "kidney." The bad-bad criminal gorging himself on Larry's baby back ribs. An old Peter Lorre movie where an invalid concert pianist who's been in an accident has a murderer's hands attached to his stumps. A black pimp in a surgical mask waving a saber at the balls of Leonard Bernstein lying dead in a

chef's hat. Larry and I falling out of a chairlift as lullabies run together in a loop: *London bridge is falling down, and down will come baby, Jill came tumbling after.* . . .

The spasm knocks me to my knees.

O Fearless Father of East and West alike, Emperor of the healing arts, do not let Larry be crispy, I pray. Forgive him his trespasses as You forgive me for cheating him out of a 1943 zinc penny. I haven't been too cavalier about this, have I? You'd let me know if these prayers aren't proper, wouldn't You? Have I used up my quota? Unless maybe—hear me out—if I haven't exhausted my lifetime allotment, taking into account my pissy teenage years . . . I get rollover prayers? Sound like a deal?

My gut feels fine. Must have been the oily peanuts. I trash the rest and set out for a change of scenery.

A few minutes later, the midnight air outside feels ridiculously fresh, like a farmer's field after haying. The stars are as sharp as any of the china shards I just discarded. I begin walking with no destination in mind. Spit globules glisten in the tar from the streetlights overhead. Neon squiggles like a puppy I've grown bored with. Two men are singing "Soul Train" at an outdoor karaoke bar, but they're so shy they sit with their backs to the handful of listeners. Despite their shyness, the mikes amplify their warbling voices into the humid night air. Are the mikes loud enough to carry their song to the windows of the hospital not far away? Could it serenade the surgeons beginning to hack at his guts? Because the surgery must have started by now. May the song bring them joy and precision as they cut.

I walk farther. A shopkeeper ducks into his store as I approach, the better to observe me through his slatted window. I help a grateful couple push their broken-down car several blocks through city traffic to a gas station; it's good to have something to do. Farther on, under a highway bridge, a cello quartet is rehearsing on a sidewalk. The instruments bellow as cars sizzle past overhead. It should be a recording studio, Bach complete with street sounds. Lovely.

Even farther, the tissue wrappings from someone's afternoon fire-works have shredded to red confetti, damp already and turning to clay underfoot. So some festivities go on, even after the holiday season's passed. Good to know. And another thing: A girl falls off her bicycle, startled by the sight of me. I extend my hand to help her up, then lift her bike for her. She is featherlight, but her bike is as heavy as lead. I've spent all this time in China and had no idea how heavy the bikes were. This also seems an important detail to know.

Navigating by the specter of the Giant Mushroom, I find a new route to the Old Faithful fountains. A school chorus is practicing in the open air. Up so late, the singers smile and whisper to one another while the choral director scolds them fondly. It's a mystery to me how a nation this huge manages to foster such a feeling of family: calling one another aunt and uncle, treating one another like sibs. Maybe it's because there's a shortage of real-life relatives. Scrutable! China's enacted the One-Child Policy not only to halve its population but also to foster national unity. Everyone's an only child, so the nation is their family. What a stroke of genius. I miss my children.

And then I arrive at the waltzing terrace. There they are, the former Red Guards, waltzing in trim little circles around the colored fountains, round and round. But tonight they're not frightening, these former cannibals and rapists and butchers; they're just unfortunates, doing the best they can to salvage what's left of their lives. Wasn't that always what they were, unfortunate pawns of generals and tyrants? Given the right circumstances, couldn't we American student protesters of that era have been manipulated into becoming monsters ourselves? Seeing them tonight, I imagine they're dancing not in celebration of their misdeeds but in shame for how they were duped into ruining so many lives. They're waltzing round and round to atone for their sins, the way dirty water can cleanse itself by recirculating. Maybe that's what these fountains are about, too: redemption through recirculation. Whether they realize it or not, it's some sort of purification dance, oxygenating themselves free of their polluted past. Isn't there an old Chinese saying that if you rinse your hands in running water for an hour every day, after nine years

you may be pardoned for your past? So maybe if you waltz every night for ninety-nine years, you finally waltz away your crimes. Quick, there's somebody I need to share this with. . . .

"Hon?"

"Dan?"

"It's happening. He just went under the knife—"

"Are you sure it's safe to say this over the cell?"

"He's in surgery. It's too late for anyone to stop it. It's happening. . . ."

I'm close enough to the small fountains that little droplets of spray are coming onto me, dampening my hat. I hold the phone out toward the scene: the waltzers down below and, in the background up above, the hulking shape of the hospital, its top floor ablaze where Larry is. "Can you hear this, honey?" I call to my wife. "I know it's noon where you are, but it's midnight here, and the Red Guards are swirling to this music. And can you hear this traffic, all the cabbies honking? And the bicycle brakes screeching? And the street vendors calling? This is what goes on here around the clock! All this blessed cacophony—"

I put the phone back to my ear. "Doesn't the noise bother you?" she's asking.

"Nah—threw out my earplugs weeks ago."

A pause. "Dan, what's going on? Are you okay?" she asks.

"It's just . . . I'd forgotten how lucky I am," I say, "to get to go halfway around the world and be privy to this. I might have stayed home and missed this. Thank you for allowing me to be reckless."

"Dan," she asks, "you haven't gone back to carrying your flask around, have you?"

"I'm standing here watching these people I thought were monsters, but they're not," I say. "They're victims, too!—of their lives. Because you can't hurt others without ultimately hurting yourself. And now they need a lifetime to heal themselves, any way they can."

A cannon goes off somewhere far away, accompanied by cheers. "And, hon?"

"Yes, Dan?"

"Larry's not going to die of kiddie failure. We won't let him. 'Cause

he's a victim, too, just like Mary is, and these poor souls here, who're really pretty good waltzers, by the way. We ought to take some lessons, you and me. . . ."

Shelley takes a moment. "I *like* how you sound," she decides. "You sound kind."

"Yeah, well, blame your older son for that. Is the little one still faking sick, by the way?"

"No, he finally went to school today. His conscience got the better of him."

"Conscience, eh? Let's nip *that* in the bud."

She chuckles. "Call me in the morning and let me know how Larry's doing."

"Will do."

Hanging up, I see the waltzers gesture to me. I withdraw by habit, hesitate, then come forward and join my generation-mates. "When I Grow Too Old to Dream . . ." Old Faithful's on a timer to keep her faithful, and off she goes, adding to the general hoopla. We waltz under the water drops, and it's bountiful, being sad and festive together with my generation under the hulk of the hospital where Larry lies unconscious. Then, faintly at first, but with more and more clarity, I make out a more insistent honking than any of the stray honking that's pealing through the night. It's adamant, rhythmical, eloquent. *"Jong may yo yee—"*

"Ma?!" I cry, jumping out of the way to avoid getting splattered by my exuberant friend, the Queen Latifah cabbie, waving wildly to me out her window as she weaves around the dancers like she's one herself, splashing through the puddles, round and round the fountains pumping her horn, and you don't need a translator to know exactly what it's saying, in any language at all:

"Long live the friendship between the Chinese and American peoples!"

CHAPTER 19

Long Live Larry

You can only go halfway into the darkest forest; then you are coming out the other side.

Larry is dead. I bolt awake after three hours' sleep, wearing box-turtle shades, and am convinced of it. Larry didn't survive. He was too feeble to withstand the anesthesia. His heart gave out. Because of the tonsils that were mangled when he was a kid, he started hiccupping and choked on the breathing tube. He gagged on his own vomit. Even in the depths of his anesthesia, he fought the surgeons tooth and nail, mindless brutal flailing that threw them off their game. Larry is dead.

Then the phone rings.

"Operation a winner," Cherry says.

I rip off the shades I must have put on in the middle of the night. "Cherry, don't be messing with me—really? A complete success?"

"Complete."

"No 'sad effects'?"

"None."

"I can't believe it. He's not rejecting it? No complications at all?"

"At all," she says. "We keep an eye on him the next week, but maybe kidney last another thirty year of life. The rest of Larry may fall down, but that kidney take a licking and keep on ticking."

I locate Mary, who's been in the Crush Room worriedly studying

English all night. She tried to sleep but couldn't. "Larry, Larry, sleep . . . Larry, Larry, sleep," she explains. I give her the news. We're jumping up and down. "Long live Larry!" we shout to each other.

A few hours later, Cherry, Mary, and I don surgical masks and shuffle into the ICU with plastic Baggies over our shoes. Larry's unconscious. Looking down on his slumbering face, I view him as a mother would— as his dear, gentle Rivie must have seen her baby boy. And here's a ridiculous thing: He *does* look handsome, he *is* handsomer than he looks. Minged up, to be sure, older than when he got here, but also younger and less scrappy somehow. Part of the reason is that he has a kidney that's working; it's given him a glow of health. But there's something else, and I don't know what it is. Why do human beings do that to one another? Just when you think you've got everyone squared away in his or her little pigeonhole—this one's pug-nosed, that one's square-assed—they jump out and turn beautiful on you. Why'd it take me so long to see it?

Slowly he stirs, opens his eyes, gestures me over. He can barely croak out the words. "How's China Life Insurance?"

Forty-eight hours later, Larry is sitting up in bed, partaking of a celebration cake Mary has brought, complete with sparkly candles and a side of Chinese eggplant. His face is less puffy than before, with a flush of baby pink in the cheeks. The kidney is doing what it's supposed to do— cleaning his blood. So simple, so primitive, and so life-changing.

"My feet are back to size nine after being twelve for two years," he says.

"Also his brain back to itself," Cherry confirms. "Very good kidney, very good match. But must taking it slow," she reminds him.

"It's like breaking in a new transmission, I get it," he says. "You have to let it get used to the rest of the vehicle."

"Perfect," Cherry says.

"Do I *feel* perfect? No," Larry says, chomping down what look like tiny pork balls from the top of the cake, using chopsticks. "I woke up this

morning and still wondered what I should get Judy for a souvenir. But I'm ahead of the game. I'm free of the dialysis machine, which is a minor miracle in itself. I've got my life back."

"So we think next week you go home," Cherry says.

"Yippie yi yo," he says. "You mean after almost two months of captivity, I'll be able to resume a normal existence?"

"Was it normal before?" Cherry counters.

"I take your point," Larry says. "Bottom line, I may die of general decrepitude, or I may decide to off myself, but odds are good I'm not going to die of kiddie failure. Say, any way I can get the recipe for this eggplant? It's ever so much better than at home."

It's a joyful scene, with Cherry looking on fondly and Mary looking lovely, all decked out with pink sweater and blue plastic necklace she bought herself in celebration, nothing too expensive on Larry's dime, resting her head on Larry's shoulder and saying, "I very like Larry. I tell my son, every day he nice to me. Every day." There's even a birthday party tune from the softspeakers: *How old are you now, how old are you now. . . ?*

But something odd's going on with me. As warmed as I am by all that's happening, too much is at stake here for me to surrender to fuzzy feelings. Instead of getting all throat-lumpy at the proceedings, I find myself clearing my throat. I have work to do—now.

"So by the way, Larry," I say almost airily, "if you do elect to 'off' yourself after all this?"

"Yes?"

"You'll be doing what Judy did after you cured her of epilepsy and her newfound health was too much for her to handle. It'll be a similar thing."

"Not identical."

"But similar enough for me to kill you a second time, Larry—so don't even think about it," I say. "Don't drink the warm Coke, Larry. For once in your damn existence, reach for a cold one, keep it, enjoy it, don't fucking blow it."

He looks startled, not sure if I'm joking or if there's an actual edge of anger to my voice.

"I'll try," he says.

"Don't try," I say. "Whatever you do, don't you dare do that. Trying gets you in more fucking trouble than I've ever seen in my life. Just fuckall *do it,* plain and simple, *do it.*"

Mary and Cherry may not know these are swearwords, but my tone makes them drop their eyes and fidget self-consciously.

"Dan, I've never heard you swear so much in a single sentence—"

"Shut up, Larry," I say. "I'm trying to wax self-righteous here for a minute, if I may."

Larry sweeps his arm out before him. "The floor is yours."

As if on cue, Cherry pushes a knob on the side of the TV. At once the softspeakers fall silent. For the first time, we have no background music. Why wasn't I able to locate that knob two months ago? What a relief.

"Listen up," I say, abruptly pushing Mary's chair, with Mary in it, so it faces the center of the room. "It's time to speak hard balls to both of you."

"As you wish, Dan," Larry says, giving me a vacant look.

Cherry excuses herself, correctly, and leaves the room. In the fresh silence, I fix Mary with a look that tells her I mean business. Carbonation may not have come to her village near North Korea, but straight talk apparently has. She takes hold of Larry's hand and looks at me as though I'm going to pronounce them man and wife.

"Mary," I begin. "Larry is a good man."

She is nodding.

"A good man and a true man." I've never spoken so slowly in my life, never enunciated so carefully. It's like I'm willing my words into that brain of hers, whether it's an honest brain or a dishonest brain, whether it's a product of forty-below temperatures where she was forced to steal or whatever. I want my words in there.

"And he needs you to be true as well."

"True? B-a—"

"No. True. T—"

"Oh, true! T-r—"

"Yes."

"T-r-u-e."

"Yes, Larry will be true to you, if you become true to him."

Mary's face changes. Her eyes become . . . what I can only call . . . true. "I become true to him," she says. "I be really, really true."

I look down at my hands. I see age spots. Where'd they come from? I've gotten three age spots since I came here two months ago. This is how we age, I understand. This is how we age.

"Mary, maybe Larry is a sucker. Do you know what that means? Maybe he keeps wanting to believe you are true, even when we all know you already lied: about your job, and your size, and your age. . . ."

Mary squeezes Larry's hand harder. "I lied, yes."

"But he needs to believe in you, Mary. He needs it for his life to get better. And he can make your life so much better, Mary. You have no idea how much better your life can become. But he just needs to believe that you'll be true to him, too. Never lie to him, never, ever lie to him."

"No, no, never, I sorry." Mary is crying, and Larry's a little choked up, too. No, he's crying. Those are wet, hot tears skittering down my cousin's cheeks. They won't let go of each other's hand.

"Human beings are complicated," I say. "We lie sometimes, because we feel we have to, and because we feel it will help us. But if we are true, it is better."

"Is better, is better." They are both crying.

"You know, he got the kidney to save his life. We called it Princess. But now he needs someone to make his life worth living. If you turn out to be his real Princess . . ."

A cannon sounds from somewhere, like the one from last night. It reminds me not to take up too much time; there are other concerns in the world, most more pressing than ours.

"Sermon's over," I say.

"I'm going to do you a big favor," Larry says, "and not tell you who you just sounded like."

"My father?"

"I was going to say Yoda, but sure, knock yourself out." No time knock anything, however, the job's not done This sermon of mine turns out to be a twofer, and the target of part two is Larry, himself.

"Larry," I say.

Again he's taken aback by something businesslike in my voice. He looks up at me.

"You trust me, right, Larry? Of all the people in the world who've double-crossed you and fucked you over, I never have, right?"

"We've had our disagreements, but right," Larry says.

"And it looks like we've saved your life, right?"

"I wouldn't say 'we,' Dan. All I did was lie here while you harassed the poor citizens of this country."

"We've always been straight with each other?"

"Within reason."

"And these two months I haven't asked you for anything, right?"

"Right."

"Because I'm going to ask you for something right now," I say.

"Anything you want. You know I have connections. Name it and it's yours."

"For real?"

"It wasn't like I had a list of other people who'd come to China and help me with this thing, Dan."

"How many would have?"

"I can't think of one."

"And it turned out to be your cousin."

"I don't hold it against you."

I'm still impressed by how he does that: the tough-guy bravado, the unsentimentality that is itself a form of sentimentality.

"So name it," he says. "Your wish is my command. Deluxe cruise to Bermuda, remote-control microwave, pinball machine with bump-and-nudge-proof U-Shock Board, you name it."

"All right if I have five wishes? I'd like to press my advantage."

"Go for it: I certainly would."

"Okay, Wish Number Five. You know those sagas you're always telling? I might want to tell a couple myself, about our little adventure here. And if I do, I want you to let me tell them the way I want, no interference."

"By all means, Dan, why would I care? My sagas are mine, yours are yours—tell anything you want."

"Just confirming."

"Okay, that's a fair answer to what I think was a fair question. So moving along, Wish Number Four?"

"Number Four," I begin.

"But wait, before you hit me with Number Four, let me just put in a request that in any sagas you tell, don't make me out to be lovable, okay? I mean, I know you're not a sappy guy, but please don't suggest that I'm cuddly in any way, because what the hell do you know? Don't have your listener fall in love with my complexity, or my human contradictions, or any of that crap. I don't need a larger fan base."

"I'll do my best."

"Matter fact, feel free to maximize my dark side, I'd appreciate that. Demonize me to your heart's content."

"*Mais oui*," I say with some exasperation. "Can we get to Number Four?"

"Number Four, sure. Oh, but one last thing before we leave Number Five? You may have noticed I try to include a moral in most of my sagas. Something the listener can take away with him. But often I'm guilty of leaving it too implicit, and that's a failing I don't want you to make. Give 'em a nice clear moral, something—"

"All right, I'm skipping to Number Three, because you're wearing me down here."

"I'm a professional negotiator, what do you think I'm doing—"

"Number Three. Never use the word 'Chink' ever again. 'Chink, rice-picker, zipperhead'—none of those: The Chinese have been absolutely unstinting on your behalf. So banish those words from your vocabulary."

"Done. That was easy. Next."

"Number Two. Stop the rest of my hair from falling out."

"Beyond my power."

"Then just leave me the little I have left?"

"No can do."

"Okay, in that case I'm going to load everything onto Wish Number

One, the only one I really care about, the hardest one, maybe the hardest you've ever had, for big boys only. You up for it?"

"I hope so."

"Ready?"

Larry sucks in his breath like a heavyweight before the opening bell. His brain is buzzing: Am I going to ask him to reimburse me for the past two months? I can see him calculating costs, adding figures. At last he nods.

"Ready," he says.

"Release Burton," I say.

My request catches him sideways, like a roundhouse punch to the jaw after some playful poking. This is even huger than he expected. I see it in his impassive face.

"I'm not saying you have to forgive him," I elaborate. "Just let him go. Release him."

"You bastard," he says.

"Tough, huh? That's my only request. Can you do it?"

"Oh, you would have to choose that one. That was the sweetest revenge I was ever going to take."

"You're using the past tense. Does that mean it's over?"

Larry closes his eyes. He does not sigh. He doesn't breathe at all for a minute. He looks like a zombie. But then he often looks like a zombie: waxy, inert.

Then: "Yes, Dan."

"I have your word, right? No reaching out to underworld connections. . . ?"

He extends his hand to offer me a weak handshake. "Of course, Dan. Now leave me be. I'm exhausted suddenly. I'm drained."

I stand up to take my leave. "Thank you, cuz," I say.

"Thank you." He says this impersonally, like a guy thanking a bartender for extra olives. But I know he doesn't mean it impersonally.

That's how I wanted our conversation to go, but call it wishful thinking, because reality doesn't always follow the script you'd like it to. Rewind-

ing the tape a bit, here's how the conversation actually goes:

"Release Burton," I say.

"Absolutely not," he says. His head has pulled back, the neck muscles coiling. He watches me warily, with great slowness, like a snapping turtle readying itself to spring. "Not on your life," he says. "It's set in stone."

"Larry—"

"Look, don't get me wrong, I think it's a magnificent idea, aesthetically. It has a certain artistic merit that even a cretin like me can appreciate. You come here to save one cousin and end up saving two. But no, I can't do it, I won't do it, and in fact I'm deeply offended that you would ask such a thing." He holds up a hand to keep me from interrupting. "It makes me think you're on Burton's side, that you're a backstabber after all, that maybe you've been in collusion with Burton this whole time, and I ought to put a fatwa on you, too—"

"Slow down there, pardner," I say, taking a deep breath. "You're going to blow an artery. I'm asking this for your sake as much as for Burton's. You've got a brand-new kidney inside you, but if you subject it to all the revenge that's in your system, you're going to poison it faster than a—"

"It's a strong kidney," he reminds me. "It's the kidney of a killer."

"Oh, that fact has not escaped me," I say. "But believe me, it'll shrivel up and die against all the bitterness and self-pity you've accrued. You'll have wasted it. You'll prove yourself unworthy of it. I'm asking this for the sake of *your* life as much as for Burton's. You're both my cousins. I want what's best for both of you."

"I'm sorry, Dan."

"Larry, don't you see that you're trying to do to Burton exactly what was done to you, by Uncle Auguste? You want to screw him just as you yourself were—"

"I don't see. I don't care."

"You have to see! You have to care! In the context of all the good that Burton has done, you have to let go of one or two bad things—"

"Never. He has to pay the price."

"Larr—"

"The answer is no, Dan. He almost got a huge gift from you that he doesn't deserve. But no. It will happen on my death. You can quote me."

"Goddamn it, Larry—"

"Here's what you don't get," Larry says, shading his eyes. His face has darkened. The baby pink flush has withdrawn itself into little pinpricks of rage through a thunderhead of gray. "What you don't get is that it would be *shameful* for me not to do it. That I haven't done it yet is shameful to me, and it will remain shameful until the day the deed is done. I'm doing it for my mutha, who was crying on her deathbed—"

"But on her deathbed, or wherever she is now, Larry—"

"Watch where you're going with this, Dan—"

"—she would not have wanted you to avenge her death."

A tear rolls down his cheek. "That's strike two. You've been warned, Dan."

"I don't want to feel like I'm being threatened here, Larry. Haven't I earned the right to say what I have to say?"

"Say it."

"Here it is: I think you're fixating on Burton instead of the real issue. Burton may have tried to screw your mother, or he may not have, I have no way of knowing, but what I do know is that you're spending all your energy plotting revenge against him rather than doing the work you have to do."

"What work?"

"The grief work. It's too easy this way, Larry. You have to do a difficult thing, and that's to accept that families die: yours, mine, everyones's. They just die, that's all. It's life, Larry, and life's a bitch. But the fact is that Burton's not responsible for their deaths, and obsessing about him is keeping you from feeling the rage—"

"What rage?"

"About everything! About the lousy cards you were dealt in life! About not having a father who taught you how to hit a baseball and about having a sister who killed herself without letting you use her kidney and about all the bad that's ever been done to you, from your childhood on. "

Larry's looking down at his hands.

"Hate Burton all you want, but keep that hate in a separate box, is all I'm saying. You know that's what your mother would want you to do. She wouldn't want you to injure Burton."

He lifts his head to gaze at the scroll across the room. "Poor goldfish," he says, "not enough room to turn around. . . ."

I know my words have sunk in, but I need to nail this down. I pick up the cell phone and start tapping numbers.

"Who you calling?"

"Burton, for you to tell him it's over."

But this is going too far. I've lost him. Larry gets up on one elbow, the neck vein throbbing. "One last time," he says distinctly. "The answer is no."

"All right," I say, putting down the phone. "I'm going for broke here. Larry, not to be blunt, but don't you think you owe me the one and only thing I truly want, after taking out two months to get you a kidney?"

"You know how I see it, Dan?"

"Tell me."

"I see it that we're even."

"How you figure?"

"You got me a kidney. I got you a nice adventure to tell your kids. You can go home with a great saga for your friends, bragging rights from here to—"

"Jesus Christ, Feldman, you think I give a damn about—?"

"We're even-steven. And notice I'm not even asking you for a cut, if you make this into a movie or something, though it would be nice if you could get Clint Eastwood to play me—"

"He's like ninety years old, Larry."

"Oh, yeah, I must still be a little misoriented. But don't ask me for anything extra, that's pushing it. And by the way, not that I'm not grateful for all you've done, because I am, but just in case *you* feel like doing something extra for me?"

"Yeah?"

"If you ever find yourself walking with Burton and a car is out of



control coming toward you? Push Burton out of its path. Make sure he's not hurt. Because I want it to happen to him my way."

Neither of us knows what to say for a moment.

"In the good-news department, though, lying here with all this free time, I've come up with a killer invention: Autumn Foliage Sunglasses, the lenses flecked with paint for stay-at-home leaf peepers. . . ."

Subjects are closed, all of them, as effectively as if he's withdrawn his head into its shell and snapped it shut. If that's how he sees things, I've banked no obligation. I've accumulated no leverage. Mary raises her eyebrows to me in sympathy, for the sucker punch that's just laid me out cold.

Over the next few days, I prepare both of us for departure. Larry doesn't really need me anymore while he recuperates. I book our flights—me to my family at home, after a good-bye to Jade in Beijing; Larry directly to Florida from Shi a few days afterward. I crate up his belongings, six boxes in all, and cab them to the post office so he'll have nothing but a shoulder bag to tote home. The cost is fifty dollars per box, and it may take them a couple of months to get to Florida, but it would be four times that amount to do air. I figure he can make do with the delay.

My thrift is canceled out, though, by the overly lavish gifts Larry directs me to disburse. I take his MasterCard to the ATM time after time to get generous wads of cash for everyone. ("Every time I hear myself say ten thousand," Larry says about the gift to Cherry "my heart jumps. I know it's only about twelve hundred dollars American, but I have a hard time giving away ten thousand anything. Even pennies. Especially pennies. What can I tell you—the habits of an old penny collector.") Also, I buy an ostentatiously expensive scotch for Dr. X that, naked of its velvet wrapping, fits in well with the parrots on his shelves. Word comes down that Dr. X is offering his personal Bentley and driver to take Larry to the regional airport three days after I leave. The generosity (and the self-interest) of the Chinese people goes on and on.

Luckily, just in case I'm getting overly fond of the place, the smog's returned. We're back to breathing Frappuccinos, even tastier than be-

fore. The sun's a white token in the milky sky, like a zinc slug Larry once gave me to get into the subway free. But at least the smog's dissipating somewhat from Larry's brain. "800-555-1212," he says. "Hey, look what I know. I didn't know those numbers last week. Toll-free information. Now I can call the airlines and wrangle a disability upgrade."

At the appointed time early one morning, checking out of the Super 2, I find my den mother the housekeeper and tell her I'm leaving.

"Not just for a walk this time," I say. "For good and all."

She stamps her feet and sticks her tongue out at me! What's *that* about? Then, what a hug she gives me! A full frontal, complete with burrowing her nose in my neck and roughly inhaling me.

Getting to the hospital to make my good-byes, I find Cherry, who loads me up with hospital papers and last-minute instructions to tell Larry's Florida doctors about his ongoing care. I press her two hands to my heart: "Good hands," I say as she nods, smiling. For the first time, it is not a promise or a plea. It is a statement of fact.

I go to the second floor to see Abu but can't locate him. From his bed his dusky-skinned father says, "How is the Professor doing?"

"He's pink!" I say, then realize that's not necessarily a color that would speak to him. Besides, Abu's father is not faring as well. He's still awaiting a transplant, with no word on when it may arrive; an associate from Yemen has had two surgeries so far, and both have been problematic.

Leaving Abu's father's room to resume my good-bye rounds, I'm ambushed by someone throwing his arms around me. "Take me wiz you!" cries Artie the KFC deliveryman, near tears despite his helpless smile of double-harpsichord teeth. "I fatten you up!" I gently disentangle myself and give him the fake watch from my wrist. What the hell, I give him the fake one from my other wrist, too. With Artie on the case, maybe it'll catch on in China as a power fad.

"Dan, ah, I think he be sweet at you," says Mary, who has shown up unexpectedly, no doubt lost.

New mysteries all the time . . .

I accompany Mary to the ninth floor, where she tells me that a sur-

prise is waiting. Sure enough, in our suite is a tall, weedy young man she introduces as her son. "Captain of college team-ah basketball."

It's a full-court press—a final-quarter tactic as the clock ticks down— to get Larry to seal the deal, but I don't mind feeling manipulated, because I like Ling; he's an upstanding young man, despite his loose-knuckled handshake. He even brought a gift of a personal plastic fan, which Larry's placed on the table beside him, its gift ribbons blowing in the breeze. Ling is shy and also a bit rehearsed, with a lot of big words that could come from nowhere but a thesaurus. "My mother is a diligence and docile woman, also hygienic and plausible," he tells me artlessly.

"You yourself are also diligent, I see. And I'm touched by your loyalty to her," I tell him. "But it's Larry's decision, to make when he sees fit."

"I see, I see. In that situation I give you two time alone to make farewell," the son says. He squires his mother toward the hallway. But Mary is not ready to go yet. She balks at the door in her fur coat, looking as glamorous as a movie star. How'd that happen again? Whether or not they stay together, I'm glad she has my grandmother's baby sister's coat.

She speaks. "I need you understand me. We all together long long time, not just Larry-Mary: Larry-Mary-Dan. When you go home, I'm no happy."

She starts dabbing at her eyes.

I still can't tell if I see tears or not. But you know what? It's not my business any longer.

"I hope you be happy every day," I tell her. "And I hope I see you in Florida, if that's what's in the cards."

Her son translates. "Oh, yes," she says, lighting up. "In cards! Hope yes!"

I busy myself with last-minute packing while they make their way down the hall. When they're out of earshot, I put it to Larry.

"So what's the verdict? Marry Mary?"

Larry's more chipper than I've seen him this whole trip, almost sunny. I have the feeling it's not just because he's relishing his newfound health; it's also because he's vanquished me. He won. He didn't give me what I wanted. His victory gives him strength.

"My muscles feel lazy as a Kobe cow," he tells me. "Ever have one of

those steaks? They're hand-massaged for twelve hours a day and given a steady diet of beer. Nuffing like good old-fashioned American beef. I look forward to getting some of those when I get home."

"They're Asian," I point out.

"Are they?" he asks, merrily stretching his back muscles.

I'm feeling the tension, even if he isn't. I regard his uncharacteristic vivacity with a certain detachment. "You look well rested," I say.

"Do I?" he says. "Because I'm not. Mary and I finally found something better to do last night than sleep."

I ignore his leer. It's Mona Lisa in the clubhouse with her cronies after a satisfying round of golf.

"Congratulations," I say.

"So what I figure is this," he says. "No matter how it plays out from here, I still got the better part of the deal."

"Tell me."

"I came here for two things. To see if it would work out with Mary. And to see if I could get a kidney. Even if Mary doesn't work out, I'm still batting .500. And just between you and me, the better .500 of the two, at an eighty-five-percent discount, fifteen cents on the dollar. That's not bad for my rookie visit to China."

"You say 'rookie' as though there might be more."

"You never know, Dan. I may just decide to come back and run out the clock here. My pennies will last a lot longer here than at home. . . ."

"Not a bad plan," I say.

"And my blood pressure's still coming down, so I just may not stroke out after all. Plus, I'm gonna ride in a Bentley."

He pauses while he treats me to the sound of his diseased teeth triumphantly cracking the hard candies he's nicked from various nurses' stations. I place my toiletries in my bag, leaving out the black and gold yarmulke for Larry to keep. I'm aware that these are the final moments I'll be breathing a certain loamy scent. Everything's ready except for my laptop, but just as I reach to turn if off—KNOCK-KNOCK-KNOCK—it's the brood from candeyblossoms.com. Yet they'll have to go unanswered, by me, forever. I shut it down and zip my bag closed.

"And Mary?" I ask.

"I've talked to her in depth about her deceptions. That's what I called them, no beating around the bush. I'm being very tough with her."

"Good."

"I told her there will have to be changes from now on. Because I continue to catch her lying about things, big and little. It's an ingrained habit, makes me wary."

"As well it might."

"I put it to her in no uncertain terms that if I'm willing to go ahead and finance her education—"

"Larry—"

"—that I'm going to insist on a prenup."

"Now you're talking."

"So she won't get her half of my estate until a year passes—"

"Larry, make it five years! Ten years! This is supposed to be a long-term relationship."

"I'm cutting her a little slack."

"I swear, Larry, in your own way you're a lot more forgiving than I am."

"I'm just not ready to close the door. Maybe she has her reasons for doing what she does."

"People always do."

"Yes they do! And who knows, under my tutelage she may just turn into an honest woman after all. In which case I'm fully prepared to marry her and make her my wife. But if I decide she's playing me for the village idiot, she's dead in the water."

"You don't mean literally."

"Probably not. But I'll cut my losses and move on."

"That's what I like to hear."

"You can beat a dead horse for only so long before it starts to decay."

"Glad to hear those words, Larry, even if they do sound Chinese."

"You want Chinese? 'Be virtuous, but without being consciously so; and wherever you go, you will be loved.'"

"What, you're quoting Confucius now?"

"Hey, I keep my ear to the ground. Bottom line, who are we to judge if she's the real McCoy or not? The only thing I know for sure is that she's spending a lot of effort to please me, and if she keeps that up, I'll end up fat and happy. Does that make sense to you?"

"It makes Larry sense to me."

"Thank you, I think," he says. "It's like what my futha used to say: 'What's good for the goose is good for the gander.'"

"Larry!" I say as the fridge squawks, dying yet another death. "Did you hear what you just did? You just quoted your father."

"I know. I'm speechless."

But not for long. He picks up the portable fan from the table and holds the grille against his lips. *"You made my day, Dan."* He puts it down.

"You're welcome. So can I set you up with a wheelchair at the airport?"

"Right. Like I'm gonna accept a wheelchair. Dan, think about the stories you have to tell when you get home: How good a character would I be if I did everything you asked? Who'd want to hear about me if I was the type to take a wheelchair?"

"So really you're doing it for me, as you have been all along."

"An argument could be made, yes. Just don't act like you didn't get something out of this, too, don't forget."

"And that would be what?" I ask.

"You didn't get smoke rings puffed in your face by Chinese soldiers this time."

We exchange a small smile. But that's the most we're going to get or give.

"Want an update on my latest lawsuit, nuffing to do with caviar?"

"No thanks."

"Didn't think so."

So long. So long. We shake hands. No question of a hug; I've had plenty with the others.

"Get that goldfish a bigger bowl, will you please?" I say.

"Right. And you check both ways before crossing the street."

I'm out the door, down the elevator, crossing the silent lobby where

the usual patients shuffle sadly about in their dingy Yankee uniforms. I'm going to miss this Giant Mushroom of Hope and Dread, with its glittering marble floors and carpets of broken calligraphy. I leave the hospital for the last time, followed by a maid who polishes off my footsteps so there's no trace of me left. No sooner am I down the steps to the sidewalk than Abu putters up on his motor scooter, wearing childlike woolen mittens, badminton rackets in a pouch over his shoulder like a quiver of arrows. He's unhappy because his father's in such dire straits, but he insists on taking me to the train station, my suitcase on my lap, so I can make my way back to Beijing.

"Come visit me in America," I say when he drops me off at the station. "We'll play badminton in my backyard."

"Or come to Pakistan," he says, "for an excellent holiday."

Well, that's maybe not the first place I'd go for an excellent holiday just now, but who knows? We shake hands good-bye. After I walk into the station, it occurs to me that he still had his mittens on when we shook. With that single gesture, that lack of skin contact, I receive the information that we are not deeply befriended. Larry got the kidney before Abu's dad did, and besides, there are political differences. If America were to find itself in a war with Pakistan, Abu would hesitate only long enough to say a prayer before slitting my throat. Sunny-side-up dude I may still be, after all that's happened here these past two months, but a dumb one I am not.

Or am I ever.

The Art of War

It is only when the cold season comes that we know the cypress to be evergreen.

Home sweet home. It's good to be back among so many Western faces, so much English lettering. Except I'm not in America but Beijing, which only feels like home after I've spent seven weeks in Shi. Suddenly I'm filled with nostalgia for scruffy old Massage Central with its repainted cabs and screeching bikes. I have a few hours to kill before I have dinner with Jade and then proceed to the airport, so I decide to pay my respects to the rooftop of my old luxury hotel. Great view from up there, of my life if not of the city. Then I decide to pay a visit to Alfred, the bow-tied dean from the Shabbos service who asked me to keep in touch. We greet each other like old friends in the rotunda of the foreign-language institute, but when I start to debrief him, he shushes me with a finger to his lips and without another word walks me to the institute's cafeteria for a snack. Only there, amid the bustle of scattered diners, does he speak again, telling me that the temple has been praying for Larry every Friday night since I left Beijing—a Misheberah, prayer for those in need of healing.

"Really?" I say, pushing my plastic tray along the rack. "I'm touched. I wasn't aware that was going on."

"If I may be so bold, Daniel," he says, using an ice-cream scoop to dig

out a healthy dollop of potato salad. "I daresay there are many things of which you are not aware."

I want to know what he means.

"It's okay now, it worked out safely," he tells me. "We did have a few scary days there, however."

Now I really want to know what he means.

"Daniel," he says, "you're a reasonably attractive man."

"Okay," I say, taken aback.

"But then again, I'm a man of sixty-four," he continues. "That is to say, I'm not a woman of twenty-four. Do you honestly think you're so irresistible that young Chinese women trip over themselves for the pleasure of squiring you around?"

"I'm not sure I understand," I say, but even as I'm saying the words, I'm feeling a trickle of the old charley horse or something related, some echo of something I've purposefully kept muted in my musculature the past two months.

"Perhaps you understand more than you think you do," he says, selecting a bowl of crimson Jell-O.

"What do you mean?"

A pause as he pays the cashier. "You've been very lucky these past two months," he says.

"I've been excruciatingly lucky. I'm very grateful. So?" I follow his backside through the semicrowded cafeteria. "You're saying I'm luckier than I know?"

The whole way across the room, the echo inside me is turning into heat, which is turning into an itch. In my chest, which I can't scratch because I'm carrying a tray. I'm suddenly very uncomfortable.

"What are we talking about?" I repeat as we find a table.

He's opaque as he pulls out a chair and sits down, then fiddles in the briefcase at his feet. "Daniel, do you not read the papers? Are you not aware that there are reports almost every day about the amount of surveillance that goes on in this country?"

My knees itch madly. I feel like a monkey, wanting to scratch everywhere.

"Look, right here," Alfred says, producing a couple of newspapers. "Just this morning a report that over half the foreign journalists based in China have been spied on or detained. Don't get me wrong, it's *always* been bad, but since the world began focusing its spotlight on Beijing with the Olympics, it's become, let us say, pervasive."

"Okay-okay, I get it," I say, even though I'm uncertain what I get. I'm too busy clawing at the itch surfacing in the unlikeliest places: my eyebrows, my armpits.

"And you're an American writer poking around on your own; of course they'd want to know what you're up to. Not to say that you're not perfectly attractive on your own merits, but I mean, c'mon, Daniel: twenty-four?"

"I'm trying my best to misunderstand you," I say, tongue-tied. Now it's the small of my back that's itching.

"Don't take it so hard," he says, gauging my reaction closely. "It's in the culture—a tradition of deep strategic thinking that's as old as the country itself. In their ancient book *The Art of War,* written in the sixth century B.C., they talk about the importance of placing spies in the opposite camp to learn what they were up to. China is a nation that takes its espionage very seriously."

I know all this yet am a ridiculous mass of symptoms: itchy, coughy, confused, upset.

"You're feeling like an idiot," he says, reading my thoughts. "But look, when I first came to the institute, I was astonished to learn there were more than two hundred teachers who volunteered to read the e-mail of their fellow faculty. They considered it a privilege to spy on one another for their beloved mother country. Even today I estimate that a third of my staff is state security."

I'm a monkey idiot, busy tracking my itches. That word "spy," I abhor its sound. . . .

"So let me ask you, did it really never occur to you when your waitress said she would be your guide for free. . . ?"

No, I think, and just as clearly, *yes.* Of course. In a way I knew it all along but didn't want to admit it. Jade befriended me just a few morn-

ings after I turned away Yuh-vonne. The powers that be must have re-
fined their research, and on a second try selected someone they knew
would be more my style. That's why her supervisor let her idle with me
that first morning at breakfast, bowing out of the way. It all makes sense.
How passionate she was about Tibet and Taiwan when she was tipsy.
Her father in the government—of course! Studying foreign relations—
indeed she was! She never asked me one question about my career—no
doubt because she knew all about it. My mind races to catch up with
itself. Ow my God. So she was a member of the cult of Mao rather than
the cult of Larry? She was someone else's spy before I recruited her to
be mine? Worst of all, does this mean Jade didn't care for me or Larry?
That she was only—

"Now, that doesn't mean she's a bad person," Alfred says, reaching
for the sugar bowl. "In fact, those teachers who volunteered to spy? They
were lovely individuals, some of them. Some were the loveliest of all! It
was a form of patriotism on their part, Daniel. Think of your friend Jade
as a kind of idealist, if that helps. . . ."

My mind is blown. And that's a phrase I haven't even thought of in
decades. It feels like a portion of my head has been exposed to the ele-
ments. The back of my skull pulsates.

"Oh, you dreamers." Alfred laughs lightly at the expression I'm wear-
ing. "That's why we love you: Your vanity makes you such pushovers! But
don't worry, she must have genuinely cared for you, for her not to blow
the whistle and do all sorts of serious damage, such as having the hos-
pital padlocked and Dr. X stripped of his license. She must have grown
very fond of you both and judged that what you were up to wasn't going
to hurt the state in any way. In fact, at the risk of blowing your mind a
second time—"

"Uh?" I say.

"C'mon, it's obviously blown from the look on your face, Daniel," he
says. "I hope you never try to make a living as a poker player."

"Uh . . ."

"Anyway, hold on to your hat, because she may have even helped your

quest for a kidney, greased the wheels behind the scenes, getting the paperwork approved by the higher-ups. She was watching over you, like a fairy-godmother."

Or a fairy god*daughter* . . .

Damn dim bulb is all I can think. I was in the dark all that time.

"But how'd you know. . . ? I mean—"

"Oh, let's just say a few of us took an interest in your project," he says, smiling at me in that complicated way of his.

"An official interest?"

"I'm not prepared to say," he says, affecting a look of modesty as he bites off the top of a sugar packet and picks the paper from his tongue. "In any event, it's partly speculation on our part, with very little hard-and-fast proof. Maybe she's just an innocent little waitress and we're hyperventilating for nothing. If you think back on the cast of characters you've involved yourself with, however, I think you'll agree that it has all the earmarks of being the classic scenario, on both sides."

Cherry? I think. Ow my God, Cherry was on *our* team? Good hands indeed. And why was Queen Latifah so Johnny-on-the-spot? Did she have a dog in this fight, too?

I find myself clinging to the one thing I need to know for certain. "But the kidney's good, right?"

Alfred laughs again, a tinkling like broken teacups. "You tell me. So long as Larry keeps taking his antirejection drugs, I'm told that everything should keep going well."

"It's not bugged or anything?"

"What, so the Chinese can keep tabs on his latest inventions?"

He laughs at me, not unkindly.

"And you're sure it was a murderer, right, the donor?" I ask. "It wasn't one of those religious guys the state's outlawed?"

Here Alfred makes motions that say our little snack is coming to an end. "Let's not even go there, shall we? Because in truth we've no way of knowing for sure. I doubt very much whether even Dr. X has a way of knowing for sure. I mean, China in its wisdom killed ten thousand

prisoners the last year they reported, with very little lag time between verdict and execution, and the number is now officially a state secret, zealously guarded."

He glances at my face.

"But listen, we don't know *anything* for sure! We don't even know about Jade for sure. The point is, you did what you had to do. Don't second-guess yourself. Did you kill an innocent man? Possibly. Did you jump the queue, along with everyone else? Of course you did. Is it ruthless business? Without a doubt."

I clear my throat. "I killed an innocent man?"

"Look, I can't give you a free hall pass, Daniel: There are a lot of unknowns here. But you did what you came here to do: You saved your cousin's life."

"He's not even my first cousin," I say.

"So you're not precisely your cousin's keeper," he says without missing a beat. "You're something else, maybe less alliterative."

I take a breath. It feels like the first one I've taken since entering the cafeteria. Alfred puts his hand on top of mine and pats it supportively.

"You know what, though? Can I give you one word of warning, from my limited experience seeing cases not unlike yours? Don't expect to be applauded when you get home. A lot of people will be put out that you managed to pull this off. Certain family members may be angry that you lifted a finger to help when they didn't. Certain segments of the medical community, don't expect them to be overjoyed, either, at taking matters into your own hands. Others will say you played fast and loose, that you're an American vampire, all those profundities that miss the point entirely. You know the expression 'No good deed goes unpunished'? There's an even more apt expression from this part of the world: 'The captive buffalo resents the free buffalo.' So don't expect a ticker-tape parade."

"I know," I admit. "Even Larry kind of resents me."

"We have a joke in Baltimore: 'Why are you mad at me? What'd I do to help?'"

I try to smile, but it isn't coming.

"As for those others who disagree with your methodology, they're

simply not playing on the same field as you," he says. "They want a rational, step-by-step approach; you whisked yourself here and said, 'Universe, use me.' They want to play chess, and you're already playing Go."

"I'm sorry, I don't know about any of this," I say, shaking my head. "I'm a little misoriented right now."

"Here's the bottom line," he says, giving my hand a final pat and getting ready to stand. "All these carpings about whether we have the right to take an organ, even from a murderer, they're just sentimental luxuries we can't afford. I don't necessarily want to get into this, because frankly it's none of anyone's business, but I lost a niece to a murderer back in the States, a long time ago, and I would have reached inside his rib cage and pulled out his heart with my bare hands if that would have brought her back to us."

The speech has made him a little breathless. He gathers himself. "I'm sorry," he says. "I just mean to say that my ordeal has clarified a few things, taught me that if we have a chance to use good organs, even from bad people, it's a sin not to. The rest of it, it's not worth debating."

"All set?" he concludes, picking up his tray. "The second-to-last thing I want to say, and then I'll let you go, is don't feel compromised by this whole experience. Don't feel dirtied. This is the real world. . . ."

"And the last thing?" I manage to croak out.

"Don't forget to bus the table."

A dream comes back to me. I can fly. I've had it recurrently since childhood, less and less frequently as I've grown older, but I realize now I might have been having it several times in the last week. My arms are winglike. I possess just the right amount of power to rise to a state of being airborne, lumberingly at first, but then higher, aloft dipping up and up to soar around the spaces I ordinarily look up to. In the dream this past week, I've been offering to carry Larry with me, Mary, too, but they don't want to go, so I'm flying by myself, suddenly zooming upward into the nighttime stars. . . .

At first, leaving Alfred in the late-afternoon light, I don't want the

dream to end. I want to go directly to the airport and get on a plane and fly home without seeing Jade, all my dreams intact. But gradually I realize I have to see her. I can't go home without seeing her one last time.

On the phone Jade tells me her father's taken ill, just a "middle squeeze" and nothing serious. She's very sorry, but she has to take a train to her faraway home after our dinner together, she can't accompany me to the airport.

Fine. Just dinner will be fine.

So do I feel dirtied, in the cab on my way over to see her? Not so much dirtied as deepened. Not so much compromised as complexified. I've had layers added to my soul . . . or at least age spots added to my hands. I feel many things: overjoyed about coming home and seeing my wife and kids, apprehensive about coming home and facing my critics. All that, yes, but mostly how I feel this steaming autumn twilight afternoon on my way to see Jade is . . . conflicted. With my new knowledge of her beneficent duplicity, I'm not sure how I feel about those oblong nostrils, those bubbles in her teeth. But I'll never find out by sitting on my hands.

We're to meet at the best duck restaurant in Beijing. I'm almost too tired to keep my eyes open in the cab—been up since dawn, with a long flight ahead of me before I get home. Part of my fatigue is from the bombshells Alfred just dropped on me, and part of it's nervousness, as though this is a first date and a last date rolled into one—first because I'll be seeing Jade with my eyes open as never before, last because we'll never see each other again. Will we really, really not? I hate breakups more than anything in the world.

And then there she is, standing in front of the restaurant. A tiny figure. Why are life's biggies always so much tinier than they ought to be? As a young man, one time I was doing sit-ups on a beach, and afterward I looked down at the impression my back had made in the sand, and it was minuscule. That was *me*? All my foolish drive and strifer, my precious fuck-upedness, and that was all I had to show for it—a pint-size dent in the earth? So does Jade turn out to be only Jade: a small, solitary figure on a dirty sidewalk, examining her thumbnail with great gravity, nearly engulfed by colorful people streaming past.

I see her before she sees me. Then, as my cab rolls to the curb, she ignites with pleasure. She hops to my door—one, two, three—and yanks it open.

Then she stops hopping. She seems to know at once, sensing it with a single glance. With animal subtlety she reads it in the set of my shoulders, the angle of my chin. She hears it in the catch of my voice as I thank the cabbie. It pains me to see her look so stunned.

"You are feeling just so-so?" she inquires, not meeting my eyes.

"Just so-so," I reply.

She is careful not to ask me why. With unusual quietness we walk into the restaurant and take our seats. Jade is further stunned by the opulence of the place: six kinds of spoons, a glut of drinking glasses. "So many windows," Jade says, meaning glasses, clicking her fingernail against each of three at her setting. With an attempt at lightness, she picks one up and holds it to her eye, peering through it. "You can see through me?" she asks.

"Why would I want to do that?" I ask.

But this is cruel. And cruel is the last thing I mean to be. She is made speechless by my words, suffering the Chinese equivalent of a deep blush—more a flush of immobility than a change of color. It's almost scary to see that highly animated face immobile for nearly half a minute.

Her downcast eyes don't meet mine even as she tries to make conversation. "How Larry is doing?"

"The kidney's great. Can't vouch for the rest of him."

Is this guilt I'm witnessing on Jade's face? But why? She did what she had to do and then some, maybe helping save Larry's life in the bargain. We sit there, Jade and me, churning with separate unspoken guilts. Both of us did what we had to do, and would do so again. But it wasn't without cost.

"And your father, how's he doing?" I ask.

"This middle squeeze take place every autumn," Jade says. "She has the burning heart, so I am sure she okay, but I go home to see."

I look at her, my dear double agent, my co-conspirator on the opposite side of a deep divide.

"He," I say, correcting her.

"He," she says.

Neither of us smiles.

We order. As usual, the dishes come out in random order: bowls of rice first, then cups of crème brûlée for dessert. Eventually the duck comes. We watch it being sliced.

"You feel more delicious with chopsticks," Jade says, plucking adroitly. I think she means that one eats more slowly this way, savoring the morsels.

We're both eating slowly, not wanting the meal to end, wanting it to end as quickly as possible.

"I have ducks not so different from this one at my home," I tell her. "In my pond."

I'm used to her eyes being blank, the emotions coming from somewhere else and not the eyes themselves, yet now they are filling up, overflowing with liquid light. A tear falls into her crème brûlée. "I am never see that," she says.

Suddenly she whirls up to go to the bathroom. It's strange to see her walk in so unlively a fashion, hop-less. I write a note and stick it in her purse before she comes back. So how do you like that: For all my talk of the crude cloak-and-dagger tactics of the Chinese, I'm the one who performs the most blatant act of all. Going into a personal pocketbook! But of course my particular cause is just, which distinguishes it from 99 percent of the other causes in the world. *Right* . . .

"Don't talk about the leaving," she instructs upon her return. "We transfer to another topic." But there are no other topics. And now a hip-hop band has begun performing in an alcove near the bar, so we can't hear each other anyway, which only highlights the fact that we have nothing to say. The bass is so booming it sounds like a trapdoor's open in my chest and my usual emotions have drained out. Making room for new emotions to seep in. I'm a jumble of contradictory feelings, but rising to the surface is something I didn't expect: admiration. I can't help it. Keystone Kops, like hell—the laugh's on me: The Chinese did a better job of pairing Jade and me than candeyblossoms.com ever could. And

Jade herself—bravo! I was already impressed by how well she spied for me, but that wasn't the half of it. What a girl! The cult of Mao and the cult of Larry are pretty mutually exclusive, yet she managed to juggle both. I'm as sad and proud as a papa bear bone-bitten by his cub: Ow! Very good! This must be what a father feels walking his daughter down the aisle. She's not mine any longer, and never really was. I'm thrilled, and a bit closer to death. What a maudlin combination! But yes, these compromises do reconcile us little by little to our graves.

As if mirroring my mood, the bass sounds like a death knell, syncopated. It's energetic, but it's death.

There are more tears, not springing from her seal eyes but leaking, falling silently onto the shellacky crust of her crème brûlée, mixing with the soft custard beneath. "I am sorrow for this sorrowness," she says.

"Don't apologize," I say. I don't want to make her cry harder. Yet maybe I do, because suddenly it's vitally, perversely important for me to hear myself telling her about Tiananmen. That it wasn't the way her government makes it out, they mowed down thousands. . . .

"I know." She is weeping. "I hear a little bird of this."

Still I make her weep more. It's like draining a wound as I speak. They machine-gunned innocents . . . they ran over teenagers with tanks . . . they disemboweled one another, they torched one another. It's been a lot of years now, but that hasn't dulled the horror of it in one degree. . . .

Suddenly I'm claustrophobic, just when the appetizers arrive with the bill. We have to leave. We can't stay here. Besides, her train leaves in less than an hour. I take her hand to escort her to a cab. Up front, the driver swims slowly through the traffic, as though sensitive to our restless, funereal mood. The cab feels like a hearse.

"This is not a joyride," she says.

"No, more of a joy die," I confirm.

She doesn't look at me. "You want take that ride?" she asks.

"I can't," I say. "My family . . ."

I turn away. There's another reason I can't take that ride, I acknowledge to myself. I'm an American. I don't want to be like that Foreign Service guy from the temple who felt he wasn't from anyplace anymore.

Also—and this seems almost as important, somehow—my hat needs cleaning. It's collected two months worth of limbo dinge; any more and it might never come clean. So there we are.

But of course the main reason I can't—I know it, she knows it—is if I did, I'd be stuck here for good. Situation not splendid, or splendid in its own way, even though it means we'll never see each other again.

I lift the hand I'm still holding, plant kisses on it. Not a few. Many.

"You are doing this because you are cold?" she asks, not flinching.

"No," I say. I put her hand away. Her tears continue, silently, a reluctant leakage. But now I'm perverse in a new way and want to make her laugh. "And what about you? You are crying for the duck we ate?" I ask.

"Maybe," she says, sniffling and smiling.

"Or for the ducks of my home?"

"All of them." She laughs through her tears.

"Because I can eat the ones at home, too, if that will make you feel better."

"No no no!" She laughs, beating fists into her lap and crying more now, making so many bubbles in her teeth that I can't keep track of them all. Are these the same bubbles as the ones I fell for so long ago? They aren't, of course—woe, woe!—she must be making new ones all the time. This thought fills me with unease, but also a kind of joy. She's using herself up but also remaking herself all the time! Again I have the unlikely thought: She must never die! How can the flower of Chinese youth bite the dust, and by extension American youth, all of us everywhere? They must never suffer depressionism, or earthquick, or even death when death is due. I can't ask such a thing, can I, Cool God? Or is that how it works: You dare to hope for whatever you can, the bolder the better?

"I know why I came here," I say. "Looking at you, so young, I understand. Larry and I were young together. Now he's facing death. But he's the first person I care about in my family's generation to be up against it like this. There was no way I was going to let death take him without a fight."

"I understand this," Jade says.

"Even a baby fight, even a token resistance. This was my protest,

my shrimpy sit-down strike, saying you can't snatch us that easily, every damn time, we've got to be able to postpone the inevitable just a tiny bit longer. . . ."

"I am capable to understand all this."

"I know you are. Whatever is the true, whatever is the false, I know you know."

"I do," she says.

"We're still naïve, you and me. I'm the most naïve of all, to think I could come here without knowing anyone and score an illegal kidney. To think that Larry has the golden heart even though I've seen the awful tarnish on it. This kind of naïveté is irresponsible, reckless—the Disapproving Docs are right!—almost inexcusable. And yet I keep it, I prize it. . . ."

"Me as well."

"To feel about you the way I do—"

But we bang the cab in front of us. We're in a queue of cabs jostling for position in front of the train station. And suddenly it's a mob scene even worse than two months ago, because after all the Chinese population has continued to grow in the last sixty days. People are coming in on ancient trains from the countryside who've never been to a city in their lives. They are bewildered country bumpkins with stick-out hair who've never seen a Caucasian before, certainly not one with a wiry goatee and a panama hat, holding the hand of a twenty-four-year-old Chinese woman, leading her to her track.

"What is your name?" I shout, pulling her along in the crush.

"You know my name."

"No, your *real* name."

She tells me. I have to have her repeat it. "Jinghua."

"Jinghua," I say.

"Jeeeeen, jeeeeen," she prompts.

I pull my lips back over my front teeth. "Jeeeeen."

"Gwuah!"

It's a throat thing, deep near my tonsils, an uncustomary sound, almost obscene, like kissing the inside of a flower or tonguing a humming-

bird. No wonder her teeth are always wet; it's like soul-kissing in a sun shower. I dig the sound out with my breath and utter it forth, the sound of what she goes by, the sound of who she is. "Jeeeeen-gwah!"

"Give it up!" she shouts.

The peasantry is gawping at us, more than one of them with fingers in their noses, causing the pedestrian jams to thicken. It's almost time for her train to leave. We shove and wedge until finally we're at her track.

"I must get something off my chest," I tell her as we approach her train, steaming there like an old workhorse. "I'm reluctant, but I feel I must."

She looks frightened.

"I've been around the world a few times. I've seen a lot of things, but you . . ."

Our hands are pulled apart as the peasantry intervenes, looking dazed as they shuffle through. This is the ageless, long-suffering substance of the Chinese nation, deeply sunburned, immemorially burnished by the sun as though they've been sleeping outside for centuries, in the fields with their crops for millennia. They've been rained on by history, they've had the elements happen to them for so long that it's like they've become part of the elements, an elementary force of nature. Most of them are pushing one another unthinkingly, but some are stopping in their tracks to stare at the Western man with the Eastern woman who is weeping openly now, groping for each other's fingers.

"But you," I resume, "are more beautiful even than a cauliflower."

The tears gush forth in a spurt of laughter, which she fights to stifle because she has something to tell me in response.

"So may we never use the word 'love,' not proper between father and daughter. . . ."

"Okay," I say.

"But maybe, when I have babies, I tell them I love them. Maybe our generation will be different. *May* be. . . ."

"Good-bye, daughter I never had."

"Do not remove my memory from you heart, please."

"I do not. Never. Never."

"I miss forever your smart face and pretty sound."

"Long live the naïveté of the Chinese and American peoples!" I say. She pushes my shoulder ever so slightly.

I push her shoulder ever so slightly back. Then I push her harder, toward her train.

So in the end I leave China by myself. Instead of Jade seeing me off at the airport, I see her off at the train station, and it feels right that I make my departure alone, the way I arrived. I feel extremely solitary in the back of my cab, driving past Tiananmen Square with the giant portrait of Mao looking more like Larry than Larry ever did, seeming to send me a big inscrutable wink . . . out past the hutongs where people live, the houses I can't see into, the whitewashed rooms with harsh sunlight bleaching the threadbare cots and lizards running up and down the walls . . . or maybe that's Africa . . . or maybe that's everywhere I've never heard of . . . where millions of patients lie waiting with veins ticking for a transplant that will never come. May I have one last rollover prayer, O Sharpest Dresser of them all, King of Coincidence and Singer of Sagas Supreme, that they be tossed a holy bone, too? Reduce the suffering, I pray.

And then I'm at the airport, checking my bag at the sidewalk. In my isolation I fantasize that Dr. X will surprise me by showing up to see me off, in a Bentley overflowing with people I've grown attached to: Mary and Cherry, and the Super 2 den mother here to blow kisses good-bye, Artie the KFC deliveryman, some of the waltzing Red Guards. And maybe some of my favorite cabbies will show up, as well: the kidnap cabbie with his dimply wife, the Queen Latifah cabbie weaving her way through the airport traffic honking her horn and shouting "Long, long live!" And maybe Abu on his motor scooter, deciding to take off his mittens and give me a proper handshake good-bye. And others I don't recognize: a Puerto Rican student now working as a flack for the cruise lines—what's she doing in my fantasy send-off? Along with others I've never seen before: godchildren and colleagues of Larry's, and a bevy of nuns, including a round one clutching a letter of recommendation, un-

forged this time. And Jade, dear double agent Jade, coming clean once and for all, swearing loyalty, waving a companion ticket to America to be adopted into my family as the sister my boys never had, or something. Maybe even Larry, a younger version of Larry before he took ill, Larry at his bar mitzvah, the tubby kid who brought me a plate of strawberry shortcake in the parking lot, panting a little because his bow tie was on too tight.

Maybe even this: a bad-bad criminal pleading for his life back in a language I'll never understand.

But none of this happens, of course. In the end I'm alone as I make my way through the airport, as I shuffle across the tarmac, as I climb the steps into my plane and take my seat and adjust my earphones. But I'm filled with all these people. They're inside me now, part of the multitude who make up who I am. As the plane lifts itself from the runway, they join me in crossing fingers for the next person who dares come out from under the blankets to take charge of his own destiny, throwing himself upon the good graces of this world, in China or beyond: *Good luck, we trick you.* . . .

Epilogue

To know the road ahead, ask those coming back.

My cousin and I were young together. Now we're young no more. But at least Larry's life is preserved for the time being. One year later, his kidney's going strong.

Such is not the case for the rest of him, however. He's a fifty-some-thing-year-old man with a thirty-something-year-old kidney living in-side him. The kidney's willing; the body's in decline. How long they will continue to work together is anyone's guess. He's weaned himself off his quad walker, limps along with only a cane, and rarely speaks of suicide.

Ironically, the only medical complication of the whole ordeal arose shortly after he returned home—and it was not from the Chinese side of things but the American. He landed in a Florida hospital for a week either because he wasn't taking his antirejection meds or because his American doctors misread the instructions from Dr. X and prescribed four times the antirejection meds he required. To hear Larry tell it, it could have been either, but in any case he was nothing but delighted about this for a time, because he figured he could sue the doctors and recoup what he put out for his trip to China . . . before ultimately decid-ing against it.

Did Mary talk him out of it? But why? Did it go against her con-voluted code of ethics? We may never know the complexities of that

human being . . . because she's gone. When all was said and done, her miscommunications, her cultural misapprehensions, whatever name we want to put on it, proved too much for Larry. He wanted nothing more than to live out his days in wedded bliss with her down by the pool at his condo—maybe he'd take up crochet, maybe she'd be phoning in hits to the mob—but it was not to be. They remain pen pals, and he demonstrates his continued fondness by sending her gifts through the mail.

For her part, Mary has put herself back on candeyblossoms.com. With the correct data this time.

There was another woman Larry met in China, a nurse who caught his fancy. Not the medical resident who resembled his dead twin, but a nurse from the dialysis clinic outside Beijing where he refused treatment. A nurse I never met and about whom Larry breathed not a word the entire trip. Maybe she had something to do with his refusal to undergo dialysis that day in the dusty courtyard? Maybe that was why he insisted on getting gifts for everyone there? I don't know and am content to know that I'll never know. A genuine Larry Inscrutable.

Of which there remain many. Has he dropped his fatwa against Burton? I'm not sure. I would think that the fact that I've included it in a book about our adventure would satisfy Larry that he's made his point . . . or at least scare him out of it, since it's now a matter of public record. But I simply don't know. He's a tree stump—immovable by its nature, ultimately unknowable. All I can do is inform Burton of the continuing threat, and this I am hereby doing.

I assume Larry has not put a fatwa on me, but I did do him a pretty big favor, so I'm just not sure.

I do know that Larry has been a bit troubled, off and on, by the idea of my announcing our mission to the world this way. It breaks the second of his cardinal rules, which is: Never admit to a crime. No matter what, never admit to a crime. When I explain that we didn't commit a crime, exactly, there's a Mona Lisa silence on his end of the line, and my admiration for da Vinci knows no bounds.

Cardinal rule number one, by the way, is: Never sign your name. I don't know how a person is supposed to follow that, but Larry swears

by it. Sign George Washington or Sgt. Pepper, but never sign your name.

Neither rule, incidentally, prevents him from running for chairman of his condo association, a race he thinks about entering, if he judges he's up for the nastiness such a campaign often entails.

After getting home, did it briefly cross Larry's mind to maybe send me a strawberry shortcake, by way of thank-you? I'm romantic enough to think that maybe it did. I do know that I briefly considered sending him a 1909 VDB-S penny, in tribute to all we've shared. But I ultimately decided against it. Maybe something similar went on with him. Or maybe it slipped his mind.

Oh, talk about slipping the mind: the nurse, I almost forgot. Larry is actively courting her by e-mail and plans to go back to China to see if they're meant to be together. If it doesn't take, he hopes to finish out his days in China anyway. Despite how arduous our adventure was, he grew very fond of China and considers our two months there one of the best times of his life. "Plus, way cheaper."

As for me, I'm grateful to be back with my family, pooling our body heat. My wife remains incomparable, Spencer continues to teach me about kindness, and Jeremy has taken up the sax, a development that has necessitated the return of my earplugs. The ducks are fine, again for the time being. All is temporal. "What does not change," as the old gravestones say.

One last thing to report. When the weather warmed again, after a brutal winter, I put on shorts I hadn't worn since leaving China that last night. I found a folded up, handwritten note inside my front pocket. I'll leave it to you to name the person who put it there, but she must have done so around the time I was sneaking a note into her purse. This is what it said: "If you are ever sick, come back to China and I will take care of you."

I thought that was kind of nice.

Farewell, and (Cool) Godspeed to us all.

Nice Clear Morals, as Larry Prescribed

Moral 1. Don't try to go to China for a kidney. We got the last one. However, you can take charge of your own medical destiny. You can question your health care. You can jump on a plane for wider options. In general, it is entirely possible to save your own life, as Larry did.

Moral 2. Don't let your organs die with you. Everyone should visit the Web site www.donatelife.net to see how simple it is to donate an organ or two. Additionally, the United States can reverse the donation default, the way Spain and a number of other countries have, so when you die your organs will automatically be considered available for donation, unless you specifically opted out. Finally, people can pressure their legislators to offer donors any number of inducements such as tax credits to help save the thousands of patients who die each year awaiting various transplants.

Acknowledgments

Funny thing: The last time I penned an acknowledgments page, almost a decade ago, I complained that writing was a solitary business. That's how it felt back then. But my progression as a writer has been largely one of comprehending how much help is out there in the air we breathe, and that all writing is collaborative to a greater degree than I ever imagined. *Larry's Kidney* has been a joint effort from the beginning: first with the Chinese people, who were extraordinarily gracious and kind in all their dealings with us. Then, too, the actions described herein could never have happened had not my Western contacts in China stuck their necks way, way out to help a couple of complete strangers. To the individuals of both groups, who must out of necessity go unnamed, I offer my awe for your unstinting generosity and courage.

On these relatively safe shores, the names can readily be sung. Don Snyder, novelist and screenwriter, has been my guardian angel throughout the writing. It was Don who first hammered out with me, in the course of a shared work-out session, how this book could be structured, and he has stuck by me ever since. Our colleagues at Western Connecticut State University's MFA Program in Writing, where Don and I are both writers-in-residence, have been more than supportive: They have

been inspirational. Not only mon vieux John Briggs, but also Brian Clements, Cecilia Woloch, Mark Sundeen, Paulo Corso, Elizabeth Cohen, Dan Pope, and Laurel Richards; as well as the many brilliant students who never missed a trick. Thanks also to the National Endowment for the Arts, whose support was deeply appreciated, and to Larry himself, for giving me the opportunity to help. Couldn't have done it without you, cuz.

Has ever an author had a more sterling agent-editor team than I've had? The indomitable Jennifer Joel, with her polish and nuance, and my editor, Henry Ferris, with his vision and resolve, have been staunch allies on my behalf. Together they prodded, pummeled, even withheld affection till they were satisfied I had delivered myself of the best of which I was capable. Hats off to you both.

I am indeed fortunate to have an exquisite backup team of early readers: Bonnie Friedman, Jamie Miles, Avery Rome, Lawrence Goodman, and my genius cousin S.I. Rosenbaum. Also sundry stalwarts who did me various solids: Peter Loescher, Lee Kitchen, Sue Bodine, Steve Sheppard, Andrea Cannistraci, Peter Temes, Niki Castle, Peter Hubbard, Tavia Kowalchuck, Brianne Halverson, Wendy Kaufman, Marty Resnick, Peggy Bacon, Laurel Touby, Carolyn Hessel, Dan Schnur, Anita Chakin, Mike Roberts, April from the soccer match, Maureen the best copyeditor ever, Martha and Tim, Andy and Jen, John and Fay, James and Nina, Laura and Bill, Mark and Laura, Larry and Kim, Susan and Tony, Gret and Julie, David and Penny, Cec and David, Kate and Lawrence, Ron and Stacy, Mary Jane and Mark, Rachel and Peter, Hester and Michael, Josh and Jeanne, Johnny and Teresa, Nick and Nancy, Sy and Ilene, Stephen and Jill, Ginger and John, Addison and Stacey, Liza and Barnaby, Carolyn and Tom, Merrill and Phoebe, Ellen and Jason, Gil and Graciela, Barbara and Walter, Renee and Paul, Clarice and Malcolm, Gilly and Mike.

Sacrifices were cheerfully borne, as always, by my four boys: Alex, Marshall, Spencer, and Jeremy. They all made their indelible marks on the book, though I didn't include the first two in the text because (a) they're grown, and (b) they've been victimized by me enough in ear-

lier books. Alas for her, my wife, Shelley, does not so easily escape my gratitude. Sorry, Slim. You kept the home fires blazing in a pretty stiff breeze.

In spirit, I have had Sara and M. Edward Rose with me through every step of the journey. And, lately, my mother. Thank you, dear souls.

The named above, and many more unnamed, are the real heroes of this saga—all I did was the glorious grunt work.